The British Film Institute, the government and film culture, 1933–2000

Manchester University Press

The British Film Institute, the government and film culture, 1933–2000

Edited by
Geoffrey Nowell-Smith and Christophe Dupin

Manchester University Press
Manchester and New York

distributed in the United States exclusively by Palgrave Macmillan

Copyright © Manchester University Press 2012

While copyright in the volume as a whole is vested in Manchester University Press, copyright in individual chapters belongs to their respective authors, and no chapter may be reproduced wholly or in part without the express permission in writing of both author and publisher.

Published by Manchester University Press
Oxford Road, Manchester M13 9NR, UK
and Room 400, 175 Fifth Avenue, New York, NY 10010, USA
www.manchesteruniversitypress.co.uk

Distributed in the United States exclusively by
Palgrave Macmillan, 175 Fifth Avenue,
New York, NY 10010, USA

Distributed in Canada exclusively by
UBC Press, University of British Columbia, 2029 West Mall,
Vancouver, BC, Canada V6T 1Z2

British Library Cataloguing-in-Publication Data is available

Library of Congress Cataloging-in-Publication Data is available

ISBN 978 0 7190 9574 0 paperback

First published by Manchester University Press in hardback 2012

This paperback edition first published 2014

The publisher has no responsibility for the persistence or accuracy of URLs for any external or third-party internet websites referred to in this book, and does not guarantee that any content on such websites is, or will remain, accurate or appropriate.

Printed by Lightning Source

Contents

List of illustrations	*page* vii
Notes on contributors	xi
Foreword: Sir Denis Forman	xiii
List of abbreviations	xv
Introduction *Christophe Dupin and Geoffrey Nowell-Smith*	1
1 Foundation and early years *Geoffrey Nowell-Smith*	14
2 Postwar renaissance *Geoffrey Nowell-Smith*	30
3 'Je t'aime … moi non plus': Ernest Lindgren and Henri Langlois pioneers of the film archive movement *Christophe Dupin*	46
4 The BFI and film exhibition, 1933–1970 *Christophe Dupin*	69
5 The vanguard of film appreciation: the film society movement and film culture, 1945–1965 *Richard MacDonald*	87
6 From the 1964 Labour government to the 1970 BFI crisis *Geoffrey Nowell-Smith*	102
7 The view from outside London *Melanie Selfe*	116
8 Paddy Whannel and BFI Education *Terry Bolas*	133
9 The 1970s *Geoffrey Nowell-Smith*	152
10 The Smith years *Geoffrey Nowell-Smith*	179
11 The BFI and film production: half a century of innovative independent film-making *Christophe Dupin*	197
12 The BFI and television *Richard Paterson*	219
13 The *Sight and Sound* story, 1932–1992 *Geoffrey Nowell-Smith*	237
14 A public showcase for the BFI: the Museum of the Moving Image *Lorraine Blakemore*	252
15 Towards the millennium *Geoffrey Nowell-Smith*	272
Epilogue 2011 *Geoffrey Nowell-Smith*	304
Select bibliography	310
Index	319

List of illustrations

1.1 Ernest Lindgren (National Film Library), Oliver Bell (director), H. D. Waley (technical officer) and R. W. Dickinson (deputy director) in the Great Russell St viewing theatre, late 1930s (credit: BFI) *page* 22
1.2 The BFI premises in Great Russell St, London WC1, after being hit by a German bomb in September 1940 (BFI) 24
2.1 The newly appointed BFI director Denis Forman, c. 1950 (BFI) 33
2.2 James Quinn (director 1954-1964) with the actor James Cagney at the National Film Theatre in November 1958 (BFI) 39
2.3 Organisation of the BFI in 1954/55 (BFI) 40
3.1a Handwritten draft of a letter in French from Lindgren to Langlois, c. 1956. (BFI/Ernest Lindgren Estate) 48
3.1b Handwritten note from Langlois to Lindgren, c. 1958. It translates as: 'Alas I have the feeling that you see traps everywhere. If only you knew how, beside the necessity of maintaining FIAF's unity, I have so many other things to do.' (FIAF/Henri Langlois Estate) 49
3.2 Studio portrait of Ernest Lindgren (BFI) 51
3.3 Harold Brown conducting the pioneering 'artificial ageing test' for nitrate film (BFI) 53
3.4 Caricature of Henri Langlois at the Stockholm FIAF Congress in 1959. Langlois has just seized the fan belonging to Mme Kawakita, the much-respected promoter of Japanese cinema worldwide. Drawing by Rosemary Heaword (BFI) 62
3.5 Programme for the 1969 NFT season featuring Langlois's achievements as head of the Cinémathèque française at the height of the dispute between Lindgren and Langlois in the archive movement (BFI) 64
4.1 The Telecinema, also known as the Telekinema, designed by the distinguished Canadian architect Wells Coates as part of the 1951 Festival of Britain and serving as the first home of the National Film Theatre from 1952 to 1957 (Festival of Britain) 71
4.2 A queue forms for the first Free Cinema screening at the NFT on 5 February 1956. Over four hundred people were turned away (photo courtesy of the Geoffrey Jones estate)
4.3 A programming meeting at the BFI in 1959 with, from left, Stanley Reed (BFI secretary), Peter Barnes (programmer of the One Hundred Clowns 76

	season), Richard Roud (NFT chief programmer) and John Huntley (programme controller) (BFI)	77
4.4	Poster for the 1969 Budd Boetticher season programmed by Jim Kitses of the Education Department (poster courtesy of Reg Gadney)	80
5.1	Programme of the National 35mm Viewing Sessions, May 1960 (BFI)	95
6.1	Jennie Lee at the opening of the 1969 London Film Festival (BFI)	103
6.2	Poster for Peter Watkins's film *The War Game* for which the BFI obtained cinematic distribution rights after the BBC refused to broadcast it (BFI)	107
6.3	Cartoon from the pamphlet 'A New Screenplay for the BFI' (1971) in which the Members Action Committee portrays the BFI as a pathetic imitation of the Rank Organisation whose famous resounding gong provided the opening credit for Rank films throughout the postwar period (BFI)	112
7.1	The Nottingham Film Theatre, the first of the Regional Film Theatres, opened in September 1966 in the Nottingham Co-operative Education Centre (BFI)	119
7.2	Map of the network of Regional Film Theatres from *BFI Outlook* (1968) showing 15 theatres already open (black) and a further 40 or so optimistically projected for the near future (shaded) (BFI)	121
8.1	Paddy Whannel lecturing at the Eastbourne BFI Summer School in 1957 (BFI)	135
8.2	From left to right on the panel, Brian Groombridge (University of London Extra-Mural Department), Paddy Whannel, John Huntley, the film director Lindsay Anderson, and the *Universities and Left Review* editor Stuart Hall at the Hoddesdon BFI Summer School in 1958 (photo courtesy of Garry Whannel)	138
8.3	Signboard at the BFI Education Department office at 70 Old Compton St, London W1, c. 1967 (Christophe Dupin)	141
9.1	The BFI Director Keith Lucas on the stage of NFT1 (BFI)	160
9.2	Picket line outside 81 Dean St during the 1974 BFI strike (photo courtesy of Richard Combs)	163
9.3	Structure of the BFI in 1974 (BFI)	167
10.1	Anthony Smith, BFI director from 1979 to 1988 (Carolyn Jones/BFI)	181
10.2	The Prince of Wales presents the Royal Charter to the BFI chairman Sir Richard Attenborough at a banquet at Guildhall on 5 October 1983 (Sten M. Rosenlund/BFI)	188
10.3	The BFI's benefactor, John Paul Getty Jr, plants a tree to celebrate the opening of the new Conservation Centre at Berkhamsted on 15 June 1987 (photo courtesy of Heather Davies)	192
11.1	Sir Michael Balcon, film producer, longstanding BFI governor and chairman first of the Experimental Film Fund and then of the Production Board, here in 1960 (Jack Worrow)	198
11.2	Bruce Beresford, production officer 1966–71, on the set of BFI-produced *The Adventures of X* (BFI)	203
11.3	Poster for the Bill Douglas trilogy, whose production was initiated by Mamoun Hassan (BFI)	204
11.4	BFI reception at the 1980 Cannes film festival, where *Radio On* was shown in the Directors' Fortnight section. From left, director Chris Petit, Anthony Smith (BFI director), Jeremy Isaacs (chairman of the Production Board), and Peter Sainsbury (head of Production) (Carolyn Johns/BFI)	208
12.1	Cover of the Autumn 1961 issue of the BFI's quarterly television magazine *Contrast*, which ran from 1961 to 1965 (BFI)	225

List of illustrations ix

12.2 The National Film Archive's Video Unit in Berkhamsted in the 1980s (Jim Adams/BFI) 233
13.1 Editor Gavin Lambert working on the paste-up of *Sight and Sound* with his assistant Penelope Houston, early 1950s. In 1956 Houston succeeded Lambert and remained editor of the magazine until 1991 (photo courtesy of the Lindsay Anderson Archive, University of Stirling) 240
13.2 Cover of the Winter 1962/63 issue of *Sight and Sound* with still of Richard Harris in Lindsay Anderson's *This Sporting Life*. After 1963 the magazine ceased to give enthusiastic support to the British New Wave, leading to a definitive bust-up with Anderson at the end of the decade (BFI) 245
14.1 An early sketch by Leslie Hardcastle of the projected interior of the Museum of the Moving Image (courtesy of Leslie Hardcastle) 254
14.2 The masterminds of MOMI, David Francis (curator of the National Film Archive) and Leslie Hardcastle (controller of the National Film Theatre), walking past the site of the Museum shortly before its opening in 1988 (BFI) 261
14.3 Members of the Actors Company invite visitors to enter the foyer of a recreated 1930s picture palace. The featured film is William Wyler's *Wuthering Heights* (1939) (BFI) 265
14.4 The last picture show. Leaflet advertising a last chance to visit MOMI before it closed 'for refurbishment' in 1999. It never reopened (BFI) 268
15.1 Wilf Stevenson, BFI director 1988-97 (BFI) 275
15.2 Works nearing completion on phase III of the J. Paul Getty Conservation Centre in 1992, which added a new film and video vault and a two-storey paper store housing stills, posters and designs, and the BFI Library's Special Collections (BFI) 280
15.3 The BFI London IMAX, with Waterloo Station in the background (BFI) 290
15.4 Poster for John Maybury's film about the artist Francis Bacon, *Love Is the Devil*, one of the last BFI productions to be released before the incorporation of the department into the UK Film Council in 1999 (BFI) 297

Notes on contributors

Geoffrey Nowell-Smith is Professorial Research Fellow at Queen Mary University of London. He was principal investigator on the AHRC-funded research project of which this book is an outcome. He is the editor of *The Oxford History of World Cinema* (Oxford University Press, 1996) and author, most recently, of *Making Waves: New Cinemas of the 1960s* (Continuum, 2008).

Christophe Dupin is the Senior Administrator of the International Federation of Film Archives (FIAF), based in Brussels. From 1997 to 2011 he was based in the UK, where he wrote a PhD thesis on the BFI' Production Board before becoming research assistant on the AHRC-funded project on the history of the BFI.

Lorraine Blakemore gained her PhD in History at Queen Mary, University of London. She lectures in the School of Languages, Linguistics and Film at QMUL and is a research Fellow in the Department of History at Nottingham University.

Dr Terry Bolas is author of *Screen Education: From Film Appreciation to Media Studies* (Intellect, 2009). He worked in the BFI Education Department in the 1960s and early 1970s. Recently he researched the history of SEFT (Society for Education in Film and Television).

Richard MacDonald is a researcher in the department of Media and Communications at Goldsmiths, University of London. His PhD thesis on the voluntary contribution to alternative film culture in Britain is titled 'Film Appreciation and the Postwar Film Society Movement'.

Richard Paterson has worked at the BFI since 1980 and is currently Head of Research and Scholarship. He is also Senior Research Associate of the Centre for Cultural Policy Research at the University of Glasgow.

Melanie Selfe is a lecturer in the Centre for Cultural Policy Research, University of Glasgow. Her key research areas are the policy and practice of specialist exhibition, audience reception of international cinema and the history of British film criticism.

Foreword

Sir Denis Forman

In March 1949 I was working in the Films Division of the Central Office of Information. One day my boss, John Grierson, sent for me.
'I think you should take on the BFI,' he said.
'BFI? What's that?' I asked.
'The British Film Institute,' said Grierson.
'Never heard of it,' I said. But I took the job.
It is inconceivable that any person working in film today could be unaware of the existence of the British Film Institute. But more important than the rise in status of the BFI is the rise in status of film itself.
In the 1930s film was regarded as pabulum for the masses, and not without justice. Spread across the length and breadth of the country hundreds of picture palaces ran three or four houses a day, six days a week. On a wet Edinburgh morning one could gain entry to Poole's Picture Palace at 10 a.m. for the price of two jam jars and remain there warm and dry until two sitting through a main feature, a second feature, an interest film and a cartoon, and if you felt like it see the whole cycle again.
The War gave film a new respectability and whilst the intelligentsia could still sneer at *Mrs Miniver* and *The Lion Has Wings* America had produced *Gone with the Wind* which vanquished even the most extreme sceptics. But still in the late 1940s there were only two serious film critics writing in the daily press. The upper and middle classes rarely went to the cinema except to see some 'special' films recommended by reliable friends.
It would be ridiculous to claim for the BFI the main credit for the revolution that has taken place in the status of film in Britain over the years. Film is now accepted as an art form and perhaps the most relevant art form to our daily lives, but we should remember that it was the *Sight and Sound* team that started the revolution by giving the postwar generation an entirely new focus on film and in particular gave the British a new respect for the film culture of America.
And if you want proof that film has really arrived, look at that bastion of academe the *Times Literary Supplement* and see how it now gives more space in its arts pages to film than it does opera and theatre. It's a long way from the Keystone Kops.

Alongside its role in promoting the art of film, the Institute's other main task has been the stewardship of the National Film Archive. In the early days the preservation of films was carried out by one man and two assistants and mainly by guess and by God. The main purpose of film archivists was to build a collection of rare old films which were sparingly shown to a privileged few and bought, sold and swapped between curators in the fashion of stamp collectors. Today the Archive has over forty professionally-trained curatorial and technical staff. It holds no fewer than 60,000 fiction films and 120,000 non-fiction items in a variety of formats and some 750,000 television titles. The emphasis has moved from the romance of early cinema to a more historical and social perspective. And at last the treasures of the Archive are being made available to the public through mediatheques which are spreading across the country.

In other areas the Institute's commitment has ebbed and flowed. The film societies quite properly set up their own organisation. MOMI, a great success in its day, proved too costly to maintain. Film production passed from the BFI to the Film Council, only to come back ten years later. But over the years the National Film Theatre, the powerhouse of the Institute (now renamed BFI Southbank), has from season to season and from year to year sustained a policy of imaginative and popular screenings. The British Film Institute's achievements over the past 75 years have been remarkable – and long may it continue to illustrate the art, history and impact of film.

October 2010

List of abbreviations

ABCA	Army Bureau of Current Affairs
ACAS	Arbitration and Conciliation Advisory Service
ACGB	Arts Council of Great Britain
ACTT	Association of Film and Television Technicians
AHRC	Arts and Humanities Research Council
AIP	Association of Independent Producers
ASTMS	Association of Scientific, Technical and Managerial Staff
ATV	Associated-Television
BAFTA	British Academy of Film and Television Arts (formerly British Film Academy)
BBC	British Broadcasting Corporation
BFI	British Film Institute
BFFS	British Federation of Film Societies (formerly FFS)
BFPA	British Film Producers Association
BKS	British Kinematograph Society
BSC	Broadcasting Standards Council
BUFC	British Universities Film Council (later BUFVC – British Universities Film and Video Council)
CBA	Central Booking Agency
CEA	Cinematograph Exhibitors Association
DES	Department of Education and Science
DIN	Deutsches Institut für Normung
DNH	Department of National Heritage
DTI	Department of Trade and Industry
EAS	Education Advisory Service
EFF	Experimental Film Fund
EMB	Empire Marketing Board
FAS	Film Availability Services
FBI	Federation of British Industries
FFS	Federation of Film Societies (later BFFS)
FIAF	Fédération Internationale des Archives du Film (International Federation of Film Archives)
FSU	Film Societies Unit
HCF	Housing the Cinema Fund
HMSO	Her Majesty's Stationery Office

List of abbreviations

HTV	Harlech Television
IBA	Independent Broadcasting Authority
ICA	Institute of Contemporary Arts
IFA	Independent Filmmakers' Association
IIEC	International Institute of Educational Cinematography
ILEA	Inner London Education Authority
ITCA	Independent Television Companies Association
JCEA	Joint Council for Education through Art
KRS	Kinematograph Renters Asscciation (later SFD – Society of Film Distributors)
LCC	London County Council
LFF	London Film Festival
LWT	London Weekend Television
MAC	Members Action Committee (also known as BFI Members Action Group)
MFB	Monthly Film Bulletin
MGC	Museums and Galleries Association
MGM	Metro Goldwyn Mayer
MoMA	Museum of Modern Art (New York)
MOMI	Museum of the Moving Image
NAO	National Audit Office
NCC	National Cinema Centre (never created)
NFA	National Film Archive (successor of NFL from 1955)
NFFC	National Film Finance Corporation
NFL	National Film Library
NFT	National Film Theatre
NFTVA	National Film and Television Archive (successor of NFA from 1993)
NUT	National Union of Teachers
OAL	Office of Arts and Libraries
OPC	Occasional Publications Committee
PACT	Producers' Alliance for Cinema and Television
QMUL	Queen Mary University of London
RAA	Regional Arts Association
RAB	Regional Arts Board
RFT	Regional Film Theatre
SEFT	Society for Education in Film and Television (formerly SFT)
SIFT	Select Information on Film and Television
SFT	Society of Film Teachers (later SEFT)
UKFC	UK Film Council
UNESCO	United Nations Educational, Scientific and Cultural Organisation
V&A	Victoria and Albert Museum
WEA	Workers' Educational Association

Introduction

Christophe Dupin and Geoffrey Nowell-Smith

Anybody in Britain whose interest in the cinema extends beyond what's on at the local multiplex will at some point in their lives have taken advantage of some service or activity performed or supported by the British Film Institute. They may have been members of a film society, visited the Museum of the Moving Image during its short but glorious life in the 1990s, watched films at the BFI Southbank in London or at one of the BFI's network of Regional Film Theatres, seen BFI-produced films such as *The Draughtsman's Contract* or *The Long Day Closes*, bought a video of a classic film such as *The Seven Samurai* or *La Grande Illusion*, flicked through the pages of the magazine *Sight and Sound*, used BFI teaching materials when studying for GCSE or A levels, or simply watched a documentary on television based on footage held in the BFI's national film archive. One way or another, however, and knowingly or not, it will be thanks to the BFI that their experience has been made possible.

The role to be played by the BFI in British film culture over the past half century and more was probably not foreseen by the small group of educationists who got together at the end of the 1920s to call for the creation of a national organisation to promote the role of film in education and cultural life. They got their wish, but the Institute that came into being in 1933 was small, unambitious and, in so far as it had ambitions, hampered by a film trade which saw it as a threat and established a stranglehold over its activities. The fledgling Institute did however manage to publish a magazine – *Sight and Sound*, started in 1932 and soon taken over by the BFI and still very much alive today. In 1935 it also created a National Film Library to protect films in danger of being lost or destroyed and to provide a small collection of films for loan to film societies and other interest groups.

It was only after the Second World War, however, that the BFI really became a force in British cultural life. A Committee of Inquiry, set up by the new Labour government and chaired by Cyril Radcliffe, recommended a radical reorientation of its activities – more directed towards 'the art of film' and less towards film as visual aid – and an increase in its budget to make this possible. A new director, Denis Forman, was appointed and set about revitalising the organisation. To this

period belong the establishment of the National Film Theatre, originally on the site of the 1951 Festival of Britain's Telecinema and then from 1957 at its present site under Waterloo Bridge on London's South Bank, and the BFI's first forays into film production with the so-called Experimental Film Fund. Although the fund soon ran out of money, it lasted long enough to kick-start the film-making careers not only of Karel Reisz and Tony Richardson, whose early documentaries were at the core of the 'Free Cinema' screenings at the NFT from 1956 onwards, but of such diverse figures as Ken Russell, Peter Watkins and Ridley Scott. The year 1957 also saw the inauguration of the London Film Festival and a slow but steady growth in BFI activities across the board, leading to a move to enlarged West End headquarters in Dean St, Soho, with a proper reading room for the library, a stills collection, and (some years later) viewing facilities for archive films. Meanwhile the National Film Library was growing in size and status, changing its name to National Film Archive in 1955. This growth was to continue exponentially as the years went on. In 1961 the BFI changed its statutes to include television in its remit and shortly afterwards began archiving ITV broadcasts. The Archive's role as official custodian of ITV1, Channel 4 and the new Channel 5 was officially recognised in 1993 when it changed its name again, to become National Film and Television Archive. It is now called BFI National Archive and is the largest and most prestigious film and television archive in the world.

A further phase in the BFI's development as a truly national body came with the 1964 Labour government, which provided funds to enable the creation of a nationwide network of Regional Film Theatres and the transformation of the moribund Experimental Film Fund into the BFI Production Board. Although in the early stages many of the RFTs were little more than glorified film societies, a refocusing of activity in the 1970s and 1980s was to lead to the setting up of major film and media centres such as Bristol Watershed and Manchester Cornerhouse and of film production workshops both in London and in the regions. As for the Production Board, its portfolio of successful films grew by the early 1980s to include the Bill Douglas trilogy (1972–78), Horace Ové's *Pressure* (1975), Chris Petit's *Radio On* (1979), Peter Greenaway's *The Draughtsman's Contract* (1982) and Ed Bennett's *Ascendancy* (Golden Bear at Berlin in 1983). At the same time the BFI's education department was not only growing but pioneering new approaches to the study of film at secondary school and university level. These educational developments had a logical outcome in the form of an array of new publications and the creation of a new publishing arm in 1980.

The form taken by this expansion brought controversy in its wake. In the late 1960s a group of young activists calling themselves the BFI Members Action Committee fiercely criticised the BFI for being middle-of-the road and dedicated to a narrow concept of art cinema at the expense of popular culture on the one hand and the radical avant-garde on the other. In the 1970s attacks came mainly from the opposite quarter. The radicals were now making most of the running inside the BFI and it was the traditionalists who taxed them with elitism and with neglecting

Introduction

the BFI's core constituency of mainstream film lovers. It took all the political skills of a new director, Anthony Smith, who took office in 1980, to square the circle. Along with a new chairman, Sir Richard Attenborough, Smith brought the Institute back into the mainstream by arranging the grant of a Royal Charter, presented by the Prince of Wales in 1983; in the difficult circumstances created by the 1979 Conservative government (whose first step was to cut the BFI's grant) he transformed its financial position by securing private sponsorship. most notably from John Paul Getty Jr; the Institute's public reach was massively expanded through the Museum of the Moving Image, of which Getty was the principal sponsor, and through a deal with Channel 4 Television for the co-production and televising of Production Board Films – and all this without blunting the radical edge of the BFI's cultural and educational initiatives.

The late 1980s marked the zenith of the BFI's public standing and successful outreach. In the early 1990s the BFI made an attempt to overcome decades of suspicion on the part of the trade by putting itself forward as 'advocate' for the British film industry. This culminated in a proposal to bring together the two sides of government support for cinema, cultural and industrial. In 1997 the incoming Labour government did precisely that, but instead of the BFI acquiring a new strategic role it found itself subordinated to a new body, the UK Film Council, to which it was forced to cede its production arm and regional support. At the time of writing another new administration, the Conservative and Liberal Democrat coalition formed in 2010, is in the process of returning the BFI to its historic status as a direct recipient of grant-in-aid from government, but whether this will involve restoring to it the limbs amputated in 1998 and 1999 remains to be seen. Whether in the changed media environment of the early twenty-first century the BFI will regain the cultural pre-eminence it enjoyed in the second half of the twentieth is also doubtful. What remains in no doubt, however, is that it once was pre-eminent and this pre-eminence is something to be celebrated.

Amazingly, this dramatic story has never been told before, either in whole or (for many aspects) in part. In fact the BFI fares singularly poorly in the public record. It barely seems to figure in major works of contemporary history, including the official biographies of politicians such as Herbert Morrison and Jennie Lee who, in 1948 and 1964 respectively, did so much to make the BFI what it was to become.[1] The only politician whose memoirs have much to say about the BFI is Hugh Jenkins, Lee's successor as Minister for the Arts in the early 1970s, and what he has to say is mostly disparaging.[2] Its absence from the history books is partly due to the ambiguous status of cinema in British cultural life, uncomfortably squeezed between 'the arts' and popular entertainment. But it is also the case that most of what specialist writing as does exist about the BFI is precisely that – highly specialist, with on the whole few links to the historiography of the wider world in which the BFI functions. This lack of public profile was something of which the BFI itself was aware back in 1969, when it commissioned a short history of itself. Written by Ivan Butler and entitled *To Encourage the Art of the Film: The Story of*

the British Film Institute,[3] the book had the misfortune to appear in 1971, just when the BFI was in the throes of a crisis from which it was to emerge a radically different organisation from the cosy outfit the book set out to celebrate.

With the rise of film studies as an academic discipline, beginning in the late 1970s, the BFI and the activities it supports have been the subject of a number of articles in scholarly journals and of a handful of PhD dissertations, all except one so far unpublished. It has also been the object of much anguished debate in specialised circles, sometimes spreading out into the wider culture. Rarely, however, does the debate recognise quite what an important organisation the BFI has been and still is, how many publics it has served over its 75-year history, and what the role of successive governments has been in supporting (or not supporting) its multifarious activities over the years.

The research project

It was to address these manifold gaps in knowledge and awareness that, in 2003, Richard Paterson at the BFI convinced his colleagues that it was time for the BFI's history to be revisited in its entirety and made the object of scholarly research. It was clear from the outset, however, that this research would need to be properly resourced. The principal primary source of information would have to be the BFI's own records, which were voluminous but haphazardly catalogued and not necessarily complete. For an archiving institution and one which moreover prided itself on the quality of the cataloguing of its film and video holdings, the BFI had over the years been singularly indifferent to the archiving of its own records. Before any history writing could commence, therefore, a considerable work would have to be done on assembling, ordering and cataloguing the primary source material. A 'rough list' had been prepared in 2001 of the boxes of documents held at the BFI's Conservation Centre in Berkhamsted and another store in the nearby village of Northchurch, but it was less than a full catalogue and besides it was by no means certain that what was contained in the boxes was anything like a complete record. Paterson therefore approached Geoffrey Nowell-Smith, then at the University of Luton, to prospect the idea of obtaining a research grant from the Arts and Humanities Research Council (AHRC). With Paterson's help, Nowell-Smith prepared a bid under the title 'The British Film Institute, the Government and the Film Culture, 1933–2003' – emphasising in the title the fact that what was intended was not an inward-looking institutional history but one which looked at the BFI in its cultural and political context. The bid was successful. The timescale envisaged starting work in the autumn of 2004 with research to be completed by March 2008, in time for the BFI's 75th anniversary due to be celebrated that autumn.

Research started in October 2004 as planned, with Christophe Dupin (then in the process of completing a PhD on the BFI Production Board) appointed as research assistant, and with a PhD student, Lorraine Blakemore, also attached to the project. By then, however, arrangements had been made to transfer the grant

Introduction 5

to the History Department at Queen Mary University of London, which offered a more propitious intellectual environment for the research. An academic advisory board was set up, which met regularly during the course of the project. Leslie Hardcastle, former controller of the National Film Theatre and the Museum of the Moving Image and a mine of information on the BFI's history, was invited to act as special consultant to the project. A dinner was held, hosted by Anthony Minghella, then chairman of the BFI board of governors, and attended by the former chairman Richard Attenborough and former director Anthony Smith as well as the current director Amanda Nevill, to give the BFI's formal blessing to the project.

The first thing the research team discovered on starting work was that the BFI's records were in an even worse state that we had already feared. The state of relatively recent records was not too bad. When deputy director in 1987, Wilf Stevenson had issued instructions to departments to send all important but no longer operational documentation to the Berkhamsted paper store and, when he became director the following year, instituted a system of central record-keeping which meant all papers reaching the directorate were systematically filed and sent to store in good order. But for all earlier periods, chaos reigned. There was a more or less complete set of minutes of meetings of the board of governors (also available on microfilm at the BFI Library), but these were not always accompanied by copies of the papers discussed by the board. For example, no copy could be found, either in the governors' papers or anywhere else, of the sub-committee report to the board on the Education Department, prepared by Professor Asa Briggs, which had precipitated a major crisis in 1971, leading to the resignation of the charismatic head of education Paddy Whannel later that year. (In spite of diligent searches in the BFI records and elsewhere, this crucial document has still not come to light.) Meanwhile, in addition to the boxes catalogued in 2000–1 by Nick White, assistant curator of BFI Special Collections, others kept being uncovered. Within the Berkhamsted Conservation Centre itself there were boxes which had not been put in the climatically controlled paper store because they were contaminated by mould. When decontaminated and made safe to consult, these boxes proved to contain, among other things, the rich correspondence described in Chapter 3 of this volume between Ernest Lindgren, curator of the National Film Archive, and his famous counterpart at the Cinémathèque française, Henri Langlois. A large cache of boxes, mainly relating to the NFT and MOMI, was found in a storeroom in Waterloo, many suffering from damp. Besides those in Northchurch, already mentioned, there were boxes in another warehouse in Tring, a few miles away. Even as late as 2010 key historical records were still being found. The BFI's recent decision to sell the Ernest Lindgren House, the eighteenth-century building on the Berkhamsted site, meant that the house had to be cleared: it proved to contain, among other documents, the only known copy of a 1986 report to the Resources Committee which prefigured the shift of emphasis in BFI activities from 16mm to video as an alternative to 35mm. As Dupin worked to incorporate the new findings

into the catalogue and he and other members of the team added more detailed cataloguing information about the contents of the boxes, White's original rough list (a MS Word document) grew from 147 to 505 pages, with the archive more than tripling in volume from 419 to 1355 boxes.

Besides the BFI's records, supplemented by documents from elsewhere, such as the National Archives in Kew, the Cinémathèque française in Paris and FIAF's headquarters in Brussels, as well as the personal collections of several former BFI staff members, the main source of information for this research has been interviews with surviving participants in BFI affairs.

Interviewees (for a full list see pp. 10–12) include former chairmen (Sir Denis Forman, Lord Attenborough, Jeremy Thomas), former governors, directors (Denis Forman again, James Quinn, Keith Lucas, Anthony Smith, Wilf Stevenson, John Woodward), deputy directors (Alan Hill, Gerry Rawlinson, Michael Prescott, Jane Clarke) and staff both past (the earliest joined in 1936) and present. A number of these interviews were made on video 'for the record'. Others were on audio or simply noted down in the traditional reporter's notebook. A number of tapes and transcripts are being lodged with the BFI to be made available for consultation. Some, however, were definitely off the record and cannot be made available without the consent of the interviewee.

After funding ran out for the main research we applied for, and were awarded, a further grant in conjunction with the BFI under the AHRC's Knowledge Transfer scheme. This enabled us to transfer the historical knowledge acquired during the initial phase of the project back to the BFI, for the benefit of not only its staff but also researchers in that field and the wider public interested in cinema and cultural history. In practice, this meant launching a vast programme of digitisation of historical documents covering the 75 years of the BFI's history, ranging from constitutional papers and a selection of important policy papers and minutes, to various reports and catalogues published by the Institute (including all annual reports since 1934), publicity material covering all BFI activities and all periods, press cuttings, correspondence, photographs and examples of the BFI's corporate branding over the years. The digital collection thus created now contains over fourteen thousand single digital files stored on several hard drives. The next stage of this project was the incorporation of this vast collection into an in-house digital asset management system and the creation of an online resource giving immediate access (in a contextualised form) to thousands of those digitised documents which collectively represent the entire history of the organisation. Because of a number of unforeseen (mainly technical) problems, the web-resource is yet to go live online although progress continues to be made even as we write. Also as part of the 'knowledge transfer' exercise, we curated two exhibitions celebrating 75 years of the BFI (September 2008) and of the BFI National Archive (August 2010) at BFI Southbank. We have also acted as the BFI's clearing house for all matters relating to its history, helping both BFI staff and outside researchers on a near daily basis. Finally, the project continued to add to the BFI paper archive's catalogue as

Introduction

more records were found, and after one last clean-up it was officially handed over to the BFI's Special Collections in December 2010. The catalogue is now in the process of being made available to the public, who will therefore shortly be able to fully access, for the first time, this unique collection.[4]

The book

The state of the documentation has largely dictated the form taken by this book. The more documents we uncovered (or in some cases, failed to uncover), the clearer it became that an exhaustive history of the BFI and its various components would be way beyond the scope of a 300-page book – or even a 500-page book if any publisher could be found for such an undertaking. It would also require many months, if not years, of further sifting through papers and assessing their significance. The history of the BFI Production Board, of the BFI's activities in the regions, of the BFI's pioneering role in film education, of the National Film Theatre and, above all, that of the Archive, each requires a volume of its own, and no doubt in due course these volumes will be written. So what the editors decided, with the support of the Advisory Board, was that Geoffrey Nowell-Smith would be responsible for the 'grand narrative' of the BFI's history from 1933 to 2000, providing a documented overview in breadth of all major events, while the rest of the book would consist of a number of probes in depth, conducted by members of the research team and outside contributors, into particular significant aspects of the history of the BFI and the surrounding culture. Christophe Dupin contributes three chapters: one on BFI production; one on the BFI's first forays into film exhibition culminating in the foundation of the National Film Theatre and the London Film Festival; and one on a crucial episode in the history of the film archive movement, opposing Ernest Lindgren, curator of the National Film Archive and dedicated conservationist, and Henri Langlois, founder of the Cinémathèque française and a passionate believer in showing prints of films even if that put their preservation at risk. Lorraine Blakemore summarises some of the research she did on the Museum of the Moving Image for her PhD as part of the project. Richard Paterson examines the BFI's growing involvement with television as a companion art and industry to cinema. Geoffrey Nowell-Smith also tells the story of the BFI's flagship magazine *Sight and Sound* from its foundation in 1932 (preceding the BFI itself) to the mid-1990s. In addition there are three chapters from outside contributors: Melanie Selfe on film culture outside London and the formation of the Regional Film Theatre network, Richard MacDonald on the film society movement, and Terry Bolas on film education. The authors of these chapters are all members of a small research group set up in the early stages of the project to bring together scholars working in fields directly or indirectly related to the history of the BFI and elaborate on papers given at a conference held at Senate House in the University of London in November 2006. These three chapters also provide a balancing perspective, since they are written from a standpoint which is not that of the BFI as

institution and offer a salutary reminder that other forces were at work in shaping film culture in Britain, not always in a harmonious relationship with the BFI.

Another decision taken in the course of the research and again approved by the Advisory Board was that the story told in the book should effectively end in 2000, rather than in 2003 as originally planned. Although source material exists for more recent history, the confused state of the BFI since the takeover by UK Film Council, augmented by the present government's announced intention to abolish the Council while failing to make clear what this would mean for the future of the BFI (not to mention making a major cut in the BFI's government grant), makes recent events hard to evaluate in properly historical terms. With everything in a state of flux, we have decided to end the book with an Epilogue giving a thumbnail sketch of recent developments up to the time the book went to press.

Acknowledgements

This book could not have been written without help from many quarters. Our thanks are due, first of all, to the Arts and Humanities Research Council, which provided the grant that made the research possible, and to the Department of History at Queen Mary University of London, which housed the research team and supplied seamless administrative support and intellectual encouragement throughout the duration of the project. Among individuals at Queen Mary we would single out Dr Virginia Davis, who as head of department took the necessary steps to secure the grant for the university, and the late Professor John Ramsden, whose enthusiasm for the project was a constant inspiration to us. Eugene Doyen from the Department of Film helped us with the first video interviews, after which Louis Jackson took over in that role. Jackson also helped with editing the interviews, entirely beyond the call of duty. Thanks are due also to the BFI, collectively and in the person of certain individuals in particular, starting with the former chairman Anthony Minghella whose sudden death on 18 March 2008 was a grievous loss to the BFI and to film-making in Britain. Leslie Hardcastle was generous with his expertise over the length of the project, and Richard Paterson, as well as contributing a chapter to this book, was continuously supportive and helped smooth the way to obtaining co-operation from the BFI across the board. Heather Stewart, head of UK Wide, was likewise supportive of the project, as were other senior staff. Most help, however, came from the BFI National Library and its staff, notably David Sharp, head librarian; Sean Delaney, library services manager, together with the rest of his team; Janet Moat, curator of Special Collections, and her successor, Nathalie Morris; and above all Carolyne Bevan, also in Special Collections, who looked after us during our visits to the Conservation Centre in Berkhamsted. In other departments we should like to thank Nigel Arthur and Dave McCall in Stills and Kathleen Dickson in the BFI National Archive. Elsewhere, particular thanks are due to Laurent Mannoni and Laure Parchomenko at the Cinémathèque française in Paris and Christian Dimitriu at FIAF in Brussels.

Introduction

Most importantly, however, we should like to thank the many, many people listed below who gave up their time to be interviewed by members of the team as part of the project and whose combined recollections of the BFI at various parts of history were as important a source for the book as the documents consulted. Besides people actually interviewed we should also like to thank the following people who supplied materials, answered queries or provided useful information on the phone or by email: Kevin Brownlow, Vida Guinn (Library Association), John Lindgren, Angela Martin, Guy Penman (London Library), Jonathan Rosenbaum, and Garry Whannel. Many thanks, too, to Christopher Bray for help in pulling some unruly parts of the manuscript back into shape, and to our copyeditor at MUP, John Banks, for his meticulous work on the whole manuscript. Any surviving errors or infelicities of style are, of course, entirely the responsibility of the editors.

Sources

BFI papers

These are held by the BFI National Library as part of its Special Collections, housed at the John Paul Getty Conservation Centre in Berkhamsted. They are kept in numbered boxes of various sizes, some of which contain a number of separate folders. Some boxes just have a number (they are boxes in the general sequence of miscellaneous and isolated boxes) while others have a number preceded by a letter, which corresponds to their belonging to a large sub-collection – D for Directorate, A for National Film and Television Archive, P for production, etc. Footnote references to these papers are in the form BFI/D-86/8 – i.e. BFI Paper Archive, Directorate Box D-86, folder 8. Minutes of the board of governors are held in a series numbered G-1 to G-44, but since these minutes are available on microfilm in the BFI Library at 21 Stephen St, London W1, they are referenced in the book by date rather than by box number. Also in the Library at Stephen St and readily available for consultation are a complete set of BFI Annual Reports from 1933 and a collection of press cuttings relating to the BFI and its various activities.

Other BFI collections

The BFI National Library also holds a number of other Special Collections, of which occasional use has been made in this book. References here take the form BFI/Balcon/K-48, etc.

National Archives (formerly Public Record Office)

Files in the former Public Record Office bear the prefix NA, followed by file number.

Other collections

Files from the archives of the Cinémathèque française are cited with the prefix CF and those from the International Federation of Film Archives with the prefix FIAF. Those from private collections acknowledge the holder by name.

List of Interviewees[5]
Directors, deputy directors and chairs
Denis Forman [v]
James Quinn [v]
Alan Hill
Keith Lucas [v]
Gerry Rawlinson
Anthony Smith [v]
Richard Attenborough [v]
Wilf Stevenson [v]
Michael Prescott
Jane Clarke
Jeremy Thomas
John Woodward
Jon Teckman

Governors
Matthew Evans
Nicholas Garnham
Christopher Frayling
Alan Howden
Anthony Sloman
Brian Winston

Heads of division/department
Leslie Hardcastle (NFT) [v]
Penelope Houston (Editorial)
Bruce Beresford (Production)
Mamoun Hassan (Production)
Barrie Gavin (Production)
Kevin Gough-Yates (NFA)
David Francis (NFA)
Michelle Aubert (Stills, then deputy curator NFA)
Colin McArthur (Distribution) [v]
Douglas Lowndes (Education)
Peter Sainsbury (Production)
Ian Christie (Distribution)
Colin MacCabe (Production, Research)
Philip Simpson (Education)
Clyde Jeavons (NFA)
Sheila Whitaker (NFT) [v]
Irene Whitehead (Funding)
Adrian Wootton (NFT)
Manuel Alvarado (Education)
Ed Buscombe (Publishing)

Introduction 11

Other BFI (alphabetical)[6]
Nigel Algar (Distribution, NFA)
Manuel Alvarado
Brian Baxter (NFT) [v]
Charles Beddow (Regions, NFT) [v]
Susan Bennett (Education)
Harold Brown (NFA) [v]
Elaine Burrows (NFA)
Paul Collard (South Bank)
Richard Combs (Editorial)
Heather Davies (NFA) [v]
Barrie Ellis-Jones (Funding)
Pam Engel (NFT)
Colin Ford (NFA)
Reg Gadney (NFT)
June Givanni (Afro-Caribbean Unit) [v]
Peter Harcourt (Education)
Mo Heard (MOMI)
Liz Heasman (MOMI)
Stephen Herbert (MOMI)
Frank Holland (NFA, Distribution)
Clare Kitson (NFT)
Marysia Lachowicz (MOMI)
Alan Lovell (Education)
Helen Mackintosh (MOMI)
Paul Madden (NFA)
David Meeker (Distribution, NFA) [v]
Rod Morgan (Finance)
Ian Nelson (Finance)
Margaret O'Brien (MOMI)
Jill Pack (Production)
V. F. Perkins (Education)
Jim Pines (Education, Funding) [v]
Neal Potter (MOMI)
John Pym (Editorial)
Jane Roberts (MOMI)
David Robinson (Editorial, NFT) [v]
Deac Rossell (NFT)
Elizabeth Russell (Library)
Rochelle Slovin (MOMI)
Mary Smith (NFA, Library) [v]
Ann Wheeler (NFA) [v]
Jan Wilkinson (NFA [v]
Christopher Williams (Education)

Ken Wlaschin (NFT)
Peter Wollen (Education)

Politicians and civil servants
Gerald Kaufman
Chris Smith
Rodney Stone (OAL)

Outside the BFI
John Lindgren [v]
John Newbigin
Donata Pesenti-Compagnoni (Museo del Cinema, Turin)
David Puttnam
Linda Redford

Academic Advisory Board

Charlotte Brunsdon (University of Warwick)
John Caughie (University of Glasgow)
Ian Christie (Birkbeck, University of London)
John Ellis (Royal Holloway)
Mark Glancy (QMUL)
Peter Hennessy (QMUL)
Luke Hockley (University of Bedfordshire)
Colin MacCabe (Birkbeck, University of London)
Richard Paterson (BFI)
Vincent Porter (University of Westminster, emeritus)
John Ramsden (QMUL)
Philip Schlesinger (University of Glasgow)
Jean Seaton (University of Westminster)
Sarah Street (University of Bristol)
Neil Watson (UK Film Council)

In memoriam

Finally we must report with deep regret the deaths that occurred during the project of people who contributed to it in various ways.
James Quinn (1919–2008)
Harold Brown (1919–2008)
Anthony Minghella (1954–2008)
Manuel Alvarado (1948–2010)
John Ramsden (1947–2009)

31 January 2011

Introduction

Notes

1 Bernard Donoughue and G. W. Jones, *Herbert Morrison* (London: Weidenfeld and Nicolson, 1973); Patricia Hollis, *Jennie Lee: A Life* (Oxford: Oxford University Press, 1997).
2 Hugh Jenkins, *The Culture Gap* (London: Marion Boyars, 1979). Although abrasive in his comments, Jenkins was in fact a very supportive minister.
3 Ivan Butler, *To Encourage the Art of the Film: The Story of the British Film Institute* (London: Robert Hale, 1971).
4 A word of warning for future researchers: although a number of boxes were catalogued at item level (to meet the needs of our research project), the majority remain for the time being listed at a more general (usually folder) level. This means that the search for a specific document in the catalogue might not be successful even though the document required is likely to be in the collection.
5 V = video interview.
6 Both jobs and department titles could change, so the indication of the areas people worked in is only a rough guide to what they did and where at different points in their career.

1

Foundation and early years

Geoffrey Nowell-Smith

To use a term not in use at the time, there were basically two film cultures in Britain in the late 1920s. The first, majoritarian and taking its cue mainly from America, saw the cinema – 'the pictures' or 'the movies' ('talkies' were still barely on the horizon) – primarily as entertainment, while recognising that this entertainment was there only because supported by an industry. The locus of this culture was the picture-houses which were a growing feature of the urban and suburban landscape, but also newspapers and fan magazines such as *Picturegoer* (founded 1921) as well as the trade press. The second, decidedly minoritarian, and taking its cue from France, saw, or imagined, the cinema – or 'the film' – as art, and had its locus in such places as the Film Society (founded in 1925 on the initiative of Ivor Montagu and Hugh Miller)[1] and the magazine *Close Up* (1927–33).[2] The two cultures were not completely mutually exclusive. The film directors Adrian Brunel and Anthony Asquith were both leading lights of the Film Society. Alfred Hitchcock was also a member. Another founder member, Iris Barry, who went on to found the Film Library of the Museum of Modern Art in New York, wrote in the *Daily Mail* as well as in the *Spectator*, while on the literary front modernist novelists such as Virginia Woolf and Dorothy Richardson (the latter in *Close Up*) wrote about popular film and the experience of going to the movies. For the most part, though, the two sides tended to look at each other with mutual suspicion.

There were however the makings of a third film culture also in existence, with very little connection to either the entertainment or art film cultures. This was a culture of film envisaged as a medium of communication and more narrowly of communication for educative or instructional purposes. This had a long history, going back to pre-cinema days and the experiments of Étienne-Jules Marey in the 1880s. It had its institutions, both in Britain and internationally, notably the International Institute of Educational Cinematography (IIEC), affiliated to the League of Nations from 1928 onwards and based in Rome. As a movement it had little cohesion but the general idea that more could and should be done with the film medium than use it as a vehicle for entertainment regarded as generally low-grade was one that received widespread, if often passive, assent among educated people in Britain.

Foundation and early years

It was in this third culture, such as it was, that the idea germinated for what was to become the British Film Institute.

The Commission on Educational and Cultural Films

The starting point was a conference organised by the British Institute for Adult Education and the Association of Scientific Workers, held in London in November 1929 and attended by about a hundred people from various branches of the educational world. The main moving spirit behind the conference was J. W. Brown, secretary of the British Institute of Adult Education, and the upshot of it was the setting up in December of a Commission on Educational and Cultural Films, with Brown again in the forefront. The terms of reference the Commission set itself were these:

> 1. To consider suggestions for improving and extending the use of films (motion pictures and similar visual and auditory devices) for educational and cultural purposes, including use as documentary records.
>
> 2. To consider methods for raising the standard of public appreciation of films, by criticism and advice addressed to the general public, by discussion among persons engaged in educational or cultural pursuits, and by experimental production of films in collaboration with professional producers.
>
> 3. To consider the desirability and practicability of establishing a central permanent organisation with general objects as above.[3]

The chairman of the Commission was the retired educationist Sir Benjamin Gott and its secretaries were Brown and A. C. Cameron, director of education for the City of Oxford and husband of the novelist Elizabeth Bowen. The choice of the other members of the Commission is interesting. Representatives of the existing film cultures were notable by their absence. There were two film producers, M. Neville Kearney and H. Bruce Woolfe of British Instructional Films, both from the Film Industries Department of the Federation of British Industries (FBI), but no one from the world of film distribution, exhibition or popular journalism. The trade may have been approached and refused, but it is more likely that a decision was made that that the presence of trade representatives as such would be irrelevant or even obstructive. There was no one at all from the Film Society or from the documentary movement that was beginning to grow up alongside it. The nearest thing to a film critic was St John Ervine, drama critic of the *Observer*. Cameron made no attempt to tap up anyone from the literary circles frequented by his wife. Apart from a couple of his friends from Oxford, J. L. Myres, professor of ancient history, who served as vice-chairman, and the literary scholar Lord David Cecil, there was no one from the higher echelons of the intellectual establishment of the day and there was no one from the churches. Most members of the Commission were educationists of one kind or another – teachers, lecturers, local education authority officers, etc. Representing the public libraries was Duncan Gray, later an

important figure in the Library Association, and there were scientists, civil servants and local councillors. The representatives of the Federation of British Industries were counterbalanced by a trades unionist, C. T. Cramp of the National Union of Railwaymen, best known for having persuaded the TUC General Council to call a halt to the 1926 General Strike. The general principle governing the composition seems to have been that it should be a spectrum of middle-of-the-road opinion, with broad regional coverage and eschewing in equal measure the great and the good and the great unwashed. Besides Cameron and Brown, the Commission also contained two other figures who were to play a role in the affairs of the BFI when it was founded: these were R. S. Lambert, editor of the *Listener*, and Sir Charles Cleland, then on the Corporation of Glasgow Education Committee, who became a governor and the Institute's de facto chairman from 1933 to 1936 and actual chairman from 1936 to 1937. Listed as an 'Additional Member' of the Commission was Oliver Bell, who became director of the BFI in 1936 and held that post until January 1949.[4]

At its foundation, the Commission had no money, whether from government or other sources (the government sent observers to its meetings but refused official endorsement). In June 1930, however, it was given a two-year grant (later extended) by the Carnegie Trust, which enabled it to have an office and clerical assistance. A second conference of the sponsoring organisations was held in November 1930, and in July 1931 Cameron began to draft the Commission's report. Gott took charge of relations with the film trade, which at this stage was guarded but not unfriendly in its approach to the Commission and its activities. Members of Parliament were also approached and in March 1932 a deputation from the Parliamentary Film Committee went to see the home secretary, Sir Herbert Samuel, to canvass government support for the setting up of a national film institute.

The Commission's report was published in June 1932, under the title *The Film in National Life*. It set out the case for the importance of film, culturally and as an educational tool, and proposed the creation of a national film institute, funded by government sources, to pursue these objectives. It also noted, more or less in passing, the useful role that could be played by a national film library.[5] The government was sympathetic. Samuel indicated a willingness for the proposed national film institute to be funded via the Privy Council with money raised from the Cinematograph Fund out of a tax on Sunday Entertainments. The trade, however, was not so pleased. It resented both the Sunday Entertainment bill (passed by a narrow majority on 29 June) and the idea of an institute. According to Rachael Low,[6] it was the word 'cultural' that set the alarm bells ringing. So long as the new institute confined itself to educational and instructional films, all was well. But if, under the banner of raising cultural levels, the institute began to interfere in matters such as censorship, or simply engage in denigrating standard movie-house fare, and if furthermore it were to do so with funds raised by taxing popular entertainment, then the trade saw an unwarranted threat to its interests. In this respect, it felt it could rely on the sound philistinism of both Houses of Parliament, which

Foundation and early years

had shown a few years earlier, in debates on the 1927 Films bill, that, as far as the majority of legislators were concerned, cinema was first and foremost an industry and the role of the film in national cultural life no concern of theirs.[7]

The trade drove a hard bargain. It reluctantly accepted the idea of an institute and the provision that it could be financed by a proportion of the monies raised under the Sunday Entertainments Act. But in an exchange of letters in the correspondence columns of *The Times* in August 1932, Brown and Cameron were pressured into affirming the 'disinterestedness' of the Institute in relation to the trade.[8] The expression was meaningless, but it contributed to putting the institute on the back foot from the outset. More importantly, the trade persuaded the government that one-third of the membership of the institute's governing body should consist of trade representatives – one each from the production, distribution and exhibition sectors – and that one or other of the senior officers of the institute should also be a trade nominee. After protracted negotiations, the trade and the educationists finally agreed a draft constitution for the proposed institute to present to the Home Secretary in February 1933.

Having broadly speaking achieved its objectives, the Commission on Educational and Cultural Films closed down in August 1933 and on 30 September the new British Film Institute was incorporated as a Company Limited by Guarantee under the Companies Act. (The Commission had hoped it would be incorporated under Royal Charter, but it was not to achieve that elevated status until 1983.) It had a governing board of nine members. The three trade nominees were C. M. Woolf of the FBI Film Department, representing the producers, F. W. Baker of the Kinematograph Renters Society (KRS) for the distributors, and Thomas Ormiston of the Cinematograph Exhibitors Association (CEA).[9] Balancing them were three education members, Cameron, Lambert and Cleland. There were then three further members to represent the 'public interest'. These were the novelist and Conservative MP John Buchan, a director of British Instructional Films and a vigorous supporter of the new Institute both in Parliament and outside from the outset; the Labour MP John Lawson; and Lady Levita, whose husband Sir Cecil Levita was to play a curious role later in the Institute's affairs. Provision was also made for there to be a chairman, but for the time being the post was vacant.

The first years

After this long period of gestation, the British Film Institute actually opened its doors, in rented premises in Great Russell St, London WC1, in November 1933. Before that, however, and even before its formal incorporation, it held a first meeting of its board of governors, with Sir Charles Cleland in the chair. The first thing the meeting did was bring out the begging bowl. It passed a resolution to request money from the Privy Council and also requested £500 each from the CEA, the KRS and the Film Department of the FBI, plus whatever was left in the kitty from the Commission on Educational and Cultural Films. It then approved

the appointment and salaries of the Institute's officers, the uncomfortable duumvirate of the educationist J. W. Brown as General Manager (£750 p.a.) and trade appointee R. V. Crow as Secretary (£500 p.a.). The board also needed to appoint a chairman. Cleland proposed the name of the Duke of Sutherland, who was duly appointed by the government and was to remain chairman until 1936, when Cleland took over. His Grace, however, was never much more than a figurehead. He attended few board meetings during his years in the chair, leaving all the business to Cleland and, from 1937, Cleland's successor, Sir William Brass.[10]

Once established, and with the Privy Council's first annual grant of £5,000 gratefully received,[11] the new Institute had to decide what it would actually do and how it could do it. Cameron and the educational faction more or less knew what they wanted to do, while the trade faction was more or less clear on what the Institute should be stopped from doing, which was interfering in matters that affected their business. This did not in fact lead to complete deadlock, because there were a number of broadly educational initiatives the Institute could take which the trade either supported or at the least was not unanimous in opposing.

The simplest and least controversial thing the Institute saw itself as doing was promoting the circulation of educational films, which generally took place on 16mm. It reached agreement with the trade that it would take responsibility for vetting educational films so that they did not have to pass through the British Board of Film Censors. It also successfully lobbied the government to accede to a resolution passed by the IIEC at its Congress in January 1933, calling for the abolition of customs duty on the export and import of educational films between member nations. This in fact took the best part of two years to achieve, but was a useful practical measure. Less successful was its attempt to establish a technical standard for 16mm sound-on-film projectors and film stock. Taking advice from abroad and from the British Kinematograph Society, the BFI opted in 1934 for the German DIN standard, but this turned out to be incompatible with existing standards for silent films, with the result that first the British Standards Institute and then the BFI had to revoke the decision and opt for the rival American standard two years later.[12]

At the time the BFI was founded, the Home Office was in the process of drafting new regulations on the dangers of fire caused by film projection outside licensed cinemas. Word had got out that it had succumbed to trade pressure to bring the projection of acetate, or safety, film under the same tight regulations as nitrate, which would have been a serious blow to film societies and educational institutions.[13] Challenged by the BFI, the Home Office denied this and assured the BFI in September 1934 that the new regulations would scrupulously separate public-order and safety issues so that projection of films on the safety stock recently recommended by the British Kinematograph Society for use in schools and elsewhere could take place unimpeded.[14] But at the beginning of 1935 a curious event took place which called the Home Office's bona fides seriously into question. A miners' film society in Jarrow in the north-east of England was taken to court for

Foundation and early years

publicly projecting a film judged to have posed a fire hazard. A Home Office expert, one Lt.-Col. Simmonds, appeared as a witness for the prosecution and attempted unsuccessfully to demonstrate in court that acetate stock could catch fire as easily as nitrate. When it emerged that what was inflammatory about the projection was not the film stock but the film itself – described as '*Potemkin*, a Russian film' – the case was ignominiously dismissed.[15] But the BFI remained concerned and its concerns were not assuaged until the legislation was finally published in 1939 and the safety of acetate stock officially confirmed.

At this point the fledgling Institute was on a steep learning curve. Principally, the Jarrow episode taught it not to trust the Home Office. But there was a second lesson, which it was beginning to learn and which the episode reinforced. This was that the trade was divided in its attitude to the Institute's activities. The spread of non-theatrical film screening did not worry the distribution side of the trade so long as rental fees were paid, but it was seen as a threat by the exhibitors to the extent that it took away business from public cinemas. Although the two sides put on a united front in their official dealings with the BFI through their representation on the board of governors, in practice their interests were often distinct, and as time went on the BFI developed increasingly close day-to-day relations with distributors either individually or via the KRS, while those with the CEA remained formal and at times hostile.

The 'Mongoose Case'

The young Institute suffered two early embarrassments. In February 1934, barely three months after it opened for business, it was violently attacked in a pamphlet written by a journalist called Walter Ashley who accused it of being an impotent tool of an unholy alliance of trade and educational vested interests. Although the BFI did succeed in having the lurid dust jacket bearing the words 'BFI exposed' removed from copies on sale, the pamphlet had been widely distributed to MPs and generated a lot of negative publicity for the Institute.[16]

The next embarrassment took place two years later, in 1936. R. S. Lambert, editor of the *Listener*, and Harry Price, a spiritualist and film collector (and donor of the first collection of films to enter the National Film Library of whose committee he became chairman), co-authored a book called *The Haunting of Cashen's Gap* about a house on the Isle of Man supposedly haunted by a talking mongoose. Lambert at least was a sceptic (Price possibly not), but the publication raised a storm. Sir Cecil Levita, a former chairman of London City Council, and husband of Lady Levita, a BFI governor, denounced Lambert as unfit to work for the BBC. Lambert successfully sued for slander, but lost his job as editor of the *Listener*. The damage to the BFI was great, but greater to the BBC, which was severely censured in a report commissioned by the prime minister, Stanley Baldwin, and published at the end of the year.[17]

Art and entertainment

Although its main focus in the early years was educational or instructional film and the use of film in the classroom, the new Institute soon found itself edging in the direction of promoting superior film entertainment in the circles where it had influence. These circles were not confined to the metropolis. One of the BFI's first acts was to promote the formation of local film institutes, or film institute societies, throughout the United Kingdom. The first of these, on Merseyside, actually pre-existed the BFI itself. A number of others were started – in Belfast, Brighton and Hove, Manchester and other places – and formed a core institutional membership for the BFI. Although the local institutes were mainly interested in educational uses of film, they, like the BFI, also had a cultural role. In 1935 these regional branches were given a constitution which invited them to engage in all sorts of film-related cultural activities while granting them full autonomy provided their activities were consistent with the Memorandum and Articles of Association of the BFI.[18]

To cater for the interests of its growing membership, the Institute decided early in 1934 to produce a monthly bulletin, priced at one penny, with basic information on all new instructional and entertainment films released in Britain. It had already taken over the quarterly magazine *Sight and Sound*, previously published by the British Institute for Adult Education, and both magazines soon found themselves catering for a readership at least as interested in films as art or entertainment as in films for instructional use. Given the baleful influence of the trade over the Institute's activities, the *Monthly Film Bulletin*, as the new magazine was called (and continued to be called until its incorporation into *Sight and Sound* in 1991), had a slightly troubled start. For such a small organisation, the BFI had saddled itself with an inordinately complicated structure, with various sub-committees and panels of uncertain powers and responsibilities, all with the laudable aim of reflecting the balance of interests on the board and more widely. Contributions to the *Monthly Film Bulletin* were provided by a panel of reviewers, responsible to two separate sub-committees, one for education and one for entertainment. The education sub-committee, chaired by Cameron, was mainly concerned with establishing basic filmographic principles for recording film credits, footage, etc., but the entertainment sub-committee seems to have been principally anxious to avoid films getting damning reviews which would hamper a film's commercial prospects. Various tensions ensued, which the governors twice attempted to resolve, in December 1934 and again a few months later. Eventually it was agreed that Brown, rather than Crow, should report to governors in respect of the contents of the *Bulletin*, that the magazine should be sold to the public and have an actual editor, and that the governors should stay out of its workings as much as possible. A storm in a teacup, no doubt, and a small victory for Cameron and the educationists against the trade, but symptomatic of the petty squabbles that dogged the Institute in its formative years.

Foundation and early years

The trade faction suffered a further blow when Crow resigned in April 1935 and it was decided to abolish the uncomfortable duumvirate and give the Institute a new structure with a director in charge and a deputy director and a secretary as the other senior officers. Crow had come to the Institute from the CEA, supposedly to represent that organisation's interests, but once arrived had shown himself a staunch defender of the BFI, even if it meant crossing swords with his former employers. The new secretary was Olwen Vaughan, founder of the London Film Institute Society and a friend of the film-makers Jean Renoir and Robert Flaherty.[19] Vaughan's arrival added a new element to the mix. In addition to film as entertainment and film as communication there was now film as art in the Institute's portfolio of interests. *Sight and Sound* had already broken free of its dependence on its original educational constituency and gradually the rest of the Institute was to do the same.

In February 1936, Brown was forced to resign as general manager, having lost the confidence of the governors as a result of a failed attempt to associate the BFI with a company of film equipment suppliers in which he was involved. William Farr became acting general manager while a search was made for a permanent director. The choice fell on Oliver Bell, who had formerly worked for the League of Nations but since 1934 had been press officer at Conservative Party Central Office. Bell arrived in July 1936. Farr stayed on for a few months as assistant general manager and editor of *Sight and Sound* and was replaced in those capacities by R. W. Dickinson. Although *Sight and Sound* continued to give house room to Paul Rotha and other left-wingers, the tenor of the new management, Vaughan excepted, varied between the middle-of-the-road conservative and the decidedly right-wing. This was to have consequences later.[20]

The National Film Library

As mentioned above, the idea of setting up a 'national film library' had been suggested in *The Film in National Life* as a possible task of the future film institute. With this in mind, in the autumn of 1933 the BFI Governors asked the British Kinematograph Society (created in 1931 to serve the industry on technical matters) to investigate technological issues relating to the permanent preservation of films.[21] The Society's report, published by the BFI as an eight-page pamphlet in August 1934, not only served as the technological basis on which the National Film Library was to operate but also proved an invaluable guide for the benefit of all institutions involved in the long-term preservation of film.[22] As a first step towards creating a film library, the BFI lobbied the government to be allowed to take possession of the film collection of the recently disbanded Empire Marketing Board. In this it was unsuccessful. After much shilly-shallying, the Postmaster General refused to hand over the collection (by now including the films of the EMB's successor, the GPO Film Unit) to an 'unofficial body' such as the BFI, and finally in April 1935 it was decided to entrust them to the Imperial Institute.[23] But

1.1 Ernest Lindgren (National Film Library), Oliver Bell (director), H. D. Waley (technical officer) and R. W. Dickinson (deputy director) in the Great Russell St viewing theatre, late 1930s

the BFI was not discouraged. A governors sub-committee 'on the establishment of the National Film Library', consisting of Lambert and F. W. Baker, was set up in 1934 and reported its conclusions in May 1935.[24] Meanwhile, in July 1934 the BFI had also appointed a young English graduate from University College London, Ernest Lindgren, to be its first Information Officer, in charge of a small but growing collection of books and magazines. Although not officially appointed Librarian until June 1935, Lindgren's very heavily annotated copy of *The Film in National Life* now in the possession of his son John Lindgren suggests that from the outset he had taken an interest in the prospects for a film library and had been asked to contribute to the project early in the proceedings.

The NFL Committee held its first meeting in June 1935. Harry Price (of 'mongoose' fame) was rewarded for his donation of £100 and a collection of trick films by being appointed chairman. The Library was officially launched on 9 July, with a public appeal for funds and donations of films relayed by the national and regional press. Its policy, revealed in another BFI pamphlet, showed a scheme dramatically scaled down from the plans reported by the sub-committee a couple of months earlier, since it had become clear that the government's refusal to endorse the project meant that it would have to be 'worked within the Institute's existing staff and accommodation' and should 'involve no expense to the Institute'. Its two proposed pillars – a repository of films of national and historical

Foundation and early years

value and a distribution library of educational films – had different objectives and intended publics and in fact constituted different collections, which were to develop quite separately. Despite lack of funds or staff and the initial hostility of the film companies, the film repository grew rapidly, thanks mainly to Lindgren's professionalism and enthusiasm for the task. But the development of the distribution library (also known as the loan section) was held back by the reluctance of distributors of educational films to entrust copies of their films to the Library. The NFL's first catalogue, published in September, records 268 films in the preservation section, against 55 in the loan section.[25] By 1939 the preservation collection had grown to encompass two million feet of film, as distribution companies started responding more favourably to the Library's request for prints. Impressed, the government finally agreed to make a one-off grant of £3,000 towards the costs of acquisition and preservation. Meanwhile, in a move that was to take the Library – and ultimately the BFI – in a new direction, Lindgren decided to start duplicating key films from the preservation section to make them available for loans to schools, educational groups and film societies which were members of the BFI. By 1941 the loan section consisted entirely of duplicated prints from the repository (as 'illustration material for the study of film appreciation'), while the small collection of educational films was hived off to the BFI's Educational Panel.[26]

International relations

The BFI in its early years was unfortunate in its international partners. The countries with most interest in the educational and cultural aspects of the cinema tended to be those with a powerful political agenda, Communist or Fascist. Lenin's famous statement in 1922, 'The cinema is the most important of all the arts', was to be echoed later by a similar declaration from Mussolini, 'For us, the cinema is the most important weapon'. It was Mussolini's Italy which created the first national film institution, the Istituto Luce, in 1924,[27] and it was the head of the Istituto Luce, Luciano De Feo, who was the moving spirit behind the creation of the IIEC. The IIEC held a big Congress in Rome in 1934, attended by J. W. Brown as BFI representative. By this time the Nazis had come to power in Germany and Goebbels organised a massive International Film Congress in Berlin, with Brown described as one of its presidents. Brown's role in this Nazi-sponsored jamboree provoked a certain amount of adverse press comment.[28] The BFI must have had some misgivings about the way the field had been hijacked because Cameron then arranged for a film component to be added to the World Education Conference, to be held in Oxford in 1936. The Germans and Italians were to be invited but would not be in a position to control the agenda. Then, at the end of 1937, the League of Nations finally got round to condemning the Italian invasion of Ethiopia two years earlier and Italy was forced to withdraw from the League. The IIEC thus found itself without a sponsor and was dissolved, putting an end to this small experiment in international film politics.[29]

With the demise of the IIEC, the idea of an international organisation of film institutes disappeared from the agenda, never to be revived. What was to take its place, from modest beginnings, was an archival organisation, the International Federation of Film Archives (FIAF). FIAF now has over 154 member archives (including associates) in over 70 countries and is affiliated to UNESCO; but in the mid-1930s fewer than a dozen countries had anything approaching a national film collection, let alone an archive devoted to film preservation. At its foundation in June 1938, FIAF comprised no more than four members. These were the British Film Institute, represented by Olwen Vaughan; the Cinémathèque française, represented by Henri Langlois; the Reichsfilmarchiv in Germany, represented by Frank Hensel; and the Museum of Modern Art, New York, represented by Iris Barry and John Abbott.[30] A congress of the Federation took place in New York in July 1939, still with the same four members, but the war supervened and the organisation went into abeyance. A second congress had to wait until 1946, by which time a number of new members had joined. Lindgren replaced Vaughan on behalf of the National Film Library (which, rather than the BFI, became Britain's leading representative on FIAF), paving the way for the great battles over film preservation detailed by Christophe Dupin in Chapter 3 of this volume.

1.2 The BFI premises in Great Russell St, London WC1, after being hit by a German bomb in September 1940

The War and after

The British Film Institute did not have a good war. Few papers have survived from the period on the basis of which to assess what it did, but it clearly was not very much. The attempts of the director, Oliver Bell, to interest the government in giving the BFI a role in the war effort came to nothing. Bell offered his services to the Ministry of Information and was briefly seconded there at the end of 1939, but he did not fit in either personally or politically among the young activists who were increasingly making the running in the Ministry's Films Division and soon returned to the BFI with his tail between his legs.[31] The Institute also suffered a blow when its top-floor premises in Great Russell St were twice hit by bombs during the Blitz. Fortunately nobody was killed, the Library did not catch fire, and the film collections were in safe storage at a site found by Lindgren at Aston Clinton in Buckinghamshire, where they were to remain for another 45 years. Meanwhile, the Institute suffered all the indignities of an institution with no specific wartime function. Owing to paper shortages, *Sight and Sound* was reduced in size, while its scope (and that of the BFI in general) was limited by the fact that no new films could be imported from occupied continental Europe for the duration of the conflict. The regional network gradually unwound, with only a few affiliates surviving to contribute to the revived film society movement in the postwar period. There were a few bright spots. The National Film Library reorganised itself to service an increasing demand for classic films to be shown around the country – a demand helped, no doubt, by the paucity of alternative cinematic fare. Membership meanwhile rose both during the war and after, suggesting a growing interest in cultural film, even if the BFI did little to satisfy it. On the film appreciation front, the BFI held a Summer School for members in 1944 (this became a regular institution, lasting until 1990) and in 1945 appointed the writer and lecturer Roger Manvell as Film Appreciation Officer. But the general picture remained gloomy.

Postwar

After the War, the BFI made attempts to resume normal service. *Sight and Sound* was restored to its full size and scope and Olwen Vaughan even paid a visit to Paris to meet Henri Langlois immediately after the liberation of Paris in 1944 to arrange for a season of French films to be shown in London. But her hopes for postwar revival were in vain and in June 1945 she resigned as secretary, citing as her main reason the Institute's failure to take film seriously as an art, and thereafter devoted herself to her French connections – on the one hand her association with Langlois and on the other hand the running of a small drinking and dining club frequented largely by French émigrés.[32] Overall the organisation found itself sadly diminished. Its national network had collapsed and its insipid war record and history of dubious right-wing connections gave it little credibility in the eyes of the Labour government which came to power in May 1945.

In the postwar dispensation the BFI came under the auspices of Herbert Morrison, Lord President of the Council and deputy prime minister in all but name. The sudden death of William Brass (recently elevated to the peerage as Lord Chattisham) gave Morrison the opportunity to appoint his protégé and Parliamentary Private Secretary, the young Labour MP Patrick Gordon Walker, as the BFI's new chairman. Gordon Walker's appointment, however, was a holding one only. The composition of the rest of the board remained broadly unchanged and while Gordon Walker on at least one occasion successfully argued the case in government for more money to enable the BFI to do the work it was doing well he must also have expressed misgivings about the generally unimpressive nature of the organisation whose board he chaired.[33] For the time being nothing was done to initiate changes. It was certain, however, that changes were in the offing, but no clarity as to what they might be.

The Committee for Visual Aids and the British Film Academy

One inkling of the new Labour government's thinking was provided in late 1946, when the Ministry of Education announced a proposal to set up a Committee on Visual Aids in Education. Although this would clearly encroach on traditional BFI territory, the Institute seems to have no advance warning of the initiative and Bell complained bitterly, when the Committee began its work in 1947, that he and the BFI were being sidelined in the discussions about its remit.[34] In March 1947 the Privy Council wrote to the BFI announcing that its grant would be increased to £31,500 conditional on its carrying out what were described as its four future permanent functions. These were:

a. Maintenance of a Film Library
b. The encouragement of public appreciation of film
c. The preparation of a descriptive and critical catalogue of film
d. The provision of information about film generally.[35]

Visual Aids work, said the Privy Council, should continue until the National Committee for Visual Aids in Education was up and running. While the increased grant was welcome, the abrupt announcement of new priorities for the Institute was a disturbing sign that the BFI was no longer in control of its own destiny.

Meanwhile, also in 1946, a small group of leading British film-makers had got together to create a parallel organisation, loosely modelled on the American Academy of Motion Picture Arts and Sciences and to be called the British Film Academy (subsequently BAFTA – British Academy of Film and Television Arts). The founder members were a roll-call of distinguished names from the creative side of the British film industry, including Anthony Asquith, Michael Balcon, Roy and John Boulting, Thorold Dickinson, Alexander Korda, David Lean, Muir Mathieson, Laurence Olivier, Michael Powell and Emeric Pressburger, Carol Reed, Raul Rotha and Harry Watt, none of them except Rotha having any past or present connections with the BFI. When the new Academy was incorporated

Foundation and early years

in October 1947, its Memorandum and Articles of Association bore a number of striking resemblances to those of the BFI. Besides 'stimulating creative work', it was to encourage research, compile statistics, establish a library of books, scripts, film scores and photographs, and encourage and sponsor publications. A lot of this may have been propaganda, designed to ensure the Academy could qualify for status as a charity. But it did, at least in the early years, take many of its intellectual aspirations seriously and in a way that offered potentially serious competition to the struggling BFI.

The chairman of the Academy was David Lean and the writer and lecturer Roger Manvell (then with the BFI) was appointed Secretary General, bringing with him outline plans for what was to become the *History of the British Film*, to be published by George Allen and Unwin in several volumes between 1948 and 1985 and covering the years 1895 to 1939. The Academy's librarian was Rachael Low, who became principal author of the history.

The Academy was entirely supported by subscriptions from its members. But these were insufficient to support its full range of ambitions, even if members paid up promptly and in full, which they often didn't.[36] A financial crisis in 1950 led to a radical scaling down of its ambitions as a research resource. Although it continued to collect scripts and other materials, it could no longer afford to employ Low, and sponsorship of the *History of British Film* reverted to the BFI. It is doubtful if the Academy could ever have constituted serious competition to the BFI, let alone an alternative, but the threat that it offered at a particularly low point in the BFI's history was a major stimulus behind the reform of the BFI in 1949. With the National Committee for Visual Aids taking care of a major educational plank, and the Academy challenging it on the artistic and research fronts, a new role needed to be found for the BFI. To understand the nature of the reforms the government decided on, however, it is necessary to take a step backward in time, to the new cultural climate in postwar Britain.

Notes

1 For the Film Society, see Jamie Sexton, 'The Film Society and the Creation of an Alternative Film Culture in Britain in the 1920s', in Andrew Higson (ed.), *Young and Innocent?: The Cinema in Britain, 1896–1930* (Exeter: University of Exeter Press, 2002), pp. 291–305.
2 For *Close Up* see James Donald, Anne Friedberg and Laura Marcus (eds), *Close Up, 1927–1933: Cinema and Modernism* (London: Cassell, 1998). The magazine's impact on British film culture was limited by the fact that it was edited from Switzerland.
3 Commission on Educational and Cultural Films, *The Film in National Life* (London: Allen and Unwin, 1932), §2, pp. 182–3.
4 Bell's affiliation is described as 'British National Committee of Intellectual Co-operation' – i.e. the British branch of a League of Nations sponsored organisation called the International Institute of Intellectual Co-operation which was founded in 1922 and in turn helped found the IIEC in 1928.
5 *The Film in National Life*. The reference to the national film library is in §238.

6 Rachael Low, *History of the British Film, 1929–1939: Documentary and Educational Films of the 1930's* (London: Allen and Unwin, 1979), p. 185.
7 Margaret Dickinson and Sarah Street, *Cinema and State* (London: BFI, 1985), pp. 30–3.
8 Low, *Documentary and Educational Films*, p. 186.
9 Baker was there because the abrasive Sam Eckman of MGM, an American, was not eligible. See Low, *Documentary and Educational Films*, p. 188.
10 Sutherland did however offer to guarantee the Institute's overdraft from his personal funds, which were considerable (he did after all own five Titians as well as many other precious works of art), when it encountered financial difficulties in 1934. Minutes of BFI Governors Finance Committee, 30 November 1934.
11 The grant was for one year only and in the early period of its existence the Institute had to re-apply to the Privy Council every year for a renewal of its grant.
12 Rachael Low, *History of the British Film, 1929–1939: Film Making in 1930's Britain* (London: Allen and Unwin 1985), pp. 18–19. The problem was that the sprocket holes were on the wrong side. The American standard was one approved by the American Academy of Motion Picture Arts and Sciences.
13 *Manchester Guardian*, 29 September 1933.
14 Letter from J. H. Henderson of the Home Office, 26 September 1934; copy in BFI/G-7, Papers for Governors Meeting, 4 October 1934.
15 Article in *Manchester Guardian*, 23 January 1935.
16 Walter Ashley, *The Cinema and the Public* (London: Ivor Nicholson and Watson, 1934).
17 A full account is in an article by David Wilby, available at www.bbc.co.uk/historyofthebbc/resources/bbcandgov/pdf/mongoose.pdf For Lambert's own version, see R. S. Lambert, *Ariel and All His Quality: An Impression of the B.B.C. from Within* (London: Gollancz, 1940) pp. 216–99.
18 Governors Minutes, 2 December 1935.
19 She also soon formed a friendship with Henri Langlois, founder of the Cinémathèque française. See Christophe Dupin in Chapter 3.
20 On the conservative side, Brown made amends for the Institute's failure to engage the churches in its formative period by holding a couple of meeting with the Archbishop of Canterbury, Cosmo Gordon Lang, in 1934 and 1935. This led to an arrangement with the Christian Cinema Council, whereby the BFI gave the Council financial support and found room for religious films in *Sight and Sound* and the *MFB*. According to Low (*Documentary and Educational Films*, p. 195), Bell and Dickinson never got on with the young leftists of the documentary movement who were to colonise the Ministry of Information's Films Division in the 1940s. See also Sue Harper, *Picturing the Past* (London: BFI, 1994), chapter 5. Denis Forman in his memoirs refers to an unnamed member of BFI staff (presumably Dickinson), who was still there until 1948 and who 'was said to have appeared in jackboots and a Nazi armband until the outbreak of war made this unwise'. See Denis Forman, *Persona Granada: Some Memories of Sidney Bernstein and the Early Days of Independent Television* (London: André Deutsch, 1997), p. 24.
21 For a detailed account of the establishment of the National Film Library, see Christophe Dupin, 'The Origins and Early Development of the National Film Library: 1929–1936', *Journal of Media Practice* 7:3 (2006), pp. 199–217.
22 *The British Film Institute: Report of Special Committee Set up by the British Kinematograph Society to Consider Means that Should Be Adopted to Preserve Cinematograph Film for a Indefinite Period*, BFI, August 1934..
23 Notes of the meeting between R. S. Lambert, Mr Robinson and Sir Stephen Tallents at the Treasury, 4 April 1935. NA/T 162/1001.

24 Film Library Committee, *Final Report* [Unpublished report incorporating *Memorandum on a National Film Library* and *A National Film Library: Memorandum 2*]. London: BFI, [May 1935]. BFI/A-11/4.
25 *National Film Library Catalogue*, BFI, 1936. As a (very) rough rule of thumb, a 35mm print of a 90-minute feature film is about 10,000 feet.
26 *BFI Annual Report* 1941.
27 Besides meaning 'light', Luce was also an acronym for L'Unione Cinematografica Educativa.
28 See for example an article in the trade paper *Daily Film Renter* 9:2973, February 1935. Goebbels's speech to the Congress was reprinted in *Sight and Sound*, Summer 1935.
29 See Hilla Wehberg, 'Fate of an International Film Institute', *The Public Opinion Quarterly*, July 1938, pp. 483–5. According to Wehberg, the Swiss had been very keen on the idea of such an institute and were decidedly miffed when it was hijacked by the Italians. By 1937, however, they had lost interest.
30 Other archives existed – in Sweden, the USSR, Italy – but were not represented at the meeting. See Penelope Houston, *Keepers of the Frame* (London: BFI, 1994), pp. 17–22. A fuller account of the early history of the archive movement can be found in Raymond Borde, *Les Cinémathèques* (Lausanne: Editions L'Age d'Homme, 1983), pp. 57–73. For the postwar revival of FIAF see Borde, pp. 86–98.
31 For a account of this episode see James Chapman, *The British at War: Cinema, State and Propaganda 1939–1945* (London: I. B. Tauris, 1998), pp. 23–7.
32 The motives behind her resignation were reported to the meeting of BFI Governors in June 1945. See Christophe Dupin, 'The Postwar Transformation of the British Film Institute', *Screen* 47:4, Winter 2006, pp. 443–51. See also Charles Drazin, *The Finest Years: British Cinema of the 1940s* (London: André Deutsch, 1998), pp. 235–44..
33 Memorandum, 'The Future Development of the British Film Institute', 7 October 1946, submitted to the Inter-Ministerial Committee discussing the future of the BFI. NA/CAB 130/9.
34 Governors Minutes, 4 March 1947. The idea of a Visual Education Committee had in fact originated with the BFI in 1945, which made it doubly galling that the idea was stolen and a separate organisation proposed.
35 Governors Minutes, 1 April 1947.
36 See www.bafta.org/heritage/history/origins-of-the-academy,30,BA.html.

2

Postwar renaissance

Geoffrey Nowell-Smith

From late 1942 onwards, as the fortunes of war swung in favour of the Allies, both the popular mood in Britain and government planning switched from anxiety about possible German invasion to thoughts of victory and the sort of country that should emerge from it. The Beveridge Report on eradicating poverty, published in December 1942, was a first step in the new direction, followed by the Butler Report on secondary education in 1944 and other initiatives. In the spectrum of activity that went from art to industry, the Council for Industrial Design was established by a Labour minister in the wartime coalition, Hugh Dalton, in 1944. Under the 1945 Labour government this became the Design Council. The rather ad hoc Council for the Encouragement of Music and the Arts, which had come into being initially to entertain British troops overseas, was transformed into the Arts Council, with its Treasury funding put on a statutory basis. The Royal College of Art, evacuated during the war, returned to London and was reconstituted under the leadership of Robin Darwin to be a leading presence in the world of fine and applied arts.

Many of the reforms in the field of arts organisation were prefigured in a series of wartime reports under the general heading of Arts Enquiry, produced through the agency of the Dartington Hall Trust. These reports (on the arts in general, on visual art, on music, on film and on theatre) had no official standing and were not formally published until after the end of the War, but they fed into and influenced the thinking that led not only to the postwar creation of the Arts and the Design Councils but to the transformation of the BFI at the end of the 1940s.

The Enquiry's draft report on the 'factual film' (non-factual and entertainment films were, typically, not regarded as of artistic importance) was confidentially circulated in 1944. It did not make comfortable reading. Although its scope was nominally wider, it devoted a lot of space to a criticism of the BFI, poorly managed and hamstrung by its domination by trade interests, and went so far as to call for its abolition and replacement by an organisation with 'a more workable constitution, wider terms of reference and more adequate facilities'. 'Because of past history,' it concluded, 'we regard it as essential that this should be a new organisation with a new name.'[1] When the final version of the report was eventually published in

January 1947 (having gone to press in October 1945), the tone was milder. The criticism of the BFI was no longer headlined at the outset of the report and the recommendation was for the BFI to be 'reconstituted' rather than replaced by a new body.[2] By this time, however, the draft report had been an important input into a series of inter-ministerial debates held under the auspices of Herbert Morrison throughout 1946,[3] the outcome of which was to be far more positive.

Morrison, whose official title was Lord President of the Council but who was in effect deputy prime minister, was an unusual politician in all sorts of ways. Largely self-educated, he was a lifelong filmgoer and enthusiast – an enthusiasm rewarded towards the end of his career when, by now Lord Morrison of Lambeth, he was made President of the British Board of Film Censors. It was not just his love of cinema, however, that made him take a particular interest in the affairs of the British Film Institute. In the immediate postwar years his dominant obsession was the Festival of Britain, projected for 1951, a nationwide event but one whose central focus would be on the south bank of the Thames in his native Lambeth. The Festival was to be a celebration of British achievement in the arts, sciences and industry. For this he needed the support of organisations such as the Arts Council and Design Council. A film component was also needed – and an organisation to deliver it, which could only be a revamped BFI.

In November 1947, Morrison set up a Committee of Enquiry into the Future Constitution and Work of the British Film Institute. Its chairman was Cyril Radcliffe, formerly director-general of the wartime Ministry of Information, who had just returned from India where he chaired the Boundary Commission adjudicating on the partition lines between India and Pakistan.[4] Radcliffe took evidence from various quarters, including the BFI itself, and the work of the Arts Enquiry and the inter-ministerial committees, and came to conclusions which were very positive in tone for the BFI, if not for the existing management. The Committee recommended giving the Institute a new brief – 'to encourage the development of the art of the film, promote its use as a record of contemporary life and manners and foster public appreciation and study of it' – and a level of funding suitable to enable it to be carried out (an annual grant of about £100,000). It defined the Institute's main future executive responsibilities as:

1. The administration of the National Film Library
2. The conduct of a first-class information service
3. The development of a central and regional organisation to promote appreciation of the film art and new or extended uses for the cinema.[5]

It also recommended an overhaul of the BFI's constitutional arrangements and an end to the system of nomination of governors by trade and educational interests. Good diplomat that he was, Radcliffe also had some kind words to say about the limited but real progress the Institute had made since 1944 in fostering film appreciation. The boldest recommendation, however, was that means should be found to create a theatre seating three or four hundred for the repertory showing of films.

The report was issued in April 1948. In May 1949, Parliament voted to approve the changes and to give the Institute an enlarged grant from the Treasury – though not as large as Radcliffe had recommended. To save money Morrison also vetoed the proposal for the BFI to have a greater national presence by opening offices in major provincial cities. It was to be nearly another twenty years before the BFI took any major steps to establish a presence in the English regions.

Implementation of the reforms was swift and brutal. The governing body, including the chairman, resigned en bloc. To replace Gordon Walker, Morrison chose Cecil King, the Labour-supporting publisher of the *Daily Mirror*. A new board was constituted, which was not, in fact, all that different in character from the old one. It still had a strong trade representation – Sir Henry French from the newly formed British Film Producers Association, W. R. Fuller from the CEA and Frank Hill from the KRS. Now, however, the trade governors were there because they had been invited by the Lord President to assist the reformed BFI, not because they had been nominated by their organisations to keep an eye on it. There were also two film-makers, Anthony Asquith and Arthur Elton; there was the film critic Dilys Powell; and (a very forward-looking development) there was a representative of television in the form of Norman Collins, controller of BBC Television. There were politicians, two Labour MPs (J. H. Hoy and Dr Stephen Taylor), one Co-operative (J. M. Peddie), plus the Welsh Labour politician Eirene White, who was not yet an MP, and a solitary Conservative, Lady Tweedsmuir.[6] The main losers were the educationists, who were represented only by the relatively anonymous E. G. Barnard and by Lady Allen of Hurtwood, who almost immediately resigned to take up a post with the United Nations, to be replaced by the archaeologist and writer Jacquetta Hawkes.

The first meeting of the new Board was held on 8 November 1948. On 20 January 1949, King announced that, in the words of the Governors' Minutes, it had been 'agreed to make a change in the directorship'.[7] Bell was to resign but be offered compensation. Dickinson's resignation and that of other senior staff followed within a few months. Lindgren alone kept his position and was indeed rewarded by being made deputy director and with an increase in salary. The development of the National Film Library had been singled out as a priority by Radcliffe, and Lindgren's competence in steering it through the difficulties of the war years was unquestioned.

Following Bell's departure in January 1949 there was a brief interregnum while a successor was found. Three candidates were shortlisted: Ernest Lindgren, the documentarist Edgar Anstey, and a young man (31 years old) about whom little was known called Denis Forman. Wounded in action during the Italian campaign, Forman had spent the last few years in a desk job at Films Division in what had been the Ministry of Information but was now the Central Office of Information. There he had come to the attention of the founder of the British documentary movement and *éminence grise* of British film culture, John Grierson, who recommended him to King as a possible director.[8] His appointment as BFI director in

Postwar renaissance

preference to Lindgren or Anstey was a sign that King wanted change, and wanted it fast.

A new secretary and senior administrator was also found, in the form of R. S. (Bob) Camplin, who later went to work for the CEA and returned as a governor of the BFI in the 1960s. Camplin did not, however, double up as editor of *Sight and Sound* as Dickinson had done. For the Institute's flagship magazine, as in many other areas, Forman had more ambitious ideas.

The Forman reforms

On arrival in May 1949, Forman instantly set about a root-and-branch transformation of the Institute. There were a few staff who regretted the departure of the amiable and easygoing Bell,[9] but on the whole the briskness and dynamism of the new regime was warmly welcomed. Forman's first major step, recounted in detail in Chapter 13 below, was the revitalisation of *Sight and Sound* and the *Monthly Film Bulletin*. Again Grierson played a role, by suggesting that the editors of the film magazine *Sequence* should apply to the BFI for help. They went to see Forman,

2.1 The newly appointed BFI director Denis Forman, c. 1950

but instead of help with *Sequence* they found themselves invited to take over *Sight and Sound*, which they did, beginning in December 1949. The new editor was Gavin Lambert, with Penelope Houston as his assistant. Lindsay Anderson, who had stayed loyal to the now struggling *Sequence*, became a regular contributor to the new magazine after *Sequence* folded in 1952. In 1950, another of the *Sequence* group, Karel Reisz, who had been working for the British Film Academy, was also given a job in the BFI.[10]

Meanwhile, preparations for the Festival of Britain were in full swing. As recounted by Christophe Dupin in Chapter 4, the BFI was put in charge of planning a state-of-the-art cinema, known as the Telecinema (it could also show large-screen television), on the South Bank near the Festival Hall, principally to showcase technical innovation. The BFI was also initially offered the sum of £120,000 to produce a series of documentaries for the new cinema, but this was cut to £15,000 when cuts were made in the Festival budget. Even so, the Telecinema was a huge success with over 450,000 spectators paying to attend its screenings between May and September 1951.[11] In October of that year, however, a new Conservative government came to power eager to wipe away all traces of the previous administration – including all the buildings on the Festival site apart from the Festival Hall. The Telecinema, which the BFI hoped would be retained as a repertory cinema, was also threatened with demolition, but Forman managed to persuade the British Film Production Fund, which distributed the proceeds of the so-called Eady Levy on film exhibition, to provide £12,500 to keep it going.[12] He also managed to negotiate a further £12,500 for the making of films to be programmed there. Thus was born (after some delay, because the money took some time to arrive) the Experimental Film Production Fund, chaired by Michael Balcon, which was the precursor of the later BFI Production Board.[13] After a brief closure, the Telecinema reopened in October 1952 in its new guise, re-equipped for regular film projection and renamed National Film Theatre and with a mix of archival and more popular programming. Reisz was put in charge of programme co-ordination.

A further initiative of Forman's, together with Ernest Lindgren, had to do with the acquisition of films for the National Film Library, where Lindgren and Basil Wright, now chairman of the NFL Committee, felt they were being frustrated on all sides by the reluctance of government and trade bodies to recognise the importance of preserving films for posterity. There were obstacles across the board. The government was shilly-shallying over the preservation of films made by government agencies such as the COI. The British authorities in Germany had requisitioned numerous Nazi propaganda films which, in line with official denazification policy, they were threatening to destroy. The newsreel companies were interested in preserving footage only if it had resale value (for example for television). The donation of British feature films to the NFL was entirely a matter of grace and favour on the part of companies who owned materials and/or the right to exploit them.

Faced with this situation, the BFI's position was resolute. Films should be preserved if at all possible, and the National Film Library should be the principal

if not sole agency to ensure their preservation. (Also, if lack of resources meant that not all films could in fact be preserved, the same NFL should be responsible for selecting those which were priority candidates for preservation and those which, regretfully, were not.)

Successful in their negotiations with the Foreign Office and the Newsreel Association, Forman and Lindgren turned their attention to a bigger target, a scheme whereby the NFL would acquire, as of right, preservation copies of all films publicly released in Britain – or, if not all films released, at least all British-produced films for public distribution. The principle that Lindgren had in mind (and had had in mind ever since the NFL was first founded in 1934) was akin to the Statutory Deposit of a copy of every book in the Library of the British Museum in London, inaugurated by the Copyright Act of 1711 and later extended to cover other so-called copyright libraries elsewhere in the British Isles. But whereas most books are printed in sufficient numbers for the gift of a handful of copies to libraries not to make much of a dent in the publisher's finances, film prints were expensive and, in the case of small producers or distributors, adding a sixth to a run of no more than five prints was a heavy burden.

Forman and Lindgren decided to attach their scheme for Statutory Deposit of Films to the new Copyright bill, expected to come before Parliament in 1951. Two problems instantly arose. One was that if the NFL wanted the right to preserve all films distributed in Britain, including American and continental ones, this was not strictly a copyright issue since those films were not published in Britain, only circulated. Secondly, who would bear the cost? Forman's initial view was that the NFL should arrange to acquire those films it wanted at a price equal to the cost to the producer of distributor of running off an extra print.[14] But when it became clear that Parliament was unlikely to want to vote extra funds for the purpose, Forman and Lindgren changed tack. For all widely distributed films, Lindgren argued in a draft submission to the Board of Trade,[15] the trade should offer a print at its own expense. This expense, he argued (with a bit of sleight of hand), was in fact no greater proportionally to the total cost of the film than the print cost of a copy of a book would be to a publisher. In the case of films of which fewer than five prints would normally be made, then and only then the NFL would pay.

Needless to say, the trade was not impressed by Lindgren's arguments. It discreetly indicated to the BFI that it would oppose the proposal. Lindgren filed the papers away. For nearly twenty years the project lay dormant, to be revived only in 1969. Meanwhile Lindgren concentrated his energies on cultivating trade contacts to secure as many voluntary donations as possible, in which endeavour he was to be remarkably successful.[16]

The principal achievement of the Forman years, without a doubt, was the two-pronged strategy of a revitalised *Sight and Sound* and a permanent site, the National Film Theatre, for showing films, at least to audiences in London. The link between the two was not at first sight a natural one, but Forman had made it so by employing members of the same group of talented people to edit the magazines

and to programme the theatre. It was then consolidated by a new structure for BFI membership, inaugurated in 1952. Since, by agreement with the trade, the NFT was to be open to BFI members and their guests only, Forman and Camplin set up a scheme which divided members into two principal categories. In addition to access to the NFT and a copy of the monthly programme, full members would have a subscription to *Sight and Sound* and use of the Library and Information Service as part of their membership package, while a secondary category of associate members would have NFT access only.[17] The success of the scheme was instant. Membership, which had been flat-lining at just over two thousand since 1945, shot up. In November 1952, which was the first full month of NFT operation, it rose to 3,787 full plus 7,276 associates. A year later the figures stood at 5,791 and 17,699 respectively. The rising curve was to continue throughout the 1950s. Associate membership actually peaked in 1959 at just over 32,000 and then fell back to 25,000 or lower, but full membership, and with it the circulation of *Sight and Sound*, went on rising. By the mid-1960s, the circulation of *Sight and Sound* had reached 25,000 – a more than tenfold increase since 1949. The Institute now very definitely had a public for its activities, a public consisting of its membership – basically, NFT patrons and readers of *Sight and Sound* – and that public, supplemented by film society members serviced by the Central Booking Agency, not only gave the BFI a role to perform but increasingly came to dictate its priorities. Only the National Film Library remained outside the loop. It is true that it still had a lending section, much used by film societies, and it organised viewings of rare films for bona fide researchers. It also related to the membership through the seasons it put on at the NFT. But its main priority was the preservation of the national and international film heritage – a task it performed regardless of whether there was an immediate public for the films preserved. When it came to looking after the heritage of documentary and factual film, the public was in the first instance quite small and barely overlapped with the main BFI public, but it became immeasurably larger when the material was used, as became more and more the case, as a resource for television documentaries.

Consolidation

At the end of 1952, King resigned as chairman, to be replaced by S. C. Roberts, master of Pembroke College, Cambridge, a less charismatic figure but equally used to navigating the corridors of power. Then at the end of 1954, Forman also felt it was time to move on. The government had announced its intention of setting up a new commercial television channel and he decided to throw in his lot with Sidney Bernstein, who was bidding for the north of England franchise. At the beginning of December he offered his resignation and in April 1955 he left the Institute, where he was replaced by James Quinn, who was to remain director for nearly ten years, all of them under a Conservative government.[18]

The Forman years were a period of immense achievement, which laid down the

template for what the BFI was to become for the next fifty years. But this achievement was precarious. Money was tight. Government grant never came near to reaching the £100,000 proposed by Radcliffe and what was on offer was hedged around by restrictions. In 1951/52 the grant from the Treasury was £44,620, of which £9,000 was already earmarked for the Festival of Britain. This was supplemented by £22,000 from the Cinematograph Fund, channelled via the Privy Council. When the Conservative government came to power in October 1951, the Treasury grant was cut to £33,000 and the Privy Council component to £20,000 and it was to rise only slightly in the years that followed. Out of this grant the Institute was committed to providing grant-in-aid of £4,500 to the Scottish Film Council and a further £2,500 to the Scientific Film Association, meaning that it had in all £46,000 for its own purposes – including the NFL.[19] Increasingly it was the Treasury that called the shots. As Lord President until 1951, Morrison had treated the BFI as a strategic priority. Subsequent holders of the office, however, had no particular interest in the Institute, and, though they were sympathetic to its cause, they were easily overruled by a Treasury eager to rein back on public expenditure. The Treasury even tried to tie the level of grant to the Institute's turnover and stop it from taking on staff to service its blossoming revenue-earning activities. It was only at the end of 1953, when Roberts appealed directly to the chancellor of the exchequer, R. A. Butler, over the head of the Lord President, that a promise was made that there would be no further cuts and the Treasury finally backed down on its restrictive attitude to the self-financed development which had been the keystone of Forman's expansionist policy.

The attitude of the trade was also unpredictable. Although Sir Henry French in particular worked hard to convince the trade associations to be supportive, persuading the administrators of the British Film Production Fund to part with their precious 'Eady' monies to support Institute activities such as the NFT and the Production Fund was never easy. The CEA continued to regard the NFT as unfair competition and the members of the KRS only reluctantly acceded to the principle of letting the NFT show 'their' films free of charge. It was therefore a matter of enormous relief to the Institute (as well as to the trade) when Butler, as well as promising to maintain the level of grant to the BFI for the foreseeable future, gave an undertaking that the government saw itself as the prime funder of the BFI for all purposes other than film production.[20] A parallel agreement with the trade that support for production would continue meant that from 1954 onwards a sort of stability was restored to the Institute's strained finances.

Even so, the situation which James Quinn inherited when he took over as director was not a comfortable one. Money was still tight. The Lord President's office was calling on the BFI to reduce its deficit.[21] The budget for 1955/56, Quinn's first year in office, envisaged further cuts of nearly £4,000. The costs of the new NFT building to replace the temporary premises in the old Telecinema were threatening to escalate and the internal affairs of the Institute also needed attention. Most of the energies in the Forman years had been spent on the public face of the BFI and,

although Forman had ambitious plans to concentrate all the BFI's activities on a single South Bank site, the actual buildings in central London were in a sorry state, with the Library in particular occupying dismal premises in the basement of the building in Shaftesbury Avenue which had been the BFI's headquarters since 1948. The Library had also been the first victim of budget cuts imposed in 1952 and it was only a strongly worded report from a sub-committee under Lindgren's chairmanship in 1954 that persuaded the governors to reaffirm the importance of the BFI information service.

Even in straitened circumstances, Quinn was determined both to continue with the initiatives set in train by Forman and to pay attention to areas of previous neglect. Although the Library again bore the brunt of the 1955/56 cuts, the appointment of Brenda Davies as Information Officer in October brought rapid progress. She had the premises spruced up and reorganised and introduced a proper cataloguing system for books and other materials.[22] By the time of her retirement in October 1980, Davies had established the Library and Information Service as a jewel in the Institute's crown – and possibly the only part of the BFI which the other warring departments were prepared to rally round and defend in moments of crisis.

The National Film Theatre

Quinn's main concern, however, continued to be the NFT, which was plagued with endless difficulties and disputes both before and after its opening in the new building under Waterloo Bridge on 15 October 1957. Negotiations had to be carried on with the London County Council (landlords of the new site), with Shell, who had acquired the lease on the old Telecinema site and were eager to move the bulldozers in, and, inevitably, with the Treasury. Since the Treasury refused to finance either fitting out the building or its operating costs, an appeal was issued to members and the trade, which eventually raised the £17,500 necessary to equip the building. The ceremonial opening (by Princess Margaret) was immediately followed by an equally important event, the first London Film Festival, designed as a 'festival of festivals' showcasing 24 films selected from those premiered at Cannes, Venice or other major festivals elsewhere in the world earlier in the year. The first LFF was sponsored by the *Sunday Times*, but, when the paper wanted to move it to the West End, the BFI demurred and secured modest funding from the LCC instead. Only in 1961 was the Festival to make a first tentative move outside the South Bank, with a gala screening at the Dominion, Tottenham Court Road. It was to be some years before a decision was taken to increase the size and scope of the Festival and move more and more films into larger venues in the West End.

Meanwhile material difficulties were mounting up. The LCC had plans for the South Bank involving improvements to the NFT which the BFI welcomed, but not if they cost it money. The LCC also wanted to extend Waterloo Bridge to the south, necessitating major structural works in the NFT. The idea was to synchronise the two sets of plans so as to minimise disruption, but both were delayed (for different

Postwar renaissance

2.2 James Quinn (director 1954–64) with the actor James Cagney at the National Film Theatre in November 1958

reasons) and the final upshot was that the NFT was not improved but suffered an eight-month closure in 1964 when it had to move into unsatisfactory premises across the river in Millbank, badly affecting not only audiences but membership.

Organisation, finance and constitution

The Radcliffe Report had left intact some of the BFI's original constitutional arrangements whereby it received money from the Privy Council and it was the Lord President of the Council who was the responsible minister. But the money disbursed by the Council, from the Cinematograph Fund which disbursed the Sunday Entertainments Tax, was only a small (and diminishing) part of the BFI's grant-in-aid. The bulk of it now came direct from the Treasury, which was increasingly hard-nosed in its attitude to how it was spent. The NFT was not supposed to be subsidised, nor, it seemed, was *Sight and Sound* – though a case could be made, or so the governors thought, for the *Monthly Film Bulletin* as a source of information.[23] Strictly speaking, the Treasury was supposed to concern itself only with the effectiveness of spending and was not meant to interfere to the point where its recommendations interfered with the governors' right to determine policy as agreed with the Lord President. It was with some trepidation, therefore, that in 1955 the Institute invited the Organisation and Methods branch of HM Treasury to conduct a review of its activities.

This review, which was given the informal name Mendoza Report after the Treasury civil servant who carried it out, had as its brief 'to examine and make recommendations on the organisation of the Institute, the efficiency of its methods for meeting its present objectives, and its relations with other bodies; and to comment on its staff structure'.[24] It took a long time to complete and, when it finally reported in February 1959, turned out to be both extremely thorough and eminently fair minded. On the policy side Mendoza noted (and deplored) the Institute's heavy metropolitan bias; he tried (but failed) to edge the National Film Archive[25] in the direction of improved access to its collections (and less eagerness to acquire films which lay uncatalogued and unseen in its vaults); it queried the random growth of the BFI's distribution library which, since its devolution from the Archive, had amassed a 'heterogeneous' collection of films, not all related to 'the art of film and the development of film technique' as they should have been under the principles enunciated in the Radcliffe Report. It also made various suggestions relating to the accounts, including a solution to the question of which parts of the NFT operation actually needed to break even and which could be supported out of the general BFI grant.

On the whole, amicable agreement was reached between BFI management and governors and the Treasury as to which parts of the Report should be implemented and which not and the Report served as a useful template for a further internal

2.3 Organisation of the BFI in 1954/55

review of activities carried out by the governors in 1963. But one issue did prove contentious, and that concerned the role of the secretary, Stanley Reed. Reed, a former secondary school teacher, had joined the BFI in 1950 as Film Appreciation Officer and had rapidly risen to become Head of Film Appreciation and Distribution and then, from February 1956, Bob Camplin's replacement as Secretary of the Institute. Mendoza had politely observed that Reed seemed to have too much on his plate as both secretary and head of various operating departments, including Education, to which he devoted one-third of his time. But in the course of discussions about the implementation of the Report, Mendoza's superior at the Treasury, a Mr Jones, unexpectedly widened the debate to question whether Reed, as secretary, ought to be in charge of any operating departments at all. Exactly what Jones was getting at does not seem to have been immediately clear and it was only in the summer of 1960, when the BFI's chairman, Sylvester Gates, who had taken over from Roberts in 1957,[26] had a face-to-face discussion with him at the Treasury, that it emerged that what was at stake was a fundamental issue of governance. What the Treasury required was a divorce between departmental responsibilities, including the power to commit expenditure, and financial control. All expenditure should be subject to the scrutiny of a responsible officer who could not be the person who had committed the expenditure in the first place. In the meantime the issue seems to have been fudged. Reed continued as secretary and in official charge of a number of departments, now including the NFT, but devolved day-to-day spending decisions to his subordinates. It was only later that the BFI fully adopted the principle that the secretary or deputy director should have no operating departments or budgets under his or her direct control. This principle remained in force at least until the 1990s.[27]

The reason for the fudge in 1960 was that by then the Treasury's Organisation and Methods department, to Gates's immense relief, had ceased to act as a scrutiniser of the BFI independent of the rest of the Treasury as such. By 1959 the Lord President's Office had become thoroughly tired of playing pig-in-the-middle between an importunate BFI and an increasingly hard-nosed Treasury, and suggested to the BFI that after the next General Election, whoever won it, the Institute should have a new sponsoring department. Eirene White, now an MP and back on the board of governors, thought this should be Education. The Board of Trade, which was responsible for the film industry, was also mooted. But the choice offered to the BFI after the election (at which the Conservatives were re-elected) was between Education and direct dependence on the Treasury. Edward Boyle, the new Financial Secretary, was sounded out and seemed sympathetic, so the BFI opted for the latter, reasoning that a Treasury which had actual responsibility for the BFI's affairs would have a better appreciation of its needs than one which intervened from a distance.[28]

The new arrangement with the Treasury actually worked out quite well. The BFI's constitution was changed to make the Treasury, rather than the Lord President, in charge of the appointment of governors. A Treasury observer began to

attend governors' meetings, thus getting a first-hand feel for what the Institute was doing, at least at the top level. Although still heavy-handed, Treasury interventions became less inept than they had sometimes been in the past. There were losers, the first being experimental film production, where the Treasury refused to replace the money from the Cinematograph Fund, which was drying up, with a direct allocation of its own. But financially the main problems the BFI had in the early 1960s (apart from the ongoing difficulties at the NFT) were of the kind it always had and would always have, whichever department it came under. Although the BFI's grant kept rising, it never did so enough to keep pace with wage inflation, which was beginning to put in an appearance and whose effect on BFI finances the Treasury pretended not to recognise. Harder still to satisfy, however, were the demands of the former National Film Library, since 1955 National Film Archive, which, in addition to its acquisition of feature films was now recognised as the official depository of government films and was beginning to acquire television material from both the BBC and ITV.[29] These acquisitions required space to hold them and it was only very gradually that the Treasury fully recognised this, allowing the BFI in 1963 to open negotiations for a new acetate store in Berkhamsted, near to the site in Aston Clinton where the bulk of the nitrate holdings were kept and which was now full to bursting point. The Treasury also conceded that the BFI as a whole needed larger and better London premises, giving outline approval in 1959 for the leasing of a new headquarters building at 81 Dean St in the heart of London's Soho district. Opened in 1960 after a quick refurbishment, the Dean St building finally gave the BFI a clear presence in central London and proper conditions for the Library and Stills Departments.

It is interesting that throughout the 1950s and early 1960s there was very little pressure on the BFI to become more 'popular' and widen its reach beyond the mainly metropolitan, 'art film' public of NFT audiences and *Sight and Sound* readers targeted by Forman in 1950. The public outside London was served mainly by the limited support the Central Booking Agency provided for film societies and schools and colleges and by lectures put on by the Film Appreciation Department, and, though Quinn and Reed had dreams of expansion into the provinces, the target they had in mind was a similar public to that of the NFT, but resident outside London. Reed and the new Education Officer Paddy Whannel (appointed in 1957) did, it is true, envisage reaching a broader demographic through work in schools (children were to be reached via their teachers, and the teachers via the teachers' training colleges), but this was far from being a major priority.[30] Even increasing the popularity of the NFT as a venue, which the Treasury supported on financial grounds, was consistently hampered by the trade, still disproportionately represented on the board of governors, which fought a rearguard action to stop the NFT showing too many popular films or allowing members to bring more than one guest each, for fear that this would somehow take away audiences from elsewhere. With little money available for national initiatives and restricted in what it could

Postwar renaissance 43

do even for its core public, the Institute was in a sense marking time throughout Quinn's period as director.

Nor was there much pressure for the BFI to be in the avant-garde of film culture. It had seized that position in the early 1950s and maintained it for a number of years with initiatives such as the Free Cinema screenings (1956–59) and the early London Film Festivals which played a major role in introducing the French New Wave to British (or at any rate London) audiences. But the culture it promoted was by no means the only one to which it needed to pay attention. On the one side the BFI was no longer able to support experimental film production and from the other side it was about to be outflanked by groups of young enthusiasts who found qualities in mainstream cinema to which the 'Dean St clique', in the phrase of the critic Raymond Durgnat, turned an obstinately blind eye.[31] It was to pay for this blindness later.

Notes

1 *Interim Draft of the Factual Film in Great Britain*, Arts Enquiry, London, n.d. [1944], p. iv.
2 *The Arts Enquiry. The Factual Film*. Published by the Oxford University for PEP (Political and Economic Planning), 1947. See in particular pp. 32, 40–1.
3 Notes of the meetings are in National Archives, NA/CAB 130/9. Morrison's role is not mentioned in the documents, but it is unlikely that anyone other than the deputy prime minister could have convened the meetings where the report was discussed.
4 Other members included Stephen Tallents, formerly of the GPO Film Unit, and the critic Dilys Powell, who became a BFI governor. Committee secretary was Jane Lidderdale from the Privy Council who was to be main point of contact between the BFI and Lord President's office in the 1950s.
5 *Report of the Committee on the British Film Institute* (Radcliffe Report), Cmd. 7361, §13.
6 Lady Tweedsmuir was the daughter-in-law of the novelist John Buchan, later First Lord Tweedsmuir, a moving sprit behind the foundation of the BFI.
7 BFI Governors Minutes, 20 January 1949.
8 Denis Forman, *Persona Granada: Some Memories of Sidney Bernstein and the Early Days of Independent Television* (London: André Deutsch, 1997), p. 17.
9 Testimony of Mary Smith, neé Beckwith, who worked in the Information department and then in the NFL from 1941 to 1952 (CD/GNS interview, 11 July 2006). The Governors Minutes for 17 February 1949 refer to a resolution passed by staff on the circumstances of Bell's resignation – which, however, the governors decided not to include in the minute book, so no record survives of what it said. Bell and Dickinson's habit of taking extremely long and well lubricated lunches only really came under scrutiny after they had left, when their expense claims were queried by the auditors. Dickinson also had to repay some cash advances made to him by the BFI (see NA/CAB/124/92).
10 In his *Sight and Sound* obituary for Reisz (January 2003) David Robinson wrote:: 'A crucial cell in the forming of Britain's politico-cultural renascence in the mid-50s was a grim windowless office in the BFI's premises in Shaftesbury Avenue, divided by a flimsy glazed partition with a connecting door. On one side sat Reisz; on the other Lambert and Houston; with Lindsay Anderson and Tony Richardson as daily visitors, noisy presences and provocative regular contributors to the magazine. I was a fortu-

nate witness, taking turns as everyone's assistant.'
11 See Christophe Dupin, 'The Postwar Transformation of the British Film Institute', *Screen* 47:4, Winter 2006.
12 The Eady Levy (named after the civil servant Sir Wilfred Eady who designed it at the behest of Board of Trade minister Harold Wilson) was a scheme instituted in 1950 to recycle some of the takings from cinema exhibition into a fund to support British film production. The Fund was administered by a trade body called the British Film Fund Agency under the auspices of the Privy Council.
13 For the Experimental Film fund and its successor, the BFI Production Board, see Christophe Dupin in Chapter 12.
14 Document dated 13 October 1949, preserved in BFI/A-33/2.
15 Undated, probably autumn 1951, preserved in BFI/A-33/1.
16 Ideally what the NFL wanted, and could usually secure from Rank and some other companies, was mint-condition fine-grain positives, from which an internegative could be struck to enable the making of viewing prints. Failing that, the NFL was prepared to accept used prints which the print managers of the distribution companies were eager to dispose of once they had reached the end of their commercial life. In the early 1950s, when the industry was converting wholesale to acetate (safety) stock, a lot of nitrate prints became available in this way. The problem then was how to store and preserve them.
17 It was also agreed, at an EGM in 1961, that the voting rights at the annual general meeting would be confined to full members. The same meeting also approved adding promotion of 'the best use of television' to the Institute's aims, though the Treasury insisted that this should not mean that the BFI spent any money on it.
18 Forman's departure, as recounted in *Persona Granada* (pp. 35–8), was actually a rather untidy affair. He offered his resignation, discovered that the job he was in for (not with Granada) was not what he wanted, and tried to withdraw his resignation but only succeeded in delaying it for a month. He was then offered a job at Granada, where he rose to become managing director and then chairman. He returned to the BFI as chairman after the 1970 crisis (see Chapter 9 below).
19 See National Archives files NA/CAB124/89 to CAB124/95. The obligation to pay this large sum to the Scientific Film Association, which was deeply resented by the BFI, made it hard to provide money to other potential recipients of grant-in-aid, such as the Society of Film Teachers (SFT) and the British Universities Film Council (BUFC), which both received a derisory grant throughout the 1950s, and the Federation of Film Societies, which regularly appealed for money but was always turned down by Forman, with governors' approval. (For the FFS and Forman's hostility to it see Richard MacDonald, Chapter 5, especially pp. 92–3.) BUFC, the BFFS (as it became) and the SFT's successor body, SEFT, were to receive regular grant-in-aid support from the BFI from the 1960s until the 1980s.
20 Governors Minutes, 11 December 1953. It should never have been otherwise.
21 Governors Minutes, 11 March 1955. The Institute's accounts for 1954 do not directly show any deficit, though there may have been an over-optimistic calculation of monies owed to the Institute by debtors.
22 The system chosen was the Dewey decimal system, which was easy to implement (though it took some time) and is still in use. The National Film Library also needed a cataloguing system, for which there was no ready-made model, so it had to devise its own. This was achieved in 1952 with the second edition of the modestly titled *Rules for Use in the Cataloguing Department of the National Film Library*, compiled by David Grenfell. This was steadily expanded and improved throughout the 1950s and by the time it reached its fifth edition in 1960 (with the word 'Archive' replacing 'Library')

Postwar renaissance

its principles had become effectively the worldwide standard, followed by UNESCO and the major FIAF archives. It was only in 1968 that FIAF created its own cataloguing commission. New rules established since then have not substantially improved on those set out by Grenfell and his colleagues in the 1950s.

23 Governors Minutes, 25 May 1951.
24 British Film Institute. Organisation, Methods and Staff Structure Report. OM.474/1/01. February 1959. BFI/A-2. Copy in BFI National Library.
25 The National Film Library officially took on the name National Film Archive in 1955.
26 Sylvester Gates, chairman of the Bank of West Africa but otherwise unknown as a public figure, was an unlikely choice for the position, but by all accounts was an exceptionally good and dedicated chairman.
27 Not only was the secretary (or deputy director) not supposed to commit money directly, the director did not have an operational spending budget either. The principle in fact began to be eroded in the 1980s, when large sums of sponsorship monies started to flow in to the BFI. Since the BFI was not accountable to the Treasury for these monies, the director had absolute discretion on how they were spent, but so long as Anthony Smith was director financial control rested with the deputy director in the same way as for spending of the government grant.
28 Governors Minutes, 13 November 1959. See also comment by Stanley Reed in an item 'Film Institute News' included in the NFT Programme for May/June 1965.
29 The choice of the National Film Archive as preferred repository for government films was a result of the Grigg Report into public records which reported in 1954 and some of whose provisions were adopted in the Public Records Act 1957. It took several more years before the PRO got round to releasing the films requested by the NFA. For the BFI's increasing involvement with television, see Richard Paterson, in Chapter 12.
30 The idea of concentrating on teacher training, proposed by Reed and Whannel, was strongly endorsed by the distinguished educationist J. H. Newsom, who was on the BFI board of governors from 1957 to 1958 and went on to produce the Newsom report on primary education in 1963. See Governors Minutes, 11 April 1958. For more detail see Terry Bolas, in Chapter 9.
31 Raymond Durgnat, 'Standing up for Jesus', *Motion* 6, Autumn 1963. Before Durgnat there had also been attacks on the BFI and *Sight and Sound* in particular in *Oxford Opinion*, *Movie* and other small magazines, including the Federation of Film Societies magazine *Film*. For more on the attacks on *Sight and Sound*, see Chapter 13.

3

'Je t'aime ... moi non plus'

Ernest Lindgren and Henri Langlois, pioneers of the film archive movement

Christophe Dupin

> We have worked in the same field for 22 years. I suppose we will continue to do so until the end of our lives. But in the end we are not becoming closer to each other. Must it really be so? I will never admit it, I will always have hope.[1]
> Draft of a letter from Ernest Lindgren to Henri Langlois (in French), c. 1956

'Je t'aime ... moi non plus' ('I love you ... me neither') is a 1969 pop song by the iconic Franco-British couple Serge Gainsbourg and Jane Birkin, whose title perfectly epitomises the relationship of another, if less iconic Franco-British couple whose radically opposed views on their field of expertise – film archiving – were a defining moment in the international history of that field and have set the paradigm for key debates within it ever since. Henri Langlois (1914–77) and Ernest Lindgren (1910–73), respectively founder and first general secretary of the Cinémathèque française and first curator of the National Film Library (the initial name of the BFI National Archive), worked closely together between 1945 and 1960 both through bilateral relations between their two archives and as two dominant figures of the International Federation of Film Archives (also known under its French acronym FIAF). Although they both remained in office until their premature deaths (both at the age of 62) in the 1970s, by the time 'Je t'aime ... moi non plus' reached the top of the charts on both sides of the Channel in 1969, their collaboration had long ceased being productive. Their relationship had indeed been marred by endless disagreements and frustrations, ending in Langlois's definitive falling out with Lindgren and most of the international film archive community in the early 1960s. This chapter examines their widely different views on the role, methods and priorities of a film archive (and the impact of their confrontation on their field) and at the same time tells the story of two truly extraordinary personalities whose tumultuous relationship also stemmed from cultural and institutional differences, the inevitable language barrier and, last but not least, two incompatible temperaments.

This research was first triggered by the discovery of the fascinating correspondence between the two men at the BFI National Archive's premises in Berkhamsted, later complemented by documents in similar collections at the Cinémathèque française and the FIAF headquarters in Brussels. Put together, these hundreds of

letters, unsent drafts, notes and telegrams provide a unique insight into the minds of these two men and reveal the true nature of their collaboration and conflicts. But perhaps the main reason behind this research is the imbalance in the attention that Langlois and Lindgren received during their lifetime and after in terms of serious research, media coverage and peer recognition. Langlois's life and work have been the subject of a number of books and several documentaries; he even received an Oscar towards the end of his life for his outstanding contribution to the art of film, and he is still widely recognised in France and beyond as the one and only father of the film archive movement. In contrast, Lindgren's legacy has largely been ignored, even though his role was different from but arguably no less important than that of Langlois. This chapter therefore hopes to add to recent attempts to redress the balance.[2]

Early days of FIAF

The National Film Library and the Cinémathèque française both emerged in the mid-1930s out of a largely non-concerted international movement that led a handful of forward-looking personalities and organisations to recognise ('ten years too late', later commented Langlois) that the systematic preservation of films had become an urgent necessity.[3] One of the anticipated functions of the British Film Institute established in 1933 was 'to be responsible for film records and to maintain a national repository of films of permanent value'.[4] The Institute duly set up the National Film Library in July 1935 and asked the 25-year-old Ernest Lindgren to run it. A year later, an even younger Henri Langlois and his friend Georges Franju formally established the Cinémathèque française in Paris. The other major film archives that emerged in that period were the MoMA Film Library in New York (led by Iris Barry) and the Reichsfilmarchiv in Berlin. Contacts between these young archives were soon established as they realised that international co-operation would help promote and legitimise their work (in particular to the governments that funded them and to the studios which owned the films they collected) and that the mutual exchange of films and other film-related artefacts could be key to the growth of their respective collections. The leaders of the four major archives met in Paris in June 1938, where they founded the International Federation of Film Archives, with its headquarters in Paris. They met again in July 1939 in New York, but the outbreak of war put an end to most international contacts for nearly six years, and especially those between Britain and occupied France.

Lindgren, who had not taken part in the initial contacts with foreign archives, first met Langlois in late 1945 during the Frenchman's first postwar trip to London.[5] Their regular correspondence dates back to that year. Their collaboration was on two levels. First, within the general framework of the FIAF statutes signed before the war, they sought to initiate a policy of exchanges between the two institutions. Films would be exchanged either on a 'permanent loan' basis, allowing the receiving archive to keep a copy for permanent preservation, or on a 'temporary

Mon cher Henri,

Mon collègue, David Grenfell, est ~~un catalogue~~ simple catalogue, pas un espion. Il a quand-même, des oreilles, et il est ~~&~~ loyal. Il m'a donné, donc, ses impressions qu'en conséquence d'Antibes vous êtes un peu fâché contre moi ~~que~~ j'étais contre vous dans dans les discussions et dans la vote; que j'ai l'ambition personelle d'être President; que je ~~suis~~ ne m'interesse pas dans la sauvegarde des films, mais uniquement dans le "testing"; que vous êtes contre le "testing" etc. etc.

~~Je ne sais pas si David a raison~~ Peut-être je suis mal informé; peut-être Grenfell ~~&~~ ne comprend pas suffisamment la langue française: c'est bien possible. Mais à l'autre côté, c'est également possible qu'il a raison: ~~&~~ ce n'est pas tout à fait incroyable.

~~...~~

Nous avons travaillé dans le même champs depuis vingt-deux ans; je ~~suis~~ suppose ~~convaincu~~ que nous continuerons ainsi jusqu'au fin de nos vies; mais au fond nous ne ~~divenons~~ venons pas plus proche, l'un à l'autre. Est-ce impossible? Je ne l'admettrai jamais; j'ai toujours espoir.

Il-y-a quelques ans je vous ai envoyé une lettre personelle, écrite de mon cœur, pour essayer créer une entente, une compréhension; ~~selon~~ je sais que vous ne l'avez pas reçu. Maintenant j'essayerai encore une fois.

{ et "j'étais vraiment désappointé,

3.1a Handwritten draft of a letter in French from Lindgren to Langlois, c. 1956. It is partly translated on p. 46.

'Je t'aime … moi non plus' 49

3.1b Handwritten note from Langlois to Lindgren, c. 1958. It translates as: 'Alas I have the feeling that you see traps everywhere. If only you knew how, beside the necessity of maintaining FIAF's unity, I have so many other things to do.'

loan' basis, either for screenings programmed by the two archives themselves (the Cinémathèque from 1936 via its cine-club extension the Cercle du Cinéma and the NFL from 1950 via its repertory programme cycles in various London cinemas), or for circulation to the expanding network of cine-clubs and film societies in both countries. The two archives also promised to exchange documentation about film. Despite a promising first shipment of books from London to Paris in December 1945, co-operation between the two archives quickly failed to live up to their leaders' expectations,[6] and Lindgren therefore insisted that they should officialise and clarify the terms of their collaboration by signing a bilateral agreement. Although Langlois initially rejected the idea, arguing that FIAF statutes already defined the terms of the relationship between the NFL and the Cinémathèque, an informal agreement was duly signed in August 1949 by the two archivists and their chairmen. However, the NFL's book of acquisitions for permanent preservation in the late 1940s and early 1950s suggests that permanent loan of prints from the Cinémathèque to the NFL remained the exception, while the same book shows many donations from the Czech Film Archive, with which the NFL had signed a similar agreement, over the same period. The Lindgren–Langlois correspondence

shows many exchanges being promised and an exchange programme duly drafted, but few film cans actually crossed the channel, possibly because of the heavy cost of making copies of film prints in a difficult economic context.

The correspondence also suggests that temporary loans seemed more productive, even though they led to frustrations on both sides about promised films arriving too late, not being returned fast enough, being returned in poor condition or being illegally duped whilst on loan. Lindgren also often complained about the exchanges being too often one-sided, since Langlois needed a lot of prints for his intense programming while the NFL did not organise repertory screenings itself until 1950.

The two archives also agreed to give each other occasional advice and assistance. In 1946, Lindgren gave Lotte Eisner, one of Langlois's close collaborators, a visit of his state-of-the-art film preservation vaults in Aston Clinton. She immediately reported to Langlois about the 'marvellous installation' she had seen.[7] Another revealing example is the famous 'Mark IV' contact step printer designed and built by the NFL's brilliant preservation officer Harold Brown from his childhood Meccano set in the mid-1950s. Initially conceived to help Langlois to copy his unique collection of Lumière films (which had only one pair of circular perforations per frame), the printer took several years to be perfected and, ironically, became fully operational only after the falling out between the two curators. As a result none of Langlois's films was ever copied on this machine, which was used regularly by the NFA until the 1980s.[8]

The second level of Lindgren and Langlois's relationship was through their respective roles within FIAF. Between 1946 and 1959 the two men were constant members of the Federation's elected Executive Committee (Langlois mostly as General Secretary and Lindgren as Treasurer or Vice President) and as such were instrumental to both the rapid international growth of this emerging sector (33 member-archives by 1959) and the professionalisation of its practices. The regular Executive Committee meetings and annual congresses provided natural platforms for the passionate confrontation of ideas, theoretical exchanges and the development of common projects. But it was also there that Langlois and Lindgren's confrontational relationship was most visible.

A confrontational relationship

The first and most fundamental difference between the two curators was their radically opposed approach to the role, priorities and methods of a film archive. One of the main debates was that of 'preservation versus projection'. It stemmed from one of film's fundamental dilemmas, which is that in order to be seen a film has to go through a projector, but over time the repeated process of projection damages the film to the point that it can no longer be screened.

From the moment Lindgren took over the destiny of the National Film Library, he made the 'preservation of films for posterity' its utmost priority and never

'Je t'aime ... moi non plus'

3.2 Studio portrait of Ernest Lindgren

departed from this throughout his career. His philosophy was based on the strict principle that the original copy of a film acquired by the Archive could under no circumstance be projected, access being granted only to duplicate copies. This principle was in fact first enunciated by a committee of technicians and scientists appointed by the British Kinematograph Society on behalf of the BFI in 1934 (a year before the NFL was established) 'to consider means that should be adopted to preserve cinematograph films for an indefinite period', as up to then hardly anyone had ever given the question of film preservation any serious thought. The BKS report introduced many of the principles that guided Lindgren's work, including that of the non-projection of master material, and he was to become their standard-bearer thereafter.

This strict approach would have been unanimously accepted had the Archive (and other film archives) had enough resources to make access prints from master material. But in these early days shortage of money and the huge price of film printing made drastic choices inevitable. As Roger Smither put it:

> If funds are tight, is it really more responsible to spend those funds on making a preserved film accessible, or to invest them in making a preservation master of another endangered film? The impeccable chain of logic of the precise Lindgren could not help

looking small-minded and bureaucratic compared to the romantic aura of the flamboyant Henri Langlois' Cinémathèque screenings across the Channel, which parted company with that chain of command at the first link.[9]

Langlois, whose background was the world of film societies and whose true vocations were to be a collector, a curator (in the museological sense) and a programmer rather than an archivist, did not pay much attention to film preservation until much later. In his mind, since it was too expensive to preserve films in perfect conditions, it became crucial to screen them in order to disseminate film culture there and then, both by making screenings the raison d'être of the Cinémathèque française and by generously circulating its prints among sister archives. In doing so, Langlois played a key part in the international postwar development of cinephilia and dramatically increased his and the Cinémathèque's prestige at home and abroad. It is well known that the young *Cahiers du cinéma* critics who later became film-makers of the French New Wave owed much of their film education to Langlois's screenings. Much of the 'Langlois myth' comes from there.[10] The obvious downside of his philosophy was that his unique prints ended up being for ever damaged by excessive screenings and bad conditions of preservation. However it is easy to understand why Lindgren's position was the less popular of the two, since it sacrificed the current generation of film enthusiasts for the sake of an undefined future – the famous 'posterity' which, as the film-maker and historian Kevin Brownlow later ironically commented, 'was always 20 years away'.[11] With hindsight, the idea that the long-term survival of film was more important than its short-term accessibility was a courageous and selfless one, since it would bear fruit only in the distant future (i.e. long after Lindgren himself had retired), whereas Langlois's policy paid off instantly.

Although Lindgren's focus on film preservation was clear, he always tried to give access to as many of his archive's films as possible, within the limits of his resources and the constraints of copyright. He set up a loan section to circulate film classics reprinted from his preservation collection to schools and film societies from the very start of the National Film Library. His key writings on future developments of the archive in the 1940s show his growing frustration about the NFL's lack of a cinema.[12] He programmed his first regular archival screenings in various London cinemas in May 1950, and from 1952 programmed continuous repertory cycles at the NFT. His last important mission in the early 1970s was to set up a landmark viewing service enabling researchers, students and film-makers to access films in the collection. Before that he had always enabled bona fide film students and researchers to view the archive's films on an ad hoc basis, on the premises. A revealing example is the very first encounter between Lindsay Anderson and Karel Reisz in the late 1940s, on a train to the archive's Aston Clinton site where they had double-booked the viewing bench.[13] Although not comparable with Langlois's influence on the New Wave, this shows at least that Lindgren's archive was not as inaccessible as sometimes claimed.

Nor was Lindgren as ignorant about the art of film as some (Langlois in particular) may have claimed. He was indeed, along with Paul Rotha and Roger Manvell,

'Je t'aime ... moi non plus' 53

one of the very first British film scholars. Although his cinephilia did not go as far back as Langlois's, he developed a genuine interest in film – not only as a form of art but also as a documentary record, which partly explains the National Film Archive's historical strength in non-fiction film. He lectured on all aspects of the cinema from the late 1930s and organised the first postwar BFI Summer Schools, which became a key educational event in the Institute's calendar for nearly half a century. His book on film appreciation, *The Art of the Film* (1948), was an early milestone in British film writing. Lindgren's writings about film may not have been as inspired and poetic as Langlois's, but they did nevertheless influence many British film enthusiasts in the postwar period.[14]

However, it was for his pioneering work in the new disciplines of film preservation and cataloguing that Lindgren discreetly gained a growing reputation on the international stage in the late 1940s, as he was always eager to share his findings with sister archives, via publications or presentations at FIAF congresses.[15] As early as 1940 Lindgren had acquired a new site for the NFL at Aston Clinton, forty

3.3 Harold Brown conducting the pioneering 'artificial ageing test' for nitrate film

miles from London, and supervised the building of some of the very first vaults specifically designed to store the chemically unstable and highly inflammable nitrocellulose (aka nitrate) films in the strictest conditions of humidity and temperature. During the War he also introduced, with the help of scientists, a revolutionary 'artificial ageing test' to anticipate when a nitrate film was likely to start decomposing, as nitrate film stock (used for all standard films until 1951) could deteriorate to the point of complete uselessness without warning within a few months. Results of the test then determined the Archive's programme of duplication on to acetate (safety) stock, which was relatively non-inflammable and stable and was then believed to have a much longer life span than nitrate ('two or three hundred years,' optimistically predicted Lindgren).[16] Langlois always doubted the efficiency of this method and particularly criticised the fact that it required punching several small holes in the film itself. He compared this operation to that of deleting notes in a symphony. Langlois's almost mystical veneration of nitrate film stock contrasted with Lindgren's pragmatic and methodical approach. He was particularly enraged about Lindgren's decision to destroy unstable nitrate master prints once they had been transferred to safety film. The latter may not have had the 'almost pathological loathing of nitrate' that Richard Roud suggested, but he nevertheless confessed as early as 1945 in a report on film preservation that 'if we could have all our films on acetate film, our work would be greatly simplified'.[17] Meanwhile, Langlois's preservation policy remained almost non-existent for many years. As Raymond Borde explained, 'a film that he acquired was miraculously saved of all perils to become a royal object, protected and sacred'. Roud confirmed that 'since nitrate film was, for him, alive, it could die in its cans. Taking the film out of the cans and projecting it, or at least rewinding it, protected it.'[18] This romantic attitude was to have irreparable consequences for the Cinémathèque's unique collections.

As well as film preservation, Lindgren led the way in the development of film cataloguing. His early writings show that he saw the cataloguing and indexing of the films in his collections as an absolute prerequisite for accessibility and therefore integral to the Archive's work, even though it soon became obvious that it was a particularly time-consuming process.[19] Throughout the 1940s, he pioneered a new application of cataloguing principles to film and in 1950 his growing cataloguing department wrote the landmark *Rules for Use in the Cataloguing Department of the National Film Library*. This rulebook was updated five times over the next decade, as the department kept fine-tuning its methods and other institutions (notably the Library of Congress) brought their own contribution to the debate. These cataloguing procedures were progressively adopted by the vast majority of film archives around the world. Once again, Langlois argued that it was a waste of precious time and money to create index cards and catalogues when the utmost priority, again in the context of extremely limited funds, was to 'save films'. 'We have centuries to make cards,' he reacted angrily at the 1953 FIAF after Lindgren had evoked his cataloguing rules.[20]

For Lindgren, since the Archive's collections were the nation's collections, the

public had the right to know exactly what they contained, through the regular publication of catalogues. He published the first catalogue of the NFL as early as 1936, while all new acquisitions of the year appeared in the BFI's Annual Report for many years. In the postwar period the NFL was the only archive within FIAF to publish a comprehensive catalogue of its silent film holdings, in thee parts: *Silent News Films, 1895–1933* (1951), *Silent Non-Fiction Films 1895–1934* (1960) and *Silent Fiction Films, 1895–1930* (1966). In 1951 Lindgren even submitted to fellow FIAF archives the project of a collective catalogue. The outcome, three years later, was the *Union Catalogue of Selected Films* (1954), a bound volume containing a small selection of films preserved in each archive and circulated confidentially to FIAF members. The National Film Archive also published its first catalogue of viewing copies in 1971. Langlois, on the other hand, who had the mentality of a private collector, always refused to make public any inventory of his collections. The secretive approach was supposed to protect the Cinémathèque against other film archives and rights holders. No proper list of its holdings existed until the 1980s, several years after Langlois had died and after several fires in which many unidentified films perished.

Another crucial opposition between the two curators concerned the acquisition process, and in particular the decision to operate a selection or not. Langlois was strongly opposed to any kind of selection. Again from his collector's point of view, he considered that everything had to be preserved because a film considered minor one day could become a classic later. Lindgren agreed in principle but, within the strict limits of his budget and the space available, he considered that he had no choice but to operate a selection. Langlois may have been eager to keep everything but he couldn't guarantee the safe preservation of all his films, which were often stored in appalling conditions.[21]

Finally, while the collector Langlois saw the project of a film museum as one of the key tasks of his Cinémathèque, Lindgren the rigorous film archivist always prioritised preservation, even though his writings show that he was not opposed to the idea of a museum in principle. A key episode in this debate is the astonishing story of the British collector Will Day's collection of pre- and early cinema equipment.[22] Day, who wanted to sell his collection but was keen for it to find a good home in Britain, wrote to Lindgren in February 1936, offering it to the NFL for £10,000, spread over ten years. Lindgren was enthusiastic and wrote that the NFL was indeed 'the proper body to undertake its preservation for posterity', but he failed to convince the BFI Governors to spend so much money at a time when the BFI's annual budget was £8,000 a year.[23] Day died a few months later and further talks with his brother came to nothing. Negotiations resumed in late 1948 and Lindgren this time made a £5,000 offer to the Day family, who rejected it. Eventually, it was Langlois who jumped at the opportunity. Thanks to his close relationship with André Malraux, the then French culture minister, he managed to raise enough funds (about £12,000) to buy it for the Cinémathèque in 1959. This great British collection still forms the best part of the Cinémathèque's exceptional

non-film collections today. Lindgren was never so passionate about old film equipment as Langlois was (he was more interested in other non-film objects such as stills, posters, production designs and scripts, which are today important collections of the BFI National Archive). More importantly, however, the Cinémathèque was richer than the NFL/NFA (its annual grant-in-aid from the government was roughly twice as big throughout the 1950s and 1960s).[24] Nor did Lindgren have the same direct access to government circles as Langlois enjoyed, and his archive was never supported by the British government to the same extent as the Cinémathèque was by the French one (besides, there was no culture minister in Britain until Jennie Lee's appointment in 1964).[25]

The confrontational relationship between the National Film Library/Archive and the Cinémathèque française in the postwar years stemmed not only from the opposed views of their leaders but also from their irreconcilable characters, on which many scholars and archivists have commented. In Roger Smither's words, Lindgren was the 'negative to Langlois' positive, or vice versa'.[26] Langlois was an exuberant, larger-than-life (metaphorically, as well as physically in the later years) figure, likened to a 'Fellinian character' or a 'Renaissance prince' by commentators. Jacques Ledoux, curator of the Belgian Film Archive and another immense figure in the film archive movement, recalled: 'Langlois was a man of excess in all things, but fascinating in his very excesses, an extraordinary mixture of inspiration and preconceived ideas.' For Raymond Borde, former curator of the Cinémathèque de Toulouse and historian of the film archive movement, 'Langlois possessed a tyrannical charm to which most Film Archivists succumbed' – Lindgren included. Langlois, Borde added, 'had the presence, insolence and volubility that Lindgren lacked'.[27] His charisma, brilliant mind and unmatched passion for (and knowledge of) film made him a key player on the international stage in the immediate postwar period, as many newcomers in the field looked up to him with great admiration, as well as a degree of apprehension.

For the flamboyant Langlois did not always put his demonic energy to the most productive use. He loved power and was described by many as an autocrat within his own archive (which he considered all his life a mere extension of himself) and a rather intimidating paternalistic figure for other young film archivists. For Laurent Mannoni, from the late 1940s 'his passionate nature, his growing popularity and his total control of the situation (or so he thought) made him despotic and uncontrollable'.[28] His correspondence with Lindgren indeed confirms that he found any kind of criticism or indeed any view other than his, however diplomatically formulated, difficult to accept. Throughout the 1950s he grew increasingly paranoid. He regularly accused Lindgren of illegally duplicating prints he had lent him even though, as Lindgren once put it, 'he could not produce an atom of proof', while within FIAF he increasingly saw any opinion expressed against him as a conspiracy.[29] He was also secretive, jealous and manipulative, and was known to be as generous with people he liked as malicious with anyone he took a dislike to, which Lindgren would learn at his cost.

Lindgren could have hardly been more different from the excessive, romantic and highly political figure of Langlois. He was practical, organised and logical, qualities which he himself in his correspondence with Langlois attributed to his half-Swedish, half-English origins.[30] He was also unashamedly respectful of rules, institutions and hierarchy, never hesitating to ask for advice on any issue on which he was not an expert. He was also a man of irreproachable integrity and frankness,[31] who always encouraged transparency and clarity over secrecy. He never shied away from an argument but he rarely took an adverse view or criticism personally. In the words of the former BFI director Stanley Reed, 'his force was always deployed without malice and he accepted reverses with the same equability as he took his triumphs, with never a trace of rancour'.[32]

It is not difficult to see why the two men had a difficult personal relationship. Yet the correspondence indeed clearly indicates that Lindgren always held Langlois in high esteem despite their frequent disagreements, and made numerous attempts at making the relationship work. In February 1960, at the height of the now open conflict between the two, Lindgren confessed to fellow archivist Salles Gomes: 'I have no animosity against Henri of any kind. In a way, it would be easier if I had. On the contrary, I like him and admire him for many things.'[33] Lindgren often reiterated to Langlois that his arguments with him were purely professional and never reflected his personal feelings for his colleague. Besides, when Langlois fell seriously ill in early 1952, Lindgren showed great concern and proved very supportive.[34] But for Langlois the personal and the professional could not be separated so easily. In fact, a damming internal memorandum sums up rather clearly what he really thought of Lindgren. He defined him as 'provincial and petty bourgeois, with an ambition all the more dangerous and deceitful in that it is coupled with an inferiority complex towards his superiors and, even more seriously, [he] is slow-witted and has extremely shallow knowledge of the art of film'.[35]

The difference in the official status of the two men and their archives was another clue to their endless conflicts. These institutional differences created an imbalance between them, which Langlois was always quick to exploit, to Lindgren's regular frustration. The Cinémathèque française was not only a stand-alone organisation, it was also almost entirely Langlois's own project. It had evolved from being a small cine-club, the Cercle du Cinéma, to be implicitly recognised by the French government as France's national film archive, despite its private status as an *association*. The National Film Library, on the other hand, was set up only as one department of the British Film Institute, and Lindgren was not strictly speaking its founder. Therefore, while Langlois had complete control over all of the Cinémathèque, of which he remained undisputed leader until his very last day (except for a few months in 1968 – see below), Lindgren was only ever in charge of one of several BFI departments.[36] He was not given the formal title of Curator until the 1940s, and became Deputy Director of the BFI only in 1949. He also worked under the strict authority of a committee of experts (the NFL Committee) appointed by the BFI Governors. In his correspondence, Langlois was sarcastic about his

English colleague having to consult the NFL Committee on every subject and even needing to obtain permission to travel to each FIAF meeting. If the work of the Cinémathèque française was also overseen by a *conseil d'administration*, Langlois always made sure he had enough allies on it to effectively enjoy full powers.[37]

The BFI's bigger and more complex structure meant that Langlois could have dealings with a number of BFI services and officers across the Institute. Even though Lindgren tried as much as possible to centralise all requests, Langlois often deliberately contacted each department directly. One day, having heard some gossip from a colleague of Lindgren's at the BFI, Langlois sarcastically wrote to his colleague: 'I am afraid to say, my dear Lindgren, that once again you are in total ignorance of what is going on in your own office,' using as so often the 'divide and rule' strategy at which he excelled.[38] From 1952, new competition for Lindgren within the BFI came from the National Film Theatre, which constantly needed film prints for its seasons and relied on Langlois to obtain the many films it could not get from the BFI's own archive. The Frenchman proved particularly generous with successive NFT programmers, who in return became his faithful allies within the BFI.[39] He also regularly snubbed his English colleague by writing directly to the BFI director to discuss key issues. What did not help Lindgren was the fact that successive directors, from Oliver Bell to James Quinn, were quickly charmed by the charismatic Langlois and developed a friendly relationship with him. The Cinémathèque leader also often pretended to be confused about the distinction between the NFL and the BFI, and deliberately saw the BFI, rather than the NFL, as the official FIAF member for Britain (which, in strictly legal terms, was right). This irritated Lindgren, who was understandably envious of both Langlois's freedom and the independence of his archive. In April 1955 he tried to clarify the situation in a letter: 'I can assure you that the National Film Library has a real identity, even though it is not a legal identity.' He went on to explain that film distributors donated their films to the NFL, not to the BFI, and that the curator of the NFL was appointed directly by the BFI Governors, unlike other BFI staff. A few months later, Lindgren convinced the BFI Governors that the NFL needed a new, more appropriate name (National Film Archive) and a new enhanced status within the BFI. He even gave up his title of BFI deputy director to clearly show where his priorities lay. But the matter of the Archive's status remained a difficult one for the rest of his career. In 1972, after the then BFI director Stanley Reed suggested that BFI headed paper should be unified, the NFA curator wrote a furious letter to the BFI chairman (former BFI director Denis Forman) to explain how this seemingly trivial proposal sent all the wrong signals about the lack of authority of the National Film Archive to all its contacts, from rights holders to the government to FIAF colleagues.[40]

The imbalance of the relationship manifested itself particularly within FIAF, the main reason being Lindgren's exclusion from the early FIAF developments in the 1930s. Although he had been in charge of the NFL from the start, his position was considered too junior for him to represent it on the international stage,

whereas Olwen Vaughan, the BFI secretary, was already a friend of Langlois, whom she invited to give several lectures in her other capacity as leader of the London Film Institute Society, a film society affiliated to the BFI. It was Vaughan who met the leaders of the other three film archives in Paris on 14 June 1938 at a tribute screening to MoMA programmed by Langlois, signed FIAF's founding agreement on behalf of the BFI three days later and became the new organisation's treasurer.[41] It was Vaughan again who represented the BFI at the Federation's first congress in New York the following year. Her resignation from the BFI in June 1945 to run the New London Film Society (a merger between the legendary Film Society and her own London Film Institute Society) initially made things worse rather than better, as Langlois continued for some time to act as though she was still the official FIAF representative in the UK, while Vaughan herself seemed to do little to dissuade him from doing so. His first faux-pas was not only to invite her to FIAF's first postwar meeting in Paris (March 1946) but also not to tell Lindgren about it. This triggered his first enraged letter to Langlois: 'I suggest that it was discourteous, to say the least, and was calculated to place us all in an embarrassing position [...] I must renew my protest to you personally in this letter. I protest against both what has been done and the manner in which it has been done. Your actions have shown a lack of appreciation of the position and a lack of finesse.' He even anticipated that the NFL would 'dissociate itself from the Federation until this position has been clarified'.[42] Lindgren had been patient until then, but now that Vaughan had left the BFI he was more than ready to take his earned place on the international stage. Meanwhile Vaughan kept borrowing prints directly from Langlois (as well as from Iris Barry, for that matter) for her New London Film Society programmes, despite the strict FIAF rule stipulating that member-archives could have dealings only with other member-archives. British film societies could therefore not request a film directly from the Cinémathèque, but only via the NFL. Langlois defiantly argued at the time that his special relationship with Vaughan's film society dated back to pre-FIAF days, which naturally exonerated them from adhering to FIAF regulations. Vaughan's close friendship with Langlois (she even carried out official missions for the Cinémathèque in 1948), and more generally the fact that her temperament was in many ways similar to Langlois's, never ceased to irritate the NFL curator. In a letter to Langlois some fifteen years later, he would still recall his 'bitter feelings against a certain lady in London'.[43] But beyond the Vaughan issue, Langlois never missed an opportunity to remind Lindgren of his absence from the early development of FIAF. In his typically sardonic way he wrote in June 1946, after being criticised for the slack way in which he had prepared the 1946 FIAF congress: 'I will send you details on the organisation, on its line of conduct, and the past climate at FIAF, since you don't seem to know much about it, which is normal since you have not had the opportunity to participate in its work until now.'[44] On another occasion he magnanimously forgave Lindgren for illegally lending to another archive a print that had come from him in the 1930s because 'it comes from the fact that you have not been aware since Miss Vaughan's

departure which films we sent you prior to 1940'.[45] These hurtful comments were pointless (unless Langlois's only point was to enrage Lindgren) as the latter openly recognised all through his career that Langlois was 'the unique architect of FIAF'.

The language barrier added to the two archivists' difficult relationship. Langlois's English was poor (he made a real effort to learn it only much later in life, after he and Lindgren were no longer on speaking terms) and he made little effort to speak or write it. His prominent role within FIAF in the early years was such that French was adopted as the natural language in meetings, which gave him a tactical advantage over Lindgren. The latter always tried to rise up to the challenge, but in 1956 he confessed to Langlois:

> During our meetings, you drown your listeners in an avalanche of impassioned French which we can't always understand. We can't interrupt you and we cannot ask for clarification, otherwise the avalanche starts again. You are almost certain of winning your point in the short term. But you shouldn't be surprised if your non-Francophone friends like myself eventually get tired and cynical. It was to avoid this situation that I have struggled for many years to improve my French.[46]

For the duration of their relationship he remained obsessed with the idea that he or Langlois might misinterpret each other's views. As he once confessed to an English acquaintance: 'I translate French a little laboriously and sometimes I find his communications so disconcerting that I wonder if I am mistranslating and doing him an injustice.' The correspondence shows that Lindgren increasingly tried to write to Langlois in French (he improved significantly over the years). He also encouraged his colleagues (such as Liam O'Leary, the NFA's film acquisitions officer in the 1950s) to follow suit. Whenever a letter was deemed important enough (often when reconciliation was needed), he asked a French speaker to translate it to make sure every nuance was properly conveyed.[47] These language difficulties were amplified by the fact that, if Lindgren's expression was always clear, direct and to the point ('factually unassailable and always impeccably phrased', said his BFI colleague Stanley Reed),[48] Langlois's style was more colourful and metaphorical (not to say grammatically dubious), and his argumentation so intricate that it sometimes made little sense to the very logical Lindgren.

Lindgren became so concerned about the language barrier that he came to see it as the only true problem between him and his French counterpart. In the late 1950s, in his reply to a letter in which Langlois had for once agreed with him, Lindgren admitted: 'Deep down, we share the same thoughts, but we (unfortunately) do not speak the same language, that's all.'[49] Yet the institutional differences and language problems examined above would not have mattered so much had the two men got on at a personal level, as most other film archivists did in the same period.

'Je t'aime ... moi non plus'

The 1959 schism and its aftermath

As an epilogue to the Lindgren–Langlois saga, we must examine their breakup and its implications for future relationship between the Cinémathèque française and the National Film Archive. By the end of the 1950s FIAF was strongly established and Langlois saw his influence gradually diminish. His chaotic, intuitive and authoritarian methods were increasingly criticised by fellow archivists who had progressively adopted more formal, bureaucratic and scientific approaches, and who started demanding a more democratic debate within FIAF. As Lindgren ironically wrote to Langlois in 1959, 'All children grow up to an age when they begin to assert their authority against the will of their father. It is the first sign of maturity.'[50] Raymond Borde perfectly sums up the postwar period as 'the period of the long and difficult way towards objectivity' after the (necessary) subjectivity that had surrounded the emergence of many new FIAF members under Langlois's supervision. In the end, as Borde explains, 'Film did not care about affectivity. Heavy and fragile object, difficult to manipulate, tricky to preserve, it imposed its concrete existence upon film archivists who were originally all intellectuals.'[51] But rather than adapting to the necessary changes in the archive movement, Langlois became increasingly paranoid and authoritarian, to the point when a clash between the 'Lindgren clan and the Langlois clan', as he called it, became inevitable.

Beyond this general background to the crisis, the schism had two immediate causes. The first one was a major fire on the Cinémathèque's premises in Paris on 10 July 1959, caused by stacks of nitrate film cans left in the sun in the courtyard of the Cinémathèque's Paris headquarters. Large quantities of films were lost, although the precise number was never known. These included films lent to the Cinémathèque by other film archives. At the 1959 FIAF congress in Stockholm in September, Langlois publicly accused his fellow archivist, the Belgian Jacques Ledoux (whom he deeply disliked), of transgressing FIAF rules, partly as a plot to divert the delegates' attention from the recent fire. He was however unable to provide any proof in support of his accusation and the majority of the delegates decided not to take any action. If Langlois took this gesture as an obvious conspiracy, things got worse when the Congress elected Ledoux on to the new FIAF Executive. This time it was too much for Langlois, who stormed out of the Congress and announced his resignation as FIAF's secretary general, even though the FIAF Executive decided not to ratify the decision in the hope that the situation could still be resolved. Over the next few weeks Lindgren desperately tried to bring him to reason in several moving letters but they seemed to make the situation worse.

Langlois's biggest mistake at that stage was to believe that FIAF would collapse without him. He also carried on playing an ambivalent game. Although he had officially resigned from the FIAF Executive, he still controlled the FIAF offices which were located in the Cinémathèque's building. He and his staff intercepted all FIAF mail and made life impossible for the FIAF Executive Secretary, Marion Michelle, who had remained faithful to the majority of FIAF members (she had also become

a friend of Lindgren's). In an unexpected move, Langlois decided to resume his duties as FIAF Secretary General, although it quickly became apparent that it was in order to remove the Executive Secretary from office. The next FIAF Executive meeting in Paris in January 1960 was particularly tense. Langlois, who demanded Marion Michelle's dismissal, was defeated by seven votes to three and accused his colleagues of sacrificing the Cinémathèque française rather than a 'secretary'. The next session of the meeting took place without him. But the remaining Executive members then learned of a new unexpected development: Langlois had never officially registered FIAF as an official *association* in France, although he had always claimed to have done. Lindgren made one more attempt to reconcile with Langlois in a letter on 2 February 1960, despite Langlois's open hostility toward him at the recent Executive Committee where he refused to shake his hand. But a new bombshell exploded a few months later when Marion Michelle discovered as she tried to finally register FIAF at the *Préfecture de police* that Langlois had registered a new organisation called FIAF, with himself as leader, on 20 January 1960, so that the 'real' FIAF could not be legally recognised in France.[52] In the meantime Langlois

3.4 Caricature of Henri Langlois at the Stockholm FIAF Congress in 1959. Langlois has just seized the fan belonging to Mme Kawakita, the much-respected promoter of Japanese cinema worldwide. Drawing by Rosemary Heaword.

'Je t'aime ... moi non plus'

had obtained a ruling from a judge for the FIAF office (and FIAF's administrative archive inside it) to be sealed off and boarded up. Nobody would be allowed to enter it until October 1978, after Langlois's death. FIAF had to find new offices but the decision was taken to remain in Paris for the time being, mainly with the hope that it would leave the door open for Langlois to reintegrate FIAF should the crisis get resolved. After some years camping out in the offices of the French film-maker Jean Painlevé, the FIAF Secretariat eventually moved to Brussels in 1968, where it has remained ever since.

On the whole Langlois managed to obtain the support of his board of governors and, crucially, of Malraux, who ignored FIAF's letters of complaint against him. But the Cinémathèque remained isolated internationally and Langlois became a 'solitary giant', in David Robinson's expression. FIAF indeed decided to suspend the Cinémathèque at its Rome Congress in June 1962, and although Langlois founded a 'Union mondiale des musées du cinéma et de la télévision', reuniting the handful of archives which had remained faithful to him, the new organisation remained largely ineffective. Meanwhile, in 1965, the Cinémathèque de Toulouse was admitted as the new French member of FIAF, to Langlois's fury.

As for Lindgren, after years of trying to make his relationship with his nemesis work, he finally ran out of patience. The correspondence became much more formal. Friendly letters of the past were replaced by threatening registered post letters, as the FIAF Executive decided to file a lawsuit against Langlois and appointed Lindgren to represent the Federation before the French judge. The case dragged on for several years, as the French authorities and judges showed their reluctance to prove FIAF right against the Cinémathèque. The Federation was finally registered in France in 1968, the year in which it moved to Brussels.

Lindgren ordered his staff to cut all contacts with the Cinémathèque but to his immense frustration Langlois maintained a friendly relationship with other BFI staff, in particular NFT programmers, to whom he still very regularly provided film prints (notably for the huge French season in 1962), and with the BFI director James Quinn, who did not help Lindgren when he wrote to Langlois in 1961: 'There is no reason, to my mind, why the relationship in general between the British Film Institute and the Cinémathèque française should be affected [by the FIAF crisis].'[53] Yet Lindgren had warned Quinn the previous year of Langlois's various attempts to divide them.[54]

Throughout the 1960s Lindgren was keen for FIAF to finally move on from the Langlois crisis and to focus on its more productive endeavours, as he explained to Marion Michelle in 1964 after she has sent him new information on the Cinémathèque: 'I think our Secretariat should be engaged in work more positive and fruitful than keeping an eye on the CF. My inclination is to follow Voltaire's advice, and tend our own garden, rather than to look over the fence at our neighbours (unless, of course, our neighbour starts throwing bricks at us).'[55]

However, the famous 'Langlois affair' of February 1968, triggered by the French government's decision to dismiss Langlois, was a new occasion for Lindgren

3.5 Programme for the 1969 NFT season featuring Langlois's achievements as head of the Cinémathèque française at the height of the dispute between Lindgren and Langlois in the archive movement

to take sides. He immediately wrote to the new administrator Pierre Barbin to welcome him and express his hope for a 'revival of friendly co-operation between the Cinémathèque française and the National Film Archive'.[56] What infuriated Lindgren was the unprecedented level of support received by Langlois not only from eminent French and foreign film-makers and stars, but also from most of the British press. In a report to the BFI Governors he wrote angrily: 'Adulation for Langlois has been carried to extreme lengths, extolling not only his achievements (which are real), but elevating his faults (no less real) into virtues also.'[57] To the critic John Russell Taylor, who had supported Langlois in *The Times*: 'I am under vows of silence and neutrality, so I cannot make any public comment on any of the articles on the subject, although as a result I am often bursting at the seams with repression.'[58] His anger must have increased one more level when he learned

that several former BFI staff members (including Denis Forman, James Quinn, David Robinson, Richard Roud and ... Olwen Vaughan) had signed a letter to the French ambassador in London in support of Langlois. The latter's re-instatement a few weeks later was yet another blow for Lindgren, whose hopes of reconciliation with the Cinémathèque were shattered. The following year the NFT invited the triumphant Langlois to programme (with David Robinson) a 'Tribute to the Cinémathèque française' season at the NFT, while Langlois himself programmed a tribute to the BFI at the Cinémathèque. It is an understatement to suggest that Lindgren was once again incensed, especially since he had to provide (at very short notice) numerous prints for the season in Paris, and many of the prints came back damaged.[59]

The two figures never reconciled before Lindgren's death in July 1973 and the correspondence between Langlois and Lindgren's successor David Francis shows that the relationship between the two archives remained extremely limited, although a rapprochement took place around 1976, a year before Langlois died. A memo from Francis to a colleague on 14 January 1977 started with these telling words: 'Langlois died yesterday just after I had agreed to make one more effort to help the Cinémathèque.' It took several more years, and one more dramatic fire in one of its film stores in August 1980, before the Cinémathèque started resuming productive relations with its international counterparts, among them the NFA. The Cinémathèque finally became a full member of FIAF again in 1991.

To conclude in a few words, one can argue that beyond and despite Lindgren and Langlois's extremely difficult personal relationship, the film archive movement actually benefited in the long term from both the initial co-operation between the two organisations and the arguments between their two curators. As both Roger Smither and David Francis have recently pointed out, the current FIAF Code of Ethics is very much a combination of their respective approaches, especially in terms of the complementary nature of access and preservation. The last word can go to Patrick Russell, a current senior curator at the BFI National Archive, who recently updated the terms of that key historical debate to include the current revolution of the digital technology:

> In the folklore of the profession, the 'Lindgren vs. Langlois' morality play has the character of a national foundation myth: real historical persons yet also symbolic figures, competing for control of the curatorial soul. The digital era, in which access to innumerable films by innumerable people at the touch of a button is becoming normal, could easily be thought of as representing the final triumph of Langlois over Lindgren. Now, in my opinion, Langlois' conviction that archivists should be impassioned curators, not just dispassionate administrators, is more important now than it's ever been. However, on the core question of how they should have managed their collections then, it's Lindgren who's been vindicated: more of the films that he collected are in any position to be digitised, both because they exist and because they exist at less compromised technical quality than might have been the case. This is precisely because Lindgren so assiduously controlled access to master material by the analogue technology of his own time.[60]

Notes

1 'Nous avons travaillé dans le même champ depuis 22 ans. Je suppose que nous continuerons ainsi jusqu'au [sic] fin de nos vies. Mais au fond nous ne devenons pas plus proches l'un de l'autre. Est-ce impossible? Je ne l'admettrai jamais, j'ai toujours espoir.' All translations in this chapter are by the author unless stated otherwise.
2 Luke McKernan, 'Lindgren, Ernest Henry (1910–1973)', *Oxford Dictionary of National Biography* (Oxford University Press, 2004); David Francis, 'From Parchment to Pictures to Pixels, Balancing the Accounts: Ernest Lindgren and the National Film Archive, 70 Years On', *Journal of Film Preservation* 71, July 2006; Roger Smither, 'Henri Langlois and Nitrate, Before and After 1959', in Roger Smither and Catherine A. Surowiec (eds), *This Film Is Dangerous: A Celebration of Nitrate Film* (Brussels: FIAF, 2002). Other recent texts, like Laurent Mannoni's excellent history of the Cinémathèque française, have also finally delivered a more objective analysis of Langlois's achievements and shortcomings.
3 One of the main reasons was the sudden vulnerability of silent cinema precipitated by the coming of sound in the late 1920s, as production companies were quick to get rid of (and recycle for their silver content) their vast collections of now obsolete silent films.
4 Commission on Educational and Cultural Films, *The Film in National Life* (London: Allen and Unwin, 1932), p. 156
5 Letter from Langlois to Lindgren, 28 June 1946, BFI/A-45.
6 Letter from Lindgren to Langlois, 21 February 1947, BFI/A-45.
7 Laurent Mannoni, *Histoire de la Cinémathèque française* (Paris: Gallimard, 2006), p. 180.
8 Interview with Harold Brown, 21 March 2005.
9 Roger Smither, 'Henri Langlois and Nitrate, Before and After 1959', p. 248.
10 As Paolo Cherchi Usai said at the 2010 Ernest Lindgren Memorial Lecture in London: 'While Langlois was busy building a myth, Lindgren was busy building a film archive' (24 August 2010).
11 Kevin Brownlow, *Napoléon: Abel Gance's Classic Epic* (London: Jonathan Cape, 1983), p. 179.
12 See for instance Ernest Lindgren, *A Plan for the Development of the National Film Library*, unpublished policy paper, June 1947, BFI/A-12, or Ernest Lindgren, 'The Importance of Film Archives', in Roger Manvell, *The Penguin Film Review 5* (London: Penguin Books), 1948.
13 See Elizabeth Sussex, *Lindsay Anderson* (London: Studio Vista, 1969), p. 9.
14 Although Langlois never published a book, he wrote numerous shorts texts, such as brochures and programme notes, which were assembled by Jean Narboni in *Henri Langlois: trois cents ans de cinéma, écrits* (Paris: Cahiers du Cinéma / Cinémathèque française, 1986).
15 'In these early years of learning when preservation techniques were still in limbo, experiments and initiatives constantly came from London.' Raymond Borde, *Les Cinémathèques* (Lausanne: L'Age d'Homme, 1983), p. 122.
16 Ernest Lindgren, 'Preserving History in Film', *Kinematograph Weekly*, 3 May 1956.
17 Richard Roud, *A Passion for Films: Henri Langlois and the Cinémathèque Française* (London and Baltimore: Johns Hopkins University Press, 1999), p. 86. Ernest Lindgren, *The Work of the National Film Library* (London: British Kinematograph Society, March 1945), p. 6.
18 Borde, *Les Cinémathèques*, p. 110, and Roud, *A Passion for Films*, p. 87.
19 See for instance Ernest Lindgren, 'Cataloguing the National Film Library', *Sight and Sound*, Autumn 1940, pp. 50–1.

20 'Je crois que le budget et l'énergie [des cinémathèques] devraient aller vers la sauvegarde de leur propre cinéma, avant de faire des fiches […] Nous avons des siècles devant nous pour faire des fiches.' Quoted in Borde, *Les Cinémathèques*, p. 110.
21 See for instance Mannoni, *Histoire de la Cinémathèque française*, p. 136 and pp. 178–81.
22 For the detailed story see Stephen Bottomore, 'Will Day: the Story of a Rediscovery', *Film Studies* 1, Spring 1999, pp. 81–91.
23 Letter from Lindgren to Will Day, 28 February 1936. BFI: Will Day Special Collection.
24 For instance the grant-in-aid of the CF in 1956 was 397,000FF, while that of the NFA was £19,575 (= 192,422FF). Lindgren later confirmed that it was still the case in the late 1960s. Unsent draft letter to the Editor of the *Listener*, c. March 1968. BFI/A-77.
25 One could also add a fundamental cultural difference between the two men: while Lindgren took pride in working conscientiously within the limits imposed upon him, Langlois did not hesitate to manipulate people, fiddle the accounts or go into deficit in order to obtain something he really wanted but could not really afford.
26 Roger Smither, 'Henri Langlois and Nitrate, Before and After 1959', p. 247.
27 '[Langlois] a cette présence, ce culot, cette faconde qui manquent à Lindgren.' Borde, *Les Cinémathèques*, p. 108.
28 'Le caractère passionné de Langlois, sa popularité grandissante, sa maîtrise complète de la situation (croit-il) le rendent despotique et incontrôlable.' Mannoni, *Histoire de la Cinémathèque française*, p. 173.
29 Letter from Lindgren to André Thirifays, 6 October 1959. BFI/A-42.
30 Draft of a letter from Lindgren to Langlois, c. 1956. BFI/A-45.
31 Lindgren's frankness and righteousness could often pass for sheer arrogance to someone like Langlois.
32 Stanley Reed, 'The Lindgren Era', *BFI News* 6, July 1973, p. 3.
33 Letter from Lindgren to Paulo Emilio Salles Gomes, 2 February 1960. BFI/A-21.
34 See for instance the letter from Lindgren to Langlois, 30 January 1952, BFI/A-45.
35 'Provincial et petit bourgeois, d'une ambition d'autant plus dangereuse et perfide qu'elle est doublée d'un complexe d'infériorité à l'égard de ses supérieurs et, ce qui est plus grave, d'une lenteur d'esprit et d'une connaissance de l'art cinématographique extrêmement peu développée'. Mannoni, *Histoire de la Cinémathèque française*, p. 26.
36 In the immediate postwar period the Cinémathèque was a much larger organisation than the NFL. According to Laurent Mannoni, in 1946 the Cinémathèque had as many as 46 employees, while not more than half a dozen people worked for the NFL. Mannoni, *Histoire de la Cinémathèque française*, p. 140.
37 Ibid., p. 129.
38 Letter from Langlois to Lindgren, 26 September 1946, BFI/A-45.
39 Richard Roud, NFT and LFF programmer for most of the 1960s, wrote the only Langlois biography in English.
40 Letter from Lindgren to Forman, 30 August 1972.
41 Ironically, the official purpose of Vaughan's trip to Paris was to hand over the proceeds of an exhibition of drawings by Georges Méliès (who had recently died), curated by none other than Ernest Lindgren in London, to his widow. 'Aiding Film Chief's Widow', *Sunday Dispatch*, 5 June 1938. BFI/85.
42 Letter from Lindgren to Langlois, 20 March 1946. BFI/A-45.
43 Draft in English of a letter from Lindgren to Langlois, 6 October 1959. BFI/A-42.
44 Letter from Langlois to Lindgren, 28 June 1946. BFI/A-45.
45 Letter from Langlois to Lindgren, 18 November 1947. BFI/A-45.
46 'Pendant nos réunions, vous versez sur vos auditeurs une avalanche de français impassionné [sic], qu'on ne peut pas toujours comprendre, qu'on ne peut pas interrompre,

et qu'on ne peut pas questionner, parce que si on commence à en questionner [*sic*], l'avalanche commence de nouveau. Vous êtes sûr de gagner votre point immédiat; mais il ne vous faut pas être surpris si vos amis (comme moi) qui le trouve [*sic*] difficile de comprendre le français deviennent, au fin [*sic*], fatigués et cyniques. C'est pour éviter cette situation que j'ai lutté pendant des années pour améliorer mon français.' Handwritten draft of a letter from Lindgren to Langlois, 1956. BFI/A-45.

47 An early letter of reconciliation on 21 February 1947 was translated by the French actor and writer (and friend of Langlois) Jacques B. Brunius, who lived in London.
48 Reed, 'The Lindgren Era'.
49 'Au fond nous partageons les mêmes pensées, mais nous ne parlons (malheureusement) pas la même langue. Voila tout.' Letter from Lindgren to Langlois, 17 June 1959. BFI/A-42.
50 Draft of a letter from Lindgren to Langlois, 6 October 1959. BFI/A-42.
51 'Le film n'a rien à faire de l'affectivité. Objet fragile et lourd, pénible à manipuler, empoisonnant à conserver, il va imposer son existence concrète à des archivistes qui étaient tous à la base des intellectuels.' Borde, p. 107.
52 Letter from Marion Michelle to Lindgren, 12 July 1960. BFI/A-21.
53 Letter from James Quinn to Langlois, 11 May 1961. BFI/A-22.
54 Letter from Lindgren to Quinn, 21 April 1960. BFI/A-22.
55 Letter from Lindgren to the FIAF Executive Secretary Marion Michelle, 8 January 1964. BFI/A-21.
56 Letter from Lindgren to Pierre Barbin, undated (c. February 1968). BFI/A-77.
57 Lindgren's report to the BFI Governors, February 1968. BFI/A-80.
58 Letter from Lindgren to John Russell Taylor, 29 February 1968. BFI/A-80.
59 See for instance Lindgren's memorandum to Leslie Hardcastle, 18 April 1969. BFI/A-44.
60 Patrick Russell, Film and the End of Empire Conference, Pittsburgh, USA, 25 September 2010.

4

The BFI and film exhibition, 1933–1970

Christophe Dupin

> Without a shop window in which to display the films that are its main stock-in-trade, it would be only half an Institute. The National Film Theatre now provides that shop window.
>
> Denis Forman, 1953[1]

From the moment of the inauguration of the National Film Theatre in October 1952, film exhibition became integral to the BFI. Yet presenting films to the public hardly figured in the Institute's brief or practice for the first two decades of its existence. The idea of a national repertory cinema does not even figure in the 1932 report, *The Film in National Life*, which led to the setting up of the BFI the following year – and had it done so the film trade would undoubtedly have vetoed it. When in 1934 the BFI Governors first spoke of 'the need for a viewing theatre', what they had in mind was not showing films to the public or even to BFI members but facilitating the examination and reviewing of educational films by BFI staff and the numerous panels and committees set up to advise the Institute on those matters.[2] The Institute eventually built a tiny ten–seat screening room under the roof of its Great Russell St premises, but the BFI's chronic underfunding in its early years prevented it from building and operating a more ambitious cinema.

A decisive change in the BFI's thinking came with the establishment of the National Film Library. Unlike its early partners in the film archive movement, the Cinémathèque française and the Film Library of the Museum of Modern Art, New York, the BFI had not been founded around an archive, nor when it began to build one did it consider exhibiting the films it held a major priority.[3] It did organise one or two high-profile screenings of its holdings,[4] but on the whole the films from the NFL that got the most airing were those in its 'Lending Section'. This consisted of a small collection of films illustrating the history of cinema of which prints were made to distribute to non-theatrical outlets such as schools and film societies. In November 1944 the NFL curator, Ernest Lindgren, observed, 'Ultimately I should like to see the Library equipped with its own small kinema, where it could give regular performances of its films as a normal museum activity.'[5] Two years later his plans had become more ambitious. Declaring that 'a National

Art Gallery which could not exhibit its pictures is hardly conceivable; a National Film Library which has no means of displaying its films is likewise an absurdity', he now envisaged a five-hundred–seater theatre which could regularly show the Library's historically important films far more comprehensively than could the Lending Section.

Meanwhile, the BFI's governors were thinking in wider terms. In late 1946 the chairman asked the Treasury to consider 'a national repertory theatre', which 'would enhance British prestige abroad [and] provide a centre for film appreciation at home'.[6] As for what this theatre would show, the governors suggested a combination of past classics, examples of current production unlikely to receive commercial distribution, and 'film records of our famous men supplementing the portrait or the film photograph'. Recognising that building such a theatre was unlikely to be affordable in the immediate future they proposed acquiring one.[7] When the Radcliffe Report appeared in 1948, it scaled down the proposed size from five hundred seats to a more modest three to four hundred.

Denis Forman, appointed BFI director in early 1949 to implement the Committee's recommendations, put the acquisition of a cinema high on his priority list. But he was hampered by lack of money (the BFI's grant-in-aid from the Treasury in 1949 was much lower than expected) and opposition from the film trade. When he suggested the Institute might purchase the Academy Cinema in Oxford St, the board, led by the 'trade' governors W. R. Fuller (CEA), Frank Hill (KRS) and Sir Henry French (BFPA), rejected the proposal on the grounds that it might constitute unfair competition with commercial exhibitors.[8] Together with Lindgren, Forman then turned to the idea of hiring an outside venue. An initial three-month series of weekly programmes based mainly on NFL prints was put on at the Institut Français in South Kensington. Inaugurated on 18 January 1949 (by, amazingly, J. Arthur Rank), it combined silent feature films representing various national cinemas with recent documentary and experimental short films. Feature films included D. W. Griffith's *Hearts of the World*, Jacques Feyder's *L'Atlantide*, Harold Lloyd's *Safety Last*, Anthony Asquith's *Shooting Stars* and Alexander Dovzhenko's *Earth*, with Norman McLaren's abstract animations a privileged representative of the experimental side.[9]

The scheme was repeated over the next two years, but on a more structured basis. There were two strands. One, programmed by Lindgren, was a cycle of fortnightly repertory screenings spread across the year chronologically illustrating the entire history of the cinema from its origins to the 1940s.[10] The other was more thematic, with headings such as 'Films in the Commonwealth, 'Cinema and Theatre', 'Documentary Film in Great Britain' and 'Three British Directors' (Asquith, Hitchcock and Carol Reed). It was programmed and introduced by BFI officers, notably Forman himself and *Sight and Sound* editor Gavin Lambert, with a few guest programmers, including Edgar Anstey, Lindsay Anderson and Basil Wright. By the end of the 1951/52 season the BFI had built up a substantial, London-based core audience, for whom a new form of membership was created.[11]

From the Telecinema to the NFT

The breakthrough towards acquiring a theatre came from a wholly unexpected quarter, the 1951 Festival of Britain, to which the BFI had been asked to contribute a film component. In 1949 it was decided that a 'small cinema' should be built as part of the exhibition on London's South Bank. When the government cut funding, the Festival itself agreed to finance the 'Telecinema' (also known as the Telekinema and designed to be able to project both film and 'large-screen' television productions). Built between the Royal Festival Hall and Waterloo Station and incorporating the latest techniques in projection and acoustics[12], the four-hundred-seat venue proved one of the Festival's most popular attractions, drawing in 469,000 spectators to its 1,073 sell-out performances between 4 May and 21 September, even though it was the only one for which a separate admission charge was made.

4.1 The Telecinema, also known as the Telekinema, designed by the distinguished Canadian architect Wells Coates as part of the 1951 Festival of Britain and serving as the first home of the National Film Theatre from 1952 to 1957

Admitting later that the building was 'small, out of the way and rather ugly', but 'better than nothing',[13] Forman lobbied the Festival office, which owned the building, the London County Council, which owned the land, the office of the Lord President of the Council and other government departments, not forgetting the trade interests, to retain the Telecinema as a permanent cinema run by the BFI.[14] The main problem was money. Costly structural alterations would be necessary if it was to continue as a permanent venue. Nevertheless, the government approved a Treasury grant in principle and agreement seemed close until the Conservative victory in the October 1951 General Election. Hostile to anything to do with the Festival of Britain, the new government refused to approve the grant.

Forman then turned to an unlikely source, the film trade. Encouraged by Sir Wilfred Eady, the Treasury official – who at the behest of then President of the Board of Trade Harold Wilson had devised the so-called Eady Levy to channel a tax on film exhibition into film production – he approached the administrators of the fund with a two-pronged request: £12,500 to enable the BFI to acquire and operate the cinema, and a further £12,500 'for the production of experimental films for exhibition primarily at the Experimental cinema'.[15]

After protracted negotiations with the four trade associations in the first months of 1952, the BFI secured the first part of its request, while the LCC agreed to grant it a five-year lease on the site provided it would eventually pay for demolition of the building.[16] But to satisfy the trade, and in particular the London commercial cinemas, the BFI was forced to agree to stringent conditions. The cinema could operate only under strict club rules;[17] it could not receive any financial help from the BFI; it could not advertise its programmes in the press; and it had to refrain from showing current or recent releases. In return the trade agreed to supply film prints free of charge.

Forman also created an Exhibition Policy Committee, consisting of independent and circuit exhibitors, to advise the governors on 'the selection of programmes, the prices of admission, terms of hire and general administration' of the future cinema.[18] This largely nominal committee (it was abolished in 1962) was a useful sop to the trade, but the general conditions imposed were onerous and were to influence the BFI's programming policy for some years to come.

Several of Forman's memorandums from 1952 testify to his indecision as to what exactly the NFT's programming policy should be. In a first attempt at definition he wrote:

> I imagine that we are all agreed on our object, namely to stimulate public appreciation of and interest in the cinema by exhibiting the hundred or so best films ever made, by encouraging new experiments in film art and technique, and by providing a stage upon which our sort of ideas and our way of thinking in the limelight.[19]

His main dilemma, and one that would drive programming decisions throughout the NFT's history, was balancing the BFI's cultural remit of promoting the cinema as an art form with the financial necessity of accessibility. To introduce the terms of the debate, he used another established cultural model to legitimise the BFI's work:

One of the first things we have to decide is whether we should run the Telecinema as a Light, Home or Entertainment Programme, and one of the factors which governs our decision is that the Telecinema must substantially pay its way [...] So long as the popular approach has a genuine educational purpose at the back of it, and so long as it is applied with good taste it can, in my opinion, do the Institute nothing but good.[20]

After a whole year of hard-fought negotiations, internal debates on policy, major structural alterations to the building and research work to secure the first films, the National Film Theatre finally opened on 23 October 1952.[21] The programming structure, presented as a weekly 'mosaic of programmes', was very much a synthesis of the choices made by the BFI since 1950.[22] It consisted of four strands intended to serve the range of interests of its existing and potential membership. From Sunday to Wednesday, 'World Cinema' presented seasons of films linked by a common theme – whether a genre, a national cinema, a specific period or the work of a particular film personality. The title chosen for the series was in itself significant, since it confirmed the BFI's view that the NFT's cultural role should not be restricted to showing British films; it should show what it considered the best of world cinema to British (in fact, mainly London-based) audiences. Screened on Fridays, 'Fifty Years of Film' was the direct continuation of the earlier repertory cycles, and was still orchestrated by Lindgren himself. While 'World Cinema' was intended as an entertaining and popular strand, this one was set to remain unashamedly academic in tone, despite Forman's earlier reservations. Saturday was reserved for the 'Experiment for the Future' programmes, which were open to the general public. Although the immediate priority was to recycle the Festival's stereoscopic (3–D) films in order to recruit new members and generate much-needed extra income, the NFT warned that its idea of 'experiment' was not limited to this specific technological development. It intended to promote any film 'new in method and subject, in approach to reality or abstraction, satire or fantasy, documentation or poetry' and 'offer the opportunity for experiment to adventurous film-makers, British or foreign – particularly those as yet unknown – an opportunity which we believe to be unique in the world'.[23] The ideas formulated in this declaration would become an important feature of the NFT's programming policy. Finally, 'Members' Night' on Thursdays was introduced to keep the NFT in phase with the most contemporary developments of film, by screening new releases introduced by film-makers.

Before implementing this weekly schedule, the BFI inaugurated the NFT with a two-week programme open to the general public and fittingly entitled 'A Review of the Past and a Glimpse of the Future'.[24] An instant critical and public success, this greatly helped to build up BFI membership, following the introduction of new terms designed to accommodate NFT-goers. For five shillings a year, the new 'associate members' were entitled to attend the World Cinema and Fifty Years of Film series, and to receive a new monthly BFI publication, *Critics' Choice*, which both introduced the NFT programme and reviewed current film releases. Within six months, the BFI's membership rocketed from two thousand (where it had been

stagnant for years) to nearly eighteen thousand. Although the bulk of the increase was made up of associate members, the NFT also had a positive impact on the BFI's full members, whose numbers more than doubled in the same period.[25]

NFT Programming in the early years

Without a central figurehead like the Cinémathèque française's Henri Langlois, the task of programming the NFT was initially a collegial enterprise. According to the formal procedure devised in early 1953, basic ideas for films were to be produced by an Ideas Group (soon renamed the Programming Committee), consisting of the BFI's senior officers (Forman, Lindgren, Reed, Lambert) and the NFT's newly appointed Programme Editor, Karel Reisz, whose official task was to assemble the programmes once they had been selected. Although in practice Reisz had more programming power than his ill-defined job description suggested, programme planning for many years remained a co-operative activity, members of staff and friends of the BFI regularly being invited to submit ideas and arrange seasons.

In terms of programming, the BFI initially remained faithful to its plans (even though some adjustments at the margins were necessitated by circumstances, not least the non-availability of prints and copyright issues, the cautious attitude of the trade towards the NFT and the theatre's self-supporting operation) but the rapid and unexpected decline in the popularity of stereoscopic technology, as well as the non-availability of new experimental films, soon compelled the NFT to abandon the screenings of experimental films on Saturdays. They were replaced by continuous public programmes of popular repertory films (mainly Hollywood classics and recent releases). As for Members' Nights, these were also quickly dropped when the BFI failed to obtain the support of distributors to screen premieres of new releases. Early NFT programming was therefore bound to be heavily oriented towards the past.

The two main strands remained unchanged – at least in principle. Initially once but soon twice a week, Lindgren's repertory cycle pursued its steady path through film history by presenting acknowledged masterpieces of (mainly) prewar cinema in the strictly chronological and geographical order imposed by the NFL curator. But as the decade wore on, attendance figures for the 'Fifty Years of Film' screenings (renamed 'Sixty Years of Cinema' in 1955 and 'Aspects of Film History' in 1957) declined to the point where affordability was questioned by BFI officers. 'Have our film enthusiasts in London no spirit of adventure?' asked the BFI director James Quinn in a letter to members. 'Do they not want to join with us in making new discoveries?'[26] Apparently not, because by the summer of 1959 the series was discontinued.

But it soon became obvious that Lindgren's programme was important to the core membership. Six months on, following loud and insistent protest, the Archive slot was reinstated in weekly programmes on Mondays evenings.[27] The new series, consisting of a cycle of '50 Famous Films' introduced by experts, was designed to be

The BFI and film exhibition

more attractive to film enthusiasts. This new departure proved successful in terms of audiences,[28] but the series came under fire from a new generation of film critics who openly challenged a pool of film classics which was based on values established in the 1930s and 1940s and not changed since. The article that triggered the controversy, written by Victor Perkins for *Oxford Opinion*, criticised in particular the overrepresentation of certain directors (Griffith, Eisenstein, Clair, Stroheim, Ford, Pabst) to the detriment of others (Hitchcock, Lang, Welles, Hawks, Renoir), and the fact that this selection overlooked certain genres (western, film noir, animation) and techniques (no colour film), as well as any postwar film development.[29] In the mid-1960s, the cycle made way for a more thematic approach (under yet another title, 'Monday Night Archive Series'), but by the end of the decade the slot was discontinued. The idea of a revolving cycle of film classics presented by the National Film Archive would resurface only at the end of the 1980s following the opening of the Museum of the Moving Image and the launch of the '360' project.[30]

As for the 'World Cinema' series, it quickly became the central feature of the NFT's programming. Its initial focus on silent cinema can be explained not only by the difficulty of obtaining prints of recent films but also by the public's nostalgia for silent cinema, and in particular for silent film comedians. An early report on NFT audiences suggested that many patrons had not been to the cinema for years, in some cases since the silent era,[31] while statistics showed that silent film programmes were indeed by far the best attended of all NFT seasons.[32] Further evidence of the BFI's need to generate a steady income was the recurrence in the 1950s of repeats of the most popular films of past seasons, under such titles as 'Requests', 'Reprise' or later 'By Popular Demand'.

The World Cinema section was not, however, exclusively turned to the distant past. From the start, exhaustive studies of past and contemporary film-makers became one of the NFT's most regular features, and confirmed the 'pre-auteurist' approach of the *Sequence* group. For the first time in Britain, film critics and enthusiasts had the chance to see the bulk or whole of a director's filmography,. The first retrospectives examined the work of René Clair, whose reputation as a pioneer as well as a popular film-maker made him a clear BFI favourite in that period, and Vittorio De Sica, representing the Italian neo-realism also championed by the BFI establishment. But most early programming choices confirmed the influence of the ex-*Sequence* editorial team (Karel Reisz, Gavin Lambert and Lindsay Anderson). Between 1953 and 1955, the NFT screened seasons for the likes of Humphrey Jennings, Jacques Becker, John Ford, Luis Buñuel and the American musical. Looking back on the NFT's first decade, the NFT programmer Richard Roud wrote in 1962: 'Slowly and in the most non-authoritarian way possible, the National Film Theatre is re-writing film history.'[33]

A significant turn in the NFT's programming history came in 1956 with a sharp increase in the number of screenings and seasons devoted to new and recent films, as well as a more international approach to the 'World Cinema' series. The first two examples of this programming shift were 'New Activity', a season presenting

4.2 A queue forms for the first Free Cinema screening at the NFT on 5 February 1956. Over four hundred people were turned away

new foreign films which had been neglected by British distributors, and the first 'Free Cinema' programme, introducing shorts by Lindsay Anderson, Lorenza Mazzetti, Karel Reisz (by then no longer the NFT programmer) and Tony Richardson. This last was of great significance, helping the film-makers turn a screening into a 'movement'. Meanwhile the public and critical success of the Free Cinema series, and the press coverage it generated, was hugely beneficial for the NFT, confirming the need for a more current programming policy. The six Free Cinema programmes shown at the NFT between 1956 and 1959 were the first manifestation of the experimentation promised by Denis Forman in 1952.

Further evidence of a new programming policy included in the latter half of the 1950s retrospectives such as 'Russian Panorama', 'The True Face of India' (introducing Satyajit Ray to London filmgoers), 'Germany Then and Now', 'Canada and the Canadians', 'Yugoslavian Scene', 'Japanese Window' (the first major season of Japanese cinema in Britain), 'Curtain Up! Report from Central Europe', 'A Survey of Films from Sweden' (introducing Ingmar Bergman) and a major season on Italian neo-realism. Successive NFT programmers (Derek Prouse then David Robinson in the late 1950s, Richard Roud from 1960 to 1967) were quick to pick up on new trends in world cinema. As early as September 1958 for instance, Robinson arranged a screening of François Truffaut's *Les Mistons* and Claude Chabrol's *Le Beau Serge* ('Free Cinema 5: French Renewals') – almost a year before the New Wave achieved recognition in France and over two years before these films reached commercial cinemas in London.

The BFI and film exhibition

It was not long, however, before the 1956 shift in the NFT's programming policy caused angry reactions from the trade. In July 1956 the News and Specialised Group of the CEA publicly accused the NFT of screening too many commercial films, in apparent contradiction of its 1952 commitment. Stanley Reed counterattacked in *Today's Cinema*, in which he was reported saying provocatively: 'We do not want to inflict dusty classics on our members but show them live cinema so that it is reflected as it really is, a first-class popular art.'[34] Citing the recent John Ford season, he added that there was no use in 'putting on retrospective programmes if [the NFT] could not bring them up to date'.

The BFI was, however, eager to resolve this delicate situation. The NFT's Exhibition Policy Committee met at the end of July to suggest ways of avoiding the crisis. A week later, a delegation of BFI Governors met representatives of the CEA for 'friendly talks'.[35] The two parties agreed on significant changes to the NFT's practice. First, the theatre was to discontinue its public performances of popular films on Saturdays. Second, the number of guests that members were allowed to bring with them to the NFT was cut from three to one. (Otherwise, CEA members complained, the NFT's potential audience was over 80,000.) Finally, it was agreed that 'if firm objections were raised by exhibitors to a particular film due for presentation, the Institute would attempt to substitute it.'

Although these concessions were approved by the BFI's governing body and welcomed by the trade, a number of governors (including the producer Frank

4.3 A programming meeting at the BFI in 1959 with, from left, Stanley Reed (BFI secretary), Peter Barnes (programmer of the One Hundred Clowns season), Richard Roud (NFT chief programmer) and John Huntley (programme controller)

Hoare and film-maker Basil Wright) expressed their concern at the 'considerable concessions' made by the NFT, and in particular 'the limitation of the Institute's freedom to show the films it wanted'.[36] This concern soon proved justified when many commercial exhibitors (including the Classic chain of repertory cinemas in London) interpreted the last point of the agreement as their right to compel the NFT to withdraw from its programme any film already in general distribution or likely to be reissued commercially. Since by the late 1950s many of the repertory classics (from *Birth of a Nation* to *Battleship Potemkin* to *Bicycle Thieves*) were available commercially,[37] and since only eight of the 501 films shown by Classic cinemas in the first eight months of 1958 had also been screened at the NFT (and only three of them shown at the NFT *before* they were screened at Classic cinemas), the BFI was understandably exasperated. Indeed, throughout the 1960s, the NFT's success in introducing cinema from around the world (thus promoting cinephilia in London) resulted in its becoming increasingly difficult for the Theatre to obtain film prints and therefore present comprehensive seasons.[38]

Despite it all, the NFT expanded its far-ranging programming policy into the 1960s. The opening of the new, permanent NFT building under Waterloo Bridge in October 1957, and the simultaneous launch of the first London Film Festival (from an idea by the film critic Dilys Powell and BFI director James Quinn), certainly helped the BFI in its quest to become 'the home of world cinema', as the banner on the new entrance indicated. Following the planned redevelopment of the South Bank complex, the LCC had agreed to build the new, improved theatre at a cost of £75,000, to be paid back in rent by the NFT. To pay for the state-of-the-art equipment, the BFI called upon its members via an appeal that eventually exceeded its target of £17,000.

As for the LFF, it quickly became not only a key annual PR exercise for the NFT but also a crucial tool for stimulating cinephilia in London. 'The atmosphere at the Theatre during the last two weeks of October is redolent of the quasi-religious over-tones of Bayreuth,' wrote Richard Roud. Nor, he said, were the devout all Londoners: 'More than a few people from the country have said that they take their holidays to coincide with the Festival period.'[39] The success of the Festival was such that the Lincoln Center for the Performing Arts, sponsors of the New York Film Festival from its launch in 1963, based their operation on the London model and used BFI expertise by hiring Roud.

The 1960s

While the LFF showcased the latest trends in world cinema, for the rest of the year the Theatre continued to offer comprehensive seasons devoted to film-makers and personalities, national cinemas and specific themes. Although some of the retrospectives were still arranged by various BFI staff (notably John Gillett and John Huntley) and close friends of the Institute, the taste of the NFT programmer influenced the choice of films and seasons perhaps more than during the 1950s.[40]

The BFI and film exhibition

Penelope Houston remembers: 'The 1960s were right for Richard – and Richard for the 60s. European cinema was at the heart of things, and at the heart of Europe were France and Italy, the two countries whose films most permanently appealed to him, however much he might formally deny it.'[41] This was reflected in both the LFF and NFT programmes. The emphasis on Italy took the form of comprehensive tributes to new as well as established auteurs (Visconti, 1961, Antonioni, 1961, Fellini, 1963) and general surveys of Italian cinema (1965, 1967). French cinema was even more prominent. The NFT kicked off the decade with a five-month French cinema season in 1960, and later programmed retrospectives on various aspects of French film history, from 'Channel Crossing' (1961), 'The Real Avant-garde' (1963) to 'The Left Bank' (1963) and 'Paris '56–66' (1965) and no fewer than twelve seasons devoted to French film-makers (Jean-Pierre Melville, Roger Vadim, Jean Renoir, Louis Feuillade, Georges Franju, Abel Gance, René Clément, Carné/Prévert, Jean-Luc Godard, Alain Resnais, Robert Bresson and Jean Cocteau). This owed a lot to Roud's close friendship with Henri Langlois, who collaborated on a number of seasons and supplied many unique Cinémathèque prints.[42] The partnership culminated with a vast 'Tribute to the Cinémathèque Française' season in 1969.

From the late 1950s the NFT also started attaching great importance to the films from the Eastern Bloc. As many as fifteen seasons of films from Poland, the USSR, Hungary, Yugoslavia, Czechoslovakia, Romania and Bulgaria were programmed between 1958 and 1970. Beyond the reality of emerging new cinemas in some of these countries in that period, this sudden interest can also be explained by a more political factor. In the hope of improving diplomatic relations, the Foreign Office regularly collaborated with the authorities of these countries to sponsor NFT seasons (subtitled 'Film Exchange Weeks').[43]

At the other end of the cold war map, masters of Hollywood cinema continued to occupy a place of choice in the NFT's schedule, even though there was a noticeable shift as to who should receive serious critical attention. In the early years of the NFT the focus was on recognised auteurs such as Griffith, Stroheim, Ford, Welles or Wyler. At the turn of the decade, the NFT (under the influence of the new generation of critics in journals such as *Movie*) began to acknowledge some hitherto neglected American film-makers. Among those now celebrated by the NFT were Nicholas Ray (1961, 1969), Fritz Lang (1962), Vincente Minnelli (1962), Howard Hawks (1963), King Vidor (1963), Preston Sturges (1965), Otto Preminger (1966), Billy Wilder (1968), Stanley Donen (1969), George Cukor (1969), Budd Boetticher (1969), Samuel Fuller (1969) and Hitchcock's Hollywood work (every Friday, 1968–70).

British cinema, on the other hand, was poorly represented at the NFT during the 1960s. The Theatre's only incursions into domestic cinema were studies of the work of film-makers David Lean (1963), Robert Hamer (1964), Anthony Asquith (1968) and Humphrey Jennings (1969), as well as tributes to actors Noel Coward, Richard Attenborough and James Mason. Given the tight links between the

4.4 Poster for the 1969 Budd Boetticher season programmed by Jim Kitses of the Education Department

The BFI and film exhibition

documentary film-makers of the Free Cinema movement in the 1950s (Karel Reisz, as mentioned, had been the theatre's first programmer, while Lindsay Anderson was a frequent contributor to *Sight and Sound*), it may come as a surprise that no celebration of the British New Wave appeared in the NFT's schedule throughout the 1960s. But the NFT's rather denigrating attitude towards British cinema was in phase with that of *Sight and Sound* in the same period.[44]

Although NFT programming favoured seasons on individual film-makers and national cinemas, it increasingly made space for more thematic approaches. Genres in particular became a worthy subject for study in the early 1960s. In 1961 for instance, a four-part retrospective entitled 'Bread and Butter' examined westerns, thrillers, melodrama and horror, with accompanying programme notes which clearly attempted to give intellectual justification to the screening of popular films. Later retrospectives paid tribute to spy films ('Tinh Min to James Bond', 1964), film noir ('Underworld America', 1966), science fiction ('More Than Human', 1967), adventure and romance (1967), spectaculars (1969), swashbucklers and musicals (1970).

Another important – and often risqué – strand of NFT programming was the representation of historical and current social and political themes on film, with extensive seasons such as 'Living in the Present' (1957), 'The Negro World' (1959), 'The Art of Persuasion' (on propaganda films), 'The Anarchist Cinema' and 'The First World War' (1962), 'Why 1066?' (1966), 'Ten Days That Shook the World' (on the October Revolution, 1967) 'Human Rights' (1968), 'Revolution in the Cinema' (1969) and 'Film and Nazi Germany' (1970). Programming such politically charged seasons regularly exposed the NFT to public criticism. In 1959 questions were asked in the House of Lords about how the BFI could celebrate a country that was not recognised by the West after it programmed a season devoted to DEFA, the state-owned East German studio. The following year the NFT had to cancel a planned lecture by Leni Riefenstahl at the last minute. In 1962 the BFI's senior officers were officially investigated by the Foreign Office for their alleged Communist bias in programming Spanish Republican propaganda films.[45] Nor was all the criticism external. A decade later, the BFI Governors unsuccessfully tried to stop the NFT from showing a season on 'Film and Nazi Germany'.

Meanwhile, the Theatre's ambition to become a genuine 'university of film' (the claim of a 1968 policy paper) through a diverse and uncompromising programming policy was thwarted by adverse circumstances throughout the 1960s. Already handicapped by its far-from-ideal location, from 1962 the new NFT building was constantly disrupted by major engineering and construction works, from the realignment of the Waterloo Bridge approach road over the ceiling of the auditorium to the construction of the Queen Elizabeth Hall / Hayward Gallery complex.[46] In 1964 the BFI sought to turn this situation to its advantage by convincing the LCC to build a much-needed extension to the Theatre. On this understanding, it moved out of the building for eight months.[47] However, following disagreements between the LCC and the contractor, the NFT returned to the South Bank with its building

left untouched. This resulted in an inevitable drop in membership and a serious loss of income for the Theatre.

The financial situation was worsened by the ever-rising costs of programming repertory and foreign films (in terms of research work, film transport, translation and commentary or subtitling fees, reprinting of master copies from the Archive and servicing material in poor condition), as well as by the stringent conditions imposed by film renters and specialised commercial cinemas (such as the ban on NFT advertising, a strict membership policy and the limited number of screenings of each film).[48] It became increasingly obvious that the NFT's self-supporting basis could no longer be sustained. In late 1964 a campaign led by the BFI and widely supported by the country's leading film critics called for the government to recognise the NFT's contribution to the British cultural scene and subsidise it. Alas, the Treasury remained inflexible until the early 1970s, leaving the Theatre further and further in debt.

Nor were matters helped by Richard Roud's involvement with the New York Film Festival. Indeed when, in early 1967, after several years' involvement with New York, Roud was ordered to choose between Britain and America, he opted for the latter. For more than two years the NFT was without a permanent programmer,[49] stability resuming only in June 1969 with the appointment of Ken Wlaschin.

The Theatre's programming policy was affected by those difficult circumstances in a number of ways. First, the NFT increasingly had to play safe in its choice of future programmes. Each time a 'difficult' retrospective fared badly at the box office, it needed to follow it up with a more popular one. Among the most obvious examples of such crowd-pleasing seasons were 'National Film Theatre Firsts' (1961), 'Critics' Choices' (1964), 'Home Again!' (the NFT's most successful films to date, 1965), 'Cornerstones' (1968, 1969), and 'Planners' Pleasures' (1968). Repertory programmes increasingly favoured the recognised classics as well as screen comedians (Chaplin, 1961 and 1964; the Marx Brothers and Mae West, 1965; Langdon, 1967; Keaton, 1968). Another well-liked strand, entitled 'For the Specialist', was introduced in the late 1960s. Consisting of film programmes on specific interests such as trains, aviation, music hall or the opera, this also proved extremely popular.[50]

In the late 1960s the NFT came up with a more participative approach to its programmes by inviting film personalities to discuss their career with NFT audiences. Occasional celebrity visits went back to the early days of the NFT, but the new project intended to make them more frequent in a bid to generate press coverage and full auditoriums. On top of that, obtaining prints was made easier if a leading actor or director were present to introduce a film. The series got off the ground under the title of 'John Player Lectures', following the sponsorship of the Nottingham-based tobacco firm. The director Richard Lester inaugurated it on 3 November 1968, and from then on it quickly gained momentum.[51] Over the next five years hundreds of film celebrities took the NFT stage and made the lectures a key feature of the theatre's programme, as well as an essential PR exercise.[52]

The BFI and film exhibition

After several difficult years, the NFT was given the means for a new departure. A second auditorium, much talked about since the early 1960s, materialised in September 1970. NFT2's brief to screen educational, experimental and specialised programmes allowed the Theatre to broaden the scope of its programmes. The programming team was strengthened, with full-time programmers for both NFT1 (Ken Wlaschin) and NFT2 (ex-press officer Brian Baxter).[53] By happy coincidence, years of building work on the South Bank came to an end, and the effects of traffic noise above NFT1 were finally eliminated.

As for financial problems, they were eased first by a new appeal to NFT members as well as an unprecedented decision by the Arts Council (after arts minister Jennie Lee's proposal and despite the Treasury's strong reservation) to forgo £50,000 from its own grant-in-aid to help reduce the BFI's (and the NFT's) growing deficit. Two years later, the NFT's financial situation was further consolidated by its incorporation into the BFI's overall budget. Even though the Theatre remained largely self-supporting, its long-awaited deficit grant finally made possible a more ambitious programming policy.[54] Since its inception, the 'Home of World Cinema' had shown eight thousand feature films and as many shorts in seven hundred different cohesive seasons.[55] By showing everything from the most academic to the most obscure of repertory cinema and by introducing new cinemas from around the world, the NFT had introduced the public to a large number of previously unknown film-makers and national cinemas and had not only created a metropolitan cinephilia but had also been the training ground for a whole new generation of film critics, academics and other cultural activists.[56] The programming policy established and refined over the first twenty years of the Theatre has remained essentially unchanged ever since.

Notes

1 Denis Forman, 'The British Film Institute and the Work It's Doing', in 'The Ideal Kinema', Supplement to *Kinematograph Weekly*, 16 April 1953, p. 5.
2 'The British Film Institute: Memorandum on the Need for a Projection Theatre and for a National Film Library (Confidential)', September 1954, BFI/A-11. See also *BFI Annual Report*, Year ended 30 September 1934, pp. 29–30.
3 See Christophe Dupin, 'The Origins and Early Development of the National Film Library: 1929–1936', *Journal of Media Practice* 7:3 (2007). A key difference between the BFI and its sister organisations in Paris and New York was that the latter had emerged out of a strong cinephile culture (via Henri Langlois and Iris Barry), while the BFI had been set up by educationists.
4 For example a programme of early silent films presented at the Polytechnic Cinema in Regent St, London, on 21 February 1936 to mark the fortieth anniversary of the first screening there of the Lumière Cinématographe, and a selection of rare films from the NFL shown at the Palace Theatre, Cambridge Circus, on 16 October 1938.
5 Ernest Lindgren, 'The Work of the National Film Library', *Journal of the British Kinematograph Society*, January–March 1945.
6 Patrick Gordon Walker, *The Future Development of the British Film Institute*, typewritten memo, 7 October 1946, NA/CAB/130/9, p. 2.

7 BFI board of governors, *Memorandum on the Development of the BFI*, addressed to the Radcliffe Committee, c. late 1947.
8 BFI Governors Minute 3575, 23 May 1950. Forman also offered to hire the Gaumont British theatre in Wardour St but Rank's John Davis agreed only to rent it to the BFI two or three nights a week so the deal collapsed. BFI Governors Minute 3586, 20 July 1950.
9 According to the programme notes, it had been decided for this series 'to eschew the more familiar classics such as Battle Ship Potempkin [sic] for less known, but nevertheless important films, which students have not previously had the opportunity to see'. BFI/A-3.
10 These screenings, initially held in the BFI's tiny screening theatre, were soon moved to bigger venues – the Colonial Film Unit theatre, the Institut Français and the Ministry of Education theatre.
11 In 1950/51 250 members joined the scheme. The following year numbers rose to 440, accounting for 21 per cent of all members.
12 The architect was Wells Coates, who provides a detailed account of the building and its technical specificities in 'Planning the Festival of Britain Telecinema', *Journal of the British Kinematograph Society*, April 1951, pp. 108–19. See also 'The Ideal Kinema', supplement on the Telekinema, *Kinematograph Weekly*, 17 May 1951, p. 36.
13 Denis Forman, *Persona Granada* (London: André Deutsch, 1997), p. 27.
14 Ever since they first met the Festival Executive in November, Forman and the governors had in fact always wanted to retain the Telekinema permanently and the building had been designed as a 'Category A' structure (unlike most other Festival buildings). See Coates, 'Planning the Telekinema'.
15 British Film Production Fund: 2nd Interim Report, 1951–52, p. 8.
16 £2,000 was allocated for that purpose, according to the BFI Annual Accounts between 1953 and 1957.
17 This had the compensating advantage of enabling it to show uncensored films.
18 BFI Governors Minute 3747, 15 May 1952.
19 Denis Forman, *The Telecinema Policy*, memorandum to BFI senior officers, 17 March 1952.
20 Ibid.
21 Forman personally invested so much of his time and energy in the project that he asked Lindgren to take over part of his responsibilities as BFI director in the months before the opening of the NFT. As for Frank Hazell, the former manager of the Telecinema, he was hired to head the NFT.
22 For a detailed account of the NFT's initial policy see *The National Film Theatre*, presentation booklet (London: BFI, October 1952), and Karel Reisz, 'Programme Policy', in *The Ideal Kinema: The National Film Theatre*, Supplement to *Kinematograph Weekly*, 16 April 1953, pp. 5 and 9.
23 *The National Film Theatre*, official brochure for the opening of the NFT (1952), p. 30.
24 The programme, screened three times daily, consisted of two McLaren shorts and two stereoscopic films, a composite film made of extracts showing 'the stars who made the cinema', and a classic British feature from the 1930s, Anthony Asquith and Leslie Howard's *Pygmalion*.
25 Alan Dent, 'A Dream Come True', *Illustrated London News*, 15 November 1952.
26 James Quinn, *News from the British Film Institute* [January 1959].
27 The Archive's slot was from then on programmed by John Huntley, head of programming services, and not by Lindgren.
28 According to the NFT's Monthly Report for March 1962, the Archive programmes had become the most profitable section of the NFT programme, with an average

The BFI and film exhibition

attendance of 63 per cent (against 59 per cent for the other programmes). BFI Archive, Box LH/3.
29 Victor Perkins, 'Fifty Famous Films 1915–1945', *Oxford Opinion* 38, 1960.
30 Films chosen from a list of 360 'Treasures from the National Film Archive' were restored and regularly screened in the new MOMI cinema. See *360 Film Classics*, *Sight and Sound* supplement, 1998.
31 'Telecinema Attracted Newcomers', *The Cinema*, 12 November 1952, p. 7.
32 See the graphs comparing the respective popularity of NFT seasons in the 1952/53 and 1953/54 BFI Annual Reports. Two of the most popular ones were 'Great Comedians of the Silent Screen' and 'He, She and It'. One commentator noted that the latter was 'an alleged study of the film hero and heroine over the years, but in practice just an excuse to show famous films of Garbo, Dietrich, Valentino and Fairbanks'. Martin Worth, 'The National Film Theatre', *Grub Street*, March–April 1954, pp. 54–5.
33 Richard Roud, 'The National Film Theatre's First Ten Years', 1962 London Film Festival Brochure, 1962. Roud argued for instance that the shift in film criticism that took place between 1952 and 1962, as epitomised by the 1952 and 1962 *Sight and Sound* 'top ten' lists, was largely due to films programmed by the NFT between these two dates.
34 'NFT Doesn't Want "Dusty Classics"', *Today's Cinema*, 5 July 1956, p. 3.
35 'Friendly Talks Satisfy Complaints', *Today's Cinema*, 7 August 1956, p. 3.
36 Minute 4133 of the BFI's Board of Governors Meeting, 21 September 1956.
37 'Relations with the News and Specialised Group of the Cinematograph Exhibitors' Association', paper presented to the BFI's Exhibition Policy Committee, 8 July 1958.
38 One of the rare industry dissenters was George Hoellering, owner of London's Academy Cinema, who understood that, far from competing with art-house and repertory distributors and exhibitors, the NFT was actually of help to them. He remained one of its fervent supporters throughout the 1950s and 1960s, first as a member of the Exhibition Committee and later as a BFI governor.
39 Richard Roud, 'The National Film Theatre's First Ten Years', p. 3.
40 Roud's cinephilic influence actually went beyond his BFI position, as he was also the *Guardian*'s official film critic throughout the 1960s.
41 Penelope Houston, 'Richard Roud', *Sight and Sound*, Spring 1989, p. 103.
42 This friendship was all the more remarkable in that the relationship between the Cinémathèque française leader and the NFA curator Ernest Lindgren was at an all-time low in the 1960s following a dispute at the 1959 FIAF congress. (See Chapter 3).
43 The programming of such a 'diplomatic' season of Polish films angered Lindsay Anderson, then a BFI governor, in 1970. (Lindsay Anderson, 'Paper no 2', BFI Governors papers, 21 April 1970.)
44 It is hardly surprising that every NFT programmer from Karel Reisz to Richard Roud was a regular contributor to *Sight and Sound*.
45 The Foreign Office concluded that although most BFI senior officers had left-wing tendencies, they could not find any Communist infiltration of the organisation. NA/FO 953/2151.
46 While the noise of passing traffic caused by the defective Waterloo Bridge expansion gap ruined most NFT screenings for years, the continuing construction sites surrounding the building on three sides made it very difficult for patrons to access the NFT.
47 For eight months NFT screenings were relocated to far from ideal auditoriums in the Vickers tower on Millbank and the Shell building, while the 1964 LFF was hosted by the Odeon Haymarket Cinema in London's West End.
48 By the end of the 1960s, a number of renters even refused to continue to lend their films free of charge as had been the custom since 1952; the introduction by the NFT of

a universally applied service charge in 1970 eased the situation but put a further strain on its finances.
49 The former programming assistants Peter John Dyer and John Gillett stepped up as temporary programmers but neither could handle the stress of programming the NFT, leaving Leslie Hardcastle, the Theatre's indefatigable controller, with no choice but to take over the task himself on a number of occasions.
50 The introduction of these programmes exasperated many of the BFI's critics in that period – especially among the emerging underground movement – who saw it as a sign of the conservative evolution of the BFI.
51 The series suffered an early blow when the first intended guest, Jean-Luc Godard, famously failed to make an appearance and sent an enigmatic telegram instead.
52 Sponsored celebrity lectures resumed in 1980 with the Guardian Lectures.
53 The initial plan was to keep the programming of the two screens entirely separate, but at the end of the first year it was decided to make this arrangement more flexible.
54 There was, however, no room for complacency. At the turn of the 1970s the NFT was hit by the same wave of criticism as other BFI activities. One of the manifestations of this discontent was the BFI Members Action Committee: 'The NFT policy – audience-catching plus gap-plugging – should be abandoned: it doesn't catch audiences and it doesn't plug gaps.' 'BFI Members Action Committee Manifesto: Why We Want to Dismiss the Governors' [1970].
55 'Programme Policy for Two Theatres: Paper for Consideration at the Governors' Sub-Committee on the NFT", 19 August 1969, p. 1.
56 Two surveys conducted by the BFI in 1957 and 1968 provide a rather precise depiction of who the typical NFT-goer was: a young, white, single, educated middle-class man. The 1968 survey concluded: 'If we see a friendly man on a bicycle reading the *Guardian* in a London Postal District we shall know that it is just possible he is a professional man on his weekly visit to the NFT.' For further details on the surveys see *News from the British Film Institute*, July 1957 and January 1958, and *Flicks*, July 1968, pp. 3–4.

5

The vanguard of film appreciation

The film society movement and film culture, 1945–1965

Richard MacDonald

Introduction

The immediate postwar period was a golden age for the film society movement, years in which it articulated the ambition to be a pioneer within British film culture as a federated network of voluntary membership organisations that combined a commitment to film education with non-commercial exhibition of films. The numbers of film societies expanded rapidly with new groups forming throughout the country. The conditions were highly favourable; the war years brought a fresh emphasis on initiatives aimed at extending appreciation of the arts to all. Film appreciation, the educational endeavour which aimed to encourage an attitude of discrimination by acquainting audiences with good cinema, seemed in tune with the egalitarian rhetoric of the times. Film appreciation's advocates argued that cinema's popularity made it the ideal medium for bringing creative work to a large public.[1] They criticised both the highbrows who disdainfully rejected the cinema and the habitual filmgoing of the masses.[2]

The efforts of film societies to encourage appreciation of film as art were given a boost by two other prominent popular educational initiatives of the period, the Army Bureau of Current Affairs (ABCA) and Penguin Books. ABCA, which pioneered adult education in the Armed Forces during the War, became a significant supporter of film appreciation, promoting the formation of film societies on a considerable scale. Penguin, which began publishing affordable paperbacks in 1937, contributed to the growth of the film society movement by publishing Roger Manvell's *Film* as a sixpenny Pelican in 1944.[3] Concluding with practical guidance on how to organise a film society, *Film* went on to sell half a million copies, disseminating film appreciation ideas widely. Foreign-language films, Italian and French in particular, the staple of film societies and specialist cinemas, were attracting larger audiences, a trend contemporary observers attributed to the cosmopolitanism of service personnel returning from the continent.[4] Adult education was also said to be blossoming and its scope widening; educators anticipated that it would embrace new forms of purposive leisure.[5] More young men and women wanted to approach

the cinema as serious culture and undertake the education in film that the film societies offered through their selected programmes, lectures and discussions. And importantly, a new generation of civic activists, educators of children and adults, supported by institutions of adult education from co-operative educational departments to educational settlements, identified with the aspirations of cultural improvement and purposeful recreation that a film society promised.

The two tasks of film appreciation

The leading activists of the film society movement of the 1940s and 1950s communicated a high-minded and ambitious vision of their purpose. In the summer of 1945 Norman Wilson, chair of the Edinburgh Film Guild and the Scottish Federation of Film Societies, wrote an article in *Sight and Sound* intended to galvanise the film society movement for the challenges ahead whilst conducting a review of aims and objectives.[6] Wilson acknowledged that the movement had achieved certain objectives and could claim credit for the wider acceptance of film as a serious artistic medium. Two important tasks lay before them. Firstly film societies must understand themselves to be reforming agents, working on the millions of filmgoers whose tastes were 'deplorably low'.[7] Like others before him, Wilson stressed that film societies had a wider civic duty, which compelled them to work through the network of local voluntary associations through which the public could be guided towards serious and purposeful films. Underlying the reforming ambition was a firm conviction of the undesirable influence of the lower forms of entertainment cinema, its promotion of false values and hedonism. In contrast, a defining quality of good cinema was that it was 'recreative': to borrow Roger Manvell's description, it renewed the spirit.[8]

The second major task for the film society movement was to create an informed public actively supportive of experimentation among 'advanced film workers'. Film societies, Wilson argued, must be a 'spearhead', a vanguard audience 'ahead of the general advance of film ideas'.[9] Throughout the 1950s film society activists would compare their work to that of the BBC's new Third Programme, launched shortly after Wilson's call for a renewal of purpose. In an unsuccessful application for public funding made through the BFI in 1956, the Federation of Film Societies justified its claim for support by arguing that, like the Third Programme, its work was 'essential to intelligent leadership in taste and knowledge'.[10] Claims to leadership, of being a vanguard, inevitably rebounded on a movement periodically accused by film-makers of flabby middle age and 'boyscoutisme'.[11] Without the cushion of public subsidy, financial insecurity was a permanent state for many film societies and had a disciplining effect on cultural ambition. Although dependence on subscription was a limiting factor of voluntary organisation, there were also strengths. Film societies were organisations that fostered an ethos of self-determination and voluntary initiative. They could be dynamic and forward-thinking where established publicly funded arts organisations were slow, as was the case with

the Edinburgh Film Guild's patronage of the Edinburgh Film Festival. And film societies were a site from which new forms of independent practice could emerge. Two important waves of new film critical writing germinated in meetings of film enthusiasts at the Oxford University Film Society, coming to fruition in *Sequence* (from 1947) and in *Oxford Opinion* (1960) and *Movie* (from 1962).

The BFI and film appreciation

By the time the Commission on Educational and Cultural Films published the report which would lead to the establishment of the BFI, *The Film in National Life* (1932), film societies were a nationwide phenomenon with groups in major cities including London, Birmingham, Manchester, Glasgow, Ipswich, Edinburgh, Leicester and Southampton. Before the War the BFI had little direct influence on this flourishing film society activity. Some film societies formally affiliated to the BFI and constituted themselves as Film Institute branches, many others remained unaffiliated. The documentary movement had been influential in defining a purposeful alternative to entertainment cinema that attracted and motivated many in the film society movement. The documentary movement's film-maker theorists were tireless promoters of the documentary idea on the film society circuit and their distribution network was a valued source of film supply. The most important journal for the film society movement, *Cinema Quarterly* (1932–35), edited by founder members of the Edinburgh Film Guild Forsyth Hardy and Norman Wilson, was a forum in which documentary ideas were worked through and disseminated. Cultural organisations affiliated to the Communist Party and other radical left political groups such as Kino and Workers Film and Photo League were also supporting film society activity as a strategy for showing censored Soviet films, though they often operated in the face of considerable official hostility and harassment. The presence of John Grierson and Ralph Bond on the founding committee of the Federation of Workers Film Societies, founded in 1929, indicates some mutual support between the documentary and workers film movements. The BFI's relationship with these two sites of alternative film activity energising film society activism was distant, and its connection with the voluntary sector was largely focused on the Film Institute branches. In the Film Institute branches practical support was also short in supply. Hemming Vaughan of the Merseyside Film Institute Society, a committed supporter of the BFI (and father of Olwen Vaughan, BFI secretary from 1935 to 1945), hoped for money in return for voluntary effort supportive of the Institute's film appreciation objectives but was destined to be disappointed.

During the war years the BFI took tentative though significant steps towards defining and shaping the development of film appreciation. The reorganisation of the National Film Library in 1941 made the archive and the Institute immediately more relevant to film societies facing wartime film shortages. The lending section, previously composed mainly of educational films for classroom use, was

re-oriented to support classes in film appreciation and programming featuring key developments in the history of cinema. The loan catalogue itself became a more intellectually ambitious document, an authoritative interpretation of film history from the 'primitives' to documentary.[12] This was a positive development although it would take almost ten more years before the BFI exhibited its archive films publicly through its own repertory programme at the Institut Français. The change in policy at the archive was followed by the organisation of a BFI Summer School in 1944 where youth workers, teachers and film society organisers attended talks on film appreciation from Ernest Lindgren, the school's organiser, and Roger Manvell.

In December 1944 an informal meeting was held between Scottish film society activists and representatives of the BFI to discuss the possibility of reviving the Federation of Film Societies. An effective federal organisation for film societies had been a largely unfulfilled aspiration of the prewar movement. The exception to this was the Scottish societies, led by highly committed and energetic organisers. The Scottish Federation of Film Societies successfully co-ordinated their interests, compelled perhaps by their distance from London's specialist cinemas and helped by being few in number. Responding to the Scots' initiative, Oliver Bell canvassed Ivor Montagu on the plan and invited him to attend a meeting to discuss the proposal. Montagu declined to get involved but replied to Bell with a considered analysis of the underlying reasons for the successive failures of the prewar Federation. These were twofold: firstly the lack of funds for a permanent secretariat; and secondly what Montagu described as the reluctance of societies 'to abdicate any particle of [their] unfettered independence' in the interests of effective co-operation.[13] According to Montagu all attempts to improve film supply by co-ordinating demand through a central agency had failed owing to 'jealousies and vested interests'.[14] In the final analysis, solving the problem of the secretariat was considered the key to establishing the confidence necessary for collaboration. Bell's solution was that the Institute would provide the administrative support with the director doubling as the Federation's honorary secretary.

The draft Federation constitution drawn up at the December meeting included a clause compelling all member societies to use a central booking agency.[15] This was subsequently dropped when the constitution was approved at a meeting of all English and Welsh film societies in March 1945. A Central Booking Agency (CBA) was nevertheless established by the BFI for exclusive use by members of the Federation the same year. The CBA was conceived as a mediating agency between the commercial distributors and the film societies. For a small fee levied on each booking and calculated according to the size of the society, the Agency could relieve a film society booking secretary of the burden of tracking down countless individual distributors and independently arranging terms of hire. The CBA negotiated fixed terms of hire on behalf of the film societies and guaranteed to the film trade that the films were hired by a bona fide society compliant with the conditions set down by the Kinematograph Renters Society, such as the ban on advertising

and strict limitations on guest tickets. The CBA, keen to stimulate film supply, therefore represented the film society exhibitors as a potential market for commercially minded distributors and an exhibition sector operating in such a way that it need not be regarded as a threat to the trade's commercial interests.

The 16mm revolution

The movement that the new Federation sought to represent was growing rapidly. Before the war the main activity of most film societies was a Sunday screening in a cinema. Legal restrictions on public film shows on Sundays provided film societies with an exhibition niche, though one dependent on the co-operation of a cinema manager and the agreement of the local authority. 16mm projectors changed this pattern by taking exhibition out of cinemas and making a film society viable with far smaller memberships. Wartime usage popularised the smaller, 'sub-standard' 16mm film gauge projected using lighter, portable projectors and intended for use by individuals without professional training, exhibiting films in improvised halls and classrooms. Film activities in the Armed Forces, from training to entertainment, massively increased the demand for 16mm projectors and films. On the home front the Ministry of Information co-ordinated the distribution of 16mm films to a vast and varied network of non-theatrical borrowers, mothers' groups, women's institutes, youth groups and remote civil defence outposts served by mobile film vans. The big film societies played their part organising 16mm screenings and discussion groups for service personnel and for citizen groups on topical themes such as planning and reconstruction. Previously an amateur gauge, 16mm was comprehensively reinvented as an instrument for the civic use of film. The 16mm revolution was heralded with great optimism by a new magazine dedicated to all uses of the film gauge, *16 Mil Film User*, which launched in 1946 with an editorial claiming that people were beginning to realise that '16mil film might open as wide a door as did the invention of the printing press'.[16] It became a vital reference source on film availability for a new generation of 16mm activist exhibitors.

For the next five years the development of 16mm film transformed the film society movement. The figures show that, in 1944, 7 of the 20 societies were operating on 16mm. Five years later the number of societies using only 16mm film shot up to 114 compared with 42 on 35mm and 47 societies showing both gauges. What was significant about 16mm as an exhibition technology was that it made the film society organisational model work on a greatly reduced scale for smaller groups; film societies became viable outside of the major cities and towns. Consequently the average size of a film society shrank. By 1950 nearly two-thirds of the film societies in England and Wales had fewer than 150 members. By comparison established urban 35mm societies often had in excess of 1,500 members. Alongside this geographical expansion, new film societies formed within the civic spaces of a host of educational and voluntary bodies. The Workers Educational Association, Co-operative Societies, Training Colleges, YMCA and Little Theatres

increasingly inclined to support film appreciation work. The Federation of Film Societies struggled to cope both with the extent of the movement's growth and with the specific needs of the new 16mm societies, many of which scraped by on very limited resources and could ill afford the additional fees charged by the CBA. The spread of 16mm fostered a wave of interest in booking films directly, extending the film society ethos of activism and self-determination to the actual booking of the programme. A hike in charges for the Central Booking Agency in 1949, in an attempt to make the agency pay for itself, converted more societies to booking their programme directly from specialist distributors and libraries, and inflamed discontent among film society activists. An influential group of activists now began to press for reform and development of the Federation, stressing the need for an organisation less bound up with the BFI's booking agency and more interested in facilitating the substantial growth of small-scale voluntary societies, by circulating information that could help them navigate a non-theatrical distribution sector that was also growing fast.

The Institute and 'the lusty infant'

Financial independence was thrust upon the Federation in 1950 when the subsidy represented by the provision of an honorary secretary from amongst its senior staff was discontinued. Whilst the Federation's counterparts in France and West Germany enjoyed generous public subsidies, the Scottish and English Federations were now entirely self-financing, remaining so until 1965 when the BFI committed to funding and appointing a full-time Film Society Liaison Officer. At the Federation's Annual General Meeting in 1950, the retiring chair, Lyon Blease, stated that the Federation, previously a nurseling of the BFI and dependent on its great generosity, was now a 'lusty infant' standing on its own.[17] Some part in ensuring its viability as a national organisation was played by a Yorkshire woman named Margaret Hancock, a former WEA tutor and Oxford graduate who took over as honorary secretary and for a decade and a half dedicated herself full-time without financial reward to running the organisation's administration from her front room in Sheffield. The Federation's financial independence from the BFI created the conditions for a tense and at times fractious relationship between the two organisations. On withdrawing administrative support from the Federation, the BFI had proposed radical organisational change, in effect winding up the Federation as a national concern. The Federation's national executive would be replaced by regional groups dealing directly with the Institute with policy co-ordinated through a central steering committee. The Federation's response was to affirm that their members wanted to remain an independent national body established by the film societies themselves and democratically accountable to its members.[18]

In these circumstances relations between the two bodies deteriorated. Reporting on the breakdown to the Executive Committee in 1952, Margaret Hancock complained of the BFI's increasing tendency to take action without proper

The vanguard of film appreciation

consultation with the Federation. She cited a proposal from the BFI to establish a Union of Commonwealth Film Societies which the Federation felt to be a potential threat to their own position within the international film society movement. Previously, highly favourable rates of BFI corporate membership had been offered to Federation members compared to unaffiliated film societies. However, in 1953 the Federation strenuously objected that the BFI's new rates offered membership to film societies outside of the Federation at low rates that would be detrimental to the Federation's survival. In other words they feared that small film societies with limited means would choose to join the BFI instead of the Federation. The BFI director Denis Forman's response to these complaints was blunt: if the BFI and the Federation were in direct competition for subscription fees, struggling film societies are 'free agents and can decide for themselves which of the two bodies can benefit them most'.[19]

In a memo written to Federation officers in the midst of these discussions, Forman restated his lack of confidence that the film society movement could ever be effectively co-ordinated and led by a central executive of volunteer representatives and officers. There was clearly personal friction with individual officers: Forman argued that the working relationship between the two bodies would have been improved if the Federation's correspondence had been 'more business-like and more agreeably expressed.'[20] Evidently the BFI would have liked an opportunity to direct the voluntary resources of large film societies channelling them in support of broader film appreciation schemes such as the Children's Cinema Councils. The Federation leadership was criticised for not being sufficiently supportive of these schemes, in other words neglecting what Norman Wilson, writing in *Sight and Sound*, had characterised as their wider civic duty. Although this echoed Wilson's understanding of the movement's purpose, the BFI's criticisms lacked any clear understanding of what in practice motivated film society activists, namely running a membership organisation primarily focused on showing films that couldn't otherwise be seen. Responding to the BFI's criticism of the Federation, an angry Margaret Hancock questioned the Institute's implicit expectation of 'immediate and uncritical support for its ideas and theories'.[21] The Institute's attack, she argued, lacked any realistic sense of the Federation's terms of reference or the financial and voluntary resources available to it. The Institute, she argued, appeared unwilling 'to see the Federation as it is and as the film societies have made it, or to work with it unless it follows the Institute's pattern'.[22] Spurred by the BFI's criticisms, however, the Federation set about raising its profile among its members, developing its publications and improving the information it circulated relating to sources of film availability.

The Edinburgh Film Festival, viewing sessions and film selection

Preceding the BFI's London Film Festival by a decade, Britain's first international film festival was established in 1947 through the voluntary initiative of

the Edinburgh Film Guild. Members of the Film Guild and the Scottish Federation of Film Societies were prominently involved in the formulation of the Festival's policy and in its day-to-day running. Conceived as an alternative to the growing numbers of competitive international festivals, Edinburgh struck out in an original direction, not only because it focused on an area of the contemporary cinema largely neglected by its continental counterparts, the documentary, but also because it developed an educational approach favouring a broad survey of the field supported by lectures and debates aimed at increasing public understanding.[23] Edinburgh's concern to evaluate approaches to documentary around the world and to raise awareness of documentary, experimental and realist film through lecture series, round-table discussions, educational wall displays and publications bore the hallmark of its institutional origins in voluntary initiative. This didn't please everyone, with some critics regretting the lack of 'showmanship' at the Festival and moaning at the Scots' fondness for sermonising.[24] The film society movement however were firm supporters of the efforts to establish the festival as an educational rather than simply a promotional event. In 1954 the burden of financing the festival shifted decisively towards the film industry and with it the festival began to aim for a much broader appeal. On the occasion of the Festival's tenth anniversary, Margaret Hancock of the Federation wrote urging Edinburgh to retain its 'amateur standing and individual outlook'.[25] Hancock feared that increasing film industry involvement threatened to undermine the independence of the Festival, leading to a decline in standards. The signs were ominous as comprehensive programme notes (a feature of the Film Guild) were replaced with casual synopses, educational conferences abandoned in favour of an increasing number of 'futile receptions', and ill-defined criteria of selection taking the place of the previous coherent selection policy. Hancock concluded with a series of 'birthday wishes'. 'First and foremost, a more suitable and adequate meeting place for film-makers and film enthusiasts, so that vital and constructive discussions could become more of a reality. Lectures by film-makers each week; provision of time for discussion at the film shows in place of introductory speeches.'[26] Hancock's ideal festival was one in which a knowledgeable and informed public was afforded ample opportunities to participate, supporting the creative work of film-makers through their direct response and critical appreciation.

Edinburgh was a valuable source of information about new films of interest to film society officials. Those who couldn't make the annual pilgrimage to the Film Guild's headquarters could rely on Federation publications, among the first of which was an annual devoted to detailed reviews of the festival programme. Assistance in selecting a programme of screenings was also provided by national viewing sessions, a previewing arrangement which served the interests of both film societies and specialist distributors eager to publicise their catalogues. Each spring film society representatives from around the country gathered at the Institut Français in Kensington for a weekend of intensive film viewing, from which the following year's programmes would be planned. This was one of the few occasions when

The vanguard of film appreciation 95

geographically dispersed film society activists came together as a single community. There were two sessions: the weekend for 35mm societies was programmed by the Central Booking Agency, whilst responsibility for the 16mm event was assumed by the Federation after the BFI ended its backing in 1952. In the selection and programming there was little to distinguish the two events. A new breed of specialist film distributors, such as Contemporary Films (established 1951), Plato (1950) and Concord (1959), were building their business around the non-theatrical exhibitors, and the viewing sessions represented an important showcase for titles acquired for film society use that were unlikely to get written about in the national press. Between them, Plato and Contemporary Films dramatically improved the film supply situation for film societies in the 1950s, accounting for a significant proportion of the titles showcased at the viewing sessions. Both distribution outfits were started by committed Communists and shared the party's emphasis on challenging the dominance of American culture.[27] They agreed to specialise in different areas: Plato focused on shorts and documentaries, many of which came through the state film organisations of the new socialist countries, while Contemporary concen-

5.1 Programme of the National 35mm Viewing Sessions, May 1960

trated on handling features. Plato's slogan 'See the Other Half of the World' suited its emphasis on Soviet and Eastern Bloc films. Contemporary, to the disapproval of some Communist Party officials, pursued a broader policy of importing from all countries the best film art and films of social significance.[28] The geographical breadth of the film selection at the viewing sessions, which included features and documentaries from Yugoslavia, China, Bulgaria, Ceylon, India and Brazil, was the combined effect of the internationalism fostered by the Edinburgh Film Festival, a desire to survey global developments in film and the political and social commitments of left-wing distributors Plato and Contemporary. The point of critical interest established with these films was rarely in relation to an auteur's developing reputation. Rather, these were films valued as representative of their distinctive cultures.

Enshrined in the typical film society constitution was the pedagogic ideal of encouraging the broadest appreciation of film 'as an art, as information and education'. This aspiration to promote all varieties of film-making underpinned the extraordinarily broad selection policy undertaken by the Federation's volunteers and by the CBA staff for the national viewing sessions of the 1950s. Take for example the 1951 national viewing sessions for 16mm film societies. Among the films introduced to film society representatives were four films by Maya Deren, *At Land* (1944), *Meshes of the Afternoon* (1943), *Ritual in Transfigured Time* (1945–46) and *A Study in Choreography for the Camera* (1945); *The Petrified Dog* (1948) by Sidney Petersen; Paul Strand and Leo Humik's campaigning Civil Rights documentary *Native Land* (1938–1942), banned in the USA at the time; Roberto Rossellini's *The Miracle* (1947–48); two films by Ernst Lubitsch, *Ninotchka* (1939) and *To Be or Not To Be* (1942); Cecil B. DeMille's *Union Pacific* (1939); Norman McLaren's *Dots and Loops* (1948–49); Eisenstein's *October* (1928); the Keystone Kops in *Keystone Hotel* (1935); Jean Painlevé's surreal experiment in filming sea creatures, *L'Hippocampe* (1934); and a film about aquatic life by Jacques Cousteau. This extraordinary weekend testifies to a commitment to promoting the broadest conception of the medium, featuring films made within all conceivable production contexts. In its breadth and diversity it brings to mind Scott MacDonald's characterisation of the programming practice of New York's Cinema 16, which he suggests effectively stimulated an open-ended interrogation of the nature of cinema through the conscious juxtaposition of highly contrasting yet equally individual and idiosyncratic approaches to the medium. From our present perspective we can see that the viewing sessions brought films together in ways that would become rare with the development of increasingly specialist channels of distribution and exhibition practices – art cinema, television, art gallery, etc.[29]

In its first decade the national viewing sessions were an agency through which the wave of postwar experimental work by American film-makers found an audience. The film-makers featured included James Broughton, Charles and Ray Eames, Maya Deren, Frank Stauffacher, Kenneth Anger, Stan Brakhage, Willard Maas, Lionel Rogosin and Shirley Clarke. Films by Brakhage and Maas and other

members of the Gryphon group were distributed within the film society movement by the Grasshopper Film Group, a London-based film society of amateur film-makers. Others, such as Maya Deren's and Kenneth Anger's films, were acquired by the BFI after attracting critical interest at the Edinburgh Film Festival and promoted through the viewing sessions. Other film-makers brought to the viewing sessions following Edinburgh success with documentary films were Bert Haanstra, Alain Resnais, Georges Franju, Henri Storck and Joris Ivens. Complementing the promotion of experimental works, the viewing sessions sought to contribute to an understanding of film history. A significant number of revivals from Hollywood's past were featured, from King Vidor's *Hallelujah* (1929) and William Wyler's *Jezebel* (1938) to Rouben Mamoulian's *City Streets* (1933). Some of these titles were available as a consequence of NFT seasons following which distributors made prints available for 16mm distribution. Finally a noticeable feature of the viewing sessions was a sustained interest in all forms of animation. Familiar cartoon characters such as Tom and Jerry, Porky Pig and Bugs Bunny from Hanna–Barbera and Warner Bros appeared regularly alongside work by John Hubley (films for UPA with Mr Magoo and Gerard McBoing Boing) and Norman McLaren (both much admired as experimental animators), Halas and Batchelor, and Czech puppeteers such as Jiří Trnka, and from the archives early examples of Disney's Silly Symphonies, Oscar Fischinger's abstract films and puppetry from the studios of George Pal.

All varieties of cinema marginal to dominant commercial exhibition were assembled at the viewing sessions and all modes of film production represented. From the point of view of the movement's self-identification as the spearhead of cinematic experiment, the flaw in the discovery system was a reviewing practice that was not always a model of robust and informed advocacy in support of new forms of cinema. The Federation published two magazines, *Film* and *Film News*. *Film* combined longer features on film-makers and films with items of news relevant to a film society readership; contributors came from inside and outside the movement. *Film News* was a magazine of film reviews similar in format to the *Monthly Film Bulletin* (*MFB*), with issues devoted to the national viewing sessions and the Edinburgh Film Festivals. The reviews were written by film society members attending the screenings and willing to contribute a short critical review. The magazine was part reference source, with every review carrying useful information such as the citations of reviews in the *MFB* and distributor's name and address, usually withheld from BFI publications, and part organ of critical opinion, reflecting the judgements of the movement. *Film News* was frequently mentioned by member film societies as the Federation's most valuable service. One anonymous correspondent to *Film* questioned the amateur reviewing practice and asked, 'Have enough steps been taken to ensure that only those who can write intelligently are invited?'[30] Notwithstanding the contribution of some subtle and sensitive critical writing, informed advocacy of new and unfamiliar forms (or old and unfamiliar) battled with a critical sensibility tuned to reception, to assessments of what a film society audience would be likely to tolerate.

Amidst discussion about the impact of a growing interest in foreign-language films from commercial exhibitors, the Federation launched a film supply scheme developed by the Tyneside film society activist Heini Przibram. As the Federation had no money to import films itself, the film supply officer's brief was to lobby distributors and liaise with the CBA generating suggestions on a film's suitability for the movement. The Austrian-born émigré Przibram had strong connections to the German film society movement and initially sought to create interest in several unknown films 'discovered' by German film societies. A disappointing response within the movement resulted in a more cautious scheme with the film supply officer gauging existing demand and passing the information on to distributors such as Contemporary and the Central Booking Agency. Two films of the Russian and German avant-garde that came into circulation in 1956 through the supply scheme and the BFI were Dziga Vertov's *Man with a Movie Camera* (1928, often incorrectly assumed to be a late 1960s discovery) and Robert Siodmak and Edgar Ulmer's *People on Sunday* (1929). Both reportedly received steady bookings, though confidentially a Federation document conceded that initial interest had been less than encouraging. The bolder plans of activists within the Federation to intervene authoritatively in the pattern of distribution through the film supply scheme confronted a reluctance to risk selecting films whose critical value had not been recognised by commercial distributors and national critics.

Centres of film culture

The importance of participation as a component to spectatorship was a recurrent theme for activists within the film society movement. They sought to create modes of reception in which audiences actively participated, ranging from the most minimal forms of participation such as the film society ritual of completing audience reaction forms through to structured discussion and writing and publishing magazines of opinion and criticism. Discussion as an integral component of film screenings was particularly valued. Discussion-based teaching methods, emphasising student activity, were core pedagogical values of the adult education movement which had acquired renewed prominence through the methods adopted by the Army Bureau of Current Affairs. The film society movement was also strongly influenced by the adult education emphasis on discussion method, its role in cultivating 'active citizenship'. A few years after the establishment of the National Film Theatre, film society activists questioned the limited opportunities for participating in discussion. An editorial in *Film* attacked the NFT for its remoteness to film society members living outside London and for failing to contribute to systematic film study and be more than merely a 'specialised hall'.[31] *Film's* readers were invited to contribute their views on the NFT and what it should be doing from a 'film society standpoint'. In response, Rupert Butler of Hammersmith Co-operative Film Society deplored the failure of the BFI to 'supply facilities for plain discussion of films as distinct from academic and expensive lectures'.

The vanguard of film appreciation

He continued: 'Seeing movies is, as we all know, only half the pleasure of film appreciation. There comes a time when intelligent talk – friendly nattering – is needed.'[32] NFT members, he argued, can queue up, see a film and return home 'without getting out of their systems, in simple conversation, their opinion of the evening's entertainment. In addition, and this is more of consequence, they have lost the chance of gaining some knowledge that might have been had so easily and pleasantly.'[33] Butler also regretted the lack of discursive interaction between the professional writers and critics of *Sight and Sound* and the *Monthly Film Bulletin* and NFT members. Was film critical discussion to be the preserve of professional critics only? Butler's letter was published with news that the Federation had proposed an NFT Study and Discussion group – 'Film society and specialised cinema in one' – and was awaiting a response to the plans. The following autumn, with no progress on these plans, Margaret Hancock wondered what had happened to the Institute's 'active co-operation' with the Federation. 'Is it not time', she asked, 'to reconsider the Institute's title and substitute London for British? To remind it that it was charged in the Radcliffe Report of 1948 with certain obligations towards the film society movement and the Federation.'[34] Hancock's bitter tone can be accounted for by the timing of her comments, the Federation's second application to the Treasury for a grant-in-aid to meet the rising costs of running the Federation and promote film appreciation activity in the regions having been turned down. The Federation's London Regional Group did eventually lead to study and discussion activities at the NFT.

Participation and study around film screenings were long-standing objectives of film societies but they were also resurgent values emphasised by some activists in the face of competitive pressures. By the end of the 1950s it was evident to many larger urban film societies that they needed to adapt. As early as 1955 a *Film* editorial suggested that one phase of the film society movement had come to completion with the increase in commercial screenings of foreign-language films; new directions were urged, with a stronger emphasis on film study and more constructive support for experimental and amateur film-making. These new directions were also debated the following year by the first national film society conference sponsored by the Federation. Throughout the decade a number of film societies and regional Federation groups had drawn closer to university extra-mural departments, regularly co-sponsoring a range of film study activity with involvement from local educational professionals and BFI education department staff.

Birmingham Film Society (BFS), consistently a model of organisational vigour and clarity of purpose since its formation in 1930, pursued a policy which took full account of the changes in the local exhibition environment. In 1959, BFS reported that the changing nature of local exhibition required a fresh approach to programming, the film society no longer needed to show new continental films, many of which would get a local release. Film selection could focus on films that were genuine regional premieres, and a film study group was launched with the co-operation of the University of Birmingham Extra Mural Department. Typi-

cally the Film Study Group undertook an integrated series of lectures with supporting screenings, ten meetings in all from October through to April, around an overarching theme, such as Film and Society or Film Analysis. Lecturers included Paddy Whannel and Alan Lovell, both of whom had recently joined the expanding BFI Education Department. In 1964, the year that *The Popular Arts* was published, Whannel and his co-author Stuart Hall, who had taken up a post at the newly established Centre for Contemporary Cultural Studies at Birmingham University, co-taught a course on the film hero. The educational programme of the film study group shifted decisively away from the approaches associated with film appreciation and broad historical surveys emphasising film technique towards the detailed film analyses that *The Popular Arts* was encouraging. Many years later when Paddy Whannel resigned from his post at the Education Department he criticised the way the NFT and the Regional Film Theatres were seen as art houses rather than centres of film culture.[35] Coming out of an ethos of active engagement and integrating film screenings with innovative teaching within a locally directed organisation that brought together volunteer initiative and professional expertise, the Birmingham Film Society had shown what could be achieved.

Notes

1 Mervyn Reeves, 'The Film Societies and Adult Education', *Adult Education* 21:4, June 1949, pp. 175–8.
2 Roger Manvell, *The Film and the Public* (Harmondsworth: Penguin Books, 1955).
3 Roger Manvell, *Film* (Harmondsworth: Penguin Books, 1944).
4 Melanie Selfe, *The Role of Film Societies in the Presentation and Mediation of 'Cultural' Film in Postwar Nottingham*, unpublished PhD thesis, Norwich: University of East Anglia, 2007, p. 50.
5 'Adult Education: Its Place in Post-War Society', *Adult Education: A Quarterly Journal of the British Institute of Adult Education* 16:2, 1943.
6 Norman Wilson, 'Film Societies - the Next Phase', *Sight and Sound*, July 1945.
7 Ibid.
8 Roger Manvell, *Film*, revised ed. (Harmondsworth: Penguin Books, 1946), p. 143.
9 Wilson, 'Film Societies – the Next Phase'.
10 Memorandum on Aid for the Federation of Film Societies, July 1955, BFI Special Collections, British Federation of Film Societies (BFFS).
11 See for example John Grierson, 'The Prospect for Cultural Cinema,' *Film* 7, 1956, p. 31.
12 Catalogue of the loan section of the National Film Library, August 1941. The acquisition in June 1952 of a unique collection of 123 films from The (London) Film Society, which had ceased activities, allowed the NFL to add a number of key repertory classics to its loan catalogue, in line with its new policy.
13 Letter from Ivor Montagu to Oliver Bell, 22 February 1945. BFI/Montagu, Item 12.
14 Ibid.
15 Draft Constitution for a Federation of English and Scottish Film Societies, n.d. BFI/Montagu Collection.
16 'Editorial Reel'. *16 Mil. Film User*, November 1946, p. 3.
17 Annual Report for 1949–50 given by Professor W. Lyon Blease, chairman of the

The vanguard of film appreciation

Federation of Film Societies, at the Annual General Meeting, 4 November 1950. BFI Special Collections: BFFS.
18 Federation of Film Societies Report of the Sub-committee for the Examination of the Constitution, 1 October 1949. BFI Special Collections: BFFS.
19 Confidential letter from Denis Forman to Idris Evans, 7 September 1953. BFI/BFFS collection.
20 'Relationship between the British Film Institute and the Federation of Film Societies' 1953. BFI/BFFS collection.
21 'Honorary Secretary's Notes on the BFI Paper on Relationship between the British Film Institute and Federation of Film Societies.' BFI/BFFS collection.
22 Ibid.
23 The focus on documentary wasn't entirely without precedent. A year before the first Edinburgh International Film Festival, the Festival du Court Métrage in Tours dedicated itself to all varieties of short film.
24 Fred Majdalany, 'Films', *Time and Tide*, 4 September 1954.
25 Margaret Hancock, 'Edinburgh,' *Film* 18, 1958, pp. 29–30.
26 Ibid.
27 Bert Hogenkamp, *Film, Television and the Left in Britain: 1959 to 1970* (London: Lawrence and Wishart, 2000), p. 13.
28 Margaret Dickinson, interview with Charlie Cooper. 'Contemporary Films.' In Margaret Dickinson (ed.), *Rogue Reels: Oppositional Film in Britain, 1945–90* (London: BFI, 1999).
29 Scott MacDonald, *Cinema 16: Documents toward a History of the Film Society* (Philadelphia: Temple University Press, 2002).
30 Anon, 'Into the Looking Glass', *Film* 23, 1960, p. 28.
31 'Commentary: NFT', *Film* 5, 1955, p. 4.
32 Rupert Butler, 'Letters: NFT', *Film*, 1956, p. 30.
33 Ibid.
34 Margaret Hancock, 'Newsreel', *Film* 9, 1956, p. 26.
35 Letter from Paddy Whannel to Denis Forman published in *Screen*, 12:3 (Summer 1971), pp. 38–43.

6

From the 1964 Labour government to the 1970 BFI crisis

Geoffrey Nowell-Smith

In 1964 the BFI got a new director and a new chairman and the country as a whole got a new government. At the BFI, Sylvester Gates stepped down as chairman in January to be replaced by Sir William Coldstream, a painter and former documentary film-maker, now professor at the Slade School of Fine Art. Meanwhile, James Quinn resigned as director to go into business as a film producer and exhibitor and Stanley Reed, the BFI secretary, was promoted to take his place. Reed's appointment was a vote of confidence by the governors in the way the BFI was being managed.

Reed's appointment came at a good time for the BFI. The election of a Labour government on 15 October 1964, after 13 years of Conservative rule, was widely welcomed in the BFI, not just because it coincided with the political preferences of the majority of senior staff but for the prospect it brought of more funding and more status for the public arts in Britain. The BFI was not mentioned by name, but the Labour Party's election manifesto contained two significant pledges under the general heading of 'Leisure Services'. The government would, said the manifesto, '(iii) give much more generous support to the Arts Council, the theatre, orchestras, concert halls, museums and art galleries', and '(iv) encourage and support independent film makers both for the cinema and television'.[1] The first of these was to be carried out fairly conscientiously, the second less so, but the BFI proved to be a beneficiary of both. Within a week of the election victory, the new prime minister, Harold Wilson, announced the appointment of a minister for the arts, a post to be held by Jennie Lee, widow of the former leader of the left in the party, Aneurin Bevan, who had died in 1960. There was initially some doubt as to which department would house the new ministry but eventually it was decided to make it part of the recently created Department of Education and Science – a move which brought both the arts and the sciences under the same educational banner. This meant that for the first time in its history the BFI would belong in a specific ministry, rather than depend directly on the Treasury, or (as had been the case until 1959) the Office of the Lord President of the Council.[2]

Jennie Lee believed passionately in 'art for the people'. That is, she believed

6.1 Jennie Lee at the opening of the 1969 London Film Festival

that 'the arts' – by which was meant opera, ballet, classical music, theatre, painting and sculpture, etc. – should be made accessible to a population far greater than the narrow elites which traditionally had had the money, leisure and cultural formation to enjoy them. She was not particularly interested in popular culture, nor, it turned out, in the cinema, which occupied an uncertain middle ground between art and popular entertainment. When she visited the BFI's offices in Dean St shortly after her appointment as minister, conversations turned out to be at cross-purposes until the staff she was introduced to twigged that she was not really interested in film as an art in its own right but more as a means by which the other arts could be brought to wider audiences. Shakespeare on film, ballet on film, films about art and artists, these were the sorts of things she thought the BFI should be promoting to audiences across the country. This was far from being what the BFI saw itself as doing or wanting to do, but it was in the BFI's interest to allow the equivocation to persist and so it did.[3]

'Art for the people' meant, above all, people outside London. Ever since Herbert Morrison had stymied the recommendations in the Radcliffe Report which proposed setting up regional BFI offices in other parts of the country, the BFI had struggled with a problem of perceived metropolitan bias. It had created the

National Film Theatre (in London) and added a film festival (also in London); it had a library and an archive viewing service, but these too were in London; and its flagship magazine, *Sight and Sound*, covered films released in London's West End and in art cinemas such as the Academy in Oxford Street – many of which, however, hardly circulated at all further afield. It was only really through its role as a film distributor (mainly on 16mm), and through the Central Booking Agency and support for film societies, that it helped those members of its core constituency of film enthusiasts who did not live in the metropolis to get to see films they had heard about but which never came to the places where they lived.

Regional expansion

In anticipation of what it hoped would happen if Labour came to power, the BFI in July 1964 commissioned a report from the outgoing director, James Quinn, on the prospects for extending the Institute's activities in the regions (or provinces as they tended to be called). Quinn travelled across the country, meeting film society activists, independent exhibitors and local council representatives and came up with an ambitious plan to stud the country with a network of Regional Film Theatres modelled, at least notionally, on the NFT. Meanwhile the new government was making it clear that it did indeed intend to honour its manifesto commitments towards the arts. In March 1965, Jennie Lee attended a meeting of the BFI Governors at which she announced that her priorities were, in order: provincial expansion, establishing a National Film School (in which the BFI's role would be unclear: it turned out to be marginal),[4] and increased support for the National Film Archive and the Institute in general. Heartened by this announcement, Quinn delivered a draft of his report in April and, after some debate and editorial changes, it was published towards the end of the year under the title *Outside London*.[5]

Putting these ambitious proposals into action was not something that could be done immediately. A lot of negotiation with interested parties would be necessary, and a realistic budget would have to be prepared which the government would then need to approve. But the Institute began to profit in other ways from the new government's positive approach to arts funding. Government grant to the BFI for the year 1965/66 was £181,780, an increase of nearly 50 per cent on the previous year.[6] Then in 1966/67 the grant rose further to £230,000, which even allowing for inflation was a substantial increase. The main beneficiaries of these increases were the National Film Archive, which was able to start planning for the new vaults at Berkhamsted; the Education Department, which was beginning to acquire more staff; and the Experimental Film Fund (EFF), which had been dormant for a couple of years but was now reconstituted as the BFI Production Board and able to restart a programme of grants to film-makers.

In 1966/67 the plans for regional expansion really began to take shape and money was released (if only in small amounts). As recounted by Melanie Selfe in Chapter 7, it was then that the first Regional Film Theatres, as they were called,

were opened – in Aldeburgh, Brighton, Bristol, Colchester, Malvern, Middlesbrough, Norwich, Nottingham and Southampton. A grant was also provided to the Bradford Playhouse theatre to assist it with showing films. Except for Brighton, all these venues were part-time, showing films either once a week or for one week in each month.[7]

It was only in 1967/68 that the money properly started to flow. The BFI's general grant for the year rose to £280,000, topped up with an additional sum of £63,000 specifically allocated to 'provincial expansion'. In that year further RFTs were opened including two which were to be full-time (Manchester, which didn't last long, and Newcastle/Tyneside, which was run directly by the BFI, a decision it soon came to regret). Bradford Playhouse was upgraded and new part-time venues were established in various places. By 1971 there were no fewer than 36 RFTs of one kind or another, scattered around England and Wales in rather random fashion with rather a lot in places serving only an exiguous population. (The BFI's remit did not extend to Scotland (where the Scottish Film Council held sway) nor to Northern Ireland (though technical and booking support were offered to the Queen's Film Theatre in Belfast).)

The reasons for the random distribution are not far to seek. Although the BFI's original intention had been to establish footholds in big cities at the heart of major conurbations such as Manchester, Birmingham or Liverpool, this was not always easy to achieve. Local authority structures were complex and it was not enough to have a friendly film-buff on the Leisure Committee in order to push through a potentially costly project. Some cities, moreover, were already quite well served for film culture. Manchester, for example, had two art cinemas, a Classic and a Cinephone, two well-established city film societies, the Manchester and Salford and the Manchester Film Institute Society, and at least two enterprising student film societies, one of which (at Manchester University) ran popular mainstream films to packed houses on Sunday evenings and minority fare to smaller but still substantial audiences on Tuesdays.[8] Manchester's first attempt to run an RFT in the city, in association with the Manchester Film Institute Society, collapsed within a couple of years and the city survived without a proper venue until the opening of Cornerhouse in 1985. Birmingham had to wait until 1971 for the establishment of an RFT in the Midland Arts Centre. Glasgow, although repeatedly courted in the 1960s, had to wait until 1974,[9] and no RFT was ever established on Merseyside in either the 1960s or 1970s.

By contrast it was relatively easy to open an RFT in medium-sized or smaller towns and even in places which were barely towns at all, and the BFI all too easily succumbed to temptation. All that was needed was an enthusiastic local film society and a local council eager to enhance arts provision. But if setting one up was easy, running one was not. However uncommercial their operations might be in practice, RFTs were technically commercial cinemas, subject to safety and censorship legislation. And they had to pay commercial rates for hiring films.[10] These difficulties were to plague the RFTs, particularly the smaller ones, throughout the 1960s

and 1970s. The BFI was not unaware of the problems and would undoubtedly have preferred to put more resources into fewer, better resourced and more efficient operations, but it was dependent on Jennie Lee and the DES for its funding for regional expansion and Lee was explicit in her preference for part-time theatres, which she reiterated to BFI Governors, via one of her civil servants, in 1970.[11] The BFI was also aware, from the beginning, of the problems that could arise if the RFTs simply took the money on offer but failed to programme films to an appropriate standard, but it was shy of seeming dictatorial and the governors contented themselves with a bland minute to the effect that the Institute would exercise only indirect control on programming, although it 'would not of course continue to supply money to groups [i.e. locally appointed managements] which did not enjoy its confidence'.[12]

Administrative problems

The structure of the Institute at the time the regional expansion began was no longer the same as it had been in 1960. The new secretary, Vernon Saunders, was no longer in charge of any operating departments, but only of finance and administration. The operating departments were four, two small and two large. The small ones were Education, under Paddy Whannel, and Publications, under Penelope Houston, editor of *Sight and Sound*. Of the large ones, the most prestigious was the National Film Archive, headed by Ernest Lindgren who was also deputy director of the Institute,[13] and including the Library and Research and Information service. All the rest of the Institute's operations, including the NFT and the Experimental Film Fund, were grouped together in a division called Film Services, under the control of John Huntley. Huntley was involved from the outset in the new regional operations and in 1966 Reed formally made him Regional Controller, but at the same time removed from him responsibility for the NFT, which became a free-standing division, under the control of Leslie Hardcastle. Even without the NFT, however, Film Services with its new regional responsibilities was the largest division in the Institute and remained so until 1974 when it was split into two.

Huntley was an amiable fellow, a film collector (especially of films about railways) and a popular circuit lecturer. But he did not have the strategic qualities to mastermind such an ambitious programme. He was also not a particularly good administrator and had a fairly casual attitude to copyright which brought him into regular conflict with the ever-scrupulous Lindgren and was to lead to further problems later. Setting up the RFTs not only involved sorting out problems in the field, it also led to an increased workload inside the department, with more films to be booked and rates to be agreed. Meanwhile the BFI's Distribution Library was also growing and premises had to be hired to deal with the increasing number of film movements handled by the BFI for various purposes, for educational and film society users as well as for public exhibition. The elephantine growth of Film Services and its managerial vagaries did not attract much attention at the time but

it was to play a major background role in the crisis that erupted at the end of the decade.[14]

Film Services did however carry out an unexpected function in 1966 which showed the BFI in a positive light on the national stage. Towards the end of 1964, the BBC commissioned from the film-maker Peter Watkins a dramatised documentary on the aftermath in Britain of a hypothetical nuclear war. Watkins's previous film, *Culloden* (1964), about the suppression of the Jacobite revolt in 1746, had been a considerable *succès de scandale* and it was assumed that his new film, *The War Game*, would be equally successful and no less controversial.[15] But from the moment that Huw Weldon, BBC Head of Documentaries, saw the rough cut, it was clear that the BBC had got more than it had bargained for. The completed film was shown to BBC top brass and then to representatives of the Home Office, Ministry of Defence and security services. Lord Normanbrooke, chair of BBC governors, and Hugh Carleton Greene, director general, decided that the film could not be broadcast. They issued a press release to that effect on 26 November 1965, denying (implausibly) that this was the result of political pressure.[16] Political pressure there undoubtedly had been, but the BBC hierarchy was deeply divided and probably would have withdrawn the film anyhow. But although there might have been agreement that the film was too horrific to be broadcast into several million homes, quite a few people inside the corporation thought that a total ban would be excessive. One of those open to persuasion on the matter was Kenneth Adam, director of BBC TV and at the time a BFI governor. Stanley Reed suggested to Adam that the BFI might take the film for cinematic release, and after some hesitation the BBC

6.2 Poster for Peter Watkins's film The War Game for which the BFI obtained cinematic distribution rights after the BBC refused to broadcast it

agreed.[17] In February 1966, Reed was able to announce that the BBC had agreed to make the film available for non-commercial screenings at the NFT and elsewhere. Demand was so great – mainly from voluntary groups – that a dedicated member of staff had to be employed to service bookings. It also revived interest in *Culloden*, which the BFI also took into distribution. The BBC saved a bit of face but it was the BFI which gained most in terms of public profile (though it did not net a huge amount of money and Watkins got nothing at all).

Film Services was not the only department reporting an increase in demand for its services. The Library was acquiring more books than it could shelve and there were more readers to read them than there were spaces in the Reading Room. The number of desks was doubled in 1969, from 10 to 20, but there were insufficient staff to service them and an unpopular decision had to be taken to close the Reading Room on Mondays to enable staff to catch up on other activities.[18] The Library's restricted opening hours were to remain a regular cause of complaint from members well into the twenty-first century.

The Stills collection was also growing, adding ten thousand items in 1969/70 alone, necessitating a move to larger premises on the ground floor at Dean St. But the worst problems were at the NFA, which was continuing to acquire films and running out of space in which to house them. Between 1966 and 1970 it acquired 650 new feature films (plus over a hundred duplicates which could be used as viewing copies), over 1,300 short films, 400 TV programmes of various sorts, and 1,200 newsreel items.[19] It could not acquire everything it was offered, so there had to be selection, which was done by committees. But the committees had to be serviced and films, once acquired, had to be inspected and catalogued. The problem of storage and preservation was solved for the time being by the construction of new vaults on the Berkhamsted site, which took a full two years between the granting of planning permission and the completion of construction. But the need to compile both a technical record on each item of footage and a catalogue entry on the content, and to provide facilities for film viewing, meant a growing need for staff, which was only partially met.

While the steady growth in holdings of books and stills was a fairly manageable process, acquisition of films was random and fraught with difficulty. Although all new films since the early 1950s were on safety stock, earlier films were mostly on flammable nitrate stock and by the time they arrived at the archive could be in poor or even dangerous condition. Also, there was no way of telling, even with the filter provided by the selection committees, what might suddenly turn up and need attention. Most importantly, although the archive was getting lots of prints, it could not be sure of getting what it felt it above all had a duty to acquire – that is to say, good preservation prints of all new British films at or close to the time of their release.

Statutory deposit

The idea that the National Film Archive should not only be able to acquire these prints but be charged with a public duty to acquire them – or conversely, that the film industry should be required to deposit them, either at its own expense or with assistance from the public purse – was something the BFI had been pressing for for years and, as recounted in Chapter 2, had tried unsuccessfully to include in the 1951 Copyright Act. When that attempt failed, Ernest Lindgren had reluctantly resigned himself to relying on a system of voluntary deposit, with which some film companies co-operated better than others. But in the early 1960s the voluntary scheme was no longer working well.[20] The election of the Labour government and the appointment to the governors in 1966 of Dr David Kerr, Labour MP for Wandsworth, seemed to provide a new opportunity for change. In 1967, with Reed's support, Lindgren began lobbying the governors and the DES in favour of a new proposal for statutory deposit.[21] In July 1968 a small sub-committee of governors, consisting of Coldstream, Kerr, Helen Forman and Kevin Brownlow, and assisted by Reed, Lindgren and Lindgren's deputy, Colin Ford, was set up to review the policies and operations of the archive. Although the main focus of the review was supposed to be availability, Kerr and Lindgren soon homed in on the issue of statutory deposit and together drafted the text of a Private Member's Bill for Kerr to introduce in the House of Commons making it an obligation on film companies to deposit in the National Film Archive a print of every new film shown in the United Kingdom. The bill had all-party support, with the Liberal Eric Lubbock co-sponsoring it and the Conservative Paul Channon (later minister for the arts in the Thatcher government) lining up behind it on behalf of the opposition. The bill had a first reading in February 1969 and was brought forward for a second reading in April. At this point, however, the government withdrew support. Sensing that the film trade would resist any attempt to make them bear the cost of making extra prints, Kerr and Lindgren had asked for the prints to be provided by the industry at cost, at the NFA's expense. This would of course have been at the expense of the government, via an increased BFI grant, and Lee, concerned about the unfavourable budget settlement expected in 1969/70, decided that, although the principle was, in her words, 'very desirable' and she would like to see the measure become law 'in a more favourable economic climate', the cost of implementing it was too great. After a two-hour debate, the bill was refused a second reading by 48 votes to 29.[22] This was to be the last attempt until the 1990s to get statutory deposit on to the statute book.

The Production Board

The big success story of the 1960s, without a doubt, was the establishment of the BFI Production Board to replace the dormant Experimental Film Fund. This came about at Jennie Lee's insistence. The BFI's increased grant for 1966/67 came with strings attached: as well as for regional development, money should be set

aside for production of films by young film-makers. But the length of the piece of string was not specified, and there was some argument inside the BFI as to how much money could be allocated for the purpose. Michael Balcon, a BFI governor and chairman of the EFF, insisted that at least £7,000 a year would be needed if the fund was to make any impact. BFI officers were at first unwilling to grant more than £1,000, but in the end Balcon prevailed. £5,000 was allocated in 1966/67, doubled to £12,500 in 1967/8 and further increased to £13,500 in 1968/69.[23]

Once the first £5,000 was allocated, the board was reconstituted, still under Balcon's chairmanship, and (without cutting into the grant) the BFI appointed a dynamic young Australian called Bruce Beresford as its first Production Officer, providing him with an office, an assistant, a secretary and a modicum of technical equipment, mainly for editing. Although the sums of money at the new Board's disposal were modest, Beresford managed to organise a rapid merry-go-round of production. It even managed to provide production facilities for the ambitious experimental feature film *Herostratus*, directed by Don Levy and co-produced by the former BFI director James Quinn and the BBC.

The NFT

As Christophe Dupin recounts in Chapter 4, the NFT enjoyed fluctuating fortunes during the period. Things started badly, when the operation was forced to move to alternative premises on Millbank and at the Shell Centre for eight months in 1964 so that building works could take place on the Waterloo Bridge site. The promised works did not materialise and a lot of box-office revenue was lost to no purpose. Further disruption, but of a different kind, was caused in 1967 when Richard Roud resigned from his post as chief programmer to concentrate on his role as director of the London and New York Film Festivals, leaving a vacuum in the programming that was not filled until the arrival of Ken Wlaschin in 1969. Undeterred, the BFI continued with plans for a second theatre on the site, which was opened in September 1970 as NFT2, with a brief to programme films of more specialist and minority interest.

The gathering storm

Occasional setbacks aside, in 1968 the BFI had every reason to be satisfied with its recent achievements. It was a shock, therefore when, in June of that year, an 'Open Letter' to Jennie Lee was issued, signed by three hundred BFI members, which was highly critical of the BFI management and governors and went so far as to call for the BFI's abolition and its replacement by a completely new organisation, to be called Cinetec International London.

The moving spirit behind the letter was Maurice Hatton, a 30-year-old film-maker with a recent feature film (*Praise Marx and Pass the Ammunition*, starring John Thaw) to his credit. His name alone carried little weight, but he had gathered

together an impressive list of supporters, including those of leading film-makers Tony Richardson, John Schlesinger and Clive Donner. Lee was scathing in her response to Hatton, berating him for his discourtesy and pointing to the great increase in government support for the BFI since 1964.[24] The BFI Governors and management were also inclined to be dismissive of this upstart initiative and when Hatton and his friends returned to the attack in 1969 and again, more damagingly, in 1970, the BFI was unprepared for the strength of the opposition.

The main opposition to what the BFI was doing came not from the 'names' whom Hatton had rounded up to support his cause but from a younger group of activists all of whom had different axes to grind but who were united in a feeling that the BFI with its ageing governing body dominated by trade interests was out of touch with the vital forces emerging in the film culture. Another point of unity was the experience of France, where the New Wave of the early 1960s had been nourished by a Cinémathèque which pursued a policy of open access to films regardless of their preservation status and where, more recently, film-makers had taken to the streets in defence of the Cinémathèque's curator, Henri Langlois, adding another spark to the May Events in Paris.

Other grievances were support for the regions, which was seen as thinly spread and mainly devoted to giving middlebrow provincial audiences access to the reach-me-downs of art film culture; and *Sight and Sound*, seen as supporting the same middlebrow culture and using its dominant market position to squeeze out competition. But there was also opposition on the board itself, where Lindsay Anderson was mounting a personal crusade against *Sight and Sound* and its editor, Penelope Houston. In June 1970 the board held a special meeting to discuss Anderson's complaints. When it failed to back him sufficiently, he resigned, dragging fellow-governor Karel Reisz with him.[25]

Anderson had been a disruptive presence on the board, but he was one of the few governors with a real commitment to cinema and the role the BFI might play in promoting 'the art of film'. (Others were Balcon and Kerr, already mentioned, Helen Forman and George Hoellering, owner of the Academy Cinema in Oxford Street, who unlike Anderson was a firm supporter of *Sight and Sound*.) The most powerful figure on the board was John Davis, head of the Rank Organisation, who embodied the tradition of having a 'trade' member on the governing body whose ostensible role was to smooth relations between the Institute and the industry but who tended in practice to obstruct any attempts by the BFI to do anything that could change the profile of film culture in the country. With the well-meaning if ineffectual Coldstream nominally at the helm and Davis carping from the sidelines, Kerr received only lukewarm support for his attempts to get the board to undertake a major review of the BFI's policies and practice.

At the 1969 AGM Hatton had tried again to raise the issues he and his supporters considered important, but was again rebuffed. Having taken legal advice, he discovered that the only power possessed by members under the BFI's constitution was to move a motion at the AGM calling for the dismissal of any or all of the governing

6.3 Cartoon from the pamphlet 'A New Screenplay for the BFI' (1971) in which the Members Action Committee portrays the BFI as a pathetic imitation of the Rank Organisation whose famous resounding gong provided the opening credit for Rank films throughout the postwar period

body. He therefore formed a small group, calling itself the BFI Members Action Committee, with enough volunteers for each member to propose a motion for the dismissal of a single governor. A manifesto was issued, entitled 'Why we want to dismiss the Governors' and a press campaign launched, mainly through the pages of *Time Out*, in preparation for the AGM to be held at the end of the year.[26] Meanwhile, inside the BFI, staff were growing restive. The organisation had doubled in size over the previous five years but had not adjusted its structures to take account of changing circumstances. New staff had come in, with new ideas and with important responsibilities, but decision-making remained in the hands of a small group

of senior executives all of whom had played a role in implementing the Forman reforms of 1949–50 but were now an increasingly out-of-touch 'establishment'. On 15 May 1970 a group of 29 middle-ranking staff wrote a letter to the director calling for more democracy and improved communications. Having received no more than token acknowledgement, they recirculated their letter in November, requesting it be tabled at the upcoming meeting of governors. Another group of staff, 21 in number this time, chipped in with a counter-letter, more conciliatory in tone and expressing guarded confidence in the management.[27] In between them, the '29' and the '21' represented the near totality of middle and junior management; none of them was happy, and many of them were quite angry.

By this time the governors were on full alert. They had by now identified the Education Department as the main trouble spot, around which internal and external opposition converged (two former members of the department's staff, Peter Wollen and V. F. Perkins, were now on the Action Committee). In July 1970 a newly appointed governor, Asa Briggs, vice chancellor of Sussex University, was commissioned to prepare a report on the department's activities. At the same July meeting, the review of policy that Kerr had been calling for was formally instituted – 'to review, and if necessary redefine, the role and functions of the Film Institute, make recommendations for their [sic] implementation and report to the Board by the end of 1970'.[28] Some governors thought the situation so serious that an external review commissioned by the government, similar to the 1948 Radcliffe Report, would be necessary to re-establish the Institute on a proper footing, but Coldstream was opposed and his caution carried the day. It was decided to hold a weekend of discussions in October attended by governors and senior officers. at which papers would be presented and issues thrashed out and from which a report would emerge.

The meeting took place at Balcon's country retreat in Sussex on 23 to 25 October. Papers from Reed and from all the department heads were debated but the general direction of the discussion was dictated by a proposal previously put forward by Kerr and tabled at the governors' meeting the previous June, which envisaged radical devolution of the Archive and NFT from the rest of the Institute. Whatever the possible long-term merits of the proposal, taking it on board at that moment would have been unwise. Reed knew this, and vigorously opposed its adoption by governors. Nevertheless, when a sub-group of governors met after the weekend to prepare a draft report, its focus was all on structural issues and included a watered-down version of Kerr's proposals, recommending a much more interventionist role for the board in relation to all departments though falling short of endorsing outright devolution for the Archive and NFT. Three governors – Michael Balcon, George Hoellering and Jocelyn Baines – dissented and produced a minority report of their own.[29] For Balcon in particular, it was the governors themselves who were the heart of the problem, and further interference by the board, however well intentioned, could only make existing problems worse

Before a final version of the report could be approved, however, Coldstream had to face the dissidents at the AGM. Members of the Action Committee presented

their motions to dismiss the governors one by one.[30] A single vote was taken on all the motions, resulting in defeat for the dissidents by 189 votes to 90. In a subsequent postal ballot, the defeat was even heavier: 3,852 members rallied to the Institute's support, with only 573 voting to remove some or all of the governors. The result was not really a surprise. Those entitled to vote were full members of the BFI – i.e. those who had chosen to pay to receive *Sight and Sound* and generally represented the cultural values that the Action Committee was putting in question. But the combination of internal and external dissent, and the inept way it seemed to be being handled, put enormous pressure on the BFI. The dissidents might be few in number, but the forces they represented were not going to be suppressed. If the Board and the management had hoped to impress government and public opinion by taking a firm and unyielding approach to what they thought was an insignificant rabble, they failed, and there would be a price to be paid.

Notes

1. F. W. S. Craig (ed.), *British General Election Manifestos, 1918–1966* (Chichester: Political Reference Publications, 1970), sec. 5 Leisure Services, p. 241. There is a copy of the manifesto in the BFI Library.
2. See above, Chapter 2.
3. Lee's visit, and the confusion surrounding it, are remembered by surviving members of staff including Penelope Houston and David Meeker.
4. The idea of a National School of Cinematography, or of Film and Television, had been batted around a lot in the 1950s, with the Royal College of Art front-runner to host it. The idea of housing it in a disused film studio (as eventually happened) was first mooted in early 1964, before Labour came to power. (See BFI Governors Minutes, 6 January 1964.)
5. *Outside London: A Report to the Governors of the British Film Institute*, n.d [1965].
6. Some of this was in fact paid in 1964/65 to cover retroactive pay increases, so the net sum available for spending did not actually increase that much. See *BFI Annual Report*, 1965/66.
7. For a fuller account of the BFI's regional expansion programme, see Melanie Selfe, in Chapter 7.
8. Source: GNS interviews with Linda Redford (17 November 2005) and Alan Howden (26 March 2008). See also Geoffrey Nowell-Smith, 'Chasing the Gorgon', *Sight and Sound* 34:2, Spring 1965, pp. 40–1.
9. Glasgow was the proud possessor of the first 'art cinema' in the British Isles outside London, the Cosmo (founded 1939). By the early 1970s it had fallen on hard times and was purchased by the Scottish Film Council, which refurbished it. After a brief closure it was reopened in 1974 as the Glasgow Film Theatre, mainly with SFC support but as part of the BFI's RFT network.
10. This had a knock-on effect on the NFT, which succumbed around 1970 to trade pressure also to pay for the hire of films from commercial distributors.
11. BFI Governors Minutes, 17 March 1970.
12. This formulation was due to Edgar Anstey, who took exception to a stronger version previously accepted by Governors which said, 'A threat to withdraw Institute financial support would be a powerful weapon against programme policies of which the Institute did not approve'. BFI Governors Minutes, 6 December 1965 and 7 February 1966.

13 Lindgren had first been appointed deputy director in 1949, but had asked to relinquish the post in 1955 to concentrate on his archival responsibilities. Reappointed in 1964, he was to play an increasingly key role in the BFI's affairs in the 1970 crisis.
14 It had in fact been noted in the Mendoza Report in 1959 (see Chapter 2), but nothing much seems to have to be done to check it.
15 Watkins's early career had been helped when the EFF gave him a completion grant for his short film *Dust Fever* in 1963.
16 For a fuller account see Joseph A. Gomez, *Peter Watkins* (Boston: Twayne, 1970), pp. 56–7.
17 Ivan Butler, *'To Encourage the Art of the Film': The Story of the BFI* (London: Robert Hale, 1971), p. 48.
18 Gillian Hartnoll, *A Brief History of the BFI Library*, 1999, pp. 14–15.
19 Source: *BFI Annual Reports*.
20 See paper for governors by Stanley Reed, dated 5 May 1967, in BFI/A-77.
21 See letter by Lindgren to Ian Thom at the DES, 25 May 1967, and paper for governors by Lindgren, 5 June 1967, both in BFI/A-77.
22 Details in *The Rescue of Living History* (BFI 1969).
23 See Christophe Dupin's account of the history of the Production Board in Chapter 11, below, pp. 202–4.
24 Written documentation on this episode is sparse. There is a typewritten copy of Hatton's letter in BFI/19. It appears to been issued as a press release on 8 June 1968. Extensive quotes from Lee's response were carried in a *Guardian* report on the 14th. The matter was discussed inconclusively by the BFI Governors in July.
25 See Chapter 13.
26 Copies of the manifesto are to be found in various places in the BFI paper archive. The fullest source for this and other associated documents is BFI/19 and BFI/A-33. While *Time Out* was the main platform for the opposition, defenders of the BFI rallied around the *Listener*, where Clive James sprang to the defence of fellow Australian Bruce Beresford. For a fuller account of the 1970 crisis see Geoffrey Nowell-Smith, 'The 1970 crisis at the BFI and Its Aftermath', *Screen* 47:4, Winter 2006, pp. 453–9.
27 BFI/19.
28 BFI Governors Minutes, 21 July 1970.
29 BFI/Balcon/K-47.
30 Besides Hatton, they were: Stephen Dwoskin, Mark Forstater, Roger Graef (filmmakers), Peter Sainsbury, Nick Hart-Williams (The Other Cinema), Ian Cameron, V. F. Perkins, Peter Wollen, Phil Hardy, Claire Johnston, Jon Halliday, Ben Brewster, Nicholas Garnham and Geoffrey Nowell-Smith. Cameron and Perkins were founder-editors of *Movie*. Halliday and Brewster were on the board of *New Left Review*, as was Wollen.

7

The view from outside London

Melanie Selfe

Between 1960 and 1980 regional exhibition became a key area of the BFI's activities. The 1960s saw the notion of 'provinces' replaced by a growth in regional consciousness, and the 1964 Labour victory heralded considerably more funds for cultural projects beyond the metropolis. In 1966 the BFI launched the Regional Film Theatre Programme, and, as has been discussed in this volume and elsewhere, the nature of the RFTs became a source of conflict for the BFI throughout the 1970s. Given the form that the RFTs took, a battle was inevitable. The late 1960s was an exciting period of change and conflict for British film culture, and this was not confined to London. In 1969 the *Glasgow Herald*'s film correspondent reported that the 'cataclysmic' rebirth of the Edinburgh Film Festival had created 'deep fissures between the old guard and the new', but she welcomed the 'seriousness' of the new ideas, and praised the festival director, Murray Grigor, for transforming the event into 'a bubbling crucible' that was setting the London Film Festival agenda.[1] As the 1970s dawned, widespread local shake-ups in film thought were afoot, as many 16mm film societies in cities and universities around the UK began to develop more aesthetically adventurous and politically conscious agendas. However, the growing number of regional film theatres did not really reflect the newer approaches or the debates surrounding them. Instead, the RFTs continued to embody an older style of film culture: humanist, pointedly apolitical and firmly rooted in the values of a postwar film society movement whose luminaries were often well represented on the local governing committees.

The reasons for this were complex, and this chapter aims to explore the factors which delimited the scope and ambition of the RFTs. To this end, it considers various elements – national, local and often very practical – that fed into the BFI's regional offer and its nationwide reception. For each RFT established or attempted, the BFI's shifting regional policy connected with local circumstance. The cultural agendas of local film enthusiasts and politicians, the spectrum of commercial film exhibition within the area, and the availability of venues and audiences all played their parts. In combination, these shaped both the versions of the cinema that

could be 'housed' by the RFT scheme and much of the discursive terrain for the debates that followed.

The view from Whitehall

Funding and government policy were always key external factors limiting the BFI's regional activities. The War had roughly propelled a variety of cultural provision across the UK, but in the postwar era this was not capitalised on. Firstly though a lack of funds and then (following the 1951 Conservative victory) as a matter of policy, the position was rapidly retrenched; by 1956 the Arts Council had closed its regional offices, adopting a 'few, but roses' agenda.[2] The BFI did not fall within the old 'arts', but in order to justify its status and funding it also came under pressure to lead from the centre. Although the Radcliffe Committee had proposed that the Institute should ideally open provincial offices in order to extend its influence 'outside London [...] where there is often an unwillingness to be guided from the metropolis',[3] the funds to do so were not forthcoming, and in practice the ways in which this paternalistic aim could be achieved were heavily restricted by government attitudes throughout the 1950s.

Under Denis Forman's leadership, the Institute began to develop a greater sense of the need to serve as well as shape the UK specialist scene. With the opening of the NFT in 1952, the discrepancy between the level of services being offered within the metropolis and elsewhere in the country became acutely visible. This was acknowledged internally in 1953, when Forman investigated the possibility of screening NFT programmes in the provinces.[4] In this first consideration of exhibition beyond London, the focus was on good-quality venues. Approaches were made to a purpose-built, commercial specialist cinema in Glasgow and an arts theatre in Cambridge. Five years later, with James Quinn at the helm and the old head of film appreciation and distribution, Stanley Reed, now in the role of secretary, tentative and confidential enquiries were made about the possibility of setting up NFT 'branches'. This time the BFI's priorities had begun to shift; the potential partners not only had auditoria, they also had established educational interests in the cinema and track records in screening repertory seasons.[5]

The 1962/63 draft budget, which the BFI delivered to the Treasury in late 1961, contained a proposal to establish a provincial centre in 'the North'. From a base in Bradford or Leeds, the full-time regional officer's role would primarily be that of touring lecturer, but they would also work with local educators and film societies to develop film appreciation.[6] This three-year pilot project was framed as an attempt fulfil the recommendations of the Radcliffe Report and address concerns raised by the governors about the Institute's regional effectiveness, but it met with strong resistance at the Treasury.

In the absence of clear ministerial support for the BFI, the Treasury's attitude towards the Institute was parsimonious. Internal documents show that senior Treasury officials were highly critical of the organisation,[7] and this may have

influenced their response to specific funding requests. While there was support for the national endeavour of the Archive, both the Institute's administrative competence and the value of its educational work were questioned. Moreover, Reed was regarded with particular suspicion, characterised as a pernicious leftist influence and the driving force behind the new proposals.[8] This was not a climate in which regional expansion was possible.

The 1964 Labour victory greatly improved the position of the BFI, and particularly its regional ambitions. Jennie Lee was appointed as the UK's first arts minister, and responsibility for both the BFI and the Arts Council of Great Britain were moved from the Treasury to Lee's new location: the Department of Education and Science. In 1965 she produced the White Paper *A Policy for the Arts – The First Steps*.[9] This advocated providing nationwide access to 'the best' of the arts and culture: a shift in philosophy soon backed by significant new funding.

Lee never claimed expertise in any of the arts she aggressively sought money for, and her understanding of film culture seemed particularly thin. Nevertheless, her policy hand was still visible at the BFI in a number of ways. Not least of these was language. Over the course of the late 1960s the transformation of terminology that Lee had initiated with *A Policy for the Arts* gradually began to trickle through to the BFI, and 'regional' increasingly replaced 'provincial' within the Institute's internal and external communications.

Into the regions

When the BFI had imagined its regional role in the early 1960s, the emphasis was on strategic educational outreach. With money in hand and Lee's backing, the focus returned to exhibition. Lee envisaged cinema as one cultural facet within multi-purpose regional arts centres,[10] and consequently encouraged the Institute to develop relationships with local government, universities, arts trusts and theatres, and to strengthen its existing ties to the voluntary film exhibition sector.

As outgoing director, James Quinn's departing task in 1964/65 was to undertake a survey of 'quality film' exhibition outside the capital, culminating in a report, *Outside London*, which was published in October 1965. In March 1965 an annual grant of £184,000 had been announced, but, of this, only £11,000 was specifically earmarked for regional expansion.[11] Quinn's enquiries had made it clear that, if regional interest in RFTs were to transform into real projects, the BFI would need to be able to provide substantial financial assistance to local authorities, as the Arts Council could.[12] The Institute pressed its case with the government and soon won its fight to award grants for capital costs, always with the proviso that the funding was matched at local level. The annual allocation for new regional projects rose rapidly until 1970, when a regular £100,000 for the capital costs of 'Housing the Cinema' was instituted. Although this did not increase again until 1979,[13] other budgets, which went towards guarantees against loss, running costs and services for the existing RFTs, continued to rise, and there was new money for regional

film production. This meant that the proportion of BFI funds spent in the regions continued to grow.

The BFI's first impulse was to pursue ventures in major conurbations including Birmingham, Manchester and Glasgow, but Quinn's tour had stimulated interest beyond the nine locations initially explored. Requests came in not only from university towns like Hull and York but also from smaller and/or far–flung locations: Plymouth, St Austell and Newport.[14] The flow of money was initially slow, never adequate, and rising inflation soon eroded the real value of the static 'Housing the Cinema' fund. When combined with the requirement for local match funding and the more complex political landscapes of large cities, this made the preferred purpose-built projects and larger urban developments almost impossible to achieve.

The Institute's response was probably largely pragmatic, but it was justified in terms of principle; the BFI would stimulate local action, responding to existing interest and opportunity rather than imposing 'bureaucratic *diktat* from London'.[15] The common ingredients which would see a project brought smoothly to fruition were as follows: a modest budget, a cultural venue or building project requiring minimal modification, a co-operative local council, and someone on the ground with enough commitment and local knowledge to steer the project through. This was a strategy that saw many small RFTs flower in unlikely locations, whilst the prize regional roses that the BFI truly desired struggled to take root in the big cities.

With John Huntley appointed as regional controller, three 'experimental' RFTs were trialled in the summer of 1966 (Aldeburgh, Brighton and Malvern). The first

7.1 The Nottingham Film Theatre, the first of the Regional Film Theatres, opened in September 1966 in the Nottingham Co-operative Education Centre

permanent RFT opened in the Nottingham Co-operative Education Centre on 22 September 1966,[16] closely followed by Aldeburgh, Bristol (on a membership-only basis), Norwich and Middlesbrough in October. These operated on a part-time basis, establishing the one-week-per-month screening pattern that the majority of RFTs would follow.[17] Growth was rapid: by the start of 1967 over fifty locations had expressed an interest in the scheme, and by the end of the same year there were 15 RFTs in operation.[18] By the time *The BFI in the Regions* report went to press in 1971, the active number had risen to 36 – two more than the maximum number agreed by the governors in the late 1960s.[19] Numbers continued to increase to a peak of nearly fifty in 1976.

As the numbers multiplied so did the operational models and types of venue.[20] Two established film theatres in Bradford and Belfast came under the BFI umbrella and new part-time RFTs were established in live theatre spaces (including Newport, Leeds, Leatherhead, Bolton, Derby and Torrington), public libraries (including Sheffield, Hull and Luton), and universities and colleges (including Southampton, Exeter, York, Reading, Canterbury, Cardiff, and, in the case of Grimsby, a comprehensive school). Many more were incorporated within local arts centres and civic halls (including Basildon, Croydon, King's Lynn, Stirling, Leamington Spa and Elstree). In Dartington Hall and St Albans, local councils and film societies collaborated to screen films one day per week. On a smaller scale again, film societies in Dynevor Castle, Petworth, St Austell and Street were awarded 'aided film society' status, enabling them to open some of their screenings to non-members. In addition, there were a number of film festivals, and short-term projects.

Comparatively few RFTs were housed in cinemas but these included the most problematic ventures, the three full-time operations. Manchester was the first, opening in October 1967. It operated in an old News Theatre owned by the Jacey chain and was run by an independent committee until its financial collapse in July 1973. Tyneside (Newcastle) and Brighton followed, both run directly from London by the BFI. Reed had optimistically argued that direct programming of RFTs could result in reduced workload for the Institute, increased admissions and greater revenue,[21] but these experiments in centralisation rapidly became a financial liability.

A variety of local factors contributed to the rapid proliferation of RFTs, but the spectacular postwar decline in cinemagoing lay at the root of most of them. In the two decades since the end of the war, the whole landscape of cinema exhibition in the UK had radically altered, and, as Barry Doyle has explored, it had not done so evenly. Neither falls in attendance nor the many waves of cinema closures affected the country uniformly, and by the mid-1960s London had lost only 40 per cent of its cinemas against a UK average of more than 50 per cent, and losses in the North of England (which had more screens per head, but fewer super-cinemas suitable for subdivision) upwards of 60 per cent.[22] By 1965 many smaller locations faced the prospect of no commercial cinema provision at all, and some local councils were already beginning to consider civic subsidy as a way to preserve access to the big screen.[23]

The view from outside London

7.2 Map of the network of Regional Film Theatres from BFI Outlook (1968) showing 15 theatres already open (black) and a further 40 or so optimistically projected for the near future (shaded)

The idea of an art-house circuit had gained some currency by the mid 1960s,[24] but collaboration between Leslie Grade and Gala's Kenneth Rive failed to produce the mooted fifty-strong 'well-heeled' art-cinema chain.[25] In 1971, following his resignation from the Institute's Education Department, Alan Lovell accused the BFI of basing the RFT programme on a foolish conceit: the desire to create a kind of 'high quality circuit', screening 'good films' which would coax audiences back into the cinema. But where the part-time operations were merely thought to lack conceptual ambition – 'essentially small-scale experiments, risking little and gaining little [...] achieving little more than film societies did on the basis of voluntary effort'[26] – the full-time operations began to be seen by Lovell and others (including the Members Action Committee) as a serious financial drain, starving the BFI's other core activities – such as educational development and film-making support – of vital funds and attention.

The judgement that the RFTs did not constitute film policy progress was fair. Writing in the film society magazine *Film*, Alan Howden accurately predicted that culture-conscious councils would see them as low-cost, high-prestige investments.[27] Incorporating a film theatre could add extra facility and funding to existing plans

for a cultural venture, and authorities found ways to make the scheme work to their own local policy ends. As Stephen Woollock's work has shown, Humberside used its three RFTs to help project a common cultural identity across an unpopular new administrative region.[28] But the core of the problem was that RFTs were essentially a holding operation. Because they took their lead from motivated individuals at the local level, the Regional Film Theatres became a means to enshrine in subsidy one aspect of postwar film culture that felt itself to be seriously under threat.

Old alliances

Here it becomes necessary to acknowledge the interdependent relationship between the postwar film society movement and the BFI's 'old guard' of the 1950s and 1960s. With a broadly shared language and ethos, the BFI personnel of Reed and Huntley's generation regarded the film societies as their natural allies and advocates within the regions. Well-established local groups were routinely approached early in any RFT negotiation. Similarly, the film society movement had been firmly committed to the 'film appreciation' agenda for even longer than the BFI,[29] and local leaders considered themselves to be the ones already doing the work at regional level. Film societies frequently provided the local initiative, and, as their committees were usually peppered with the regional 'great and the good', their connections to local councils and universities could be of real value.

However, film societies had been struggling to maintain service, programme quality and membership for a number of years. Where in the early 1950s many groups had screened their choice of recent 35mm 'world cinema' in hired cinemas, by the mid-1960s this was rarely possible without assistance. The success of the movement had been a double-edged sword, paving the way for the widespread commercial exhibition of foreign film.[30] Initially, many film societies welcomed the development on principle; their aim had always been to improve availability by spearheading a cultural cinema movement. In local practice, however, it had difficult consequences. As many smaller, older cinemas and news theatres around the country specialised or diversified in order to survive, distributors woke up to a more lucrative outlet for foreign titles, and 'classic' reissues. Film societies were pushed to the back of the queue, as no distributor would consider renting to them if a film could be shown commercially within the same locale. Television screenings of classic and foreign films compounded the problem of programming.

Film societies responded reflexively, placing greater focus on experimental films, retrospectives and themed seasons,[31] but these films were less popular. As a result, pragmatism usually reigned: adventurous programming came to be viewed as gambling with an existing membership,[32] and was thus best left to newer 16mm groups, who had lighter running costs and were still in the process of building their identities.

The changing place of film societies within the local economies of cinema exhibition meant that established groups had to weigh their options carefully, balancing

the desire to advance their concept of cinema within the community against the potential loss of membership and local control. By late 1965 concerns were already being expressed within the movement that if the RFTs replaced creative local programming with 'pre-digested slabs of culture handed down from London' they would destroy the crucial sense of ownership that motivated voluntary workers.[33] As Richard MacDonald stresses in Chapter 5, film societies had never wished to be mere conduits for BFI policy, and many were reluctant to dissolve, just gifting a 'nucleus of members' to the new RFT. However, active participation within the RFTs became perhaps the most effective way for leaders of the older-style groups to achieve their aims. In both Nottingham and Manchester film society leaders were publicly credited by the BFI as the driving forces behind the local RFT,[34] but, although these individuals played key roles on the local programming committees, they did not initially merge their film societies into the theatres.

Although traditional film societies rarely survived long in the presence of an RFT, the membership schemes and 'members only' screenings offered by the majority of film theatres helped to preserve not only the access to uncertificated films enjoyed by film societies but also some sense of ownership and group identity.[35] However, by 1972 this was a cause for debate. Few films of 'quality' were still being refused certificates, and there were worries that that a membership model could send out the wrong messages; its inherent exclusivity perhaps did not promote the idea that RFTs were for everyone and, in light of a rise in 'members only' sex cinemas, there were fears that respectable audiences might confuse the two and steer clear.[36]

Sex and the serious filmgoer

In attempting to understand the BFI's regional strategy, and particularly some of its riskier financial decisions, it is helpful to pay closer attention to the issue of sex. By the mid-1960s, a form of commercial specialised exhibition had managed to emerge in larger towns and cities around the UK, but this was not the kind of respectable 'quality cinema' that the BFI and the film societies had tried to seed. Some of these commercial continentals had tried to cultivate a high-class image, but, as Leslie Halliwell found to his frustration in 1954, audiences generally preferred the dubbed prints to the ones with the 'writing on the bottom' and 'responded more readily to "X" certificates than to anything else'.[37] Before long most venues were relying on sex and sensational advertising in order to stay in business.

This conflation of sex and art created fundamental problems for serious film culture. Sex had always been a major selling point for continental films, and as British specialist film culture considered much of Hollywood's output to be infantile and/or exploitative, the comparative frankness of European films on matters of sex and relationships was warmly welcomed. However, this was always very judiciously presented. Film society programme notes and 'quality' reviews delicately managed any salacious potential, describing sexual themes in terms of their maturity, realism and psychological depth.

The spatial challenge to this carefully maintained semantic line had begun with the advent of the X certificate in 1951: a classification seen as thrusting respectable international films deemed mature in 'theme *and* treatment' together with the very worst of violent American thrillers and horror.[38] However, it was the rise of European-produced nudie and sexploitation films in the 1960s and 1970s – just at the point when the cinema that the serious audience valued was also becoming more explicit – that finally made this tension unmanageable, driving the desire for a separate art-house space and expediting the establishment of the RFTs. Whereas in central London dedicated art-house cinemas coexisted with sex and sensation venues, elsewhere the specialised cinemas fulfilled both functions, sometimes on the same bill.[39]

In his assessment of 'quality film' exhibition outside the capital,[40] Quinn had acknowledged that the London commercial cinemas had the advantage of a large cosmopolitan population to draw upon, but he none the less attributed most of their success to expert film choice. He then went on to suggest that the many failures of provincial specialist cinemas were largely of their own making:

> The disappearance from the scene of many independent cinemas is probably due in no small part to inconsistencies in programming policy. It is disconcerting for example to find oneself as happened during the course of this survey, confronted with a nudist short as a curtain-raiser to a film of the magnitude of Bergman's *The Silence*. Similarly, the uncertain image conveyed by a cinema which plays *Hiroshima mon Amour* one week and *It's a Bare Bare World* the next, is confusing to the patrons of both types of film.[41]

In *Sight and Sound* Ian Wright bemoaned the programming phenomenon of the Godard film 'yoked to a nudie',[42] and on the letters page C. McMurray argued that the Manchester Cinephone's lurid publicity was misleading everyone: 'The person who would appreciate and enjoy a well-made and intelligent film might be put off from seeing it, while the skin-flick addict will see it and presumably be bitterly disappointed.'[43] In these accounts the audience is repeatedly conceived as tripartite: the 'serious' audience and the 'dirty mac brigade' were presented as discrete groups forced into uncomfortable cohabitation, and, most worryingly, a larger body of potential viewers for 'quality' cinema was surely being alienated by the overlap.

Although the BFI's claim was that the RFTs would screen the kind of cultural cinema that the commercial sector could not profitably show, this was not entirely truthful. Their arguments about programme consistency and audience cultivation meant that they were keen to rescue individual films which were capable of performing perfectly well on the 'X and sex' circuit, and reposition them within a kind of cultural cinema *environment* that the market (with very few exceptions) could not support outside the West End. This, they suggested, would ultimately benefit the industry, by growing the regional audience to a size that would support 'quality' specialist programming on a commercial basis,[44] but difficult relationships with the Association of Independent Cinemas and various local Cinematograph Exhibitors Associations predictably ensued.[45]

Notably, the arguments for extending the number of full-time cinemas operating under the direct control of the BFI emerged in conjunction with the possibility of leasing three more cinemas (in Brighton, Birmingham and Liverpool) from the Jacey chain.[46] Where the cultural juxtapositions of a theatre or art centre were usually unproblematic, if RFTs were run within commercial cinemas on a part-time basis it was difficult to ensure that troubling 'inconsistencies' of programming and advertising (too salacious or too consumerist) did not occur in the other three weeks.[47] Occasionally a cinema could be a sympathetic culturally minded partner. In Norwich, the local arts trust who owned the host art cinema took their place on the RFT board, but the proposed relationships with Jacey were always purely tenant and landlord.

By January 1969 high losses at the directly run Tyneside RFT had caused the Liverpool and Birmingham plans to be abandoned, but the Brighton deal had reached the 'irrevocable' stage, and the board resolved to do what they could to limit the BFI's liability.[48] In Brighton the Institute had optimistically asserted that redecoration would help to remove the Jacey's 'somewhat sensational image' and that this would create a 'genuine' Brighton Film Theatre, 'full-time, well run, spruced-up' and able to 'instil something of the atmosphere which prevails in the National Film Theatre'.[49] How locally successful this rebranding was remains unclear, but in calling for an end to the BFI's 'half hearted sex and exploitation houses', just a few months after the Brighton opening, the Action Committee was perhaps aiming at a raw nerve.[50]

New priorities and shifting allegiances

Although the Members Action Committee had been unsuccessful in unseating the governors, its agenda for change soon began to have an impact. Following John Huntley's forced departure at the end of 1973, the unwieldy Film Services department was broken up. In the Regional Department, the former Northern Arts film officer Alan Knowles took charge of the practical organisation and funding issues. Meanwhile, Colin McArthur moved from the Education Department to tackle the various elements of film distribution, sales, booking and programming that now made up Film Availability Services. This combination created simultaneous pulls towards operational devolution and ideological centralisation, and, as McArthur's recent account of the era attests, the relationship between the FAS and the Regional Department was far from harmonious.[51] However, viewed across the decade both departments had significant and progressive impacts on regional film culture.

By 1974 the 'film appreciation' legacy that Paddy Whannel had inherited in 1960 had been replaced with a more theoretically rigorous education policy. This was no longer concerned with improving film taste. Instead it embraced a broader selection of films – the popular and the independent – and aimed to improve the quality of discourse about film. Through a series of structured film seasons, McArthur sought to embed these principles in the programming options offered to RFTs. He

proposed that seasons would be designed to spark 'key debates' and accompanied by 'appropriate critical documentation', but this approach, as laid out within *BFI News* in September 1974,[52] clashed predictably with regional desires for autonomy. The letters page erupted.

There were two real issues at stake for the regional writers. The first concerned the move away from 'quality' exhibition as a valid subsidised public service. In March 1975 a letter from the chairman of York Film Theatre, H. Liversidge, argued that, if regional programmers wished to keep their RFT both solvent and locally relevant, providing equality of access to 'the best of world cinema' should remain the priority.[53] Although educational programming was seen as desirable, subsidised screen-time was limited. In this context, the empty seats which all too often accompanied a structured season were viewed as more than just a financial liability; they evidenced a failure to serve a local population that did not have access to the full spectrum of films exhibited in London.

The second concern related to the nature of the 'film culture' that the BFI was attempting to foster. Although the regions were being invited to join the educationally centred 'key debates'– and some regional correspondents were very sympathetic to the new intellectual developments – there were also fears that these would be centrally determined.[54] Would the new model offer a real role in defining the criteria by which the medium should be valued and discussed? Would there still be a place for entertainment and pleasure?[55] Where McArthur had asked, 'What is the purpose of a Regional Film Theatre?' others, including the Yorkshire Arts film officer Nina Hibbin, wanted the BFI to a address a question that they considered more fundamental: 'What is regionality?'[56]

The BFI had begun to build working relationships with a number of Regional Arts Associations in the late 1960s,[57] and by 1974 the Institute had funded (or part-funded) six specialist film officers based at English RAAs.[58] These posts were to play a key role in the drive to create a more integrated vision of regional provision, incorporating exhibition, education, information and production.[59] In the mid-1970s a strategic decision was taken to devolve some of the funding and administration of the part-time RFTs to the RAAs, and in 1976 the Institute signalled that it would prefer those Arts Associations that had shown their commitment to the medium by appointing specialist film and television officers.[60] Willingness to appoint increased, although it took the Institute a few years to find sufficient funds for the new posts. By 1980 there were 13 film and television specialists covering England and Wales,[61] and considerably more BFI money reached regions via the RAAs than as direct grants to the RFTs. This allowed support for a far more flexible range of regional film projects.

The combination of regional devolution and new programming priorities necessitated a reconsideration of the purpose of the RFTs and their place within a more clearly differentiated spectrum of provision. As part of a more 'methodological approach' to evaluating requests for new RFT capital grants, the Institute proposed that resources should be focused on no 'more than six to eight' film

centres, with provision for exhibition, education and film-making, in key urban locations.[62] For part-time RFTs, the more frequent pattern of screening films on a few days each week had become more popular than the original one-week-per-month model, and, in cities and towns that could support it, existing RFTs began to move towards full-time status. By 1979, although the Manchester and Brighton RFTs had failed (and Newcastle had faltered before a relaunch) there were nine full-time film theatres.[63] However, there was also a greater sense of the need to take proper account of the local demand for specialist programming, and in smaller areas it was proposed that film societies, perhaps supported through the Regional Arts Associations, might be the most appropriate option.[64] The responsive funding mode had created a number of RFTs which were too populist, too technically limited or too constrained by their venues (for instance, theatres which used film as filler between live performances) to meet the stricter programming requirements, and following a review, the Institute divested itself of nine theatres (including Leatherhead, Horsham and Grays).[65]

In Birmingham the many attempts to create a permanent film theatre straddled the period of policy change, and this resulted in a shift in the local partnerships that the Institute wished to engage in.[66] By the mid-1970s the BFI was firmly reasserting the strategic importance of Birmingham.[67] This meant that, if an actual film centre was not achievable, then at least a substantial full-time operation, screening films in line with current policy, was required. In the absence of serious council investment, a partnership with the University of Aston seemed to offer the best way forward. Soon there were four parties involved in the negotiation, and as the BFI built relationships with West Midlands Arts (WMA), the progressive Birmingham Arts Lab and the University of Aston, their existing partner, the Midland Film Theatre – a limited company which Huntley had formed in conjunction with local film society leaders in 1967 – found itself increasingly left out in the cold.[68]

As well as the rehoused Birmingham Arts Lab, 1977 saw the launch of other BFI-funded exhibition projects. In Newcastle the Amber Films production group opened the 53-seat Side Cinema, and in Bristol the film programme functions of the Arnolfini and the Bristol Arts Centre were brought together as Eye to Eye, anticipating the development of the Watershed Film and TV Centre in 1982. These projects responded to a different kind of local film activity, often workshop-based and designed to foster a new cinema of 'social practice': integrating production, exhibition and debate-centred reception. Numerous BFI policy documents of the period stressed the need to engage with *active* regional partners, and these ventures evidenced fresh allegiances, forged between a new generation of BFI personnel and like-minded people in the regions.

By 1980 the BFI had begun to display a greater understanding of the diversity of subsidised exhibition and its financially precarious place within the regional landscape.[69] The large multifunctional auditoria used by most RFTs were unsuitable for more experimental screenings, and subsidies were simply too small to allow the box office to be ignored. Although the workshop model had begun to gain ground

in the late 1970s, cutbacks under the new Conservative government meant that subsidising two projects in one area was increasingly hard to justify, and progress on film centres that would be able to encompass both was slow.

Crucially, the new projects that emerged from the late 1970s onwards represented a move away from the monolithic 'national' branding of the RFTs. The concept of a state-subsidised chain, rolling out the metropolitan standard, belonged to the postwar era and had perhaps been outdated even in 1965. After two decades of regional consciousness, it was highly inappropriate. When fully fledged film centres such as the Watershed (Bristol), Cornerhouse (Manchester) and the Broadway (Nottingham) finally began to open in the 1980s, each carefully crafted its identity within the local cultural landscape.

Conclusion

With the RFTs the BFI had attempted to effect a cut-price cure for the perceived ills of regional exhibition, but the funding available was never enough to provide either a respectable 'quality' exhibition circuit for world cinema or a string of educationally focused spaces that could frame and facilitate experimental independent filmmaking. In the difficult exhibition climate of the late 1960s, the responsive model of RFT funding had given a lifeline to an aspect of the film society movement that was no longer viable. The RFTs perhaps encouraged 35mm film-society culture to ossify, and this was rightly a concern for the next generation of BFI policymakers. However, it should also be stressed that, within the local economies of cinema exhibition, the traditional style film theatres were fulfilling a valuable role, and their existence could stimulate the formation of new film societies, providing progressive local alternatives.[70]

Although they were born of the 'enthusiasm to get something going' rather than any clear policy,[71] the RFTs provided something to push against and to build upon. After decades of change it is remarkable how many of them are – in one form or another – still going, still the backbone of contemporary specialist exhibition and community-based film education in the UK.

Notes

1 Molly Plowright, 'A Year of Lost Opportunity for Glasgow', *Glasgow Herald*, 7 January 1970, p. 10. For an account of the battles over the direction of the festival see Matthew Lloyd, *How the Movie Brats Took Over Edinburgh: The Impact of Cinephilia on the Edinburgh International Film Festival, 1968–1980* (St Andrews: St Andrews University Press, 2011).

2 The furthest-flung 'rose' was in Stratford-upon-Avon. Jen Harvie, 'Nationalizing the Creative Industries', *Contemporary Theatre Review* 13:1, 2003, 15–32 (pp. 17–18).

3 Sir C. J. Radcliffe, chairman, Committee of the Enquiry into the Future of the British Film Institute, *The Report of the Committee on the British Film Institute* (London: HMSO, 1948), p. 8.

4 BFI Executive Committee, notes on meeting, 20 April 1953.

5 I have so far found evidence for 1958 approaches to the Scottish Film Council and the Nottingham Co-operative Society.
6 NA/T218/513, BFI Budget 1962/1963 (draft), 13 December 1961, p. 8.
7 See for example NA/T218/513, R. C. Griffiths, letter to Sir Roland Harris, 8 January 1962. Here, as elsewhere, many of the harshest criticisms seem to originate from Griffiths's deputy, Mary Loughnane. These views recur across a range of internal documents, and even framed official advice about the BFI supplied to other departments. See for example, NA/FO593/2151, minutes by D. M. Summerhaze, 18 June 1963.
8 This assessment of Reed's politics may have been seeded, or at least compounded, by Rank executive and BFI board member John Davis in a discussion with head of Treasury Arts and Sciences, Richard Griffiths. NA/T218/513, Griffiths's notes for the record, 7 July 1961.
9 This was actually produced during Lee's short spell at the Ministry for Public Buildings and Works.
10 See report on Lee's press conference, 'Govt. Raises BFI Grant – and More Money for the "Arts"', *Kinematograph Weekly*, 4 March 1965, p. 16.
11 *Kinematograph Weekly*, 4 February 1965, p. 6; 4 March 1965, p. 16.
12 See particularly BFI Governors Minutes, 5 July 1965 and 9 September 1965.
13 See *BFI Annual Reports* 1979, p. 17, and 1980, p. 17.
14 BFI Governors Minutes, 31 May 1965.
15 BFI, *A Report 1965*, p. 15.
16 For an account of the local film society politics which led to Nottingham being the first RFT see Melanie Selfe, '"Doing the work of the NFT in Nottingham" – or How to Use the BFI to Beat the Communist Threat in Your Local Film Society', *Journal of British Cinema and Television* 4:1, 2007, pp. 80–101.
17 A less common model was to open for a couple of days each week, as in Exeter.
18 See BFI, *Outlook 1967*, p. 29, and *Outlook 1968*, p. 26. The reports were released in the January of the specified year.
19 BFI Governors Minutes, 9 September 1968.
20 The following information is primarily drawn from the BFI annual reports, and supplemented by trade press reports and various survey documents produced as part of regional funding bids for new RFTs.
21 BFI Governors Minutes, 6 May 1968.
22 Barry Doyle, 'The Geography of Cinemagoing in Great Britain', 1934–1994: a Comment', *Historical Journal of Film, Radio and Television* 23:1, 2003, pp. 59–71.
23 See, for example, report on Sedburgh, Yorkshire. 'Council Plans to Move into Exhibition', *Kinematograph Weekly*, 4 February 1965, p. 6.
24 Terrence Kelly, with Graham Norton and George Perry, *A Competitive Cinema* (London: Institute of Economic Affairs, 1966), pp. 112–16.
25 Ian Wright, 'In the Picture – Art Circuit', *Sight and Sound*, 35:2 (Spring 1966), p. 71.
26 Alan Lovell, 'The BFI and Film Education', *Screen*, 12:3, Autumn 1971, p. 20.
27 Alan Howden, 'Editorial: On the Brink', *Film*, 44, Winter 1965–66, p. 6.
28 Stephen Woollock, *'Coming to a Town Near You?': Cultural Policy and Geography in Local Art-House Exhibition*, unpublished PhD thesis, Norwich: University of East Anglia, 2010.
29 See Christophe Dupin, 'The Postwar Transformation of the British Film Institute', *Screen*, 47:4, 2006, pp. 443–51, and Melanie Selfe, *The Role of Film Societies in the Presentation and Mediation of 'Cultural' Film in Post-war Nottingham*, unpublished PhD thesis, Norwich: University of East Anglia, 2007, pp. 38–46.
30 In its 5 July 1956 issue *Kinematograph Weekly* included a Continental supplement and claimed that the number of provincial cinemas screening French films had risen

from 320 in 1950 to 1,200 in 1955. 'The Growing Influence of the Continental Film: European Product Has Created a New and Different Audience', p. 23.
31 The influential Scottish Federation of Film Societies had outlined this strategy of diversification in response to commercial provision in the late 1930s. 'Film Societies of Scotland: Growth of an Active Movement', *Scotsman*, 19 April 1938, p. 13.
32 For example, see how Dundee's experimental programming policy and subsequent closure is invoked as a cautionary tale, following a request for more experimental material in Glasgow. Scottish Screen Archive, 3/1/38. Glasgow Film Society, minutes, 6 May 1964.
33 Howden, 'Editorial: On the brink'.
34 BFI, *Outlook 1968*, pp. 26, 40.
35 In 1972, 23 RFTs operated membership schemes, 12 did not, and two were forced to operate on a purely members-only basis as a result of local legislation. V&A Archive, ACGB/112/148, Barrie Wood and Richard Rhodes, Membership: a paper presented for discussion at the Regional Conference, York, 26 March 1972 (bound in conference proceedings), p. 1.
36 V&A, ACGB/112/148, Wood and Rhodes, pp. 1–2.
37 'Strictly for Eggheads: Thoughts on Running a Specialised Hall', *Sight and Sound* 23:4, April–June 1954, p. 201.
38 'Report on the "X"', *Sight and Sound* 23:4, January–March 1954, p. 124. See also *Film* 4, March 1955, p. 28.
39 For an account of widely differing audience recollections of one such venue (the Moulin Rouge, Nottingham, 1960–70), see Mark Jancovich, with Lucy Faire and Sarah Stubbings, *The Place of the Audience: Cultural Geographies of Film Consumption* (London: BFI, 2003), pp. 173–4.
40 BFI, *Outside London* (London: BFI, 1965).
41 Ibid., p. 8.
42 Wright, 'In the Picture – Art Circuit', p. 71.
43 C. McMurray, letter of complaint about the Manchester Cinephone: 'Correspondence – Deep End', *Sight and Sound* 41:1, Winter 1971/72, p. 56.
44 For instance Reed's comments in BFI Governors Minutes, 3 April 1967.
45 See, for instance, local exhibitor Robert Freeman (Hull) regarding zoning: 'Letters – The Laughable State of the BFI', *Cinema TV Today* (3 June 1972), p. 10, and a report of AIC complaint to Arts minister: 'Unfair Competition Complaint to Eccles', *Cinema TV Today*, 17 June 1972, p. 2. Films with commercial appeal and literary sources could be another point of dispute: 'Regional Theatre Policy Talks', *Kinematograph Weekly*, 20 March 1971, p. 18.
46 BFI Governors Minutes, 6 May 1968.
47 This logic regarding the 'two types of audience' and the problem of using cinemas on a part-time basis was only tentatively discussed. See comment from the DES assessor Ian Thom (deleted from the official account following the next meeting). BFI Governors Minutes, 6 March 1967.
48 BFI Governors Minutes, 6 January 1968. Negotiations with Jacey were reopened locally in Birmingham in 1971, following the collapse of the relationship with the Birmingham MAC, but this plan was quickly abandoned. See Birmingham City Archive, MS583/1, Midland Film Theatre Limited, Council of Management Minutes, 11 August 1971 and 21 January 1972.
49 This is drawn from two reports produced for the Brighton Entertainments and Publicity Committee by the Town Clerk, following communication with the BFI. One is dated 27 August 1968 and includes costings; the other is earlier but undated. East Sussex Record Office, D6/A1/196. For a BFI staffer's view of normal Jacey program-

The view from outside London

ming see Barrie Wood's account of the Manchester site's reversion to Jacey control (and the screening of *Super Dick*, 1971), following the closure of the RFT in July 1973. 'Outside London', *Films Illustrated* 3:29, November 1973, p. 188.

50 'Action Committee Calls for BFI Resignations', *Kinematograph Weekly*, 24 October 1970, p. 5.
51 Colin McArthur, 'Two Steps Forward, One Step Back: Cultural Struggle in the British Film Institute', *Journal of Popular British Cinema* 4, 2001, pp. 112–27.
52 Colin McArthur, 'Film Availability Services', *BFI News* 14, September 1974.
53 Letter from H. Liversidge, *BFI News* 16, March 1975. For a more detailed account of the regional programming battles at York RFT and elsewhere see Vincent Porter, 'Alternative Film Exhibition in the English Regions in the 1970s', in Paul Newland (ed.), *Don't Look Now. British Cinema in the 1970s* (Bristol: Intellect, 2010), pp. 59–70.
54 Support for McArthur came from the academic Tom Ryall (writing from Sheffield), *BFI News* 16, March 1975, and in a letter from Linda Woolf (who lived in the new Humberside region), *BFI News* 17, May 1975.
55 Letter from Nina Hibbin, *BFI News* 18, July 1975.
56 Hibbin, *BFI News*, 18 July 1975.
57 The initial approach came from Northern Arts in the late 1960s, prompting the BFI to consider the relationships it would be willing to enter into with other RAAs. See initial request, BFI Governors Minutes, 6 March 1967, and decision in principle (with Knowles noted as present), BFI Governors Minutes, 7 September 1968. More systematic meetings with the RAAs began in 1971: 'BFI Hosts Art Association', *Kinematograph Weekly*, 6 February 1971, p. 2.
58 *BFI Annual Report* 1976, p. 16.
59 'The Regions and the Future', *BFI News* 12, June 1974.
60 *BFI Annual Report* 1976, p. 15. This coincided with the devolution of substantial power from the Arts Council of England to the RAAs.
61 The appointing RAAs were Northern, North West, Greater London, Southern, Yorkshire, West Midlands, Welsh (Arts Council), Eastern, South Western, East Midlands, Lincolnshire and Humberside, Merseyside, and South East.
62 It should be noted that this idea had originated earlier. Although not realised until 1974, the SFC secured funding in 1969 to create a combined film centre and audio visual centre in Glasgow. See David Bruce, 'A New Venture in Scotland', *Audio Visual*, June 1974, pp. 58–9. Film centres had also been outlined as BFI policy under Reed's directorship: BFI, *Policy Report*, November 1971, p. 14.
63 *BFI News* 38, May 1979.
64 'The Regions and the Future'. In practice this could apply in large areas too. In the late 1970s and early 1980s it was an RAA-funded film society that presented BFI-style structured programming in Manchester.
65 *BFI Annual Report* 1977, p. 16.
66 Midland Film Theatre Trust Ltd. Minutes, reports and correspondence spanning 1965–1979 are held at Birmingham City Archive (BCA), MS583.
67 See BCA/MS583/6, letter from Keith Lucas to Ansell, 4 March 1974.
68 See BCA/MS583/6, letter from Dr Brian Ansell (a pharmacologist who had originally represented Birmingham Film Society and became the driving force in the MFT) to Professor William McWhinnie (University of Aston's new Pro-Vice Chancellor for Cultural and External Relations) for an account of this, 22 February 1976. This claim of official exclusion seems to be supported by the existence of 'off-the-record' updates to Ansell from old friends in the BFI (Bobby Brown) and the University of Aston (Peter Groves), all BCA/MS583/6.
69 Ian Christie, 'Regional Film Theatres: Towards a New Definition', in Rod Stoneman

and Hilary Thompson (eds), *The New Social Function of Cinema* (London: BFI, 1981), pp. 60–3. Also see Susan Feldman, *The British Film Institute and Regional Film Theatres: Developing a Profile of Subsidized Film Exhibition in Britain*, unpublished project, Arts Administration Studies, The City University, 1980. Extracts appear in Stoneman and Thompson, pp. 64–9.

70 For example, in 1972 frustration with the Nottingham Film Theatre led John Clarke and the selection committee member Martin Parnell to create the Peachy Street Flick film club as a politically and socially engaged alternative cinema space. Paul Stanway, 'Participation Will Be Key Factor', *Nottingham Guardian Journal*, 30 September 1972. This venture was short lived, but recognised by Alan Fountain as a forerunner of the BFI-funded workshop-based New Cinema. 'New Cinema, Nottingham', in Stoneman and Thompson, *The New Social Function of Cinema*, pp. 143–8.

71 'The Regions and the Future'.

8

Paddy Whannel and BFI Education

Terry Bolas

> Many of this book's ideas first took shape in debates with comrades in the early film education movement that was nurtured by the BFI's Education Department. I am grateful to them all – they are too numerous to detail but know who they are – and trust they understand my dedication in memory of Paddy Whannel is meant to acknowledge a larger debt to that era and to the polemics and pow-wows that we shared.
>
> Jim Kitses, Deputy Head of the British Film Institute Education Department 1967–69, quoted from the Acknowledgements in his book, *Horizons West* (2004)

In 1957 when Paddy Whannel joined the British Film Institute he was appointed to its Film Appreciation and Distribution Department.[1] When he resigned in 1971 he relinquished the post of head of the Education Department which was then redesignated Education Advisory Service. Contained within the fourteen years that Whannel spent at the BFI was the first key period in the evolution of film study in Britain. It was dominated by the relationship between Whannel and Stanley Reed, the latter having been appointed as the BFI's first Film Appreciation Officer in 1950. Reed subsequently became Secretary in 1956 and then Director of the Institute in 1964. Both men had been teachers in secondary modern schools and this was the shared pedigree that each brought to the Institute.

When Whannel died suddenly in 1980 he was in the UK on sabbatical from his teaching post at Northwestern University in the USA.[2] Reed, having retired from the BFI in 1972, had returned to teach part-time in a school in London's East End.[3] Their respective teaching destinations post-BFI provide an insight into what had become by the late 1960s their very different attitudes to the educational priorities of the Institute. A decade earlier Reed and Whannel had maintained a very productive collaborative partnership. By the late 1960s – as the quotation from Kitses's book endorses – Whannel had achieved something still acknowledged as very memorable some forty years later. These were the years of the Education Department.

Soon after Reed joined the BFI in 1950, he was – along with others – involved in the setting-up of the Society of Film Teachers (SFT), an organisation aiming to recruit as members teachers in primary and secondary schools together with

representatives of teacher training colleges.[4] Very influential in the early years of SFT were those who had been involved in the postwar emergency teacher training programme, aimed at returning ex-service personnel. Some SFT enthusiasts had been college lecturers, others their students. Although not involved with SFT initially, Whannel was emergency-trained – at Alnwick College in Northumberland. His immediate predecessor as Film Appreciation Officer had been Tony Hodgkinson, a founder member of SFT and also emergency trained. During the 1950s, when the Film Appreciation and Distribution Department had consisted of Reed, staff lecturer (John Huntley) and secretary (Molly Lloyd), SFT had been an important adjunct to the BFI, providing publications and enthusiastic speakers or lecturers who shared the load of promoting film appreciation.

Reed had been an energetic film appreciation officer, writing prolifically in the numerous photographic, cinema and visual educational journals that persisted from the postwar period.[5] His appointment had had strategic significance in that 1950 was the year of publication of what became known as the Wheare Report: the government report on Children and the Cinema.[6] Given the dual task of considering both the categories of film censorship and the activities of the children's cinema clubs, usually held on Saturday mornings, the report did give a somewhat hesitant official blessing to the teaching of film appreciation to children, albeit in extra- curricular conditions. More significantly it acknowledged that such teaching would require teachers who had been specifically trained to do this. Despite protests from the BFI Governors, the Institute had not been allocated representation on the Committee itself, though it did submit evidence.[7] Reed had also given evidence as a London teacher.[8]

Once at the BFI, Reed developed a strategy cited in the Wheare Report and introduced *Film Guide*, a monthly poster to which schools might subscribe.[9] The *Guide* was designed to refer to successive waves of film releases, so that students might connect their own film viewing in the local cinema with background information about the films they routinely saw. The wall-chart was a familiar form of visual aid in the 1950s and, by producing a regular chart anticipating popular films, *Film Guide* did indicate to children an implicit acceptance of 'their' cinema as an approved venue. A significant development of the *Guide* came with the addition of a tear-off strip intended for the teacher which was to be removed before the poster went up on the classroom wall. The amalgamation of these strips would have provided some teachers with their earliest formal introduction to film appreciation. Production of the poster continued until the early 1960s.

The Film Appreciation Department had two regular points of contact with those who wanted to become involved with the study of film. In conjunction with the University of London Extra Mural Department, the BFI offered a Certificate in Film for those who could attend metropolitan evening classes.[10] More widely accessible were the annual residential BFI Summer Schools, held outside London. A pattern also developed of having a shorter spring course for teachers in London. Whannel as the new officer from 1957 began to take responsibility for the Summer

Paddy Whannel and BFI Education

School and to contribute to the evening classes. In so doing he was supplementing the contribution of John Huntley, who became head of the Education Department – a rebranding of the Film Appreciation and Distribution Department, in which Whannel was styled Education Officer. The term 'Film Appreciation' was no longer considered an adequate description for what the Department did.[11]

Whereas Reed on appointment had begun to promote the work of the new department by lecturing and writing about introducing film appreciation and film-making into schools, Whannel took a very different approach.[12] He sought to encourage debates around popular culture and to question the teaching of 'taste'. Reed's outlets had been visual education and photographic journals; Whannel aimed to get published in the wider educational press. Their approaches to the presentation of film criticism were very different. Reed had set up *Critics' Choice* which was published as a regular summary of the responses of leading London newspaper critics to current film releases, gleaned while they lunched at the BFI's expense. It was distributed to BFI members as an insert in the National Film Theatre programme. For Whannel the accolade of critic was not merited in such circumstances; he was always scrupulous in referring to those who wrote for the daily or weekly press as 'film reviewers'.[13] For Whannel a critic was someone of the calibre of F. R. Leavis.

8.1 Paddy Whannel lecturing at the Eastbourne BFI Summer School in 1957

In the late 1950s both Whannel and Reed became involved, along with other mostly London-based educational organisations, in an umbrella body, the Joint Council for Education through Art, which aimed to promote the importance of the arts within 'general education'. JCEA events included major conferences and a sequence of four smaller-scale forums which anticipated the issues that would preoccupy the 1960 National Union of Teachers' conference (see below). The first Forum was 'The Artist, the Critic and the Teacher', linked as 'allies in a common struggle'.[14] The nature of the struggle is revealed:

> Art that is the cultivation of a private sensibility and criticism, that is a following of fashion rather than a revelation of truth, leaves the teacher isolated in a world in which the mass media seem to represent a threat rather than a challenge and opportunity, and in which the traditional values of a liberal education seems as inadequate as a culture based on snobbery.[15]

This statement was consistent with the stance that Whannel had been taking in the numerous magazine and newspaper articles that he was writing at the time.[16] A pamphlet based on the papers given by the Forum's speakers was edited by Whannel.[17] The most substantial of these Joint Council events was the final '8-day forum' entitled 'The Visual Persuaders' held at the National Film Theatre in May 1959 with a programme 'prepared by the Institute's Education Department and the Society of Film Teachers'.[18] This forum continued the notion that a collaborative engagement of artists, critics and teachers would be productive in exploring how the visual media might be addressed in education. Credit for organising the event was given to Whannel and Tony Higgins.[19] The choice of speakers reveals the former's determination to connect the BFI's educational work with the social, cultural and intellectual debates of the day. Reed as BFI secretary controlled the NFT at this time and it would have been his decision to commit the venue for this extended engagement.[20] This was also a period when the BFI participated actively in international conferences on children and films, collaborating with SFT on the London-based event 'Film, Television and the Child' at the NFT in October 1958. Where Whannel would become the home-based proponent of film education in the UK, at international events Reed was the speaker, though he was noticeably shifting from lecturing on 'film appreciation' to promoting 'film teaching'.[21]

In 1960 Ian Cameron and Victor Perkins of *Oxford Opinion* were engaged in a dispute about critical methodology with the Editors of *Sight and Sound* and *Monthly Film Bulletin* – Penelope Houston and Peter John Dyer.[22] Such was the vigour of the debate that the London Film Society set up an event where the opposing camps might confront each other.[23] However on the night Cameron and Perkins found themselves facing not the editors of the two BFI journals but, instead, Whannel and Alan Lovell representing the Education Department. Lovell can barely recall the occasion, but Perkins is clear that the event was not the confrontation they had anticipated when the future *Movie* Editors had selected Samuel Fuller's *Pickup on South Street* for screening and subsequent discussion.[24] This choice, the merits of which would have been disputed by Houston and Dyer, did not have a similar

impact on Whannel and Lovell, whose critical enthusiasms were certainly closer to those of *Oxford Opinion* than they were to those of their BFI editorial colleagues. The significance of Whannel's appearance on this occasion was the demonstration it provides of his readiness to take opportunities to move the Education Department from being a schools' support agency to an activist engagement with the beginnings of the academic study of film. How he and Lovell found themselves with the chance to understudy their journalist colleagues remains a mystery.

Following the Institute's collaboration with the Joint Council was its involvement with the National Union of Teachers' conference 'Popular Culture and Personal Responsibility' in October 1960. Whannel and Reed both shared a strong commitment to the enterprise as members of the Union. Reed had assisted the NUT in the setting-up of its films *I Want to Go to School* and *Our School*. With this established connection the Union's recently appointed Publicity Officer, Fred Jarvis, again approached the BFI for help with the conference organisation.[25] Jarvis has acknowledged the importance of the Institute's help. Whannel instanced that the BFI had been 'intimately concerned with the preparation for the conference' when he subsequently provided evidence to the Ministry of Education to support the case for it to fund the Department.[26] There was a 'BFI connection' with several of the speakers at the conference. They included the sometime BFI Governors Cecil King and Norman Collins, Lecture Panel regular Brian Groombridge and former NFT employee Karel Reisz. In what was the Film section of the conference, Whannel ceded priority to presentations by two teachers who were key officers in the Society for Education in Film and Television (SEFT), the name which the Society of Film Teachers had adopted in 1959.[27] They were the only teachers to address the conference.[28]

The challenge for the organisers was to provide a context and a structure which would prevent the conference from becoming an occasion dominated by those who opposed the notion that popular culture might be studied seriously. The NUT precedent was not good. In 1955 the Union had, rather late in the day, become involved with the anti-horror-comic campaign which had resulted in legislation in the form of the Children and Young Persons (Harmful Publications) Act.[29] The Home Secretary R. A. Butler's opening speech on this occasion contained the possibility of his introducing further legislation in order to address what some in the audience might have perceived to be a comparable menace.[30] Whannel had to intervene and modify the programme on at least one occasion to prevent the event from developing a very negative tone.[31] In part the problem was that although this was an NUT conference the audience contained almost no teachers; instead the determined representatives of civil society were out in force.

The NUT funded the taking of a verbatim record of the three-day event. The existence of this document and the detailed resource it provides ensured that 'Popular Culture and Personal Responsibility' would acquire seminal status and feed into numerous books.[32] For the Union the most significant would be the account it published prepared by Whannel's ally, Brian Groombridge.[33] He assid-

8.2 From left to right on the panel, Brian Groombridge (University of London Extra-Mural Department), Paddy Whannel, John Huntley, the film director Lindsay Anderson, and the *Universities and Left Review* editor Stuart Hall at the Hoddesdon BFI Summer School in 1958.

uously dissected the detailed record and constructed an account that provided a more sympathetic and positive introduction to the educational issues around popular culture than would have seemed possible to many who actually attended the conference.

Probably the most significant of the subsequent books for those teachers who were interested in popular culture was *The Popular Arts* by Whannel and Stuart Hall. It is a book of two distinct halves. The first deploys a Leavisite critical stance in considering popular culture, territory to which Leavis would never have made favourable reference; the remainder of the book provides detailed listings of, and commentaries on, materials then available for teachers. It was the potential appeal of these comprehensive listings, rather than the case for taking seriously the popular arts, that convinced Hutchinson to publish the book.[34] Part of the authors' argument is that there needs to be an institutional base within which a serious study can commence. They identify the need for 'a permanent study laboratory'.[35] In practice Whannel in his Education Department and Hall in the Birmingham Centre for Contemporary Cultural Studies would each begin to realise this ambition.

When making the case in March 1963 for direct funding of the Education Department by the Ministry of Education, Whannel felt it essential to distinguish what his department did from the broader educational aims of the Institute as a whole, which might for example be delivered by the Library or the journals.[36]

He identifies the educational contribution of other departments as 'marginal' to the work of his department, which 'is directly educational and which is staffed by qualified educationalists'.[37] The directly educational work is however shared with SEFT and a clear demarcation of responsibility may be discerned:

> A satisfactory working arrangement to avoid overlapping exists between the Institute and the Society, whereby the latter works mainly with schools, leaving the Institute to work with universities, Institutes of Education, Training Colleges, Technical Colleges, Schools of Art, etc., as well as with Local Education Authorities and in Adult Education.[38]

Although Whannel begins his list with reference to universities, in practice this would be the most difficult sector with which he tried to engage and for much of his time in the Department it would be teacher training colleges where most progress within higher education would be made. 'The Department,' he explains, 'concentrates on particular areas of education (teacher training is a good example) where its work is likely to have the maximum long term effect by "spreading outwards".'[39]

By 1960 Whannel was heading the Department and was then joined by Peter Harcourt. They undertook the bulk of the lecturing for the extra-mural classes and the delivery of the Summer School. Though part-time lecturers were engaged to supplement this provision, Whannel admitted to a problem with quality control:

> while there are always plenty of would-be lecturers clamouring for work, very few of them are any good. In fact, although the panel comprises some forty names, only about half a dozen of them are entrusted with more than the occasional lecture.[40]

Consequently not only did he and Harcourt provide for the regular departmental lecturing commitment, they were also involved in delivering one-off lectures and courses elsewhere. When Roy Shaw wanted to develop film study within the extra-mural provision at Keele, his lecturers had to come from London.[41] With Whannel and Harcourt heavily involved in such work, time available for other educational tasks was eroded.

These tasks were detailed in Whannel's letter to the Ministry. There was the specialist and time-consuming business of negotiating with distributors both for certain feature films to be in distribution and for study extracts and units to be made available. This selection of materials for study implied there was a body of scholarship which might direct the selection process. But Whannel had to concede that there was little scholarship available. Whilst originating and publishing works of scholarship was fundamental to Whannel's conception of his Department's role, it was one that would bring him into conflict with some members of the Institute's board of governors. He writes revealingly to the Ministry:

> What is required immediately is some free time for its lecturing staff so that they may work in what might approximate to academic conditions and the freeing of at least one member of staff to concentrate entirely on research and lecturing.[42]

Here Whannel hints at the Department simulating conditions to be found in the university sector. This would be an argument he would develop in subsequent

years. It would not be appreciated by a board of governors drawn mainly from the film industry.

Underlying these concerns was the issue of money. Both he and Reed acknowledged that the 8 per cent of the Institute's allocation that the Education Department received was wholly inadequate.[43] The BFI was funded by the Treasury. The Reed/Whannel strategy was to argue for direct funding of the Department from the Ministry of Education. While political change in 1964 would ensure that the BFI eventually gained a sympathetic hearing, the timing of this approach was well chosen. A committee had been investigating the appropriate curriculum provision for the less able half of the secondary school population as the school leaving age was set to rise to 16. The BFI had submitted evidence to the Committee and was anticipating the Report's publication in August 1963.[44] When it appeared, the 'Newsom Report' pronounced very positively in favour of film and television teaching; it is possible the Institute had some advance information to this effect. One Committee member was F. D. Flower, principal of Kingsway Day College, where film teaching was well established with extensive BFI Education Department support and collaboration.[45]

Whannel saw the need additionally to get 'official' recognition from the Ministry:

> We feel the need to consult more frequently and in a recognised way with the Ministry and would like to feel that someone at a suitable level is informed about our educational work and takes a direct interest in it.[46]

His next request was for 'a Ministry pamphlet in this field'.[47] However there was one area where support would be crucial: Ministry recognition for a one-year full-time secondment course for 'practising teachers and lecturers with previous substantial experience'.[48] Whannel was only too aware just how few teachers there were who had competence in teaching film. The evening classes and the Summer Schools proved there would be candidates for such a course. Whannel had then to define for the Ministry's benefit the kind of study that was envisaged for these seconded teachers. The term 'film appreciation' still had wide currency, though it had always lacked adequate definition. The influence of Leavis had been substantial and it was likely to be in evidence among Ministry civil servants, so 'appreciation' was connected to 'discrimination'. Whannel integrated these concepts in outlining his proposed course. Where he is in no doubt is in defining the object of study:

> The main emphasis would be on the cinema, as film, having developed into a fully expressive art form, offers both the most substantial body of work and the opportunity for the kind of positive appreciation that is particularly essential with young people.
> One product of the work would in fact be a clearer idea of how discrimination can best be taught and this might lead to a publication.[49]

The first substantial publication of Whannel's Education Department was delayed through lack of funds until 1964 when *Film Teaching* appeared. Edited by Whannel and Harcourt, it focused on teaching film outside the school sector, where it might be considered as part of 'general cultural education'.[50] By describing the work

> **BRITISH FILM INSTITUTE**
> **EDUCATION DEPARTMENT**
>
> 1st. FLOOR. ENQUIRIES · A. RICHARDSON
> LECTURE SERVICE: Miss. LLOYD
> 2nd. FLOOR. P. WOLLEN. V. PERKINS. A. LOVELL
> Miss BENNETT. J. KITSES
> 3rd. FLOOR. P. WHANNEL.
> Mrs. BROCK

8.3 Signboard at the BFI Education Department office at 70 Old Compton St, London W1, c. 1967

done with mostly adult students, the authors distinguish between the practices of reviewing and of criticism when they make the case for film study. Their 'Introduction' reflects just how little written material was available for the prospective film teacher or lecturer to access. Given how firmly established film study has become, it is important to acknowledge that four decades ago the BFI Education Department could legitimately pronounce that 'at present, virtually no-one is able to devote his whole time to serious film study'.[51]

By January 1967, just four years after Whannel's request to the Ministry, the Education Department was transformed. It had been based since early 1965 in a suite of rooms at 70 Old Compton St with projection and Steenbeck viewing facilities. Jim Kitses had replaced Harcourt and was now deputy head of department. Peter Wollen, who had, under the pseudonym of Lee Russell, followed Whannel as the film critic of *New Left Review*, was Editor of Publications. Alan Lovell was Editor of Film Materials. There were two Teacher Advisers: Victor Perkins (who was also an editor of *Movie*) and Alex Richardson who combined BFI duties with his role as secretary of the Society for Education in Film and Television.[52] This BFI/SEFT joint appointment had taken effect from the start of 1967; it would assume great significance in 1971 – as will be demonstrated. In all the Department now employed some 15 people.[53] There were other developments. The Department was involved as an equal partner with *Sight and Sound* in the commissioning of titles in the Cinema One series of monographs[54] and was also producing educational publications: *Talking about the Cinema*, *Talking about Television* and *Film-*

making in Schools and Colleges all appeared in 1966.[55] The full-year secondment course had not been achieved, but one-term courses were available at Hornsey College of Art and the College of the Venerable Bede in Durham.[56]

The expansion was in part facilitated by the preparatory work that Whannel and Reed had done with Ministry officials, but the Institute as a whole had benefited from the change of government in 1964 and the BFI was now funded from the new Department of Education and Science.[57] Specifically it was the appointment by Labour prime minister Harold Wilson of Jennie Lee as the first minister for the arts that most enabled the Institute's expansion. She championed the BFI's cause, and the flow of government money to the Institute was greatly increased, though the Education Department was not the principal beneficiary. Most money went to the Film Services Department under John Huntley for the setting up of Regional Film Theatres.

The Old Compton St base and its facilities supported a very productive period. Perkins was able to prepare 'Cinema', his television series for sixth formers, on site using the Steenbeck.[58] The Department's relationship with the teaching profession became more direct as teacher advisers now had a space in which to meet teachers. Consequently a steady sequence of duplicated leaflets was produced where individual practitioners reported on what the teacher advisers considered to be their exemplary classroom practice.[59] There was a viewing theatre where 16mm prints might be screened. But, given Whannel's determination to pursue a research programme, there were other developments that definitively addressed this. A pattern of regular seminars was begun in early 1967 with papers from members of the Department and outside speakers which attempted both to explore the dominant preoccupations within film study and to venture into new territory.[60] Wollen organised these events and also selected the invited audience.

The Department had long wished to have a greater involvement with the National Film Theatre and had begun to do so, as when Kitses organised the Budd Boetticher Season there in 1966. Lovell's task was to try to fill the gaps in the film extract collection and to make it more representative of the auteurs and genres that the Department was promoting. Most important, in supporting initial teacher training, were the study units which included a feature film, extracts and documentation. These were available for longer-term hire, and eleven had been compiled by January 1969.[61] The range of topics addressed was wide and demonstrates the importance of a 'thematic' approach as described in the *Talking About* books: titles included 'War on the Screen', 'Imprisonment' and 'Young People on the Screen'. Simultaneously film scholarship was being manifested more widely - especially in small volumes produced by *Movie* Paperbacks and Zwemmers Paperbacks. Many of their authors were familiar with the work of the Department and regularly engaged with its personnel. Old Compton St now accommodated the 'Film Academy-in-Waiting'.

Both the extra-mural classes and the Summer School were reinvigorated and adjusted to incorporate the current preoccupations of the Department: author-

ship, genre and the American cinema. In 1963/64 the available courses were taught by Huntley (History and Development of the Cinema), Whannel (Films and Criticism), Harcourt (The Director's Cinema) and Lovell (Qualities of Film);[62] by 1967/68 Huntley's course had not changed but he was now complemented by Kitses (Films and Criticism) and Robin Wood (The Director's Cinema) while Harcourt and Lovell combined on 'Surrealism in the Cinema'.[63] The framework that Kitses followed showed connections to Whannel's model, but his approach to National Cinema was that of 'Authorship and National Cinema', with an American emphasis. Where Harcourt had offered Eisenstein, Bergman and Antonioni, Wood considered Murnau, Hawks, Godard and Penn. Where Lovell had previously concentrated on examples only from European cinema, now an important element of his joint course was constituted by the 'surrealist' directors to be found in mainstream American cinema. The Department was defining an approach to the cinema that was very different from that of *Sight and Sound*.

The Summer Schools needed to change and become more focused. These had been rather relaxed events with leisurely film viewing and afternoons occupied with amateur film-making in groups. Whannel had taken over responsibility for the School in 1958 but, until he had a larger staff base on which to draw, he was limited in what changes were possible. Celebrity speakers from the British film industry were phased out and replaced with staff lecturers. The general introductory nature of the programme was discontinued; the new offer accommodated the current research interests of staff. In 1967 it was the Western, in 1968 Surrealism and in 1969 the French New Wave.[64] The Department's most direct intervention into teacher training was in the secondment course at Hornsey College of Art. Douglas Lowndes who ran the one-term provision was well known to the Department, which had long favoured his approach to film-making with children. Lowndes promoted the individual rather than the group-made film, established as common practice in schools and for which Reed had been one of the influential proponents. Whannel wanted actively to support Lowndes and members of the Department were scheduled in at Hornsey as regular lecturers.[65] The BFI's *Annual Report* declares:

> With the help of the Institute's Education Department a most ambitious and concentrated course in the meaning and evolution of film has been planned, making use of all the advantages that London has to offer.[66]

Compared with what had been possible before 1964/65 this was a remarkable transition. Unfortunately, what was seen by educationists as the BFI providing long-awaited intellectual leadership in the development of film study was not celebrated elsewhere in the Institute. In particular the governors became increasingly suspicious of what Whannel was doing; Reed began to distance himself from that part of his organisation in which he had personally invested so much for so long.[67]

There were many issues around the development of film study that Whannel continued to pursue in various internal and external reports; some of these were

published additionally in *Screen*.[68] He published little in pamphlet or book form which has limited recognition of the persistence of his strategy. Within the BFI his most critical, if not discerning, audience was the board of governors where there was a group who became increasingly hostile to the Education Department. Had Whannel been less ready to reveal his thinking, he might have been longer in post. There were several aspects to the hostility. Whannel readily compared the work with which some of his staff were engaged to that found in a university department. He consequently wanted to debate the notion of a film culture and how exploring this might connect with other BFI departments. Reed had seen the department as delivering to schools and colleges, thereby supporting innovation at arm's length, whereas it was always fundamental to Whannel's strategy that only by having research within the academy would a structure take shape around film study which would enable it to become properly established at earlier levels within the education system.

> Unlike other subjects the study of film as art and entertainment has been developed at the lower levels of education rather than within the university. Its emergence as a school subject before it has become clearly established as an academic discipline accounts for many of the peculiarities of film study. Most of the problems, both practical and theoretical, are traceable to this basic fact.[69]

There was also probably already an unstated suspicion about the left-wing politics assumed to preoccupy some of the members of the department.[70] Pressure on the Education Department increased and in January 1969 the department was moved back into the main BFI building at 81 Dean St, sharing a floor with the *Sight and Sound* offices.

Jim Hillier had begun working within the department in 1968. He was not during this period a BFI employee but worked for the Humanities Curriculum Project.[71] His task was to select extract material which might be used in the classroom as a stimulus for discussion on subjects such as 'Youth' or 'War'. The Project was designed around the production of evidence with which students might engage in the classroom. There was an irony here in that, while Whannel was seeking to explore how film study might be developed, the Project's research officer was selecting extracts from feature films where their narrative content was to be presented to students as 'evidence' in their exploration of broad social themes. Whannel justified this arrangement to the governors:

> To have refused to collaborate on the grounds that the films put into circulation will not be used for film study strictly defined would have been to deny the Project relevant expertise and to isolate the Department from an important educational experiment.[72]

He compared the Project's very specific use of film to the use made by history teachers in seeking evidence in the literary culture. But he was unequivocal in defining the priority of his department:

> Its major priority must be to establish the study of film as art as an important academic discipline. I also believe for the reasons given that this must be a major objective of the Institute as a whole.[73]

Since members of the Education staff were involved in planning their extra-mural and summer school lectures they were 'engaged in research into aesthetic and critical problems. To that extent the Department operates like a University Department.'[74] Whannel's repeated comparison of his department with a department in a university was not self-promotion. He sought to highlight the absence of any such department within the British academy. He then introduced the idea he had long been nurturing, that would ultimately be implemented and recognised as a crucial part of the Whannel legacy:

> Secondly, the Institute could seek to find money to establish Research Fellowships which could be operated jointly by the Institute and a university department.[75]

The context in which the governors considered his paper was a curious one. Papers had also been submitted by the Regional Education Officer and the British Universities Film Council. Reed had introduced the three papers to the November 1968 governors' meeting as representing 'the three main aspects of the Institute's educational policy'.[76] By giving equivalent status to two much less substantial elements of the Institute's work, Reed was distancing himself from the Education Department. What most antagonised certain governors when Whannel presented the paper was his insistence that the 'Institute's long term objective' was to create a 'flourishing film culture'.[77] Opposition to the Education Department's emphasis was voiced by Helen Forman, Edgar Anstey and Paul Adorian. The sketchy reporting of the minutes suggests that these governors considered Whannel's approach to be too prescriptive and limiting in its relationship to the wider aspects of film in education. After lengthy discussion there was agreement 'that an early opportunity be provided of debating further the policy issues raised by Mr Whannel's paper, as these could not be determined in respect of the Education Department alone'.[78]

If certain governors had anxieties about the Education Department and its research ambitions, these might have been exacerbated when, in summer 1969, Whannel spent a sabbatical period in the USA at the invitation of Northwestern University.[79]

Other departments came under scrutiny at subsequent meetings and at the April 1970 meeting the governors decided upon a complete policy review of the Institute as a whole.[80] This was a time of turmoil for the BFI. Dissatisfaction with the executive and governors was being voiced among staff and members. It was in this context that Education became the first to be investigated by a sub-committee on 'Educational Services' consisting of Forman and Adorian with Asa Briggs (vice-chancellor of Sussex University and only recently appointed governor) as chairman.[81] Its report, prepared at speed during the winter of 1970/71, was not finally discussed by governors until their April 1971 meeting.[82] Unfortunately no copy of the 'Report of the Review Committee on Educational Services' has

survived.[83] Briggs told governors that they wanted to 'see a more streamlined Department playing a less independent role than hitherto' and 'if the Education Department continued as it was now doing the servicing aspect, which they regarded as important, would suffer'.[84] Whannel protested vigorously when allowed to address the meeting but his views were discounted and he was asked 'to satisfy the Director within a month as to the manner in which the recommendations contained [...] in the report would be implemented'.[85] Whannel's response was delayed by illness; then the July Minutes record the following: 'Mr Whannel had presented his report to the Director but following discussions he and other members of the department had tendered resignations.'[86] Governors agreed the policy of the renamed 'Education Advisory Services' at their September meeting. Where Whannel had written with clarity and purpose, the new policy, amended at the meeting, covers five paragraphs in generalisations, being specific only in prohibiting the 'study of the moving picture itself'.[87] Reed became ill and his deputy, Ernest Lindgren, had the task of liaising with staff who remained. There was solidarity and loyalty to Whannel among these colleagues. There would be no internal applicant for the 'new' post of Head of Educational Services.

Following Whannel's departure, SEFT, the film and television teachers' organisation, assumed an importance that was unexpected both by SEFT and the BFI. When the joint appointment of a paid officer to combine the roles of teacher adviser BFI and secretary of SEFT had first been proposed by Reed to a meeting of the governors in 1966, he had presented it as essentially a BFI post with a small 'honorarium' to be paid for the additional duties entailed as secretary of SEFT. In practice the reality of the situation had been the reverse of this. With support from Whannel, who realised that the SEFT workload was substantial, the post had increasingly given priority to the Society's work. Additionally full-time secretarial support had been allocated within the Department to the SEFT secretary. When the joint post became vacant in 1970, following agreement between Whannel, Reed and the Society's Executive Committee, it was re-designated and advertised as 'Secretary SEFT / Editor of *Screen*' in recognition of the fact that most of the Society's resources were now allocated to the production of its new journal. Although there was no mention of the BFI in the job title, the post was still fully funded by the BFI as was the supporting secretarial post, now re-designated as Editorial Assistant.

When the governors set about their post-Whannel refurbishment of the Education Department, they proposed simultaneously to reduce the sum paid as grant-in-aid to SEFT from £1,750 to £500 per annum, the level at which it had been before the first joint appointment had been made in 1967. What they did not immediately appreciate was that the bulk of the BFI's contribution to SEFT was not by its grant but came in the shape of two full-time posts which BFI was already funding – inevitably because the relationship of the two post-holders with the BFI was still that of being the Institute's own employees. Much of the responsibility for handling the day-to-day BFI/SEFT negotiations fell to Lindgren as deputy

Paddy Whannel and BFI Education

director, again standing in for Reed. Those acting for SEFT were its chairman, Jim Cook, and Sam Rohdie, who had taken up the redesignated SEFT post at the start of 1971. Then a new key player emerged at this point: Denis Forman, who was on the point of replacing William Coldstream as chairman of the BFI Governors.[88]

Forman preferred face-to-face meetings to exchanges of lengthy documents. He and Rohdie appear to have developed a mutual respect and together rapidly delivered a radical solution. It was perhaps relevant that Forman had, some two decades earlier as BFI director, helped to facilitate the formation of the Society of Film Teachers. This followed his encounter (at the BFI Summer School in 1949) with a small group of activists who were wishing to set up an organisation for teachers of film appreciation.[89] Forman would consequently have had a perspective on what the Society had achieved in the two subsequent decades. Rohdie had been attracted from teaching film in higher education to the SEFT post by the potential afforded by the Society and in particular by its journal *Screen* in the emerging field of film study. Perhaps their each being new to these particular roles facilitated a flexibility that might not have been available to others with a previous history of SEFT/BFI negotiations. The solution upon which Forman and Rohdie agreed was for SEFT to leave the headquarters premises of the BFI in Dean St and to set up in its own separate offices in Old Compton St, where it would be funded (at least initially) by the BFI to the extent that SEFT would employ, and could afford to pay for, its editor and editorial assistant. This arrangement enabled the governors dramatically to demonstrate that, while BFI was keeping the educational advisory work and its direct support of teachers on site, it was nevertheless still supporting the more theoretical work, but at arm's length.

Colin McArthur, who had joined the Department in 1968, was the senior surviving member of the 'education' staff and was consequently required to act as departmental head temporarily to cover the vacancy. He has chronicled the details of the enforced transition from Education Department to EAS.[90] Eventually a new head of EAS was appointed: Douglas Lowndes, the experienced practitioner and teacher trainer, who had had close links with Whannel's department. Soon after Lowndes's appointment, Reed retired. Remaining staff were resilient. Christopher Williams, who had replaced Wollen, started a series of monographs addressing aspects of television. A link with the Inner London Education Authority led to a Film Study Course for Sixth Formers based at the NFT which would, for more than a decade, provide in-service training for a generation of film teachers. A seminar programme was reinstated, but now re-designated as joint SEFT/BFI seminars, where the BFI provided the premises and SEFT the seminar leaders. BFI Summer Schools were now planned around theories developed in the SEFT journal, *Screen*. The innovation that Whannel had long promoted, BFI-funded pump-priming university film-teaching posts, was agreed by the governors and first became reality at Warwick University in 1973.[91] There was therefore now a correspondence between the Institute's arrangements with SEFT and its policy of funding film lectureships in universities. In each instance the BFI might be

seen to be supporting the development of this new area of academic enquiry but by mechanisms which were clearly independent of the Institute's own in-house educational work. There would no longer be any possibility of the Educational Advisory Service being mistaken for a university department.

Notes

1 I am indebted to Christophe Dupin for the accuracy of dates quoted in this chapter.
2 'Paddy Whannel Obituary', published in both *Screen* 21:2, Summer 1980, pp. 10–12, and *Screen Education* 35, Summer 1980, pp. 3–4.
3 Stanley Reed in serendipitous conversation with the author at a Chingford bus stop in the mid-1980s. He was teaching in the same school premises in which he had taught before joining the Institute.
4 The Society of Film Teachers was founded in October 1950. It grew out of an initiative on the part of several teachers and others who had been on the 1949 BFI Summer School in Bangor. They subsequently circulated a document *School Film Appreciation* which was produced and distributed by the BFI with the support of its new director Denis Forman.
5 Among Reed's publications were 'Film and the Child', a series of four articles in *Visual Education* 1:9–12, September–December 1950; 'Appreciation of the Film', *Photographic Journal*, August 1950, pp. 285–91; *Film Appreciation as a Classroom Subject* (London: BFI, 1951); *Guidance in Aesthetic Appreciation: The Film* (London: BFI, 1955).
6 *Report of the Departmental Committee on Children and the Cinema* (London: HMSO, 1950).
7 BFI Governors Minutes, 28 October 1947 and 27 January 1948.
8 Reed gave evidence on 18 March 1949 on behalf of the West Ham Schools' Film Society. NA/ED121/579.
9 *Film Guide* was developed from a series of posters that circulated in youth clubs in Liverpool, examples of which were submitted to the Wheare Committee. It was produced by the BFI Film Appreciation Department between January 1954 and September 1959. In October 1959 it was renamed *Screen Guide* to facilitate the introduction of references to television and was produced jointly with the Society for Education in Film and Television (SEFT), which was the newly adopted title of the Society of Film Teachers. The final *Screen Guide* was published in April 1961
10 The BFI Governors had first discussed the possibility of a university-level qualification in 1937. BFI Governors Minutes, 6 May 1937, Item 350.
11 Use of the term lingered on. In 1967 Whannel still found a use for it: 'For the most part, the Institute's own Education Department is concerned with what used to be called "film appreciation" – an outmoded term, but still marginally useful in that people know what it means.' Paddy Whannel, 'Onward from Film Appreciation', *BFI Outlook*, January 1967, p. 20.
12 In practice, as the *BFI Quarterly Gazette* reveals, Whannel's lectures in his early years at the BFI alternated innovatory material such as 'Free Cinema' with sessions on Film Appreciation, depending on the audience.
13 Author's recollection.
14 'The Artist, the Critic and the Teacher' programme, 30 March 1958, p. 3.
15 Ibid.
16 Among Whannel's publications were: 'Towards a Positive Criticism of the Mass Media', *Film Teacher*, 17 May 1959, pp. 28–30; 'Receiving the Message', *Definition* 3,

[1961], pp. 12–15; 'Teaching Film' *Liberal Education* 5, January 1964, pp. 3–4; 'Teaching and Discrimination', *Forum* 3:2, Spring 1964.
17 Alex Jacobs and Paddy Whannel (eds), *Artist, Critic and Teacher* (London: Joint Council for Education through Art, 1958).
18 'Visual Persuaders' programme, 3–10 May 1959, p. 4.
19 Higgins was the chairman of the Society of Film Teachers which had by then already been renamed Society for Education in Film and Television.
20 The film theatre had only recently opened in its purpose-built venue beneath Waterloo Bridge and having the forums there helped to promote the new NFT.
21 See programmes of 'International Conference on Film Education of Youth', Amsterdam, 22–24 November 1957, pp. 5–11, and of 'Film, Television and the Child', London, October 1958, pp. 8–9.
22 The spur for the original *Oxford Opinion* piece had been the publication by the National Film Theatre of the pamphlet *Fifty Famous Films 1915–1945* (London: BFI, 1960). Victor Perkins had attacked what he perceived as the BFI's approach to criticism in 'Fifty Famous Films' in *Oxford Opinion* 38, 30 April 1960. Penelope Houston published a lengthy and hostile response in 'The Critical Question' in *Sight and Sound*, Autumn 1960, pp. 160–5. Ian Cameron then joined in with 'All Together Now', *Film* 25, September–October 1960, p. 12, and this in turn prompted Peter John Dyer's 'Counter Attack' in *Film* 26, November–December 1960, p. 8.
23 'The Current Picture', *Film* 27, January–February 1961, p. 7.
24 This is as recalled by Victor Perkins in interview with the author on 19 April 2005. Alan Lovell in an interview on 7 June 2005 had only a 'vague memory' of the event. It would appear from a report in *Film* 28 (March–April 1961) that John Gillett from the BFI was also present.
25 Fred Jarvis in interview with the author, 15 July 2004.
26 Paddy Whannel, 'The Educational Work of the British Film Institute', March 1963, NA/ED181/92.
27 The Society of Film Teachers had extended its remit and consequently changed its name to accommodate the increasing interest in television.
28 They were Tony Higgins, chairman of SEFT, and its secretary Don Waters.
29 For a comprehensive account of the pressure group behind the campaign see Martin Barker, *A Haunt of Fears: The Strange History of the British Horror Comics Campaign* (London: Pluto Press, 1984).
30 *Verbatim Report Popular Culture and Personal Responsibility* (London: National Union of Teachers 1961), p. 94.
31 *Verbatim Report*, p. 94. Whannel inserted an extract from the Free Cinema film *Nice Time* with the following explanation: 'Like a number of people here, I was really disturbed about the general view that things are as they are, they will continue to be like that and all we have to do is do some more research and in the meantime not do anything rash, perhaps have a few conferences. I do not go along with this line at all, and I wanted to say this in relation to this particular piece of film.'
32 Raymond Williams, *Britain in the Sixties: Communications* (Harmondsworth: Penguin Books, 1962); Stuart Hall and Paddy Whannel, *The Popular Arts* (London: Hutchinson Educational, 1964); Denys Thompson (ed.), *Discrimination and Popular Culture* (Harmondsworth: Penguin, 1965); Nicholas Tucker, *Understanding the Mass Media* (Cambridge: Cambridge University Press, 1966).
33 Brian Groombridge, *Popular Culture and Personal Responsibility: A Study Guide* (London: National Union of Teachers, 1961).
34 Stuart Hall in interview with the author, 17 March 2004.
35 Hall and Whannel, *The Popular Arts*, p. 399.

36 Whannel, 'Educational Work'.
37 Whannel, 'Educational Work', p. 2.
38 Ibid.
39 Ibid.
40 Ibid., p 4.
41 Roy Shaw in interview with the author, 29 September 2004
42 Whannel, 'Educational Work', p. 5.
43 Ibid., p. 7.
44 Ministry of Education, *Half Our Future: A Report of the Central Advisory Council for Education (England)* (London: HMSO, 1963).
45 Jim Kitses with Ann Mercer, *Talking about the Cinema*, and Jim Kitses, *Film and General Studies* were published by the BFI Education Department in 1966. Both were based on accounts of work by various lecturers at Kingsway Day College in London.
46 Whannel 'Educational Work', p. 8.
47 Ibid., p. 9.
48 Ibid., p. 9.
49 Ibid., p. 9.
50 Paddy Whannel and Peter Harcourt, *Film Teaching* (London: BFI Education Department, 1964), p. 9.
51 Whannel and Harcourt, *Film Teaching*, p. 8.
52 The offer of a joint appointment to the Society for Education in Film and Television had been proposed by Whannel and supported by Reed who secured the agreement of BFI Governors.
53 BFI Education Department Report 1968 Staff List.
54 The initial arrangement was that certain books in the Cinema One series would be published by *Sight and Sound* with Penelope Houston and Tom Milne as general editors; others would originate from the Education Department where Peter Wollen had editorial responsibility. The first to be published by the Education Department was Geoffrey Nowell-Smith's *Visconti* (1967). The Department had preceded the Cinema One series with Suzanne Budgen's *Fellini* (London: BFI, 1966).
55 Kitses with Mercer, *Talking about the Cinema*; A. P. Higgins, *Talking about Television*; Peter Harcourt and Peter Theobald (eds), *Film Making in Schools and Colleges* (London: BFI Education Department, 1966)
56 *Annual Report*, 1966, p. 38.
57 *Annual Report*, 1965, p. 32.
58 'Cinema' was a BBC Television for Schools programme for sixth forms transmitted in the autumn of 1968. It was innovatory in that the programmes both used extract material and made references to feature films that would be subsequently broadcast on BBC1 and 2 in the evenings and at weekends.
59 Between January 1966 and the end of 1969, it would appear that 17 such duplicated documents were produced or reprinted.
60 The seminars were given during the autumn–spring period at roughly monthly intervals. Six were printed in the pamphlet Peter Wollen (ed.), *Working Papers on the Cinema: Sociology and Semiology* (London: BFI Education Department, 1969).
61 Whannel and Harcourt, *Film Teaching* (1968), pp. 102–3.
62 Whannel and Harcourt, *Film Teaching* (1964), pp. 83–93.
63 Whannel and Harcourt, *Film Teaching* (1968), pp. 83–93.
64 Christophe Dupin, 'BFI Summer Schools 1935–1991', History of the BFI Research Project, 2006.
65 Douglas Lowndes in interview with the author, 5 June 2003.
66 *Annual Report* 1966, p. 38.

67 Author's recollection of conversations with Whannel.
68 Paddy Whannel, 'Film Education and Film Culture', *Screen* 10:3, May–June 1969, pp. 49–59; 'Servicing the Teacher', *Screen* 11:4–5, July–October 1970, pp. 48–55.
69 Paddy Whannel, 'The Education Department: Policy and Role', G381 Paper No. 2, 4 November 1968, p. 2. BFI/89.
70 See Colin McArthur, *The Big Heat* (London: BFI, 1992) for references to perceptions of the BFI as housing left-wing sympathisers.
71 For an account of the work of the Project see Jim Hillier and Andrew McTaggart, 'Film in the Humanities Curriculum Project: 1. Theory', and Richard Exton, '2. Practice', *Screen* 11:2, March–April 1970, pp. 46–57.
72 Whannel, 'Education Department', p. 3.
73 Ibid., p. 4.
74 Ibid., p. 5.
75 Ibid., p. 5.
76 BFI Governors Minutes, 4 November 1968, Item 5071.
77 Whannel, 'Education Department', p. 1.
78 BFI Governors Minutes 4 November 1968, Item 5071.
79 May Pietz, 'Interview with Paddy Whannel', *SEE, Magazine of the Screen Educators' Society* 3:1, 1969.
80 BFI Governors Minutes, 21 April 1970, Item 5229.
81 BFI Governors Minutes, 16 March 1971, Item 5327.
82 BFI Governors Minutes, 20 April 1971, Item 5338. Discussion had been scheduled for the March meeting but too many governors had left that meeting before the Briggs agenda item was reached.
83 Despite my own efforts and persistent enquiries by the BFI History Research Project team, no copy of this report has come to light.
84 BFI Governors Minutes, 20 April 1971, Item 5338.
85 Ibid.
86 BFI Governors Minutes, 20 July 1971, Item 5367. A full account of the events around the resignation of Whannel and five other colleagues is to be found in a series of contributions in *Screen* 12:3, Summer 1971. The others who resigned were: Eileen Brock, Alan Lovell, Jennifer Norman, Gail Naughton and Jim Pines.
87 BFI Governors Minutes, 21 September 1971, Item 5380.
88 For a detailed account of the SEFT/BFI negotiations see Terry Bolas, *Screen Education: From Film Appreciation to Media Studies* (Bristol: Intellect, 2009).
89 Following the Summer School in the autumn of 1949, a letter from A. W. Hodgkinson, E. Francis Mills and J. Smith was published in various film and visual aids journals. It invited interested parties to contact them and offered respondents information about film appreciation in schools. On offer in early 1950 was *School Film Appreciation*, a document duplicated at the BFI's expense with a congratulatory Foreword by Forman.
90 See Colin McArthur, *The Big Heat* (London: BFI, 1992), pp. 35–49, and 'Two Steps Forward, One Step Back: Cultural Struggle in the British Film Institute', *Journal of Popular British Cinema* 4, 2001, pp. 112–27.
91 As early as 1966, some senior academics at Warwick University had been seriously considering 'a film studies department within the School of English'. See Paddy Whannel 'Onward from Film Appreciation', *BFI Outlook*, January 1967, p. 23. Accounts of the first three lectureships – at Warwick, Keele and Essex Universities – are to be found in *Screen Education* 19, Summer 1976, pp. 51–60.

9

The 1970s

Geoffrey Nowell-Smith

The return of Denis Forman

To resume, the main causes of the 1970 crisis were an undemocratic and out-of-touch management inside the BFI and the existence outside it of cultural forces which the management and governors failed to acknowledge. In 1971 the BFI was in fact ripe for radical reform. It got it, but along a rocky road where there many new crises to surmount and with results that were not always what their promoters either intended or foresaw. By the end of the 1970s, however, the BFI found itself aligned with precisely the sort of tendencies it had sought to keep at bay at the outset.

Although the postal ballot of BFI members commissioned by Coldstream after the December 1970 AGM had produced a what looked like a resounding endorsement of the status quo, wiser heads on the governing body, notably Michael Balcon, knew this was not so. Noting the prevalence of industrial interests on the present board, Balcon thought, and noted in his papers, that the Institute needed a much more dedicated governing body, with fewer industry members and least one member elected by the membership and ideally one from the staff as well.[1] As long-standing chairman of the BFI's Experimental Film Fund and Production Board, Balcon had become increasingly frustrated by the failure of either government or industry, or for that matter the BFI itself, to commit fully to supporting the crucial seedbed of experimental film production. The feeble outcome of the Governors' Policy Review and the mishandling of the crisis were to him just further signs of a situation which looked increasingly hopeless.

If Balcon expressed these thoughts to his fellow governors, they fell on deaf ears. The general view at the top was that nothing needed to change and a sufficient display of determination would be enough to see off the rebels both inside and outside the organisation.

But who was to make this display? Coldstream himself had no stomach for a further fight. On 3 March 1971, less than three months after the AGM, he wrote to the new (Conservative) minister, David Eccles, formally tendering his resigna-

tion. He was 63 and, although he retained his professorship at the Slade School for a further four years, his main wish was to return to painting. Facing down a mob of activists at the National Film Theatre was not something he had any desire to do again, particularly if, as seemed likely, he had only lukewarm support from his own board.

Before he left, however, Coldstream made one final attempt to stem the tide. He agreed to a request from Colin Ford representing the Staff Association for a meeting with BFI staff. Coldstream, Helen Forman, Edgar Anstey, Jocelyn Baines and Asa Briggs attended for the governors; Stanley Reed and Vernon Saunders represented the management, while staff present included members of the '29' and the '21' as well as some who were non-aligned. At this meeting Coldstream affirmed governors' support for the line being taken by Reed and attempted to make it clear that no concessions to dissident staff would be forthcoming from management, nor would the governors accept the idea of representatives (whether of members or of outside interests) on the board. The meeting produced no new proposals, did nothing to clear the air, and left a continuing standoff.[2]

To replace Coldstream, Eccles prevailed on Denis Forman, former director of the BFI and now managing director of Granada Television, to undertake the task. This proved to be an inspired choice. Forman was (and has remained) very attached to the Institute. He was also vigorous and decisive but at the same time able to be conciliatory where conciliation was required. On his arrival, he wrote in his memoirs, 'I found the Institute in an even greater mess than I had expected.'[3] Although he was not averse to banging a few heads together lower down the scale, the problems as he saw them began at the top, with the board of governors. He agreed with Balcon that there were too many industry people on the board who did not have the interests of the Institute truly at heart. He was also more sympathetic to the idea of appointing a governor to represent the interests of members than Coldstream had been.

The first thing Forman had to address was the shambles of the governors' abortive Policy Review. Immediately on taking office in May 1971, Forman informed the governors that he and Stanley Reed would produce for publication a summary of the review's main recommendations.[4] This was issued later in the year under the title *Policy Report of the BFI Governors* and is in two parts. It starts with a vigorous 'Introduction by the Chairman' in which Forman sets out his vision of where the Institute should be heading over the next several years. This vision is remarkable mainly for the vastly increased role that Forman thought that television should have in the BFI's thinking and practical activities. It also affirms, more firmly than any previous official statement, the importance of the Production Board in helping create nothing less than 'a new and more viable kind of film industry in Britain'.[5] While nothing that the Introduction says was shockingly controversial, it is also the case that that very little of it drew on previous documents prepared for and approved by the board of governors. Rather it was an emphatic statement of the sort of Institute the chairman himself felt should be created and a call to arms to create it.

The second half of the *Policy Report* was written by Reed. It draws on material included in the majority report of the Governors' Policy Review Sub-Committee, but it is not identical with that report. Most notably, it contains none of the more contentious recommendations originally made in the majority report, for example those proposing devolution for the Archive and the NFT. Reed had been very opposed to anything that looked like a threat to break up the Institute, and in handing over to him responsibility for this part of the new *Policy Report* Forman implicitly gave him carte blanche to reaffirm the policy principles that Reed himself believed in. The combined result of the two parts was on the one hand an inspiring vision of the future and on the other a reaffirmation of the core elements of present policy. How the Institute was to get from one to the other in the midst of its present difficulties and with continuing uncertainty over future levels of funding was not made clear.

Crisis in Education

One area where Reed did feel happy to propose some degree of devolution was education. Here the *Policy Report* takes on board the result of something that had taken place since the governors' sub-committee had finished its deliberations, and that was the presentation of Asa Briggs's long awaited report on the Education Department – a report which was to have consequences that prolonged the 1970 crisis well into 1971.[6]

This report, written by Briggs with support from Paul Adorian and Helen Forman, was presented to the Board in January 1971, but discussion was deferred until April. Amazingly, no copy of it seems to have survived in the BFI's archives or anywhere else, so it is impossible to know exactly what its contents were. But the gist of it, as summarised in the governors' minutes for April 1971, was that the department was consuming too many resources and its present policies were leading it in a direction which was putting its services to teachers at risk. Briggs therefore recommended that the department be 'streamlined' and play a less independent role than before in setting and pursuing educational policy. Promotion of film study was to be devolved to teachers in the field with the department supplying light-touch advice and materials. There must also have been a suggestion that the department widen its focus to take in all sorts of uses of film in education, because Paddy Whannel, when invited to respond, countered that this 'apparent shift in direction' would require far more resources than were currently available. To rub the point home, Whannel also refuted the claim that the department was expanding and pointed out that its budget had in fact been static for the past three years.

Whannel's rebuttals were to no avail. The governors approved the report and then, in a further twist of the knife, took note of a proposal from another sub-committee, the Editorial Committee, that the grant to SEFT's magazine *Screen* be cut to £500 – a proposal which, if enacted, would have seriously hindered intellectual developments in film culture throughout the decade to come.[7]

Fortunately Forman had no desire to precipitate matters in this way. Immediately on his arrival he and Adorian agreed that the proposal to cut SEFT's grant should be quietly shelved. Adorian assured SEFT that it was all a misunderstanding,[8] and on 16 June Forman met with representatives of SEFT, listened to their concerns and guaranteed to them that *Screen*'s future was assured at least in the short term. He also commissioned a written response from Whannel to the Briggs Report, to be delivered in time for the governors' meeting on 20 July.

Whannel prepared his document as requested, but it was never discussed, since in the meantime he had taken the decision to resign from the BFI. Five other members of the department resigned with him. They made public their reasons for resigning in a memo to all BFI staff, which was later published in *Screen*.[9] Whannel's decision to leave had in fact been taken earlier, probably very shortly after his bruising encounter with Briggs at the April meeting of governors. But he held it back until he had discussed it with his colleagues and had taken steps to ensure his own future. In September he left to take up a post at Northwestern University in Evanston, Illinois.

Faced with this mass resignation of Education staff, Ernest Lindgren, standing in for Stanley Reed whose health was beginning to suffer under the strain, sent out an all-staff memo of his own on 20 August 1971 giving the management point of view. In it Lindgren picks up on a phrase which was only just beginning to come into currency: 'I will only say,' Lindgren writes, 'that when this letter, in its last sentence, argues that the purpose of the British Film Institute is "to play a central role in creating a film culture" it is going against Governors' policy and I believe this to be the crux of the whole dispute.' He goes on: 'The proper role of a public organisation in a democratic state is to provide the information and the facilities to enable people to make up their own minds about the nature of film and its purpose in society.' And finally: 'It is not the job of the Institute [...] to develop and promulgate one particular film culture.' Film culture, as Lindgren noted, was indeed the crux of the dispute, but his understanding both of what the Education Department was doing in the 1960s and of what the BFI as a whole had been doing at least since the late 1940s was fatally flawed. For the BFI already played a role in reflecting and reinforcing, if not creating, a film culture, though it was a narrow one, centred on a concept of film as art which was being increasingly challenged both outside and inside the BFI. From a conservative standpoint, however, Lindgren was probably right to be concerned about the consequences for the BFI if the new ideas on film culture were to get the upper hand inside the organisation – as they eventually did.[10]

'Film culture' was apparently discussed as an issue (though almost certainly inconclusively) in a further series of meetings that then took place, culminating in Lindgren presenting a report to governors on 21 September which was endorsed by the board and summarised by Lindgren in a further memo to heads of department on the 30th. The stay of execution for SEFT was confirmed: its general secretary Sam Rohdie and his assistant Diana Matias could continue in their jobs

for a further year and premises would be found for the Society outside the Institute, but its (and their) long-term future remained uncertain. The Institute reaffirmed its commitment to education but insisted that the department take on the unattractive title Education Advisory Service. The department then entered into a brief and relatively peaceful interregnum while a search went on for a replacement for Whannel. The governors evidently felt that the matter was settled, which in the short term it was, though not in a longer perspective.

SEFT, however, was not prepared to lay down its arms. The autumn 1971 issue of *Screen* contains Whannel's resignation letter, an article by Alan Lovell on the taboo notion of film culture and a number of other documents related to the crisis, none of them, however, stating the management's point of view. When Forman got wind of this he was furious. He offered to pay the cost of pulping the entire edition, but SEFT held its ground. Forman summoned Rohdie and the SEFT chairman Jim Cook to a meeting and had what he described in a letter to Balcon as a 'personal confrontation' with them – rather like a headmaster summoning two unruly small boys to his study.[11] Although SEFT and *Screen* never provoked the Institute again in such a blatant way, they continued to be unruly and to carry the flag for the sort of culture that the BFI and its governors, not to mention traditionalists all over the country, regarded as anathema. Forman's reference in his memoirs to 'Cohn-Bendit politics and semiology' was not far wide of the mark, though by 1971 the Cohn-Bendit politics had somewhat subsided and semiology was yet to make its mark.[12]

Management

Forman now turned his attention to the management of the Institute. Although the headline-grabbing issues all had to do with cultural policy, it was clear that there were also deep-seated problems of management, both personal and structural. Reed's health had suffered from the strain of dealing with the crisis and he was now a sick man. The fact that he had left the negotiations over the future of the Education Department to Lindgren was a symptom not only of the breakdown in his personal relationship with his former friend and protégé Paddy Whannel but of the extent to which he had been overwhelmed by the extent of the crisis enveloping the Institute. There were financial problems too, particularly with the NFT which now had two theatres to fill and had reluctantly succumbed to pressure from the trade to pay distributors a fee for showing films. There was also a longer-term uncertainty about the intentions towards the BFI of the Conservative government that had come to power in 1970. Although Forman got on well with Lord Eccles, the Paymaster General and Minister for the Arts, the new government did not have a positive expansionist attitude to arts provision.[13]

In September 1971, therefore, Forman went to the DES to argue the case for a new senior managerial post in the BFI, that of a deputy director in charge of finance and administration. Permission to create such a post was granted, but there

were difficulties in filling it. Bob Camplin, Forman's former deputy in the early 1950s and now with the CEA, was asked if he would like to return in a similar but enhanced role. He considered it seriously, but it soon became clear that the money on the table was insufficient for someone of his standing and he eventually turned down the offer.

After a second round of interviews in January 1972, the governors chose Alan Hill, a chartered accountant from Liverpool with experience in charities and both public and private sector accounting. (He was then with the publishers Thames and Hudson, who had taken over publication of the Cinema One series.) Hill was aware that the job was a tricky one ('They roll hand grenades down the corridor at you there,' a friend told him),[14] but after a bit of hesitation accepted the post, arriving in April 1972, just in time to oversee the preparation of the BFI accounts for the previous year.

Governance

Having poured some oil on the troubled waters of the Education Department and put in train moves to tighten up the administration, Forman was now ready to address the problem which he had identified from the outset as central, that of the governance of the Institute

First, however, he had to face a further AGM in December at which the Members Action Committee repeated its demand for the governors to resign. This time the rebels won the vote on the day but the chairman insisted on a postal vote in which they were again resoundingly defeated. This meeting was, however, conducted in a slightly less antagonistic manner than the two previous ones had been[15] and had one positive outcome in the form of the institution of a system of member governors which survives (although emasculated) to this day.

The postal ballot held after the AGM had come up with a larger proportion of votes in favour of the dismissal of the governing body than had been the case the previous year, suggesting that there was still considerable disquiet among the members and that they could not be ignored as a political force. Having got outline approval from Eccles, Forman therefore commissioned Reed and Vernon Saunders, the BFI secretary, to devise a scheme to allow members to choose two candidates for nomination to the board.

Saunders's scheme, presented to governors in June 1972, foresaw elections taking place every other year, with two governors being selected by a poll of members, each to serve for two years. The DES, however, proposed (and imposed) a better scheme – an initial poll in 1972 from which the winner would be nominated to the Minister to serve for two years and the runner-up for one year only, and thereafter an annual poll with the winner (provided he or she received a minimum of 1,000 votes) serving a two-year term. Once the term expired, the same member could try for re-election, but the maximum period anyone could serve would be six years. The Minister was emphatic that these were nominations only and that the decision

to appoint rested with him alone; once appointed, they would have the same status as any other governor.

The proposal was adopted by the governors at their meeting on 18 July. A rapid exchange of letters and telexes between the BFI, its lawyers and the DES led to a definitive text being produced by the end of the month, which was published in the first issue of *BFI News*, a bulletin that had been created to improve communication with the membership. Then on 30 August, Forman held a press conference announcing the new scheme.

Asked at the press conference by the *Guardian* journalist Dennis Barker if he thought the scheme would appease the militants, Forman replied, 'Obviously it is something they would like rather than dislike, but whether they will regard it as adequate, or democratic enough, or broadly based enough, I do not know. It seemed the most practical way available to us at the present time of getting membership representation on the Board.' Forman denied that there was any 'appeasement' involved and expressed confidence that the Minister would appoint anyone at the top of the poll unless there were 'extraordinary' reasons against the appointment.[16] Nominations were solicited and six candidates put themselves forward, each nominated by six members. They were Nicholas Garnham, from the (now more or less pacified) Members Action Committee; Philip Jenkinson, the broadcaster and film collector; Ralph Bond of the film technicians union, ACTT; V. F. Perkins, founder editor of *Movie* and a former member of BFI Education staff and now a college lecturer; Edwin S. Rawson; and David Peabody. Ballot papers were sent out in November and the result was announced in December: 6,509 votes had been cast, representing over a third of the total full membership. Jenkinson was the winner with 1,873 votes, followed by Garnham with 1,223: Bond and Perkins were neck and neck with 994 and 973 votes respectively, with Peabody and Rawson trailing in the rear. Accordingly, Jenkinson as the winner was appointed for two years and Garnham as runner-up for one year. The results of the election were announced at the AGM on 19 December 1972. Never again was there to be such mass participation by members in a matter affecting their relationship with the organisation.

Forman had less success with his other plans to reform the board. He wanted it to be more representative of the constituencies the BFI served and less weighted towards the industry. Supposedly governors were appointed for a term of five or six years but the minister often reappointed them for a further term. Much to Forman's chagrin, Eccles did this in 1971, reappointing not only Bob Camplin and J. S. Christie but Forman's particular *bête noire*, John Davis of the Rank Organisation, immediately their retirement fell due.[17] Meanwhile Balcon had already resigned both from the governing board itself and from his position as chair of the Production Board. David Kerr, the Labour MP who had fought so hard for statutory deposit of films in the NFA, was also not renewed by the Minister. Forman had therefore lost two of his best governors but was still saddled with Davis, who didn't leave the Board until Forman himself left, in June 1973.[18]

Reed's departure and the arrival of Keith Lucas

Overseeing the setting up of the member governor scheme was Stanley Reed's last act as director. His health was continuing to suffer under the strain of the recurrent crises that were hitting the organisation. At the beginning of 1972 the governors were sufficiently concerned to make enquiries about the state of his contract in case he proved incapable of seeing his post through to retirement. Then in February, the board held a confidential meeting at which Forman announced that he had written to Reed recommending him in his own interest to seek early retirement on grounds of ill health. A settlement was agreed giving Reed generous terms (13½ years were added to his pension rights, with the aid of a contribution from the Rank Organisation engineered by John Davis). Reed was also offered a consultancy position as regional consultant and agreed to carry on as director until a replacement could be found.[19]

Reed had been at the BFI for 22 years, eight of them as director. He was one of the few directors the BFI ever had who shared a genuine passion for cinema with an educationist's belief in spreading the message of film art as widely as possible. He had seen the BFI grow and expand in many directions, notably education and regional development. In neither of those two areas had his intentions been fully realised. The growth of the Institute's educational activities had taken an unwelcome turn which he could not have foreseen (but which he could have mitigated). And the expansion into the regions had been badly mismanaged, though not directly by Reed himself. Overall, however, his record in office, over a period which roughly coincided with that of the 1964 and 1966 Labour governments, was a positive one. Had he left a couple of years earlier, or had he been able to navigate the storm which descended on the Institute in 1970, his achievement as director would have been recognised with fewer misgivings.

Forman's immediate choice of a possible successor was the film director Alexander Mackendrick, recently appointed dean of the film school at California Institute of the Arts. When Forman floated the idea to governors it was promptly slapped down by Davis, for reasons apparently connected with Mackendrick's widely rumoured alcoholism.[20] Swearing revenge on Davis and his 'gang of toadies', Forman set about a formal search for an alternative.

The chosen candidate was Keith Lucas, then head of the film school at the Royal College of Art. Edgar Anstey, the BFI representative on the Court of the Royal College, had been impressed by his handling of a protest by an angry and vociferous group of film students and recommended him to apply for the BFI job. At the interview Forman considered Lucas an acceptable if not ideal candidate, but warned him it was a tricky job and certainly not a job for life – 'seven years at most', Lucas recalls being told. When Lucas raised the question of his lack of administrative and particularly financial experience, he was assured that his job was more that of 'artistic director' and that Alan Hill would take care of the administrative side.[21]

9.1 The BFI Director Keith Lucas on the stage of NFT1

Lucas arrived to find relative calm over the issues which had so agitated both staff and members over the preceding 18 months, but at least three areas of the Institute requiring immediate attention.

The first of these was mainly a matter of administration. As it grew, the Institute had acquired more and more premises scattered around London and the surrounding countryside, making it extremely cumbersome to manage. Forman in his introduction to the *Policy Report* (p. 4) had envisaged eventually being able to concentrate all the Institute's activities on two or at most three sites: somewhere in the country where the Archive's films (especially nitrate) could be held; the National Film Theatre on the South Bank, and then either custom-built offices adjacent to the NFT or a single West End building for the rest of the BFI's work. In fact in 1972 the BFI had two sites on the South Bank: the NFT and a small office building about half a mile away which housed the Distribution Library and the Production Board. There were two Archive sites outside London, one at Aston Clinton in Buckinghamshire and one at Berkhamsted a few miles nearer the city in Hertfordshire. Other offices were clustered around the new BFI headquarters in Dean St, Soho – one of them sharing a building with the commercial film distributors' organisation the KRS. Throughout the 1970s frantic efforts were made to concentrate activities on fewer sites, but they were frustrated by the realities of continuing expansion. By the end of the 1970s the Archive had no fewer than four out-of-town sites, having acquired some bomb-proof vaults for nitrate film on a disused airfield in Warwickshire and a warehouse in the south London suburbs near the laboratory

where preservation was carried out.[22] In 1976, Hill and Lucas managed to move the Distribution Library and Production Board to a mews just off Dean St but almost immediately these became chock-a-block and new premises had to be found for Production. Realistic solutions proving unworkable, Lucas described the problem to a young architect called Norman Foster who had been brought in to mastermind the refurbishment of NFT1. Foster came up with a back-of-the envelope sketch for a gigantic barge floating just off Waterloo Bridge. Needless to say, this never got much further than the fantasy stage. In 1977, however, the BFI did acquire a new West End headquarters building in Charing Cross Rd, enabling it to move out of the building shared with the KRS.

The Archive succession and its consequences

The other two problems requiring attention had more cultural implications and more dramatic outcomes. The first problem was finding a successor to Ernest Lindgren, the founding curator of the National Film Archive who had joined the BFI in 1934 and between 1935 and 1972 had built up the NFA to a pre-eminent place in the world archive movement. Lindgren was not due to retire until 1975 but his health was giving cause for alarm. He had a preliminary diagnosis of cancer at the end of 1971 which was thought to be containable but wasn't. He was on extended sick leave from February 1972 and although he returned in the summer it was only briefly and he was a rare presence in the Archive in the months before his retirement in June 1973. He had also had a falling out with his deputy, Colin Ford, in the summer of 1971, after Ford had seriously overspent his budget for the ill-fated Cinema City exhibition at the Roundhouse in Camden Town. At the end of 1971 Ford left to take up a new post in charge of the photography collection at the National Portrait Gallery, leaving Lindgren without a senior person to deputise for him.[23]

To replace Ford, Lindgren chose Kevin Gough-Yates, a young man in his mid-thirties with experience mainly in further and higher education. But before Gough-Yates could arrive to take up the post, Lindgren again fell seriously ill. Clyde Jeavons was therefore briefly promoted from his job as head of acquisitions to the position of acting curator to fill the gap. Then, in November 1972, Gough-Yates, newly arrived as deputy, found himself thrust forward as acting curator because of Lindgren's continuing illness. With Lindgren sick and in any case due to retire, the governors were clearly concerned about the succession and at the time when the deputy was being selected made it clear that the successful candidate should not think that he had any right of automatic succession to Lindgren's post.

Lindgren died on 22 July 1973, almost immediately after his retirement. He had no obvious successor. During his last months, and almost certainly without his knowledge, a plan was devised to avoid, rather than solve, the problem of the succession. In June Forman had resigned as chairman of governors to return to devoting his energies full-time to Granada and was succeeded by Lord Lloyd of

Hampstead. At his first meeting as chair on 17 July 1973, Lloyd approved a joint proposal from the director and a sub-committee of the board on the future of the curator post, recommending that the post of Curator of the National Film Archive should 'cease to exist in its present form' and that the title 'should be added to that of the Director for formal purposes'. The NFA would be headed by a chief officer whose title would probably, the sub-committee suggested, be Head of Archive. Meanwhile, a separate department would be created to deal with what were to be called member-user services and would include the archive viewing service and documentation (i.e. the BFI's Library and Information services), as well as relations with members and the public more generally. It was recognised that this proposal would have international ramifications and that staff would have to be consulted.

Predictably, the proposal caused a storm, not only in the BFI but also, and especially, with the International Federation of Film Archives (FIAF), which promptly threatened to suspend the BFI from membership – a step that would have badly affected the NFT, which was dependent on FIAF's member archives for its supply of prints. The following February Lucas returned to governors to admit defeat. Because of FIAF's opposition the proposal had to go on hold.

Most of the blame for this ill-considered proposal has tended to fall on Lucas, who was thought to be making an entirely gratuitous bid for power in international circles. In fact, however, the sub-committee was following up a suggestion made in the course of the 1970–71 Policy Review aimed at making the Institute's services to members and other users more coherent and better managed. The downgrading of the curator's post seems to have been an afterthought, provoked by the difficulty of finding a suitable successor for Lindgren.

A 'member-user' department as such was not created either. An internal working party chaired by Leslie Hardcastle to look into the practicalities came down firmly against it and the proposals were shelved. But, as part of a wider reorganisation of the Institute, including the splitting of the Film Services department discussed below, Lucas pressed ahead with the separation of the Library and Information Services from the Archive. Anticipated opposition from FIAF did not materialise and the reorganisation came into effect at the end of 1974.

Meanwhile the BFI had found a suitable successor to Lindgren, in the form of David Francis, formerly the Archive's Television Officer and then at the BBC, where he programmed films for BBC2. In August 1974, however, before Francis could arrive, Lucas had a run-in with Gough-Yates. Lucas accused him of insubordination and, with vigorous support from Hill, summarily dismissed him. This was a quite unnecessary *coup de main*. Gough-Yates may have been difficult to deal with, but his tenure as acting curator was due to expire in a few months time, and matters could have been left to Francis to sort out on arrival (though he might have preferred to arrive unencumbered by a stroppy deputy). Worse, Lucas and Hill had had their fingers burned the preceding year when they had suspended another senior member of staff without checking whether they were following the procedures agreed with the BFI's staff trades union, ASTMS.

Confronted with the high-handed approach of management, the BFI ASTMS branch took the step, unparalleled in an institution like the BFI, of calling its members out on strike. Support for the strike was not solid but it was substantial. Mostly support came from left-wing members of staff, of whom there were a large number, but it was also joined by many archive staff who had no interest in politics but were concerned for the future of the Archive if management had its way. Picket lines were staffed. Film directors including Wim Wenders, Rainer Werner Fassbinder, Margarethe von Trotta and Werner Herzog signed a declaration of support. Otto Preminger sent a message from his suite at the Dorchester Hotel. Vanessa Redgrave turned up on the picket line to canvass for the Trotskyite group the Workers' Revolutionary Party which was solidly embedded in the film and television industries.[24]

Two BFI leftists were conspicuous by their absence. They were Douglas Lowndes, the recently appointed Head of EAS, and Colin McArthur, even more recently appointed Head of Film Availability Services. As members of the BFI's executive committee they could not reasonably have been expected to join in an action directed against a management of which they were part. But their decision not only to stay out of the strike but to cross the picket line rankled with junior staff with stronger trades union loyalties, while the rationale put forward by McArthur in particular was found bizarre. Arguing from a position he regarded as Marxist-Leninist, McArthur maintained that it was more important for him to continue to engage in cultural struggle than to get distracted into the defence of a fellow member of the executive who represented the reactionary position associated with the Reed–Lindgren regime.

9.2 Picket line outside 81 Dean St during the 1974 BFI strike

The strike lasted for two weeks and was finally settled when the Union agreed that the issue should be referred to binding arbitration by the Arbitration and Conciliation Advisory Service (ACAS). The ACAS arbitrator produced a measured judgement which argued that the dismissal of Gough-Yates was lawful but should not have been carried out in the way it was. He also proposed, much to the disgust of Alan Hill, who thought that managers should manage without help or hindrance from bureaucratic fusspots, that the BFI should proceed as soon as possible to the appointment of a senior personnel officer with a rank equivalent to that of the Head of Finance. The BFI duly advertised such a position. The arbitrator himself, Mike Leat, applied for it and became the BFI's first Head of Personnel.

Film Services

Lucas and Hill's other big problem when they came together in 1972 was the lumbering outfit that went under the name of Film Services and was run very much as a personal fiefdom by John Huntley. Film Services was responsible for the BFI's regional operations, for the distribution of films to the film society and educational sectors and for the theatrical distribution of Peter Watkins's *The War Game*. It was not quite as large and lumbering as it had been in the late 1950s and early 1960s, when it had been in charge of the NFT and of Film Appreciation and Education, but it was still the largest department of the Institute in terms of both staff numbers and turnover. It was also notoriously badly run.

Film Services had escaped close scrutiny from the board of governors in the 1970 Policy Review but the Finance Sub-Committee had begun an investigation of its structure and finances in 1971. When Alan Hill came in as deputy director this task was delegated to him and he reported to governors in February 1973 with a number of organisational recommendations. Hill proposed rationalising the system for booking films for the NFT, RFTs and the BFI's film society and other clients and limiting the BFI's own library of films for distribution to films on the 'art and history of the cinema' – presumably meaning thereby that the films that Huntley had collected for the delectation of railway enthusiasts and the like should no longer be given valuable house room by the BFI.

What Hill did not report to governors (although it was already well known to the chairman) was the widespread sense of unease about the management of the whole operation and the lack of accountability in the way business was conducted. The KRS, which had premises in the same building as Huntley's office, had expressed concern about the possible illegal copying by the BFI of films which were its members' property. On 18 December 1972 the KRS lawyer, Bobby Furber of Clifford Turner (by coincidence also the lawyer for the BFI), wrote to Forman referring to 'steps' the BFI was taking to assuage his organisation's concerns. These steps were the setting up by Hill and Lucas of an ad hoc 'Film Investigation Committee' to investigate a situation where there was undoubted mismanagement and possible fraud.[25] What they found was chaos, but no conclusive evidence of

criminal wrongdoing. Films were scattered around the Institute's premises which were not entered on any register and it was often unclear who they belonged to or how they had been acquired, but there was no proof that their acquisition had been unlawful. Besides Huntley, various members of staff were interviewed and the committee, which suspected but could not prove wrongdoing, issued some low-key recommendations aimed at ensuring that in future the only films to be housed in Film Services were those that were legitimately in the BFI's distribution catalogue; all other films should be returned to their owners or sent for safekeeping to the NFA.

Before these recommendations could be fully implemented, however, the BFI's administrative officer, Fred Gee, discovered in Huntley's office in Royalty House over 1,400 cans of assorted films, of which 188 were on nitrate stock and constituted a safety hazard. For Lucas this was the last straw. He summoned Huntley to his office and, with Hill present as a witness, confronted Huntley with the evidence and summarily suspended him from his duties.

Lucas's action was precipitate and in violation of the procedural agreement which the BFI had recently signed with ASTMS, of which Huntley was a member. With ASTMS backing, Huntley argued that he should not have been suspended without being given a chance to defend himself and without a formal warning having previously been issued. Lucas was forced to withdraw the suspension until a settlement was worked out. Under this settlement, whose exact terms were never divulged, Huntley agreed to take retirement and a condition was imposed that neither party would comment publicly in the reasons why he had done so. On 23 November 1973,[26] Hill informed James Christie of the Governors' Finance Sub-Committee that agreement had been reached and Lucas issued a terse memo to staff saying, 'I have today lifted the suspension on John Huntley. Mr Huntley has indicated his wish to retire from his Institute post and I have accordingly made the necessary arrangements. The acting Heads of Departments in Film Services and Regions will continue until further notice.'

This was not the end of the matter. As time went on, various issues came to light confirming that the Institute had been right in its suspicions of illegal activity but it stuck to its part of the bargain and made no further public statement.[27] Huntley, however, continued to feel he had been unfairly treated and in 1974 put himself forward for election as a member governor. The previous year Garnham had submitted himself for re-election and been elected. In 1974 it was Jenkinson's turn and he too submitted himself and was re-elected by a sizeable majority. Since Huntley and Jenkinson were competing for the same section of the vote and Jenkinson was a popular TV personality the issue was never in doubt, but Huntley still polled a respectable 560 votes to Jenkinson's 1,197, with the 'art cinema' candidate Jan Dawson and Felicity Grant from SEFT trailing in his wake. In 1975 Huntley tried again and this time came top of the poll, ahead of Garnham who was again seeking re-election. This put the Institute in a quandary. Neither the governors nor the management wanted him to be on the board, but it would not be easy

to block his appointment without revealing the reason why, which the Institute was honour-bound not to do. The matter was therefore referred to the Minister, Hugh Jenkins (a Labour government had meanwhile returned to power), who agreed with the Institute's view that Huntley's appointment should be blocked. But a rationale had to be found and it was decided to state as a matter of principle that recently retired senior members of BFI staff should not be allowed to serve on the board and Jenkins wrote to Huntley to that effect.[28] Since this rationale was produced only after the event, Huntley felt even more aggrieved and protested publicly both to the Minister and through the medium of the Institute's newsletter, *BFI News*.[29] But the Minister held firm and appointed Garnham instead.

Rebuffed in 1975, Huntley tried again in 1976 and 1977. By now there were different ministers and different chairs of governors, but the result was the same. The BFI remained constrained by its promise not to say anything about why it regarded Huntley as unsuitable to be on the board. Then in 1978 the new incoming chairman, Sir Basil Engholm, sought renewed legal advice both from the Institute's lawyers and from the legal team at the DES. Out of this advice Engholm formed the conclusion that nothing less than a change to the BFI's constitution would be required if problems of this kind were not to recur in future. The result of this, further down the line and dealt with in Chapter 10, was the BFI's application for a Royal Charter.

Inside the BFI as well, Huntley's legacy was not easily disposed of, and it was clear to Lucas and Hill even before the time Huntley was forced out that a massive operation would be needed to cleanse the Augean stables of Film Services, not to mention making sense of the increasingly haphazard regional operation over which he had presided since its inception in 1964. It was therefore decided to split the department into two and advertise for heads of two newly created departments, to be called Film Availability Services (FAS) and Regional Department.

For the Regional Department Lucas and Hill selected Alan Knowles, then films officer with Northern Arts. Knowles was to interpret his brief fairly narrowly – some would say unimaginatively – in terms of the 1971 Policy Review, encouraging the devolution of the RFTs to local control. This was soon to bring him into conflict with Colin McArthur, appointed around the same time to run FAS.[30]

Financial problems

By the end of 1974, Lucas finally had in place a new executive team. Besides himself and Hill, this consisted of Leslie Hardcastle at the NFT, David Francis as curator of the NFA, Brenda Davies promoted to be head of the newly free-standing Library and Information Services, Penelope Houston in Editorial, Alan Knowles in Regions, Colin McArthur at FAS, Douglas Lowndes in EAS, with Barrie Gavin (replacing Mamoun Hassan, who in turn had replaced Bruce Beresford) at the Production Board. Gavin was to leave in September 1975, to be replaced by his deputy, Peter Sainsbury, and Lowndes left at the end of 1976, leaving a vacancy in

The 1970s

9.3 Structure of the BFI in 1974 (BFI)

EAS that remained unfilled for over a year; but the rest of the team continued to be in place to the end of the decade and in many cases beyond.

Just as the team was beginning to settle, however, the BFI encountered one more crisis, this time on the finance side. At the end of the 1973/74 financial year, the DES had called both the BFI and the Arts Council to task over their accounting practices, which were of a kind regular (and indeed statutory) in commercial firms but not in accord with Treasury rules for governmental bodies. The BFI was not overspending; on the contrary it was prudently underspent, having held back money to cover outstanding financial commitments. Not very much was at stake the first time around, and the problem was resolved by compromise. But in 1975 the problem recurred. This time the sum of money involved was considerable and the DES was in no mood for compromise. In February 1975 the DES wrote to Hill demanding a breakdown of the BFI's remaining expenditure for the year and threatening to withhold the last instalment of the BFI's grant if it did not receive a satisfactory explanation.[31] Supported by Lloyd and Camplin, Hill argued that all the money was in fact committed according to commercial accounting rules and the BFI would be technically insolvent if the grant was withheld. This argument cut no ice with the DES and the matter was referred to the minister, Hugh Jenkins, who summoned Hill, Lloyd and Camplin to a series of meetings to account for their unwillingness to accept the DES/Treasury way of doing things. At the last of the meetings, just before the end of the financial year, Jenkins told Lloyd (Hill had been asked to wait outside the door) that £157,000 would be withheld from the BFI's grant the following year, though some or all of it might be returned on a parliamentary revote if the BFI fell into line.[32]

When this happened Lucas was away on a short holiday. He returned to find the Institute in turmoil, which fortunately did not last for long. Feeling himself abandoned by the governors, who up to the last moment had appeared supportive, Hill decided he had no alternative but to resign, which he did on 1 April 1975. But he was not asked to pack his bags and leave in disgrace. On the contrary, he stayed on until September, to give the governors time for a successor to be found and to take up the position. During this period he oversaw the preparation of an emergency budget, which in fact did not have to be acted on since two-thirds of the money the government had taken away was restored on a parliamentary revote during the year. He was able to support McArthur in the first steps of the reform of FAS and to continue the tightening of administrative procedures throughout the BFI. He had been a good deputy director, respected rather than loved. His determination to take a firm line had led to mistakes: stiffening Lucas's resolve over the precipitate suspension of Huntley and the dismissal of Gough-Yates had contributed to the consequent crises, and his approach to the conflict with the DES had lacked finesse. But he left the Institute far stronger than he had found it on arrival in 1972.

Hill's successor was Gerry Rawlinson, a Scotsman and like Hill a qualified chartered accountant. Also like Hill, he understood his task to be that of supporting the director and the executive in the implementation of agreed cultural policies. But in

appointing Rawlinson, the governors also took account of his interest in film and in the arts more generally, and these qualities stood him in good stead when it came to turning policy into practice throughout the organisation.

Inevitably, one of Rawlinson's first tasks when he arrived in October 1975 was reaching agreement with the DES on how to avoid repetition of the previous year's fiasco. The problem areas when it came to spending up budgets were Regions and Production. For the Regions, Rawlinson simply had to get the Regional Arts Associations and other clients to claim their grants as soon as possible, which they were always happy to do since it suited them to have cash in hand. In the case of Production, Rawlinson insisted that the Production Board made its major spending commitments early in the financial year, and then when it came to the year end as much money had been spent up as possible. But film production inevitably suffered from delays and a technical solution was still needed for the problem of money committed but not actually spent. Here Rawlinson decided that the technical scruples which had forced Hill to try to produce a perfect match between commercial accounting and Treasury rules were simply out of place. It was not necessary, Rawlinson reasoned, to present commitments entered into as (in technical jargon) accruals; if the commitment was binding, the money was as good as spent.[33] Rather surprisingly, given its previous obduracy, the DES accepted this, and the BFI had no further trouble from the government over its spending plans until 1979, when the incoming Conservative government sprang a nasty surprise on the BFI by cutting its grant in mid-year.

In spite of the recurrent crises by which it seemed to be afflicted (and there were more to come as the decade went on), the 1970s were on the whole good years for the BFI. Although the public profile of the organisation as a whole was not distinguished, the departments throve. Both the Conservative (1970–74) and Labour (1974–79) governments, particularly the latter, continued to fund it adequately, if not always generously. The principle by which annual grants were given was that the BFI (and similar bodies) received more or less unquestioningly enough money to enable them to maintain the same level of activity as in the previous year, allowing for salary increases (decided by the government) and anticipated cost inflation.[34] This was known as standstill. Money for special purposes or for expansion of any activity was classified as growth and would be awarded only at the discretion of the government, and usually with strings attached. The BFI's commercial income also grew, though only slowly. All departments benefited from the favourable financial climate, but most of all Production, the National Film Archive and those dealing with the regions.

Production

The expansion of the Production Board's activities began in 1972. In the middle of 1971, Balcon had advised Forman of his intention to resign, which he did in January 1972. Meanwhile the production officer, Bruce Beresford, returned to

Australia to pursue a career as a film-maker. In January 1972, Beresford's successor, Mamoun Hassan, attended a meeting of governors to argue a passionate case for enough investment to enable the BFI to finance longer films. There was at the time no proper chair of the Production Board, so Denis Forman decided to make it a personal crusade to honour Balcon's legacy by pressuring the government to act. To his delighted surprise, his request for money was granted by the Minister, David Eccles, who awarded an unexpected mid-year boost in government monies for filmmaking. Production budgets then rose steadily between 1972/73 (£84,000) and 1978/79 (£156,000), but this apparent doubling barely kept pace with inflation.

The Archive

The Archive's growth from 1975 onwards was triggered by a disastrous explosion which took place at a chemical plant near the Humberside village of Flixborough on 1 June 1974, killing 28 people. This forced a government review of the dangers of hazardous chemicals of all sorts, including nitrate film. It had always been known that the cellulose nitrate used for cinema films was a dangerous substance, liable to catch fire and even explode if precautions were not taken, and the major manufacturer, Kodak, had phased out its use for new films and prints as early as 1950. But the Archive retained a huge stock of earlier nitrate films which were subject not only to the danger of explosion but also to decay. When disaster struck at Flixborough, the government was more than amenable to accepting the BFI's proposal for duplication on to acetate (safety) stock of all its nitrate holdings likely to be subject to decay. A 24–year programme was put under way, which not only reduced the fire hazard (since the original film, once duplicated, could simply be put away in safe storage) but considerably increased the number of prints available for viewing. Lindgren's policy (followed by all subsequent curators) had been that no prints could be screened unless the Archive possessed either a back-up copy or adequate materials from which a copy could be generated. Under the duplication programme, every nitrate print was copied first as a negative and a positive was then made for control purposes. Since in many cases these check-prints, as they were called, could also be projected if required, many thousands of viewing prints were added to the collection throughout the 1970s and 1980s. Whereas in 1971 only three thousand items (including newsreels) were available for viewing, by the time the NFA published its *Catalogue of Viewing Copies* in 1985 the number had grown to eight thousand (excluding newsreels but including some TV material preserved on film or videotape).

The regions

By 1979 the combined budgets of FAS and the Regional Department had reached over £1 million, of which £400,000 was spent actually in the regions, in the forms of grants to RAAs and RFTs, and most of the remainder for the benefit of filmgoers

outside London. There were, however, deep disagreements on how this money could best be spent. These disagreements dated back to the time of the first wave of regional spending in the mid-1960s when the Institute found itself handing over large sums of money to client organisation with very little control over how it would be spent. During Huntley's time as Regional Controller this question had been submerged under other more pressing concerns but the Members Action Committee was not alone in denouncing the majority of the Regional Film Theatres as little more than highly subsidised film societies which added little to genuine cultural life in their region.

When McArthur arrived at FAS in 1974 he was determined to change this state of affairs. First, however, he needed to make the department's work in general more effective. Coinciding with a move to new premises, there was a massive clearout of undistributable films. The system of film bookings was rationalised, with Nigel Algar from The Other Cinema brought in to revamp *Films on Offer*, the Central Booking Agency's invaluable guide to the availability of films from distributors, and David Meeker being released to concentrate on bookings for the NFT, which had doubled in number since the opening of NFT2 in 1970. McArthur also commissioned a new informative catalogue of the BFI's own distribution library,[35] which was expanded to take in a range of new acquisitions selected to ensure that film societies, RFTs and other customers could have access to a wide range of films thought essential to forming a proper film culture nationally. Some of these acquisitions were curious, notably the extensive selection of films from the Third Reich, which were brought into the collection mainly as objects of ideological curiosity, but most of the other choices were down-the-line mainstream.

More controversial were McArthur's plans for the regional constituency. He carved out room in the department for a team of regional programme advisers, headed by Ian Christie, which did not merely book films for the RFTs but offered advice and support to the theatres on what to programme. Christie had been a lecturer at Derby College of Art and had first-hand experience of the limitations of what was being done for film culture in the regions. McArthur and Christie used a mixture of carrots and sticks to promote what they called 'structured programming' in the regional venues they were in a position to influence, offering packages of programmes which would give audiences insight into major areas of cinema and ideas through which to conceptualise them. Not all RFT programmers welcomed these initiatives. They were happy with the efficient booking service provided by the BFI but tended to think that they knew better than their BFI advisers what would go down well with local audiences. And while 'structured programming' made sense to a lot of them, the other slogan launched at the same time, 'key debates', had an air of cultural authoritarianism to it which some found positively offensive.

Most of the support for regional activities, however, was channelled through the Regional Department under Alan Knowles. This was the department which gave grants to the Regional Arts Associations and other BFI clients and looked after the physical and technical side of the RFT operations. Knowles and his

deputy, Richard Rhodes, wished to have no truck with FAS's policy of targeting programme support to venues which accepted BFI guidance on how programmes might be structured. In this they had the backing of many of their regional clients who were resentful of what they saw as an attempt by the BFI to dictate policy. News of regional discontent reached the ears of the governors and this was to contribute to a final crisis of Keith Lucas's tenure in 1977.

The final crisis

In spite of efforts by EAS and by McArthur to change the cultural focus of the BFI's work, its core constituency remained a membership wedded to the values of art cinema. The NFT, now programmed by Ken Wlaschin, continued to flourish in a favourable cultural climate. Membership was on a rising curve. *Sight and Sound* circulation remained close to the peak of 34,000 reached in 1974. The Archive was benefiting from the attention given to the nitrate programme, which began to take effect in 1976. Education had recovered from the shock of the 1970 crisis and Whannel's resignation and was in fact carrying out Whannel's policies even though their initiator was no longer present, continuing to issue publications and to plan innovations to the curriculum.[36] The devolution of SEFT from the Education Department engineered by Forman gave space for radical initiatives in film culture to take place with tacit BFI support but without the BFI being held directly responsible for any wilder 'excesses'.[37] Thanks mainly to SEFT, the new discipline of film studies was in the vanguard of embracing semiotic theories of culture, way ahead of other humanities disciplines. Departmental successes, however, were offset by the effects of internal divisions with the Institute which were proving harder and harder to contain.

Basically these divisions were on a left–right axis, which was also one between centralisers and devolutionists. The self-styled 'left' was represented on the executive by Peter Sainsbury from Production, Colin McArthur from FAS and Douglas Lowndes from EAS. Opposing them – but indignantly refusing to let themselves be called the 'right' – were the other heads of department, David Francis at the NFA, Leslie Hardcastle at the NFT, Brenda Davies from Information, Penelope Houston at Editorial, and Alan Knowles from Regional.

Faced with these divisions, Lucas struggled to find sufficient elements of consensus to enable him to formulate a coherent policy for the Institute. The middle-of-the-road members of the executive were not much help to him in this, since they were all far more interested in running their own patch (which they mostly did very well) than in policy in general, except to the extent that they hoped it would be flexible and accommodating to their interests. The 'left' favoured strong and assertive policies, but of a kind with which Lucas was not instinctively in sympathy and which could not be enacted without damaging controversy.

Midway through 1976, Lloyd announced he was standing down as BFI chairman. His successor was John Freeman, well-known broadcaster and chairman of London

Weekend Television (LWT). He was due to take over at the BFI in October and Lucas hit on the idea of holding an extended joint meeting of the executive and the governors to thrash out the problems facing the BFI to coincide with his arrival. It might be a baptism of fire for the new chairman but it was also thought that Freeman was someone who, if given a taste of the problems he faced, would have the intellectual grasp and the decisiveness to do something about them.

The meeting was held on 20 and 21 October 1976 and appears to have been partly modelled on the away weekend organised by Reed and Coldstream as part of the Policy Review in 1970. A full transcript of the proceedings survives,[38] from which it is clear that discussion was full and frank, but on the BFI officers' side sharply polarised, with some governors present attempting to mediate and Freeman somewhat bemused. Matters discussed included the consequences for the BFI and the Production Board of the *Juvenile Liaison* débâcle described by Christophe Dupin in Chapter 11 and the government's plans for a British Film Authority, and there were brief mentions of two things that were to come to fruition in the 1980s, a cinema museum and a Royal Charter for the Institute. But the bulk of the discussion was taken up by the issue of centralisation/devolution (also formulated as unity/diversity and initiation/response). Inevitably the focus was on regional policy but the discussion also concerned the BFI itself. The centralists, led by McArthur, argued that there needed to be a firm set of cultural policies emanating from the centre and that departments should then formulate firm policies of their own in line with what the centre had decided. Other members of the executive, however, thought that departmental activities should be aligned more loosely with what were recognised to be the BFI's cultural *priorities* which each department could pursue in its own way. The meeting broke up with nothing decided but a clear sense that the issues at stake had to be resolved, probably by an imposed compromise. The question was: would the resolution hold?

The year 1977 kicked off with a report to governors in February by Lady Casson recommending wholesale devolution of BFI film activities to the RAAs. Lucas was sceptical about this and on this occasion received backing from the governors. On the wider issue of centralisation of policy raised at the away weekend, governors in May gave further qualified support for Lucas's middle-of-the-road position, recognising that the BFI had to make choices and establish priorities but that over-centralisation was impossible given that different BFI departments were differently answerable to outside constituencies. They then argued, ominously, that the director could not just be told to 'occupy the middle ground' if the result was ineffective compromise. The matter stood there until November, when Lucas was to make a final attempt to resolve at governors the conflict between the Regional Department and FAS that he was unable to resolve internally. Attention meanwhile switched back to the looming question of the Film Authority and to the continuing fallout from the *Juvenile Liaison* affair, where Lucas was trying to reassert BFI control over the Production Board and Peter Sainsbury, as head of the Production Department, was engaged in a separate struggle to reduce the Board's grip

on project selection. In the battle over film production, Sainsbury was to get his way and so to some extent was Lucas. The Board retained its independence as final arbiter of which projects were to be supported, but in other respects its powers were much reduced. Were there to be another *Juvenile Liaison* affair, it would not be able to defy the BFI as many on the Board, notably the film-maker Mike Dibb and journalist Peter Lennon, had argued.

Of the principal issues facing the BFI, that concerning the proposed British Film Authority was the least anguished, but also the one with the most significant possible consequences for the Institute. In August 1975 the prime minister, Harold Wilson, had set up a small Working Party, chaired by John Terry, managing director of the National Film Finance Corporation (NFFC), to 'consider the requirements of a viable and prosperous British film industry over the next decade'. Terry reported in January 1976 with a recommendation to set up a British Film Authority to co-ordinate the activities of the two government departments with responsibilities for film matters, the DES and Department of Trade, and those of the principal funding bodies, the British Film Fund Agency and the NFFC itself.[39] The implications for the BFI were considerable, but it was not represented either on the Working Party or on its successor, the Interim Action Committee. If the Committee, dominated as it was by trade interests, came up with a plan simply to reorganise film finance, the BFI would not be that seriously affected, but it might have missed an opportunity to push forward cultural initiatives in relation to British cinema which under the present dispensation it was powerless to do. If, on the other hand, the Committee were to recommend merging responsibility for all film matters under a single ministry, rather on the model of the Centre National de la Cinématographie in France, the BFI's independence as a purely cultural body, responsible for the National Film Archive, would be threatened. On the governors, Garnham argued firmly for an interventionist stance and the BFI's inclusion under the Authority, but on the whole caution prevailed. The BFI's submission to the Working Party was balanced and well presented but contained no killer arguments either in favour of the BFI's continuing independence or in favour of the role it could play within the Authority. When the Committee reported in 1978,[40] it was decided to leave the BFI outside and its only mention of BFI activities (though a very welcome one) was a supportive paragraph about the Archive and a generic recommendation in favour of statutory deposit. Depending on your point of view, either the BFI had been saved or a golden opportunity had been missed. The whole idea of a British Film Authority was in fact shelved in 1979 when the Conservatives came to power, so it wouldn't have made much difference in the longer term, but in the immediate the BFI's indecision on the issue was to cost Lucas dear.

In the summer of 1977 a crisis at LWT led Freeman to hand over the reins at the BFI to Enid Wistrich, while retaining his place as an ordinary member of the board. Wistrich took over as acting chair in September and chaired the crucial meeting in November when the regional issue returned to the agenda. Both the Regional Department and FAS presented papers, as did Lucas. Lucas's paper made a number

of sensible recommendations, endorsing the principle of 'structured programming' but insisting it should be advisory, not an imposition. Governors were favourable to Lucas's proposals but fell short of unequivocal endorsement, so the matter was referred for further debate in January. By this time, however, Lucas's position had become untenable. A small group of governors, led by Garnham, dissatisfied by his failure to deal decisively with crucial issues facing the Institute, was agitating for his dismissal. The board met in a closed session and Wistrich decided to wield the axe. Lucas accepted a formulation whereby he would agree to resign 'in the interests of the efficiency of the organisation'. Severance terms were agreed and ratified by the board in December 1977. At its January 1978 meeting, the board discreetly took note of the need to open a selection process for a new director.

Asked to take over as acting director during the search for a replacement, Rawlinson agreed but insisted that Lucas should be given at least six months' notice to allow an orderly transition.[41] Lucas in fact stayed on until the end of August 1978. He succeeded to some extent in damping down the tensions between Regional and FAS. He appointed me to the headship of EAS, where Jim Hillier had been acting head since the departure of Douglas Lowndes in 1976. And generally the Institute enjoyed a relative calm, which continued to reign when Rawlinson took over in September.

While Lucas's indecision over crunch issues was the direct cause of his downfall, it has to be said that he was put in a very difficult position by the attitude of the 'barons' running the major BFI departments, who consistently pursued their sectional interests over those of the Institute as a whole. On the executive, only McArthur argued consistently for coherent Institute policies across the board and offered constructive advice as to how they might be pursued. Unfortunately, this advice, although constructively offered, could only have led to destructive results and hastened, rather than deferred, Lucas's downfall.

Interregnum

Needless to say, the civil service was very concerned to limit the fallout from the defenestration of the BFI's director, but its interventions were discreet. Rawlinson noted at the time that Walter Ulrich, the senior DES assessor for the BFI, pressed on Enid Wistrich the need to make it clear in all public statements that Lucas had not resigned under pressure (although in fact he had),[42] and the paper trail was kept to a minimum. More importantly, the civil servants busied themselves to find a new permanent chairman for the Institute, and decided to impose one of their own.

The new chairman, appointed in the summer of 1978, was Sir Basil Engholm, recently retired as permanent secretary at the Ministry of Agriculture and Fisheries where he had established a reputation for resolute but tactful diplomacy. He was also a great supporter of the arts, though of a very traditional kind. His appointment was greeted with some trepidation inside the BFI – groundlessly as it turned out, since during his short tenure he proved to be an effective and respected chair.

Engholm interpreted his role as helping Rawlinson run the BFI while putting in train a search for a suitable successor. But his was not merely a holding operation. He encouraged Leslie Hardcastle to bring to governors his still tentative plans for a cinema museum in April 1979, and in September, following Margaret Thatcher's election as prime minister, he established a committee, chaired by the TV mogul Howard Thomas, to find ways of raising commercial sponsorship for the BFI. Engholm also helped to sort out the small but tricky issue of the BFI's role vis-à-vis the film society movement by splitting the British Federation of Film Societies (BFFS) into two parts: on the one hand a volunteer body which retained its independence under the BFFS banner, and a small Film Societies Unit inside the BFI, which handled day-to-day business in collaboration with BFI officers but formally reported to its original parent.

Among candidates for the succession, Garnham stood out as someone with a clear vision for the BFI and the force of character to realise it. But his role in leading the regicides played against him and the choice fell on an unknown outsider, Ted Perry, an academic from a small liberal arts college in Vermont. Perry accepted but shortly afterwards was forced to withdraw for family reasons. In the middle of 1979, nearly a year after Lucas's departure and 18 months since he had first submitted his resignation, it was back to square one.

This time, however, the BFI was to get its man. His name was Anthony Smith. He was a former BBC producer, now a research fellow at St Antony's College, Oxford, and the architect of the model that was to be adopted for the new Channel 4 Television. On entering the boardroom to be interviewed, Smith found it 'full of my enemies' – that is to say, the heads of the television companies whose attempts to make Channel 4 an appendage of ITV had been trumped by Smith's proposals for an independent and genuinely innovative broadcaster.[43] Putting old enmities to one side, the board appointed him in June 1979. The path was open for a great revival in the BFI's fortunes – particularly its public profile and its finances – in the 1980s.

Notes

1. Handwritten note, undated, preserved in BFI/Balcon/K–48.
2. Report by Sheila Whitaker to the Staff Association, 23 March 1971. In BFI/19.
3. Denis Forman, *Persona Granada: Some Memories of Sidney Bernskin and the Early Days of Independent Television* (London: André Deutsch, 1997), p. 268.
4. Governors Minutes, 18 May 1971.
5. *Policy Report* (BFI, 1971), p. 7.
6. For a fuller account of developments in Education see Terry Bolas, in Chapter 8.
7. Reported in BFI Governors Minutes, 20 April 1971.
8. Governors Minutes, 18 May 1971.
9. *Screen* 12:3, Autumn 1971.
10. Lindgren's letter is preserved in BFI/19 and BFI/71. As late as January 1972, when Forman was trying to calm things down, Lindgren was still continuing the battle. Asked to provide a briefing paper for a projected meeting between the minister and

the Action Committee, he resumed the history of the dispute, affirming roundly that the Briggs committee had been set up specifically to counter the subversive activity of past and present Education staff and declaring that it is 'our view that the Members Action Group is politically motivated with the desire to dismember the BFI in order to use parts of it (the Regional Theatres, the Distribution Library and the Production Board) as starting points for nationalisation and workers' control of the film industry' ('Draft Skeleton Briefing for Minister', 13 January 1972, paras 9–10 and 11. Copy in BFI/19).

11 Letter to Michael Balcon, 27 October 1971, BFI/Balcon/K47.
12 *Persona Granada*, p. 270. Daniel Cohn-Bendit was a leader of the French student movement in 1968, widely known as 'Danny the Red'. Later he became a German MEP for the Green movement, becoming known as 'Danny the Green'. The term 'semiology' (originating with the Swiss linguist Ferdinand de Saussure and popularised by Roland Barthes in the 1960s) was replaced by 'semiotics' in the late 1970s.
13 The civil service department dealing with the BFI continued to be the DES, but the Institute was spared direct dependence on the Secretary of State for Education, a certain Margaret Thatcher. Meanwhile Ian Thom, the DES assessor for the BFI, had made it clear to governors in 1970 that a strict interpretation of budgetary standstill was to be applied and the Institute could expect no favours.
14 GNS interview with Alan Hill, 24 April 2006.
15 Two former Education staff commented on this, Jim Pines in *Time Out* on 24 December 1971 and Alan Lovell to a letter to Paddy Whannel in April 1972 (personal collection of Garry Whannel).
16 *Guardian*, 31 August 1972.
17 At the 1970 AGM more votes had been cast in favour of the dismissal of Davis than any other governor and fewest for the dismissal of Kevin Brownlow. Since by some apparent oversight Brownlow's appointment was the only one not to be renewed or reconfirmed in 1971, there were mutterings of conspiracy. In fact Brownlow had no intention of serving a further term (email Brownlow to GNS, 18 February 2008).
18 The new governors appointed at the same time were the film-maker Barney Platts-Mills, Gerald Croasdell from Actors' Equity, Judi Dench, and Neil Duncan. In order to shorten the tenure of governors Forman had been forced to sacrifice his wife Helen, who in fact left the board before Davis.
19 Details in BFI/D-86/9. The minutes of the February 1971 meeting are preserved in the official minute book.
20 *Persona Granada*, p. 269. When I put this to Forman in 2004, his reply was curt: 'Better Sandy drunk than most people sober' (interview CD/GNS, 22 October 2004).
21 GNS interview with Keith Lucas, 20 December 2005.
22 In 1981 the Archive made a short film about itself for mainly internal use, under the title 'The Four-Site Saga'.
23 Ford then went to the Science Museum and became the first director of the newly created National Museum of Film, Photography and Television in Bradford.
24 BFI/105. Preminger's support was secured by the then deputy editor of the *MFB*, Jonathan Rosenbaum (email to GNS, 9 November 2007). Other outside supporters included Glenda Jackson and (predictably) Tony Garnett and Ken Loach.
25 Papers in BFI/D-86/1 and 2.
26 The letter is dated 23 October but this is almost certainly a typing error. This letter and other documents on Huntley's suspension are to be found in BFI/D-86/4.
27 BFI/D-86/4.
28 Letter dated 11 December 1975: 'After taking into account that you were until recently a senior official of the Institute I have come to the conclusion that it would not be

appropriate for you to be appointed a Governor.' See Hugh Jenkins, *The Culture Gap* (London: Marion Boyars, 1979), p. 132. By his own account, Jenkins seems to have both promulgated the rule and indicated to Huntley that he had doubts about it, thereby encouraging Huntley to continue to flout it.

29 *BFI News*, March 1976.
30 Hill had wanted Alan Howden, senior film programmer for BFI television and active in the film society movement, for the FAS post, but Howden turned down the suggestion on the grounds (*inter alia*) that he did not want to leave the BBC at the same time as David Francis, recently appointed curator of the NFA. Had Howden been appointed, the development of the BFI in the 1970s would have been very different (GNS interview with Alan Howden, 26 March 2008).
31 Sources: Minutes of the Governors Finance Sub-Committee; GNS interview with Alan Hill, 24 April 2006.
32 Jenkins, *The Culture Gap*, pp. 127–8.
33 GNS interview with Gerry Rawlinson, 25 October 2006.
34 Inflation was generally reckoned across the board, but, if it was exceptionally high in a particular area, allowance could be made. This was very important for the Archive in the 1970s when market speculation led to a quadrupling of the price of silver, an essential component of film stock, just as it was embarking on its nitrate preservation programme.
35 *BFI Distribution Catalogue 1978*, edited by Julian Petley.
36 Although the department had been deprived of its input into the Cinema One series, it found other ways of pursuing a publications programme, both with (modest) internal resources (e.g. the Television Monographs, started by Christopher Williams) and through collaborations with the publishers Routledge and Macmillan (Ed Buscombe). The government's Humanities Curriculum Project also provided support for curriculum development and money was found for seeding film teaching in universities. For more on education in the period see Terry Bolas in Chapter 8.
37 The status given to SEFT was as a 'grant-in-aid' body. It had its own constitution and governance but the bulk of its income came from its regular grant from the BFI, which was in its turn a grant-in-aid body of the DES. Similar grant-in-aid status was enjoyed by the British Universities Film Council (BUFC) and by the British Federation of Film Societies (BFFS). Both SEFT and BFFS were 'grass-roots' organisations whose activities the BFI thought it ought to support but not to control. BUFC (later BUFVC – V standing for Video) was more professional. It offered universities (all departments, not just film studies) the sort of service the BFI had set out to provide for education in its original incarnation but had been more or less abandoned after the 1949 reforms.
38 BFI/G-41.
39 *The Future of the British Film Industry: Report of the Prime Minister's Working Party*. Cmnd. 6372, 1976.
40 *Proposals for the Setting Up of a British Film Authority: Report of the Interim Action Committee*. Cmnd. 7071, 1978.
41 Rawlinson memo to Wistrich, 30 November 1977, in BFI/D-86/9.
42 Rawlinson, handwritten notes in BFI/D-86/9.
43 GNS interview with Anthony Smith, 24 February 2006.

10

The Smith years

Geoffrey Nowell-Smith

The whole process of Anthony Smith's appointment as director of the BFI had taken place at lightning speed, with barely a couple of weeks elapsing between his first hearing about the vacancy, putting in an application, and being interviewed, offered the job and accepting it. But he had a number of commitments on his plate, including a contract with Faber and Faber for a book the manuscript of which was due in six months' time. He therefore asked for his entry into office not to take place until November 1979, as he did not honestly think he could both run the Institute and fulfil his other commitments on time as promised. This did not mean that he blanked his future employment out of his mind. He held a number of meetings with Gerry Rawlinson and invited all the heads of department one by one to his flat in Albany, just off Piccadilly, to get a sense of who they were and what they thought they were up to. Word soon trickled out that, with one or two exceptions, he had formed a favourable impression of the people he would be working with. He also got the sense that the BFI was generally an organisation that knew what it was doing and did it well and was not in need of root-and-branch reorganisation and massive changes of personnel. On the other hand, if the organisation was doing as good a job as it appeared, why was it that, outside certain rather restricted circles, it seemed to make very little public impact and in so far as it had a wider reputation this was often negative? It was also, senior staff told him, chronically short of money, and far too much time was spent by them not in driving things forward but going round in circles at interminable committee meetings.

Sir Basil Engholm, too, had every reason to be satisfied with the way things were going. The financial settlement for 1979/80 had been satisfactory, with an increase of £900,000 in basic government grant, plus a further boost of £76,000 for the Housing the Cinema Fund, and by November a new director would be in post of whom everyone, from the board downwards, had high hopes. He therefore decided to treat himself to a short holiday in Scotland in early August, including a visit to the BFI Summer School in Stirling, accompanied by his wife. This threw the organisers into a spin, as they were not sure how the couple would take to either the theme of the School ('Realism, Cinema and Cultural Production') or

the choice of films. They need not have worried. Sir Basil found little untoward in the Marxist inflection of the subject matter and Lady Engholm, a former actress, was not overly put out by the lesbian love scene in Chantal Akerman's *Je, tu, il, elle*. But a nasty shock greeted the chairman on his return to London, in the form of a letter from the Office of Arts and Libraries notifying him of a significant cut in the BFI budget for the year. It was known, of course, that the programme of the newly elected Conservative government included strict curbs on public expenditure and the Institute was braced for hard times ahead. But it was quite unprecedented for a new government to make cuts on this scale a full three months into the financial year, when most of the budget was already committed. Emergency meetings were convened, as a result of which the Institute decided to tighten its belt, though not too drastically, and risk running into deficit – thus putting off the problem to the coming year.

In the event, the Institute ended the year with a deficit of £183,000 – uncomfortably large but manageable provided the following year's settlement was not too bad. The real problem, however, was the notice that had been given that future settlements would not necessarily respect the principle that had been in force previously. Throughout the 1960s and 1970s the government grant to the BFI had risen year by year, ensuring that the Institute could both continue with its existing activities ('standstill') and expand in selected strategic areas ('growth'). The principle was an intrinsically conservative one, since it encouraged organisations to think first of all of continuing with the same activities as in the past and only to innovate if extra money was available.

Denis Healey, Labour's outgoing chancellor of the exchequer, was not unaware of the dangerous inflationary spiral to which the government was committed if this pattern remained general throughout the public sector but had not been able to convince his cabinet colleagues of the need to rein back on expenditure. Margaret Thatcher, however, and her chancellor Geoffrey Howe, were determined to push through a radical reform of public expenditure, including the cash-limiting of budgets for grant-in-aid organisations such as the BFI. This did not mean that the BFI ceased to prepare budgets in the way it had always done, but there was now a serious risk that its needs for so-called standstill would no longer be met. Henceforward, if the BFI was not to find its activities cut back it would need to find other means of raising money, either by pursuing a more commercial approach to its services or by raising funds from sponsorship and other non-government sources.

Changes

When Smith arrived on 1 November 1979 he brought a plan of action with him, one which he hoped would be easy to put into operation without serious disruption. The first step, which took effect instantly, was the abolition of the two major internal committees of the Institute, the Executive and the Resources Committee. The Resources Committee was to be renamed Resources Group. It would have

the same composition as before and would continue to be chaired by the deputy director, but it would be advisory and its meetings would not be allowed to drag on into the afternoon as had happened in the 1970s. As for the so-called Executive, it simply ceased to exist. In its place there would be something called Policy Group, which would have no statutory membership (heads of operating departments would normally be expected to attend its meetings, but so might other senior or middle-ranking staff); it would have no standing agenda; and it would not be executive. Instead it would be a forum at which issues would be discussed as and when it seemed important for views to be expressed and a policy formulated. Someone would be asked to write a policy paper; this would be discussed; and at the end of an hour and a half the director would sum up. And that, Smith disarmingly declared, would henceforward be policy. Strictly speaking, of course, the constitutional position remained unchanged. The governors continued to be officially responsible for setting Institute policy, and no major policy changes could take place simply on the basis of a minute drawn up by the director after an hour or so of desultory discussion. But Smith was far too astute a politician to want to enter on a collision course with the board of governors on such a flimsy basis and no changes of policy decided internally were put into effect without the proposal discussed at policy group being reformulated and presented to the board.

Smith also announced some organisational changes, which in the nature of things took slightly longer to put into practice. As he saw it, the existing structure,

10.1 Anthony Smith, BFI director from 1979 to 1988

with a number of departments nominally of equal status but in practice of very different size and clout, was a bit like a United Nations in miniature. However many votes the smaller departments possessed, their interests could always be pushed aside in the interest of the superpowers, which in the BFI were the National Film Archive and the National Film Theatre. In any given year, either of those mega-departments could easily underperform against budget by a sum equal to the entire spending allowance of the Library for new books or EAS's allocation for the annual Summer School and other events. There was also a problem caused by the total lack of synergy, sometimes amounting to positive mutual obstruction, between the Regional Department under Alan Knowles and Colin McArthur's FAS. Meanwhile there was a similar, if less destructive, lack of fit between Editorial and EAS when it came to publications, where most of the initiatives came from the education side but budget decisions, at least nominally, were in the hands of Editorial.

Smith therefore decided to reshape the operating departments as five 'Divisions' of more or less equal size. The NFT and Production remained as they were, as did the Archive subject to one small change. But the Regional Department, responsible for the bricks-and-mortar side of support to regional activities, ceased to exist as such and its activities were incorporated into Film Availability Services, renamed Distribution Division. Alan Knowles's post now became redundant. Barrie Ellis-Jones stepped up to head what became known as the Projects Unit in the newly configured division, carrying out broadly the same spectrum of activities as had previously been performed by the Regional Department. Although Ellis-Jones did not always see eye to eye with McArthur or with Ian Christie in the Programming Unit, relations were to prove more harmonious and productive than in the former dispensation. Meanwhile Knowles was entrusted by Smith with a highly specific project: to develop a film and media centre in Manchester, where the BFI had so far failed to implant itself permanently. Denis Forman, by now chairman of Granada Television, had located a site at the rear of the Granada studios suitable for development as a building to house two or even three screens, with an information centre, meeting rooms, a café and a shop.[2] Start-up funding was available, but a lot of intricate diplomacy was needed to bring on board the local authorities and local interest groups. In the end the project came to nothing and it was not until 1985 that Manchester was to acquire a film centre, Cornerhouse, on an alternative site nearer to the city centre.

Information Division

The major initiative, however, was the creation of a brand-new entity, the Information Division, which consisted of three previously independent departments, Information and Documentation (renamed Library Services), Education Advisory Services (renamed Education), and Editorial (renamed Periodicals), plus Stills, Posters and Designs (previously part of the National Film Archive), and a newly

created Publishing Department, which took over the publishing functions previously carried out mainly by EAS and Editorial but also in other parts of the Institute which produced publications to enhance their other activities.

In this realignment, Information and Documentation remained unchanged, apart from the change of name (and, arguably, a slight loss of status). Stills, Posters and Designs, however, had to be split, since it was only the front office, housing the access collection and handling sales of copy stills, that became part of the new division, while the preservation of negatives and other original materials and the duplication of stills continued to take place inside the Archive, and for this part of her work Michelle Snapes, in charge of Stills, continued to report to David Francis.

The creation of Publishing involved slightly more disruption, but not very much. Smith had been alerted by Rawlinson to the unsatisfactory state of the Institute's publishing activities and had read the report to Resources I had written on the subject in 1979. It was also his conviction that the sort of institute he intended to lead needed to have a publishing programme that was visibly at the forefront of film and television thinking and scholarship. It also needed to be more effective commercially. So I was moved across from Education to head the new department and Philip Simpson was promoted from deputy to become the new Head of Education. The inter-departmental Occasional Publications Committee which handled the Television Monographs and other BFI books was dissolved and its chair, David Wilson, who was also deputy editor of *Sight and Sound*, was brought into Publishing with the title of Chief Editor. The vacancy at *Sight and Sound* was filled by John Pym. Two members of Education staff, Ed Buscombe and Angela Martin, also moved across. Marketing and production functions were to be shared with Periodicals – an arrangement which led to occasional friction, but nothing serious.

The task of BFI Publishing, as it came to be called, was dual. On the one hand it was expected to build up a list of books which would be professionally produced and marketed through the trade and might eventually be profitable. The existing core of this list was the Occasional Publications, which already enjoyed a good reputation but were hard to obtain in bookshops and were in many cases poorly produced. Already successful books such as Richard Dyer's *Stars* and Ann Kaplan's *Women in Film Noir* were reprinted with new jackets and new, more commercial prices and new books were commissioned, of which the most prestigious was a three-volume edition of Eisenstein. At the same time, however, Publishing had to act as a clearing house for the multifarious publications of other BFI departments – educational materials, catalogues and the like. These had on the whole little likelihood of being profitable, but at least they could be given a reasonably efficient in-house distribution operation. It was in this guise that Publishing handled the distribution of two major departmental publications, Education's *The Cinema Book*, edited by Pam Cook (which did eventually become profitable), and the *Catalogue of Stills, Posters and Designs*, edited by Markku Salmi, which listed under their original titles all the 37,000 films on which the Stills Department held stills or other materials.

Since those 37,000 included practically every film of consequence made between 1895 and 1981, the Stills Catalogue immediately became an invaluable work of reference for scholars looking for a reliable source of reference on the cinema as a whole. Following up an initiative from the Library, Publishing also produced a series called 'BFI Dossiers' designed to support other BFI activities such as NFT seasons. After a while the Dossiers outgrew their original function and became more and more like books, but uncommercial ones, and the series was discontinued.

As for a head for the new division, Smith decided to keep the job for himself, at least for the time being. Publishing and education in particular were seen as vanguard activities for the BFI, but Smith did not want them to be a vanguard that had lost touch with the main army as, arguably, they had done in the 1970s. In the event, it soon became clear that the new division, consisting of disparate bits each of which was capable of running itself, did not really need a full-time head and Smith remained in charge of the division until he left the Institute in 1988. His light-touch leadership, however, enabled the departments to thrive and to co-operate.

The new structure came into effect on 1 April 1980. Very few job descriptions had to be rewritten, but it proved extremely effective in releasing latent energies inside the organisation. Arguments that had become stale ceased to be rehashed, and Smith was free to concentrate his energies on realising his vision of an institute much more in the mainstream of film culture in Britain than it had been (or appeared to be) in the 1970s.

Distribution

This was the only reorganisation carried out by Smith during his nine years at the BFI. In late 1983, however, a more ambitious plan was thought up, but was never put into effect. This came about when Colin McArthur let Smith and Rawlinson know of his intention to seek early retirement. A brief flurry of activity then ensued when a plan was devised to dissolve the Distribution Division and relocate its various functions elsewhere in the Institute. Programming, which was principally concerned with film exhibition, would go to the NFT; the Film and Video Library – inheritor of the old lending section of the National Film Library – would go (or return) to the Archive; the mechanics of despatching films around the country would become part of Central Services; Projects (the erstwhile Regional Department) would report to the deputy director; and the director himself would involve himself directly in the area of theatrical releasing of films by the BFI – an activity that was growing in importance as commercial companies withdrew from the field.

This proposed reorganisation met with almost universal opposition. At the NFT, Leslie Hardcastle objected to being put in charge of an abstract activity known as 'exhibition' as opposed to running a theatre with a life of its own – not to mention planning the projected Museum of the Moving Image. At the NFA, David Francis was concerned about the effect on relations with the trade if the archive

was seen to be engaged in commercial distribution. Inside Distribution itself there were concerns about loss of synergy if activities were broken up. After a flurry of memos throughout November and December 1983, Smith decided to drop the proposal. Distribution was reprieved, with minor changes to its organisation, and Ian Christie was promoted to be its new head.

Once the future of the division was settled the relevant papers were filed away and eventually found their way to the BFI Paperstore in Berkhamsted.[3] It is a pity that their contents were not better known to future managements, since they might have provided an object lesson in how not to reorganise the BFI and how to withdraw gracefully from ill-considered steps to 'restructure' when the existing structure was more than fit for purpose. Meanwhile the abortive proposal had a useful minor side effect. During the period when it was under consideration, the civil service was conducting a review of senior posts in the Institute. The additional tasks outlined for the Curator of the NFA, Controller of the NFT and Deputy Director were a contributory factor in a decision to authorise raising the posts to a higher grade.

Smith, however, continued to have concerns about the division. In 1984, Projects was detached from the rest of the division and renamed Funding and Development, with Ellis-Jones as its head. When, in 1985, Christie took leave of absence to go and teach for a year at the Chicago Art Institute, his temporary replacement, Vincent Porter, was asked by Smith to consider ways in which the division could be rationalised and possibly downscaled, but Smith again appears to have had second thoughts and Porter was never asked for a concrete plan.[4]

When Christie returned, re-invigorated, from his year in the USA, it was to face a crisis absolutely not of his or the BFI's making. Video (more in the form of illegal off-air recordings than in that of legitimate sell-through cassettes) was beginning to make serious inroads into the crucial 16mm market in which the BFI had a major stake. The major handling company in the field, besides the BFI itself, Harris Films, was on the verge of collapse. If 16mm distribution was to survive, something would have to be done, and only the BFI could do it. The BFI therefore put in place a rescue plan. A new, BFI-owned company, Glenbuck Films, was formed to take over Harris's remaining assets, and keep the films in circulation, under the chairmanship of Sid Brooks, a longstanding BFI governor and chairman of the BFFS. Although some governors were sceptical about the idea of the BFI taking over a failing business, not a huge amount of money was at stake and the losses were covered by a donation from the BFI's great benefactor J. Paul Getty.[5] At least for the time being 16mm distribution was therefore saved until it entered nearly terminal decline in the 1990s.

Meanwhile, Funding and Development had become a very different entity from the old Regional Department whose affairs it had inherited. Already in the late 1970s it had begun to shed some of the less viable RFTs and to put resources into larger film and media centres, the first of which, Bristol Watershed, opened in 1982. Meanwhile, in 1981, as part of the deal with Channel 4, money became available to

fund small production centres known as Film Workshops, whose output could be shown on television thanks to a groundbreaking agreement with the principal film and television union ACTT. The workshops set up in the regions were modestly productive but the real successes were scored by the 'ethnic' workshops, notably Sankofa and Black Film and Audio whose films strikingly gave voice to many aspects of the black and Asian experience in Britain. This in turn was massively helped by the Greater London Council under the leadership of Ken Livingstone, but when, in a fit of pique, Margaret Thatcher abolished the GLC, together with the other metropolitan counties, administration of their funds for supporting film and video activity passed to the BFI. A major part of Funding and Development's work thus became devoted to ethnic-based and community activity, serving a very different public than that of the RFTs.[6]

Stability

Although dynamic, the Smith years were remarkably stable. Indeed they would not have been successfully dynamic without this underlying stability. The stability began at the top. Although ministers came and went (Norman St John Stevas from May 1979 to June 1981; Paul Channon to June 1983, Grey Gowrie to September 1985 and Richard Luce to July 1990), the top civil servants at the Office of Arts and Libraries remained the same throughout the period. Richard Wilding was Permanent Secretary, with ultimate responsibility for the arts, libraries and national museums. The BFI and the Arts Council were the specific responsibility of an Assistant Secretary, Rodney Stone, who was a skilful and dedicated defender of the BFI's interests. Overall, neither government nor Parliament felt the need to interfere much in the BFI's affairs, being on the whole far more interested in broadcasting (dealt with by the Home Office) and in the film industry (dealt with by the Department of Trade) than in film culture (a small part of the brief of the Office of Arts and Libraries). In February 1981, however, the BFI was asked to give evidence to the Parliamentary Committee on Education, Science and the Arts, which was investigating public and private arts funding. Questioning by the MPs was somewhat less than probing and a partial interim report in April 1982 made a number of encouraging remarks about the need for more government support for the NFA's nitrate preservation programme and the principle of statutory deposit. But the full report which appeared in October was a shock.[7] Contemptuously brushing aside Smith's and Engholm's arguments in support of the integration of BFI functions from archiving to exhibition to education to production, the report recommended a wholesale breakup of the organisation, with the Archive and the NFT established as separate Trusts and the Production Board merged with the National Film Financial Corporation. Fortunately for the BFI, neither the new Minister, Paul Channon, nor his civil servant advisers showed any inclination to take the committees's recommendations seriously. For Smith, however, the episode gave notice of two things: firstly, an integrated BFI needed to work together harmoniously and

with no weak links; and, secondly, all BFI departments had to be deprived of any reason to want to pursue a separatist agenda.[8]

Meanwhile, before the report came out, Channon gave a lecture at the NFT on 3 February 1982, which was broadcast on BBC2 two days later. This lecture was an initiative of Smith's, and was originally to have been given by Channon's predecessor, Norman St John Stevas. But Stevas was abruptly sacked by Margaret Thatcher at the end of 1981, and Channon gave it instead. The text of the lecture was supplied to the minister by the BFI and consisted largely of an exposition of the BFI's notion of what constituted film culture, plus a few first-person remarks by Channon in his role as Member of Parliament for Southend.

Attenborough

Another key element of stability was provided by the appointment of Sir Richard (later Lord) Attenborough as Chair of Governors at the end of 1981. Engholm had never intended to stay for long. He had been appointed to keep an eye on the BFI as it struggled with the aftermath of a crisis. In fact he did a lot more, but once the crisis was safely over he felt it appropriate to step down. Attenborough proved to be an inspired choice as his replacement. In all his eleven years in office (the longest period served by any BFI chairman) he never really concerned himself with the parts of the BFI that did not interest him. He turned a benevolent blind eye to the less glamorous (and potentially irritating) sides of BFI activity but threw all his weight and flair for show business behind initiatives such as the award of a Royal Charter, a grand dinner at Guildhall and a BFI contribution to British Film Year in 1985. Most crucially, his parallel appointment as deputy chairman of Channel 4 Television, where Smith was also on the board and Jeremy Isaacs, former chair of the BFI Production Board, was chief executive, helped consolidate the deal struck between the Production Board and the new channel in 1981. Smith and Attenborough also took advantage of the opportunity offered by Channon to renew the board of governors. Smith's old enemies from the TV companies retired and in their place came a number of new appointments, notably Matthew Evans, managing director of Faber and Faber, David Gordon, managing editor of the *Economist*, and the film-maker John Boorman. While not afraid to be critical, these three provided powerful support on the board for over a decade. Although Gordon and Boorman both left the board in 1992, Evans stayed on until 1997, playing a significant role in all major decisions taken when first Smith and then Wilf Stevenson were directors of the BFI.

Not all the innovations which changed the public profile of the BFI in the 1980s needed to wait for Attenborough's arrival as chairman. One such innovation was the institution of the BFI Awards.[9] Prior to 1980 the only award given by the BFI was the Sutherland Trophy, awarded annually to the best new film shown at the NFT (in practice the LFF) that year. There was also the Grierson Award for the best short film of the year given by the British Federation of Film Societies. Not

much publicity surrounded the giving of either award. Then, in early 1980, in a rare display of commonality, Colin McArthur and Alan Knowles jointly put forward a proposal for a new BFI Award, to be given, not to a film, but to an event or activity somewhere in the film culture which would otherwise remain invisible. The idea was approved by governors in May 1980, by which time Knowles had left the BFI. The new awards (incorporating the Grierson Award) were initially fairly low-key, with awards being deliberately given to people who worked in the shadows and for whom an award offered a modest glow of publicity. But when the BFI's press officer, Wayne Drew, took over their administration in 1983 the awards ceremony was turned into a spectacular event, held at the NFT, with a budget in 1987 of £23,000. There were inevitable mutterings that this was a waste of public money, but Attenborough was delighted.[10]

The negotiations to give the Institute a Royal Charter were also pushed forward in the first instance by Engholm. The idea was not a new one. It was something the Institute had hoped for from the outset but had been denied by the government both then and again in 1950. Further attempts had been made in the 1960s and 1970s but had to be abandoned in the face of government indifference.[11] In a renewed attempt in 1980 it was Engholm's persistent diplomacy which finally carried the day with the government and indeed the Palace. The moment was

10.2 The Prince of Wales presents the Royal Charter to the BFI chairman Sir Richard Attenborough at a banquet at Guildhall on 5 October 1983

propitious. The Royal Family was enjoying a phase of widespread if not universal public esteem and associating the Prince of Wales (the BFI's patron) and Princess Diana with the enterprise was the decisive masterstroke.[12]

At a symbolic level the benefits were obvious; practically the question was less clear cut. Swapping the BFI's old Aims and Articles of Association and its status as a Company Limited by Guarantee for a new, more embedded constitutional position had an instant advantage for the management of the BFI in that it deprived the membership of the lever of power that been used to such effect in the 1970 crisis. But there was a possible political downside. The members would have to be consulted, and indeed to vote on their own exclusion from power, and it was by no means clear if the sort of people who were members of the BFI would be so bedazzled by the royal connection as to wish to abandon their rights as members for the sake of a piece of parchment signed by Her Majesty. In the event they did vote in favour by a satisfactory majority, At the 1981 AGM, Engholm announced he was calling a postal vote: the results, announced by Gerry Rawlinson on 26 January 1982, were 1,649 votes for (90.7 per cent) and 169 against (9.3 per cent) and the new Charter was delivered by the Prince of Wales to the new chair of governors, Sir Richard Attenborough, at a dinner at Guildhall on 5 October 1983. Although the Charter gave neither rights nor responsibilities to members, membership continued to exist. It was important to the Institute in all sorts of practical ways. It provided the BFI with a mailing list, paid for by the members themselves; it allowed the NFT to function as a club and hold 'members-only' screenings of uncensored films; and it gave the members a sense of belonging to something, even if they had little say, in theory or in practice, in how it was run. So not only was membership preserved as a marketing tool, it was also decided to retain the institution of member governors, as a way of keeping the Institute in touch with at least a section of its core public.

The staging of the Guildhall dinner showed off Attenborough's gifts as a master of mise en scène. The event (paid for by an anonymous donor) was massive.[13] All the luminaries of British cinema were invited and almost all attended, though the film director Ken Loach sent a curt note saying the money would have been better spent on people who were being thrown out of work by the Conservative government. Guest of honour was Orson Welles, who was appointed to a BFI Fellowship together with Marcel Carné, David Lean, Michael Powell, Emeric Pressburger and Satyajit Ray. The Prince of Wales presented the trophy, Welles made a speech and Attenborough as master of ceremonies gave the whole affair a buzz more like the Academy Award ceremonies than a staid British dinner.

Continuity and change

Inside the organisation there was also continuity of personnel. Gerry Rawlinson continued as deputy director until the end of 1986. David Francis remained as curator of the National Film Archive and Leslie Hardcastle as controller of the

NFT. There were changes at the top in Distribution (as mentioned above) and in Production, where Peter Sainsbury resigned in February 1985 and was replaced by Colin MacCabe. A bit lower down the scale, Brenda Davies retired towards the end of 1980 and was replaced by her deputy, Gillian Hartnoll. Ken Wlaschin resigned as head of programming at the NFT at the end of 1983, to be succeeded by Sheila Whitaker. Clyde Jeavons left the Archive in 1986 and his place as deputy curator was taken by Michelle Snapes (who round about this time resumed her maiden name of Aubert). Most of the new appointments were internal promotions, with only MacCabe coming from outside the BFI altogether. Even MacCabe was part of the BFI circuit, having first made his name as a writer on *Screen*. Whitaker came from the BFI-supported Tyneside Film Theatre, and had previously worked in the BFI Stills Department.

In general Smith interfered very little in the internal affairs of departments. He saw his role as encouraging innovation and was adept at persuading senior staff to embrace it. But once an innovation was decided on, it was left up to departments and divisions to decide how to implement it. In one area, however, he intervened in a vigorous and unorthodox way. In December 1980, Jeremy Isaacs resigned as chair of the Production Board in order to concentrate on the preparations for Channel 4, which was due to go on air in two years' time. While a replacement was being looked for, Smith himself was authorised by the governors to take over the chairmanship of the Board. He did this until July 1981, when Verity Lambert took over, but when Lambert herself left in November 1982 Smith again stepped into the breach and continued to chair the Board until Margaret Matheson succeeded him in January 1984. This was a crucial period for BFI production, which, thanks to the Channel 4 agreement, had established itself as a major force in British independent and art cinema.[14]

Just occasionally, Smith became frustrated by a lack of synergy between parts of the Institute. He freely admitted not understanding what went on inside the Archive and what all the people in white coats who were purportedly repairing films were actually up to, but he kept his doubts to himself and let Francis and his colleagues get on with the job. Towards the end of his time at the BFI, however, he became seriously concerned by the fact that the Institute, with all its resources, did not seem to have either a coherent policy or co-ordinated practice when it came maximising the availability of good prints of the key films that were generally felt essential to the constitution of a strong national film culture. Films were being preserved but not shown, or shown in inferior copies, or unduly restricted in where they could be put on show. There were distribution prints held by Distribution Division, not always of good quality. The Archive held some films in preservation copies only and made viewing prints of films it had decided needed to be copied to protect the originals, but these films were not necessarily the ones for which there was an audience. The NFT had its own additional sources of print supply, but prints from these sources could not be shown in, for example, the RFTs. Each division was clearly doing its best to pursue its own principal ends, but there was an equally clear lack of common

purpose. In July 1987, Smith submitted a paper to the board of governors entitled 'Chemical decay, commercial crisis, cultural catastrophe – current problems in the supply of films', which summarised the very real problems involved but offered no immediate solutions. Then in October he returned to the attack with a set of proposals which involved prioritising the making of prints, from Archive or other sources, some of which would be shown only at the NFT but others of which should be shown as widely as possible if copyright restrictions could be overcome. Implementation of this policy was to await the appointment of his successor.[15]

The reason why Smith waited so long to come up with his recommendations, many of which were in principle at least blindingly obvious, lay in the changed financial situation of the BFI in 1987, which was due almost entirely to Smith's success in raising sponsorship.

Sponsorship and J. Paul Getty

As mentioned earlier, Engholm had identified funding from non-government sources as essential to the BFI's survival in what promised to be a hostile financial climate. But it was a huge step from seeing the need to actually raising the funds required. Smith's efforts at raising private sponsorship started in a small way in 1980 when he persuaded Sir Charles Forte to put up £36,000 to carve out a space in the NFT which could be used for receptions, meetings or small-scale film screenings. This space, known for a while as the Forte Room and then as NFT3, proved an invaluable addition to the NFT's facilities. The BBC and Smith then made a joint approach for funds to the John and Mary Markle Foundation, an American charity which promoted research into mass communications, resulting in the establishment of a Broadcasting Research Unit, co-funded by the BBC, which became part of the Information Division in 1981.[16]

The ease with which these monies had been raised encouraged Smith to raise his sights higher. On his arrival at the Institute, Smith found on the agenda a proposal from Leslie Hardcastle for a Museum of the Moving Image attached to the NFT on the South Bank. This proposal, although tentative, had already been presented to governors in April 1979.[17] Provisionally the cost of constructing and fitting out this museum was reckoned at £2,700,000, a huge sum by the standards of the day and equal to some 40 per cent of the BFI's annual grant at the time (in the event it was to cost much, much more). Since the finance would have to be raised from private sources, Smith and Engholm turned for help to Lady Howe, wife of chancellor of the exchequer Sir Geoffrey Howe, who chaired a committee aimed at raising business sponsorship for the arts. Between 1980 and 1982, Lady Howe's committee had raised £2,500,000, including a donation of over £1,000,000 from the Hong Kong shipping magnate Yue-Kong Pao, but more was desperately needed. It was then that John Paul Getty Jr entered the picture.

Many stories have circulated about how Smith courted the billionaire philanthropist to turn him into the biggest donor the BFI ever had. The truth is, however,

that the initial approach came from Getty to Smith, not vice versa. At some point in 1983, Smith received a telephone call from Getty's lawyers to set up a possible contact. Getty, a film enthusiast, had heard a programme on BBC Radio about the work of the National Film Archive and its need for funding to carry out its work and would like to know more. Smith went to see Getty in the Harley St clinic where he was an almost permanent resident. A relationship was established. Getty expressed himself more than willing to help not only the Archive but the BFI in general with donations for specific capital projects which could not be funded from government sources. As the relationship grew, so did the scale of funding which Getty proved willing to provide.

Besides MOMI, for which he eventually put up more than half of the capital cost, plus additional funding later, Getty's main contributions were to the Archive for a new conservation centre at Berkhamsted, and to the purchase and refitting of a new headquarters for the BFI in Stephen St, just north of Oxford St, replacing

10.3 The BFI's benefactor, John Paul Getty Jr, plants a tree to celebrate the opening of the new Conservation Centre at Berkhamsted on 15 June 1987

The Smith years

the rented buildings in Charing Cross Road and Dean St and elsewhere dotted around Soho. The new HQ was an ugly building, even after its refit, and had certain disadvantages, notably for the Library, which could no longer operate on one floor, and for Stills, which had to reorganise its archiving of copy-stills because the low ceilings in the new building could not accommodate the massive Lektriever cabinets used in Dean St. It also introduced a mostly reluctant staff to the dubious benefits of working in open-plan offices. But it was rent-free and the rates bill was slashed because the new building was in a different borough, Camden, which charged charities only half the commercial rate. The government reacted very positively to this development. Reasoning that enterprise of this kind deserved to be rewarded rather than punished and that what the BFI no longer had to spend on rent and rates could now be spent in more productive ways, it refrained from cutting the BFI's grant to claw back the savings – though it did offer the BFI only a below-inflation increase in grant in 1987/88, the year the savings came into operation, prompting Smith to declare to governors, rather melodramatically, that all the savings had been 'nullified' at a stroke.[18]

The new conservation centre at Berkhamsted, now named John Paul Getty Jr Centre after its funder, was the film-lover and philanthropist's greatest legacy to the BFI. It meant that the NFA could move out of the increasingly ramshackle buildings in Aston Clinton where it had been since Lindgren had selected the site at the time of the Blitz and it provided purpose-built facilities for the storing, examination and where necessary restoration of the Archive's mushrooming collection. It opened in June 1987, with additional facilities added in 1989. Berkhamsted, too, before the construction of the centre, was a ramshackle site, used as a dumping ground for surplus BFI publications as well as for certain archive functions. Its showpiece was an elegant eighteenth-century house, used as offices, now named Ernest Lindgren House. It was hoped at one time that it could be made into a research centre, but this never materialised, and it continued for many years to be used as offices.[19]

The story of MOMI is told in full by Lorraine Blakemore in Chapter 14. Suffice it to say here that without Getty MOMI would never have happened. Indeed the scope of Getty's munificence cannot be exaggerated. A passionate film lover, whose mother had been a Hollywood actress, he gave more generously to the BFI than to any of his favoured causes. Altogether, over the course of 15 years, his gifts to the BFI extended to nearly £50 million, a prodigious sum by any standards.

A change of deputy

Towards the end of 1985, Rawlinson was beginning to feel he had been at the BFI long enough. He advised Smith of his wish to take early retirement but was persuaded to stay his hand for six months at least. By the time Rawlinson took the decision that he did indeed want to leave, Smith had come to the conclusion that a change would in fact be desirable. Rawlinson had served the Institute well for over

a decade, arriving in the wake of a crisis and effectively running the Institute for nearly a year between Lucas's departure and Smith's arrival. Together with Smith he had overseen a revival of the BFI's fortunes and a great expansion in its activities. Fluctuating finances – unfavourable grant settlements offset by a massive inflow of sponsorship monies – had been handled astutely by tried and trusted methods. But the BFI needed a fresh dynamism in its internal affairs to match the dynamism of Smith's policy initiatives, and a new deputy director was seen as a way to set this in train.

The man chosen as Rawlinson's successor was Wilf Stevenson, a senior administrator from Napier College in Edinburgh, less cultured overall than Rawlinson had been but a keen filmgoer with an avowed commitment to British cinema. On his arrival in April 1987 he soon discovered that the BFI was a complex and in many ways quirky organisation which it would take him some time to understand. His initial plans for reform were therefore modest. But in acquiring an overview of the organisation he came to one very important conclusion. The BFI's finances were far too heavily weighted in favour of expenditure on staff salaries. It was not that there were too many staff, or that they were overpaid, but the 'gearing' was wrong. Staff with budgets to commit did not have enough money to spend on the activities they were paid to promote. Unless financed by Getty, capital projects were not easy to get going. Computerisation in particular was highly capital-intensive but the expenditure on purchasing and maintenance could be expected in the long run to be offset by staff savings. There were also continuing demands on the BFI, with which Stevenson sympathised, to extend its grant-giving activities in the regions. For those with ears to hear, the Institute was being put on notice that uncomfortable times might lie ahead.

End of an era

The year 1987 was a turbulent one in British television. The abrupt dismissal of Alasdair Milne as director general in January created a vacancy at the top of the BBC. Jeremy Isaacs, whose contract at Channel 4 was due to expire at the end of the year, applied for the post but did not get it. Instead, the BBC appointed an organisation man, Michael Checkland. Isaacs decided to leave television and accepted a job as head of the Royal Opera House. Meanwhile Attenborough took over as chairman of Channel 4 in July and was instantly faced with the need to appoint a successor to Isaacs. It was widely rumoured that Anthony Smith was the favoured candidate for the post and Smith himself was confident that Attenborough, now chairman of the company, would push through his appointment. Interviews were held in the autumn and by the beginning of November the shortlist had been whittled down to three – Smith himself, Will Wyatt from the BBC and Roger Graef. Then, out of the blue, Attenborough received a phone call from Michael Grade, expressing interest in the job. An interview for Grade was hastily convened at Attenborough's house in Richmond, the result of which was a decision that the flamboyant Grade

was the man to take the channel forward into the 1990s. When Attenborough told him the news, Smith was devastated. So was Isaacs, who famously told Grade that he would throttle him if he betrayed what Channel 4 stood for.[20] Having failed to get the Channel 4 job, Smith decided on a change of tack. In eight years at the BFI he had achieved even more than he or anyone had thought possible at the time he took up his post. The BFI was now ensconced in its new headquarters. The conservation centre at Berkhamsted was at an advanced stage of construction. The Museum of the Moving Image was nearing completion and with it the hope of bringing in a vast new public to a BFI initiative. The relationship with Channel 4 meant that BFI-produced films were reaching far larger publics than could have been imagined possible. Meanwhile Magdalen College in Oxford was looking for a new head – someone with entrepreneurial flair as well as an academic track record. At the beginning of 1988, Smith accepted the post of President of Magdalen.

At the February 1988 meeting of governors, Attenborough announced Smith's imminent departure. He had also, he said, offered his own resignation to enable a new chairman to lead the search for Smith's successor, but this had been turned down.[21] Attenborough therefore took over the search. An advertisement for the post appeared in March and long- and short-listing of candidates began immediately. By early May the candidates had been whittled down to two. One was Wilf Stevenson, who as deputy director had made a very favourable impression on the board of governors. The other was Christopher Frayling, professor of cultural studies at the Royal College of Art and himself a former member governor at the BFI. Frayling would have been an imaginative and popular choice, but Matthew Evans on the appointing sub-committee and Smith on the sidelines urged caution. By the time of the final interviews Frayling was aware that the tide was running against him and on 18 May Attenborough announced to the board that Stevenson was the unanimous choice of the committee. The game of musical chairs was over, with administrators in charge at the BBC and the BFI and a showman at Channel 4.

Notes

1 Published as *The Geopolitics of Information* (London: Faber and Faber, 1980).
2 GNS interview with Barrie Ellis-Jones, 15 November 2006.
3 BFI/86/11.
4 Personal communication, October 2004.
5 BFI Governors Minutes, 19 November 1986.
6 Inside the BFI itself a temporary post of Ethnic Film and Television Adviser was created in 1985, held by Jim Pines. When this post lapsed after two years there was a gap in specific ethnic provision until 1989, when June Givanni from the GLC was appointed Planning Officer. Pines also returned to the BFI in 1990.
7 House of Commons, *Eighth Report from the Education, Science and Arts Committee, Session 1981–2*, 3 volumes (London: HMSO, 18 October 1982). See in particular vol. 1, pp. liv–lvi. Subsequent correspondence between the BFI and the OAL is preserved in BFI/D/1.
8 No one from the Archive or the NFT had given formal evidence to the Committee but there had been considerable tapping up behind the scenes.

9 Detailed information on the Awards can be found in BFI/21, BFI/104 and BFI/122.
10 See BFI Governors Minutes, 21 October 1987. Ideally the awards, including the Sutherland Trophy, would have been given during the LFF, but this would have involved expensively having the Festival reclassified as a competitive event like Cannes or Venice (CD/GNS interview with Sheila Whitaker, 24 January 2008).
11 See BFI/152 and BFI/D-29.
12 GNS/CD interview with Anthony Smith, 16 June 2006.
13 The donor was in fact the Hong Kong shipping magnate Sir Yue-Kong Pao, who generously agreed to allow the accumulated interest on an advance donation he had made to the still embryonic Museum of the Moving Image to be used for the purpose.
14 For more on the Production Board in the period see Chapter 11.
15 Papers attached to Governors Minutes, 15 July and 21 October 1987.
16 The Broadcasting Research Unit, headed by Michael Tracey, brought new intellectual inputs into the BFI, notably a focus on quantitative research. Its work was valued by industry policy-makers but made little impact on BFI activities except marginally on regional policy (see, for example, the article on regional film audiences by David Docherty in *Sight and Sound* 57:3, Summer 1987).
17 For more on MOMI see Chapter 14.
18 Governors Minutes, 19 November 1986. The government's general positive attitude to the BFI's success in fundraising was confirmed to me by Rodney Stone, the BFI's OAL assessor (interview, 2 February 2006). In fact the loss of grant money was very small compared with the immense benefits provided by the new accommodation.
19 The house was sold to a developer in 2010.
20 See Maggie Brown, *A Licence to Be Different: The Story of Channel 4* (London: BFI, 2007), and Jeremy Isaacs, *Storm over 4: A Personal Account* (London: Weidenfeld and Nicolson, 1989).
21 Probably because it was hard to think of a suitable successor. Richard Luce, the then arts minister, canvassed David Puttnam for the position, offering him the choice of the BFI or the National Film School. Puttnam chose the film school, to which he had a long standing loyalty and of which he was already a trustee (GNS interview with David Puttnam, 11 February 2010).

11

The BFI and film production
Half a century of innovative independent film-making

Christophe Dupin

In December 1970, in an article defending the BFI's film production scheme against recent attacks in the press, the BFI Director Stanley Reed observed: 'what is overlooked is that the British Film Institute until recently had no brief to get involved in film production at all'.[1] Established in the early 1930s, the BFI's move into film funding and production did not occur until the 1950s. But even then it remained for many years a minor and rather unofficial activity, acquiring the status of stand-alone department with significant financial means only in the 1970s.

This late move into production was largely due to the film trade's colonisation of the BFI in the early 1930s. Negotiating the terms of the Institute's constitution, the trade associations made it clear they would not allow the BFI to interfere with their commercial interests, not least by producing films itself. Since the interest of the educationists behind the BFI project was primarily to promote the use of film in the classroom, this did not bother them particularly. However, the first modest signs of the BFI's future involvement in film production can be seen as early as the late 1930s. Ernest Lindgren, the curator of the BFI's fast-growing National Film Library, commissioned several composite films based on material held in the Library. Two notable examples were *Drawings that Walk and Talk* (a collection of early animated films by Marie Seton and K. H. Frank, 1938) and Alberto Cavalcanti's *Film and Reality* (an early history of documentary and 'realist' films, 1942, assembled by Lindgren himself).[2]

Festival of Britain: a turning point

After the War, the Radcliffe Report (1948) laid down the foundations for a radical overhaul of the BFI, though it made no reference to film production as a potential BFI activity. The report did, however, create a more favourable framework for potential film production by recommending that the Institute should focus its activities exclusively on the promotion of film as an art form, and by limiting the influence of pressure groups (namely the educationists and the film trade) on its governing board. But it was the Festival of Britain in 1951 which gave the BFI

the opportunity to emerge as a film sponsor, when the government asked it to take charge of the cinematic side of the event.

Although the initial plan was for the BFI to commission a series of ambitious documentaries, the 1949 recession drastically reduced the Festival's finances. The Institute managed to salvage just over £10,000 of its initial £120,000 budget to commission and supervise the production of a handful of short experimental films to be shown in the Telecinema, a temporary four-hundred-seat cinema on the South Bank.[3] The great popularity of the Telecinema had a decisive impact on the future of the BFI not only as exhibitor but also as a film sponsor and producer.

There are various reasons why Denis Forman, the director of the BFI, was keen to push the idea of film production. First, it would provide the new cinema with new films to show. More generally, the industry's permanent state of crisis was increasingly blamed on the fact that it did nothing to encourage new ideas and film-makers. Worse, Britain had no formal training facilities for film technicians. Meanwhile the state-funded documentary tradition, unable to adapt its structures and methods to the fast-changing postwar British society, was in serious decline. Indeed, in March 1952 the Crown Film Unit, last representative of that system, was closed down by the new Conservative government on economic grounds. On top of all this, Forman believed that experimental film production would confer

11.1 Sir Michael Balcon, film producer, long-standing BFI governor and chairman first of the Experimental Film Fund and then of the Production Board, here in 1960

The BFI and film production

on the Institute a more dynamic and forward-looking attitude towards British film culture.

In December 1951 the BFI director took advantage of the introduction of the Eady Levy, a new scheme introduced by HM Treasury in conjunction with the film trade, to apply for two £12,500 grants for the Telecinema and the production of new experimental films.[4] The trade associations' reaction to the BFI's request for money was two fold. Though they agreed to provide money for the Telecinema, they rejected the second application on the grounds that the Institute wanted sole authority on expenditure. Ever pragmatic, Forman invited eminent film-makers and technicians to serve on the Fund's selection committee and asked the Ealing producer Michael Balcon to chair it. Balcon, who immediately accepted, was in many ways perfect for the task. A respected figure in the industry, he was also considered a spokesman for 'independent' producers, and he saw the support to new film-making talents as an essential condition for the survival of the British film industry.

The Experimental Film Fund

The 'Telecinema Production Committee' (as it was first called) held its first meeting in June 1952, though it took another year of intense lobbying before the trade associations awarded the requested grant. By October 1953, the work of what was now known as the BFI Experimental Film Fund could finally start – albeit with a total budget hardly sufficient to produce a feature film trailer in the commercial sector. Over the fourteen years of its existence (1952–66), the Fund managed to raise only two grants-in-aid, from the film trade and the Gulbenkian Foundation, amounting to a meagre total of £22,500. Unsurprisingly, this affected the pattern of the production programme. Rather than developing a long-term strategy, the Fund worked pragmatically in a series of distinct cycles of production.[5] It also encouraged the BFI to try to generate revenue from distribution and sales. The revenue generated (estimated at £10,000) was paid back into the budget and proved vital in the Fund's final years between 1963 and 1966.[6]

Throughout its existence, the Fund remained a marginal BFI activity. It received no money from the Institute's budget, was not referenced in its constitution and was not even acknowledged in organisational charts published by the Institute. Nor were there any official administrative and technical staff to manage the everyday work of the Fund, still less equipment or premises dedicated to production activities. Even its committee meetings usually took place at Balcon's studios. In practice, however, the BFI's director and other senior officers ensured the administrative continuity of the Fund's activity, playing a key part in the decision-making process, in terms of both general policy and selection of particular projects. They also closely followed the films in production and mediated between the film-makers and the committee. A primitively equipped basement room in the BFI's headquarters soon became an unofficial post-production base for a number of films sponsored by

the Fund. As for selection and funding procedures, guidelines to applicants were hardly ever publicised. Film-makers were expected to send in a short synopsis of their project along with an estimated budget and, when applicable, a supporting film. The best applications were submitted to the committee for discussion. When applicants had no previous film-making experience, they were required to shoot a test sequence. Once a project was officially selected, its maker was reimbursed for bills paid for equipment and services during the making of the film.

The pragmatism of the Fund's procedures was matched by that of its funding policy. The BFI Governors had left the Fund's committee 'free to interpret the word experimental in a reasonably liberal sense', while suggesting that 'films which are experimental in either a technical or an artistic sense should be eligible for consideration'.[7] Gradually the Fund became a mini-laboratory where film-makers, ideas and techniques could be tested. It saw 'experiment' not as a practice against the industry (as would be the case in the 1970s), but, rather, on its behalf and to its benefit.

Policy debates within the committee initially reflected the strong influence of the Telecinema experience. The first projects considered were in the fields of stereoscopic technology and art documentaries. But the emphasis on 3–D was soon abandoned as the trend faded and the projects proved too expensive. The Fund then turned its focus to animated shorts, as well as the co-production of semi-commercial films on art.[8] But the real turning point in the Fund's policy was its encounter with a group of young film-makers soon to be associated with the so-called Free Cinema movement. In the mid-1950s the BFI acted as a forum wherein Lindsay Anderson, Karel Reisz, Tony Richardson and Walter Lassally (all regular contributors to *Sight and Sound*, while Reisz occupied the strategic post of first programmer of the NFT) could share their views on cinema. Meanwhile, the Experimental Film Fund was seeking innovative projects to support. Its selection of Lorenza Mazzetti's *Together* and Reisz and Richardson's *Momma Don't Allow* heralded a fruitful collaboration which culminated in the showing of the films as part of the first Free Cinema programme at the NFT in February 1956. The Experimental Film Fund soon became de facto the movement's main sponsor. In return, Free Cinema secured the immediate future of the Experimental Film Fund by legitimising its work.

From then on, the Committee increasingly incorporated the movement's aesthetics and production methods in its selection policy. The main reason was economic. One of Free Cinema's principles was that the only way of making personal and innovative films was to opt for black-and-white, 16mm, small-scale production, in which the imaginative use of sounds and images would make up for the lack of glossy finish. But thematically, too, projects selected became more relevant to contemporary British society. Films depicting children's and youth culture were particularly well represented, examples ranging from *Momma Don't Allow* (1956), *Nice Time* (1957), *One Potato Two Potato* (1958), *Amelia and the Angels* (1958) or *The Rocking Horse* (1962) to *The Peaches* (1964). Others, such as *Blackhill*

The BFI and film production

Campaign (1963) and *Aldermaston Poetry* (1965), treated current political issues, while a film like *Dry Hands* (1964) examined the monotony of mechanised society. As for *Ten Bob in Winter* (1963) and *Top Deck* (1962), they pioneered the portrayal of black people as main characters of a British film. The former was also one of the very first British films directed by a black film-maker. The Fund's assistance to more formal experiments which challenged, to some extent, the traditional visual or narrative structure of film – *Man of Rope* (1961), say, or *The Pit* (1962) or *Untitled Film* (1964) – reflected a shift in the Fund's policy from the funding of 'films on art' to the funding of 'art films'.

With an total budget of little more than £30,000 over the 14 years of its existence, and with no proper administrative or technical structure, the Fund's most obvious achievement was the financing, entirely or in part, of as many as fifty films selected from more than four hundred applications. The diversity – in style, genre and content – of the films supported reflected the committee's commitment to investigating all areas of film-making. Even though not all the BFI-sponsored films were critical successes, a fair proportion won major prizes in film festivals around the world and received positive reviews in the national press. In the discovery of new talents the Fund's results were also rather impressive. Of the fifty or so film-makers supported, at least 32 went on to work in a variety of jobs in the British (and occasionally overseas) film and television industries, where most of them continued their innovative work in 'cultural' cinema or pioneering television programmes and documentaries. Finally, in a period when collective film practices were extremely marginal in Britain, it is to the Experimental Film Fund's credit to have recognised and encouraged the work of independent film collectives such as the Unit Five Seven, the Grasshopper Group or Mithras Films. The fact that the Fund also gave their first chance to seven women film-makers at a time when creative jobs within the film and TV industries were the almost exclusive property of men was no small achievement either.

Most of the Fund's failures can be attributed to structural and financial weaknesses. Despite the dedication of the committee and BFI officers, the Fund lacked the influence that would have enabled it to play a more proactive role in 1950–60s British film culture. It never really managed to prove its worth to either the film trade or the government. It also failed to penetrate, let alone transform, the conservative structures of 16mm short film distribution and exhibition, and its films were therefore generally confined to the BFI's network (the NFT and occasionally film societies).[9] The Fund's sphere of influence was also limited in geographical terms, since it rarely ventured outside the capital. Most film-makers lived in London, and London was the background to almost every film.[10] The amateurism of the Fund's structures and working methods as well as its lack of equipment and technical expertise resulted in the poor quality – or even the non-completion – of a number of the films supported, which contributed to undermining the Fund's reputation.

Such failures partly explain why by 1963 no further money was found to continue the Fund, which became quasi-dormant for three years. It was Jennie

Lee's appointment as Britain's first arts minister in 1964 which provided new prospects for the scheme. Increasing the BFI's annual grant-in-aid from the government, she insisted that part of it should go to experimental film production and young film-makers. As a result, the scheme – renamed BFI Production Board – was officially reconstituted in July 1966, under the supervision of the same committee. But with the promise of an annual budget, a permanent production unit with offices, cutting rooms, basic equipment and supporting staff, the BFI's production activity entered a new phase of its development marked by the sharp professionalisation of its practice.

The Production Board

These changes made possible an improvement in the technical standards of the films, and allowed for more efficient training of inexperienced film-makers. In the late 1960s the Board financed and often produced, on shoestring budgets, nearly seventy films (all but two of them shorts), largely thanks to the dedication of its first production officer (1966–71), the young Australian film-maker Bruce Beresford. It provided a creative environment where film-makers with diverse backgrounds and interests (from young would-be mainstream directors such as Stephen Frears and Tony Scott to artists experimenting with film, such as Jeff Keen, Mark Boyle and Tony Sinden) could meet and exchange ideas. The positive reviews of BFI-funded films in the press and the prizes won in short film festivals attested to the success of the scheme.

Yet with an average annual budget of £12,000 between 1966 and 1971, the Board's influence was bound to be limited. In the fast-changing context of British cinema at the turn of the 1970s, the Production Board faced a new identity crisis. New independent film-making practices associated with the emerging counter-culture challenged what they saw as the Board's obsolete views on film-making. The establishment of the National Film School in 1970, as well as the development of practical film courses in art schools, polytechnics and universities, threatened to deprive the Board of its 'training' function, while the Arts Council's new funding scheme for artists' films the same year also encroached on the Board's wide-ranging brief.[11] Meanwhile, following the withdrawal of American finance after 1968, the low-budget end of British feature film production had virtually disappeared, which made it almost impossible for first-time directors to find a way into commercial film-making. Hopes that the state-supported National Film Finance Corporation would help to reverse this situation were quickly shattered by the 1970 Conservative government's refusal to adequately finance development.

A shake-up of the Production Board's policy, methods and finances became inevitable. This had been anticipated by Stanley Reed as early as May 1968 when he had first advocated the Board's move to low-budget feature film funding in order to 'bridge the gap between the making of a modest film for the Board and [the film-maker]'s first commercial feature'.[12] An early beneficiary of this new approach was

The BFI and film production

Tony Scott, who was given the opportunity to direct first a short, *One of the Missing* (1968), then a low-budget featurette, *Loving Memory* (1970). However successful this example was, it was bound to remain an exception until the Production Board had the financial means for its new brief. Several years of campaigning paid off in 1972, when the Board obtained substantial financial support from the industry through the allocation of an annual grant from the Eady Levy, while the arts minister David Eccles also agreed to a significant increase in government money. The Board's operating budget for that year reached £75,000 – three times the level of the previous year, though hardly enough to embark on an ambitious production programme.

The Production Board's new departure was also signalled by a complete change in personnel, as Bruce Beresford resigned in July 1971 to pursue his film-making career in Australia, Michael Balcon retired in January 1972 and all Board members were replaced during that year. The nomination of the producer Michael Relph, whose collaboration with Balcon went back to the 1930s, as the new chair ensured board continuity, whereas the new Board members were younger and more aware

11.2 Bruce Beresford, production officer 1966-71, on the set of BFI-produced *The Adventures of X*

of the latest developments in British cinema than the 'great and the good' whom they replaced, and represented a wider range of qualifications and interests. As for the new Head of Production, Mamoun Hassan, he was eager to implement the new policy of funding innovative low-budget feature films. Besides, one of its first decisions in July 1971 was to recommend the allocation of a £3,650 grant to a semi-autobiographical mini-feature film about a poverty-stricken childhood in a Scottish mining town, submitted by the London Film School graduate Bill Douglas. Shot by a limited crew, with non-professional actors and on 16mm, the 48–minute *My Childhood* proved a turning point in the Production Board's history. A deeply personal and poetic film, it went on to gather high critical praise and was awarded the Silver Lion for Best First Feature at the Venice film festival, thus proving the validity of the Board's new policy while earning Douglas the chance to direct two more films for the BFI, *My Ain Folk* (1974) and *My Way Home* (1978).

The semi-professional conditions in which Douglas's film was made characterised all the narrative feature films funded under Hassan, from Kevin Brownlow and Andrew Mollo's *Winstanley*, a full-length feature on the Diggers' radical movement during the English Civil Wars in the 1640s, through Peter Smith's *A*

11.3 Poster for the Bill Douglas trilogy, whose production was initiated by Mamoun Hassan

Private Enterprise, a sensitive portrayal of the problems surrounding Asian immigrants in Britain, to Chuck Despins's musical *Moon over the Alley* and David Gladwell's *Requiem for a Village*. Hassan insisted that the producer, director, crew and main actors be paid during the making of the films (albeit below minimum union rates). The Board also introduced the idea of small script development grants to film-makers about to embark on feature-length projects. Meanwhile, the Board still funded a great variety of shorts (28 of the 38 films initiated under Hassan were under 60 minutes), from professionally produced narrative shorts and featurettes by first-time directors to a wide range of experimental films.

The Board's decision to devote a small proportion of its budget to the funding of alternative film-making practices such as the London Filmmakers' Co-op stemmed from the pressure exerted on the Board by one of its new members, the avant-garde film-maker Malcolm Le Grice. He obtained significant results over the next three years, with the selection of avant-garde projects by Stuart Pound, Stephen Dwoskin, William Raban, Peter Gidal, Gill Etherley and Tony Sinden. The Board also made a gesture towards film-making collectives by setting aside £10,500 towards a Group Support Fund which awarded equipment grants to 12 independent film and video groups in April 1974, followed by a one-off £16,000 capital grant to the London Filmmakers' Co-op in April 1976. By the time Hassan resigned in early 1974, the Board was a transformed operation and its profile had been considerably raised. His endeavour to regenerate cultural British cinema through a programme of low-budget features was praised by mainstream film critics who welcomed the advent of a body of films made not only in Britain with British funds but also 'in the continuing British cinematic tradition'.[13]

But while the success of the operation remained fragile, as the department's premises and equipment had become inadequate for the standard of production to which Hassan aspired, the scheme's major flaw remained the poor distribution and exhibition of the completed films. Hassan blamed it on the non-existent market for short films in Britain, the difficulty of distributing 16mm films in commercial cinemas and the lack of expertise of the BFI's Distribution Department, and the failure to involve film-makers in the process. One of his last decisions before his resignation in early 1974 was to bring in Peter Sainsbury, a film buyer for the BBC, to help solve the problem.

The avant-garde years

Hassan's successor was BBC producer Barrie Gavin, whose background in television arts programmes and documentaries influenced the Production Board's move away from narrative feature films toward social and political documentaries. Gavin was eager to recognise the radical end of British independent cinema as one of the Board's key constituencies.[14] Significantly, it was around that time that this sector organised itself into a pressure group, the Independent Filmmakers' Association (IFA). At the other end of the independent film spectrum, the supporters of a

low-budget commercial cinema soon reacted by forming their own lobby, the Association of Independent Producers. Suddenly the Board found itself the stage of a heated ideological battle between opposed film-making practices.

Where Hassan had enjoyed having to convince the Board of the worth of specific projects, Gavin found the confrontational nature of this relationship utterly frustrating and he resigned within fourteen months. Yet his short tenure remains one of the most audacious periods in the Board's history. Of the 32 films selected for production during his term, 12 were political documentaries. The majority of these were the work of far-left and feminist film collectives (from the Berwick Street Collective to the London Women's Film Group or the Newsreel Collective) who rejected conventional documentary modes and instead sought to produce political meaning at all stages of their film-making practice. They showed a strong engagement with political debates of the 1970s, such as workers' struggles (*Miners' Film, Occupy!, '36 to '77, So That You Can Live*), abortion and women's liberation (*Abortion – An Egg Is Not a Chicken, Whose Choice?*) or Northern Ireland (*Ireland Behind the Wire*). Other selected documentaries were more conventional in their mode of production but were critical enough of the deficiencies of the state's bureaucratic apparatus to expose the Board to public controversy (*Juvenile Liaison, Welcome to Britain*). Most of these documentaries received relatively large grants (up to £20,000) previously reserved for low-budget feature films. As for the aesthetic avant-garde, it also received more attention from the Board than ever before, with relatively large grants also awarded to Peter Gidal, Chris Welsby and Mike Dunford, and to Peter Donnebauer for his exploratory work on video. Among the few fiction films selected under Gavin, the most notable one was Horace Ové's *Pressure* – the first black feature film in Britain.

When Peter Sainsbury became Head of Production in late 1975, the Production Board was about to go through a series of major crises. The first of these revealed the ideological differences between the majority of the Board and the Head of Production. It was triggered by Sainsbury's call for a set of explicit criteria for the selection of projects. The vast majority of the Board challenged this approach to decision-making, which they saw as a manifestation of the politicisation of certain BFI departments.[15] In October 1976 several independent film-makers, past Board members and grantees rallied behind an enraged Hassan to attack what they considered 'an attempt at manipulation of the film-makers' works in pursuit of petty political purposes within the British Film Institute'.[16] The Board and the head of production eventually reached a compromise by publishing new Guidelines to Applicants which clarified policy somewhat by setting a number of practical selection criteria, but fell short of the explicit plan advocated by Sainsbury.

The second crisis publicly exposed the Board's ill-defined relationship with its parent body, as well as the ambiguous status of both the head of Production (a BFI employee at the service of the Board) and the Board chairman (who was also a BFI governor). Its origin was Joan Churchill and Nick Broomfield's *Juvenile Liaison*, a documentary on the workings of the Juvenile Liaison scheme of the Lancashire

police. After the BFI (as the film's copyright holder) gave in to police pressure and refused to screen the film publicly, seven of the nine Board members, led by Mike Dibb and Peter Lennon, threatened to resign. This mutiny was followed by a six-month dispute, which died down only after the bulk of the mutinous Board members retired at the end of the year – without the case being settled (the film was not shown to the public for decades) or the Board's constitutional crisis solved. It also exposed the BFI's poor distribution of its films, which triggered the Board's third crisis.

By the time Sainsbury took over as Head of Production, none of the recently completed features had found a commercial distributor, the main reason being the cost of transferring films made on 16mm to 35mm. Another press campaign (from Philip Oakes in the *Sunday Times* to Chris Petit in *Time Out*) condemned the BFI's incompetence over the distribution of films like *Pressure*, *Brown Ale with Gertie* and *Welcome to Britain*. Sainsbury made the improvement of the distribution system one of its top priorities, appointing a Films Promotion Officer in September 1976. The opening of several important new exhibition outlets for independent films in London between July and October 1976 (Derek Hill's Essential Cinema, the ICA's New Cinema Club and The Other Cinema's own theatre) eventually made possible the commercial release of six BFI features in the space of six months.[17] Between 1977 and 1979 a dozen new BFI films had a London theatrical release followed by screenings in RFTs, six of them being bought by the BBC for television transmission. For the first time, every new BFI film was also automatically added to the Institute's distribution catalogue and advertised to a wide range of non-theatrical venues.[18]

As well as the modernisation of distribution, Sainsbury was committed to pursuing the professionalisation of the production activity. He wanted a stronger, more legitimised state-funded independent sector in which the Board would be a key agency able not only to respond to the changing needs of film-makers but also to play an active role in shaping film culture. In order to improve the BFI's standards of film production, the Production Department augmented its staff numbers from three to seven between July 1976 and April 1977. Although the department remained structurally under-equipped, every spare penny was spent on the acquisition of film-making equipment to avoid the escalating costs of equipment hire. A couple of years later, in 1979, Sainsbury negotiated a formal Code of Practice with ACTT and Equity, stipulating that BFI-funded films produced by the Board would be allowed special dispensation to pay their crews at the short and documentaries rate – the full feature rate being paid in residuals should the film go into profit. It also allowed the employment of a number of non-union technicians and actors on certain non-commercial projects. He also initiated a close working relationship with the IFA, with which he negotiated a new standardised contract between film-makers and the Board increasing the film-makers' rights over the distribution of their films and their royalties, as well as inviting two IFA members on to the Board.

11.4 BFI reception at the 1980 Cannes film festival, where *Radio On* was shown in the Directors' Fortnight section. From left, director Chris Petit, Anthony Smith (BFI director), Jeremy Isaacs (chairman of the Production Board), and Peter Sainsbury (head of production)

The consolidation of the production activity proved costly. A campaign for more funds paid off in early 1979 when both the Department of Education and Science and the film industry increased their respective contributions, making the Board's budget for 1979 the highest in its history (over £480,000 against £213,000 the previous year). The Head of Production also sought more modern types of financial arrangements for the films, such as pre-production sale agreements with television companies and co-productions with other production companies or organisations in Britain and abroad. The first notable example of this new strategy was Chris Petit's *Radio On*, co-produced with both the National Film Finance Corporation and Wim Wenders's production company.

Despite the increased complexity of the projects selected between 1976 and 1979, most of them remained situated within the debates on film theory and far-left politics which characterised British independent cinema in that period. Several films resorted to Brechtian techniques of mise en scène (Phil Mulloy's *In the Forest*; Susan Shapiro's *Rapunzel Let Down Your Hair*; Ed Bennett's *Life Story of Baal*). Others questioned historical truth by mixing archival footage with dramatisation (Jonathan Lewis and Elizabeth Taylor-Mead's *Before Hindsight*, Conny Templeman's *Home*; Thaddeus O'Sullivan's *On a Paving Stone Mounted*; Anthea Kennedy and Nick Burton's *At the Fountainhead*) or combined animation and live action (*Rapunzel Let Down Your Hair*; Vera Neubauer's *Animation for Live Action* and *The Decision*). The radical aesthetic of these films was often matched by their –

The BFI and film production

often feminist – politics (Laura Mulvey and Peter Wollen's *Riddles of the Sphinx*; *Rapunzel Let Down Your Hair*, Jane Jackson's *Angel in the House*, Anna Ambrose's *Phoelix*, Carola Klein's *Mirror Phase*; Vera Neubauer's animation work). Not uncoincidentally, the number of BFI-funded films directed by women dramatically increased in that period.

A new departure

Sainsbury's controversial production programme polarised critical debates on British independent cinema. While anti-establishment magazines such as *Time Out* praised the support of the Board to political and theoretical film-making, mainstream critics – not least the BFI's own *Sight and Sound* – virulently rejected what they saw as a dogmatic and narrow view of British film culture.[19] In fact, Sainsbury's own views started evolving towards the end of the decade, as he became increasingly disappointed with the poor quality of many of latest BFI productions and with the lack of audiences for films whose aesthetics and politics were seen as intimidating and elitist. A new trend of innovative yet less 'dogmatic' BFI-funded films followed, from Peter Greenaway's *A Walk Through H* and *The Falls* to the Quay Brothers' *Nocturna Artificialia* and Chris Petit's debut feature film *Radio On* (all three initiated in 1978–79).

The latter, shot on 35mm with a budget of £100,000, was the clearest sign of the Board's change of orientation. Although it was a narrative film, its black-and-white aesthetics and disruption of subjective narration, its creative use of contemporary popular music and landscapes, its cultural references and modes of production and promotion owed more to contemporary European art cinema than to the recent avant-garde. The film was selected for the Directors' Fortnight at Cannes, an event which epitomised art cinema and auteurism, and was then released on the art-house circuit.

This latest strategy owed as much to the circumstances as to Sainsbury's own vision. The continuing decline of British feature film production indeed reinforced the Board's responsibility as a producer of low-budget features. Another important development was the appointment of new BFI personnel – especially Anthony Smith as director and Jeremy Isaacs as chair of the Production Board – who immediately embraced the art cinema project.

But the key factor was the establishment of Channel 4. The appointment of Isaacs as its first Chief Executive and of Alan Fountain (a former Production Board member) as its commissioning editor for independent film and video led to the development of a privileged relationship between the station and the BFI Production Board in the early 1980s. A co-production agreement was negotiated between the two organisations in 1981, whereby the television company took a first option on broadcast rights in BFI films in return for an annual subvention not tied to any specific project. The first of those, amounting to £420,000, almost doubled the Production Board budget and enabled it to engage even further in low-budget

feature film-making. The critical and box-office success of Greenaway's *The Draughtsman's Contract* (1982) fully established the Board as one of the three pillars of the institutional funding of British art cinema in the 1980s, along with Channel 4 and the NFFC (replaced in 1986 by British Screen). In John Hill's words, 'more than any other film in that period it appeared to demonstrate the economic viability, and cultural cachet, of the newly emerging British art cinema'.[20]

The shift from one policy to the other was not, however, as abrupt or radical as it seemed. The Production Board (and Division) continued to insist publicly throughout the 1980s that the plurality of concern was an essential component of its funding policy. Besides, under the combined pressure of the IFA and the ACTT, the Board continued to fund a number of non-feature and non-commercial projects (including the work of regional workshops and collectives).

A key moment in this development was the ACTT's decision in March 1982 to suspend the ACTT/BFI Code of Practice as a warning against the Production Board's increasingly commercial endeavours and, a few months later, the publication of the famous ACTT Workshop Declaration negotiated with the BFI, Channel 4 and Regional Arts Associations.[21] As a result the BFI agreed to set aside a significant amount of money (around £200,000 a year) taken from the Production Board's budget to feed a Regional Production Fund administered by the Projects Unit of the BFI's Distribution division (and from 1984 by the BFI's Funding and Development Division) under the authority of a committee whose members were chosen from key organisations in the independent sector.[22]

Throughout the 1980s the Regional Production Fund funded the infrastructure and salaries of a number of workshops recognised by the Declaration, recipients ranging from the Sheffield Filmmakers' Co-op, Trade Films (Gateshead) or the Leeds Animation Workshop to the Liverpool Black Media Group or Birmingham Black Film Group. This did not prevent the Production Board from occasionally backing projects by franchised workshops directly, examples including *The Love Child* (a feature-length comedy by Frontroom Productions, a London-based workshop), *T Dan Smith* (a drama-documentary by Amber Fims) and *Out of Order* (a feature-length comedy drama shot on video by the Birmingham Film and Video Workshop).

Meanwhile, many of the feature films backed by the Board in that period, from Mulvey and Wollen's *Crystal Gazing* to Sally Potter's *The Gold Diggers*, fitted to some extent the art cinema format (length, increased production values, non-rejection of narrative) yet retained a number of aesthetic and political concerns of 1970s independent film-making. The new level of funding made available to the independent sector in the 1980s led to a transformation of its practice and, as Michael O'Pray has argued, to a progressive amalgamation of avant-garde, oppositional and art cinema.[23]

One significant change was the BFI Production Division's increased efforts to get the films it produced seen by wider audiences in Britain and beyond. Its Film Promotion unit, under the leadership of Carol Myer, indeed played a key

The BFI and film production

role in the transformation of BFI Production (as it became called from 1984) as a key player in British art cinema by dramatically increasing the visibility of, and revenue from BFI productions. It consolidated and expanded its activities not only in London and around the UK but also abroad, through festival participation, the organisation of retrospectives and tours and its proactive work with exhibitors, critics and buyers in the European, North American and Australian markets. After the isolated precedent of Bill Douglas's *My Childhood* in 1972, BFI productions were now regularly selected in the various sections of the major festivals (Cannes, Venice and Berlin) where they competed with the 'best' of world cinema and occasionally picked up top awards, from Edward Bennett's *Ascendancy* (Golden Bear, Berlin, 1983), to Derek Jarman's *Caravaggio* (Silver Bear, Berlin, 1986) or Terence Davies's *Distant Voices, Still Lives* (International Film Critics' Prize, Cannes, 1988). That the films often fared better (both critically and commercially) abroad than at home was perhaps one more sign of BFI Production's gradual appropriation of the themes and aesthetics of European art cinema. Thanks to the agreement with Channel 4, most of the BFI-funded films were also broadcast on television, in particular in Channel 4's 'Eleventh Hour' slot (1982–88).

Around the middle of the decade however, just as the policy of low-budget, innovative narrative features was gaining momentum, the Production Board went through yet another unsettled period following a government White Paper (July 1984) which proposed the complete redefinition of Britain's film policy and in particular the abolition of the system of state intervention in place since 1927 (quotas) and 1948 (Eady Levy). The effective withdrawal of the Eady Levy in 1985 took away £125,000 a year from the BFI's budget. Peter Sainsbury, who provocatively suggested that BFI Production was 'an organisation which may, given the development of workshops on the one hand and the variety of Channel 4 activities on the other, have come to the end of its natural life, especially in the event of further real cuts in overall BFI funds, abolition of Eady, etc',[24] resigned a few months later and was soon followed by several of his colleagues in the Division.

To cut short the many questions about the future of the Production Board asked in the press, the BFI's director Anthony Smith made it clear that withdrawal from film production was not an option.[25] The successful negotiation of an improved subvention deal with Channel 4 (and the consolidation of the grant from the ITCA, the Independent Television Companies Association) ensured the survival of the scheme. Although the appointment of radical theoretician Colin MacCabe as the new Head of Production generated a lot of scepticism in the press and among independent film-makers, MacCabe himself immediately announced his intention of continuing his predecessor's feature film policy.[26] The first projects he oversaw were *Caravaggio*, Peter Greenaway's *A Zed and Two Noughts* and Terence Davies's *Distant Voices, Still Lives*, three important British art films (and film-makers) of the 1980s.

The swan-song of BFI production

Fewer shorts were backed in the 1980s than in any previous decade, and those that were were often the work of experienced film-makers or artists (Lis Rhodes, Ron Peck, the Quay Brothers, Sally Potter) rather than newcomers. On his arrival, MacCabe made it clear that since opportunities for a first film were now given by film schools, film studies departments and regional workshops, it was no longer the Production Board's role to support first-time directors.[27] Yet the establishment of the New Directors scheme in 1988, funded for half through the Channel 4 subvention, signalled a rapid U-turn in MacCabe's thinking. If the new scheme had as its natural constituency would-be film-makers with some previous experience, it also remained within the Production Board's traditional role as a discoverer of new talent to be led towards a career in innovative feature film-making. 'It is a place where the feature film-makers of the future can be spotted and then nurtured,' a paper on the scheme confirmed. 'If BFI Production is a laboratory for the rest of the industry – experimenting, mixing styles and stories with sometimes explosive results – then New Directors is a laboratory for BFI Production.'[28]

New Directors originated in the appointment of Ben Gibson as Video Production Officer in December 1986 and the introduction of a £50,000 fund to support the production of imaginative new work made on video. Following the success of the first year, during which five short fiction videos were made, the Production Board decided, on Gibson's suggestion, to allocate £200,000 to a more broadly based fund open to all kinds of short projects, experimental, documentary, fiction or animation projects on video, 8mm and 16mm, with a budget ceiling for each film of £20,000 (gradually increased to £35,000 in 1997).[29]

In its first year the scheme selected nine projects from over five hundred applications (the number would rise to over two thousand a year in the late 1990s; in total, the scheme produced more than seventy films over twelve years). The films were produced in the highly supportive environment of the Production Department at all stages of the development, production and distribution process; they were also guaranteed a theatrical showcase, as each year's New Directors shorts had a run together in London's Metro cinema, then toured the regions and most of them were broadcast on Channel 4. They also regularly picked up top prizes in short film festivals.

A number of those 'new directors' were later given the opportunity to direct low-budget features with BFI Production (Carine Adler, Patrick Keiller, Andrew Kötting, Chris Newby) or with other producers (Richard Kwietniowski, Sandra Goldbacher). Film-makers were not the only beneficiaries of the scheme, which also gave their first chance to untried scriptwriters (Simon Beaufoy, for instance, who went on to write *The Full Monty*).

Meanwhile at the turn of the 1990s, just as Ben Gibson replaced MacCabe as Head of Production, the old Regional Production Fund was integrated into the Department under the new name of Production Projects Fund. The RPF had

been criticised for having remained static and locked into a long-term funding relationship with a handful of franchised workshops. A more flexible response to the changing environment of regional film and video funding was needed, based on a broader interpretation of regional production which included non-franchised workshops and other non-commercial bodies, as well as individuals working in unconventional ways. Its reaffirmed priorities were to develop work from the regions (London being counted as a region) and by underrepresented groups (i.e. women and ethnic minorities).

The new scheme also intended to drop the long-term revenue-funding of workshops for a more project-based approach, following a similar move by Channel 4 with its own funding of the sector. It co-financed (in collaboration with regional partners and broadcasters) a wide range of film projects at any stage of the production process – development, production, completion – on the advice of a new officer within the Production Division rather than a large representative committee as previously. Over the next decade the Production Projects Fund backed over a hundred projects and helped reveal future feature film-makers such as Shane Meadows (*Smalltime*, 1996) and Joe Wright (*The End*, 1998). Although this new role as a hands-off funder was distinct from BFI Production's more traditional work as a producer, the pooling of all production and funding resources for shorts, features and regional projects within the Production Division enhanced the status of BFI Production and confirmed it as a key player in British cultural cinema.

Another area where the role of BFI Production changed significantly in the 1990s was feature film production. With a total budget for features which had stagnated since the mid-1980s, it could no longer afford to be the main funder of the films it produced or the schemes it developed.[30] Yet if the financial contribution of the BFI to the features it co-produced between 1991 and 1996 was only 26 per cent of the film's budget on average,[31] the Production Department managed to expand its production level without relinquishing any control and so reaffirmed the model of a production atelier. Its initial role was to commission projects via the consolidation of its development work (about £50,000 a year was spent on development), then raise the majority of the films' budget from other sources, either in co-production (often with European partners and the major broadcasters – Channel 4 and the BBC) or pre-sale of the films.

It then brought in a number of new producers (Ben Woolford, Kate Ogborn, Chiara Menage and Janine Marmot to name a few) and thus started or fed many production careers. BFI Production's uniquely integrated practice, with the close involvement of its highly skilled staff production executives, technical support thanks to its in-house post-production facilities, and its in-house sales and distribution expertise, allowed innovative film-makers, producers and writers to work in a highly supportive environment at all stages of the production process, from script to delivery.

One of the areas explored by BFI Production in the early 1990s (a recurrent occurrence in its history) was the creation of a sustainable sector of very low-

budget film production. This arose partly because of the scarcity of funds available, partly because of the widening gap between a first professional short and a first commercial feature. In 1994 it launched a 'low low-budget initiative', with a production programme of extremely low-budget films (with a ceiling set at £450,000, later increased to £650,000), although only a handful of films emerged from that programme. The Department also organised seminars and workshops for writers and directors committed to working in this area (under the telling titles of 'How Low Can You Go', 1991, or 'How Much Can You Do About Nothing', 1994). In 1996, BFI Production also housed a new initiative, the Script Factory, which staged annual seasons of performed readings of unproduced screenplays by acclaimed actors. It was an immediate success.[32]

From the mid-1990s, changes in the economic and political context were to destabilise BFI Production and eventually bring about its demise. The advent of the National Lottery in late 1994, and the ensuing availability of significant funding for film-making (via the Arts Council of England), opened new perspectives for the Department, which successfully applied for money for several of its feature film projects, from Andrew Kötting's *Gallivant* (1995) to *Love Is the Devil* (1998), John Akomfrah's *Speak Like a Child* (1999) and Jasmin Dizdar's *Beautiful People* (1999). It also submitted, in December 1995, a longer-term funding proposal to the Arts Council of England for a £5 million subsidy of Lottery money over three years (rather than on a film-by-film basis), hoping to reach 'a sufficient critical mass to make a much bigger impact on the whole area of cultural filmmaking'.[33]

However, the decision over the allocation of the Lottery's non-commercial franchise, later renamed Alpha Fund, was constantly delayed, to the frustration of the Production staff as in the context of budget cuts at the BFI since the mid-1990s the position of the Department kept weakening. In the latter part of 1996, a Production Activity Review was conducted by the BFI 'to establish the direction BFI Production was going and how its work might be enhanced'. The Review Team (chaired by Lynda Myles and consisting of representatives of the major broadcasters and independent producers) proposed a number of changes, such as the evolution of BFI Production towards a 'commissioning editor' structure, with the devolution of as much of the production activity to independent production companies as possible and a more advisory role for the Production Board, whose influence had tended to diminish over the years. Although the governors chose to interpret the report as an endorsement of the work of Production Board overall and decided that no further action should be taken, it did signal a noticeable change of mood towards BFI Production within the independent sector.

In April 1997 the Department also lost its sales and distribution activity, which was relocated to the new BFI Sales Division as part of the 'BFI 2000' restructuring. In early 1998, as no decision had yet been made regarding the Alpha Fund, the Labour government announced a new £900,000 cut in the BFI's budget. The new BFI director John Woodward immediately ordered the Production Department to put all new projects on hold while a comprehensive review of the BFI

The BFI and film production

was carried out.[34] The shock was such that Woodward had to reassure the Production Board that neither he nor Alan Parker (the new BFI chairman) had a hidden agenda and that 'they did not instinctively wanted to close down the Production Division'.[35] He also made clear, however, that, should the Production Division fail to be awarded the Alpha Fund to run, 'there would be no argument against closing down BFI Production'.[36]

Eventually, the Alpha Fund remained parked as the government was working on the complete overhaul of the system of public subsidy to British film production, while the BFI's internal review confirmed the BFI's new focus of its activities on education and a consequent dramatic reduction in the Production Department's resources and activities. Both the Production Projects Fund and the Department's feature film production were abandoned, the latter only to be resumed should the Lottery money finally become available. The New Directors scheme therefore became the Department's only involvement with the direct financing of new film-making.[37]

Then, in May 1999, just as Jasmin Dizdar's *Beautiful People*, one of the last feature films to be completed by the Department, was picking up the Best Film prize in the 'Un Certain Regard' section at Cannes, the secretary of state for culture Chris Smith officially announced during the same festival the creation of the Film Council (later UK Film Council), a new body amalgamating the various agencies dealing with film funding, which sealed the fate of BFI Production. Ironically, the latter had been doing rather well of late, its last feature films picking up more prizes in festivals and awards ceremonies, and being seen by bigger audiences than ever before, both in the UK and abroad.[38] The Department's final year, before the official transfer of its remit to the Film Council on 1 April 2000, was spent completing its last productions, winding down its programme of work, preparing the transition with the new body and deciding where what was left of the Production staff (headed by Roger Shannon since September 1997) moved to while the new arrangements about the public funding of film production were being finalised.

Over nearly half a century, the publicly funded mini-studio that the BFI's production arm was, or quickly became – arguably the only operation of its kind anywhere – had helped to launch the careers of several generations of innovative film-makers, from Karel Reisz and Ridley Scott to Peter Greenaway and John Maybury, at a ridiculously small cost to the British taxpayer.[39] By backing nearly four hundred films which would not have been supported by the commercial film industry, the Production Board and its corresponding BFI Department were instrumental in shaping the history of British independent cinema. BFI Production was never a particular school of film-making, however. By always maintaining an open and flexible attitude towards the independent sector and changes within it, it ensured the backing of a wide variety of films, and of film-makers with very different agendas, and gave a chance to underrepresented groups (women, gays and lesbians, ethnic minorities). Finally, it managed to retain a strong cultural remit until the very end. The Film Council, with its clear emphasis on the entrepreneurial nature of the film

industry and its more populist ethos, was always likely to take the public funding of independent film production into a whole new direction.

Notes

1. Stanley Reed, 'Helping Filmmakers', *The Times*, 10 December 1970. A more detailed analysis of the early days of the BFI's film production activity can be found in two other texts by the author of this chapter: 'Early Days of Short Film Production at the British Film Institute: Origins and Evolution of the BFI Experimental Film Fund (1952–66)', *Journal of Media Practice* 2:4; and 'The BFI and Independent British Cinema in the 1970s', in Robert Shail (ed.), *British Cinema of the 1970s* (London: BFI/Palgrave, 2009).
2. These films remained confined to the non-theatrical sector as the National Film Library could not afford to clear the rights for so many film extracts.
3. These included four stereoscopic (i.e. 3–D) films, four art shorts combining the work of contemporary British painters and poets, and a short 'drama documentary' about Wales.
4. Introduced in July 1950 to support domestic film production, the levy was paid by exhibitors on every cinema ticket sold. It was then paid into a fund (the British Film Production Fund) administrated by the four trade associations.
5. The three cycles occurred in 1952–1956, 1956–1958 and 1958–1963. They all evolved according to the same pattern, starting with the search for a sponsor and ending when the money had entirely been spent. Between 1963 and 1966 no new projects were funded as money had run out.
6. The unequal terms of the distribution contract between the BFI and the film-makers were devised to help the Fund to recover its investment as quickly as possible, since the Institute received 75 per cent of the revenue until the production costs were recouped, and 25 per cent thereafter. In practice, only a handful of films made enough money to benefit the film-makers.
7. Governors Minutes, 15 May 1952.
8. Examples include *Rowlandson's England* (1955), *Coventry Cathedral* (1958) and *The Vision of William Blake* (1958).
9. This was partly explained by the almost nonexistent publicity strategy, although the publication in 1958 and 1963 of small brochures promoting the films sponsored marginally improved the situation.
10. The situation evolved slightly towards the end of the Fund's existence, with the funding of a number of films shot (and sometimes produced) in the regions, such as Michael Grigsby's *Engineman* (Manchester), *Gala Day* (Durham), *Blackhill Campaign* (Northumbria), *Boy and Bicycle* (Hartlepool), and *Tomorrow's Saturday* (Blackburn).
11. In 1972 a Committee of Enquiry set up by the Arts Council and chaired by Richard Attenborough concluded that the Arts Council should retain responsibility for funding film 'as a fine art medium', while the Production Board should focus on the funding of cinema as an 'industrially-produced dramatic art'. The BFI Governors rejected these conclusions and the overlap problem was left unresolved.
12. Stanley Reed, 'Future Policy', paper presented to the Production Board, 29 May 1968. BFI/P-5.
13. See David Wilson, 'Images of Britain', *Sight and Sound*, Spring 1974, pp. 84–7, and David Robinson, 'British and Proud of It: Uncommercial Cinema', *The Times*, 14 May 1976.
14. The fact that Sainsbury was one of the early promoters and theoreticians of alternative cinema, first at Essex University, then with the distributor of political films The Other

Cinema and as co-editor of the magazine *Afterimage*, partly explained the Board's responsiveness to the claims of the independent sector.
15 For a personal account of this 'cultural struggle' within the BFI see Colin McArthur, 'Two Steps Forward, One Step Back: Cultural Struggle in the British Film Institute', *Journal of Popular British Cinema* 4, 2001, pp. 112–27.
16 'Broadsheet', *Roughcut*, Special issue on independent British cinema, 1976, p. 20.
17 The Other Cinema's exhibition project, set up thanks to a capital grant by the BFI, proved a major outlet for BFI-funded films during the fifteen months of its existence. This period marked the apogee of British independent cinema in the 1970s and its closure was symptomatic of the economic fragility of this sector and its inability to survive without institutional support.
18 The publication between 1977 and 1981 of three catalogues of BFI productions, which provided not only a critical examination of the films and the Board's practice but also in-depth analyses of various aesthetic, institutional and technological concerns of the independent sector, epitomised Sainsbury's innovative approach to distribution as an integral part of the film-making process.
19 See for instance 'The Triangle in the Tower', *Time Out*, 27 October 1978, pp. 11–12, and Nigel Andrews, 'Production Board Films', *Sight and Sound*, Winter 1978/79, pp. 53–5.
20 John Hill, 'The British Cinema and Thatcherism', in John Hill (ed.), *British Cinema in the 1980s* (Oxford: Oxford University Press, 1999), p. 20.
21 The ACTT Workshop Declaration ensured ACTT approval for properly funded and staffed production units engaged in non-commercial and grant-aided film and video work. The agreement ensured in particular continuity of employment as a basis for workshop work.
22 The idea of a Regional Production Fund had initially been suggested during the 1980 BFI Regional Conference but the BFI had declined to set it up until it was forced to by the negotiations on the Workshop Declaration in 1982/83.
23 See Michael O'Pray, 'The British Avant-Garde and Art Cinema from the 1970s to the 1990s', in Andrew Higson (ed.), *Dissolving Views: Key Writings on British Cinema* (London and New York: Cassell, 1996), pp. 178–90.
24 Quoted in Julian Petley, 'Which Way for the Board?', *AIP and Co*, March 1985.
25 Ibid.
26 Colin MacCabe, 'Production Division and Policy', Paper to the BFI Governors, 22 January 1986, p. 2. BFI/P/19.
27 Ibid.
28 Kate Ogborn, 'New Directors: The Past, the Present and the Future', policy paper, 27 October 1997. BFI/P/59.
29 In 1987 Channel 4 had set up in collaboration with British Screen a short film scheme called 'Shorts and Curlies', which served as a model for the New Directors scheme although it was designed for more sophisticated projects.
30 As Channel 4's subvention remained at a standstill throughout the 1990s, BFI Production worked increasingly with the BBC, in co-production deals (from *Love Is the Devil* to *Speak Like a Child*), as well as various schemes for development ('Screen on the Tube') and programmes of shorts developed with European funds ('Continental Drift').
31 Memorandum from BFI head of finance Ian Nelson to Production Board chair Tony Elliott, 12 March 1998. BFI/D9798/25.
32 Following the success of its first three years, the Script Factory became a stand-alone company in 1999 and had become one of the leading script-development organisations in Europe.

33 *1995–96 BFI Annual Report*, 1996, p. 37. Because of its particular expertise, BFI Production also took on the new role of assisting with the assessment of film production applications received by the National Lottery (this activity was distinct from the Department's own applications for funds).
34 Memorandum from John Woodward to Roger Shannon, 26 February 1998. BFI/D9798/25.
35 Minutes of the BFI Production Board, 19 March 1998. BFI/D9798/25.
36 Confidential discussion with John Woodward, Minutes of the BFI Production Board, 19 March 1998. BFI/D9798/25.
37 The Department also took over from the BFI's Regional Development Unit the administration of a fund of around £1 million spent by regional partners on film production and infrastructural activities.
38 Upon its opining in the autumn of 1998, *Love Is the Devil* became the biggest box-office success for a BFI production and was sold to all major territories around the world (from *1998/99 BFI Annual Report*, p. 85).
39 For Ben Gibson it was precisely the modesty of the scheme which kept it 'below the parapet of government interference' and therefore ensured its survival for nearly fifty years. Quoted in James Caterer, 'Playing the Lottery Twice: The Dual-Nationality of *Stella Does Tricks*', *Journal of Media Practice* 5:3, 2004, p.134.

12

The BFI and television

Richard Paterson

In the past century moving image culture has had to respond to constant changes in technology. As new means and modalities of production and distribution emerged – of which television was the most important in the twentieth century – the BFI had to adapt.

This chapter examines the impact of television across the various BFI activities – archiving, information, education, production and exhibition. The analysis seeks to establish the relationships between individuals, networks of power (both internal and external) and the material context, where the latter includes the allocation of resources to develop work inside the BFI alongside broader cultural, technological, political and industrial factors and the wider public discourses about television. In short, this is a story of how the BFI's interventions in television culture were influenced by key stakeholders (staff, management, governors, industry, regulators, academy, pressure groups); the organisational forces inhibiting or promoting interventions; and the surrounding events which shaped the trajectory of development.

Foundations

The BFI's remit was formally extended to television in 1961. The early evolution was a story of gradualism, marked by an erratic and changing view of television and its relation to film. In the late 1940s and early 1950s the potential social and cultural impact of television was first recognised with BFI involvement in the Telecinema at the Festival of Britain acquainting itself with television technology and programming through working alongside BBC staff.[1]

There was an upsurge in the ownership of television receivers with the Coronation in 1953 and then in 1954, with the imminent launch of commercial television. A first formal recognition of TV's relevance to the BFI was reflected in a paper that the director, Denis Forman, tabled at the June 1954 meeting of the governors. This paper, 'The British Film Institute and British Television', covered seven points: distribution, where there was an ambition to become the principal outlet for the non-commercial release of BBC television films; Archive, where it was proposed to

add a BBC representative to the History and Science Committee, and a TV critic to the Arts and Entertainment Committee (there was already a relationship with the BBC through newsreel collecting); the NFT, with a desire to provide large-screen TV exhibition; the Information department, proposing cataloguing of the *Radio Times* and key newspapers and beginning to answer television enquiries; Stills, to collect material from the BBC; Film Appreciation, to recognise its responsibility to television and consider holding a TV school; *Sight and Sound*, to consider devoting a third of its space to TV. All these proposals were agreed by governors, except the suggestion that a third of *Sight and Sound* should be devoted to television, which proved to be a sometimes contentious and continuing trope in the evolution of television policy.

Within the organisation, the politics of resources were in play at an early stage. In 1955, shortly after Forman left to join Granada Television and with James Quinn newly installed as director, Ernest Lindgren wrote a paper entitled 'National Film Archive – Future Development', noting that television was a new source of visual record on film, which it had already been agreed should be preserved by the Archive. He suggested the appointment of a special committee or committees to select television items for the Archive collections, but added the caveat that 'these cannot be properly serviced without more staff. It is probable, too, that such staff will have to bear an exceptionally heavy responsibility because of the difficulties of viewing, selecting and cataloguing', and recommended the creation of a small section: TV acquisitions officer, two TV cataloguers, secretarial assistant.

Towards an expanded remit

Television resurfaced as an issue in 1957 when James Quinn sought guidance from governors on a number of topics including the Institute's attitude to television[2] followed by a paper 'Television and the Institute' (10 October 1958). A perceived territorial threat had emerged from various organisations including the National Council for Social Service, the Institute for Educational Television and the nascent British Film Academy keen to set up a Television Institute.[3] The BFI's key archival and critical role were seen as obvious automatic extensions of the involvement with film.[4]

Internally, the resource issue – implementing an expanded remit without additional income, later the cause of considerable political lobbying – was initially handled through internal reallocation. Lindgren's plans for the Archive were partly implemented, beginning in early 1959 with the appointment of David Francis as the first Television Acquisitions Officer.[5] A year later agreement was reached with the BBC on the supply of television films to the Archive.

Pilkington

Following the introduction of commercial television, there were anxieties about television and its effects on children,[6] as well as with 'popular culture' more generally. At the same time there was an increasing awareness of television's educational potential. For the BFI and its grant-aided teachers organisation, SFT (Society of Film Teachers), awareness led to action: it changed its name to SEFT (Society for Education in Film and Television), and the BFI worked with the National Union of Teachers on its conference on 'Popular Culture and Personal Responsibility' in October 1960.[7] In 1959 external forces also came into play and Granada Television, where Denis Forman was now managing director, undoubtedly aware of the reactions in the political establishment to ITV's output, approached the BFI[8] with an offer to finance the publication by the Institute of a TV magazine (which eventually emerged as *Contrast*) – comparable with *Sight and Sound* and entirely independent – for three years. The governors' view was that the sponsorship should be spread more widely and Gerald Beadle (a governor and director of television at the BBC) assisted in getting BBC buy-in. Attempts by the director James Quinn and two governors, Eirene White (Welsh Labour MP) and Sir Hamilton Kerr, failed to get Norman Collins, a former BFI governor now at ATV, or others interested. Eventually the BBC and Granada contributed £12,000 each for its first three years of publication.

In 1960 the government set up the Pilkington Committee. The BFI by this time was prepared to play a major role and was courted, albeit as a bit player, by the increasingly powerful TV industry. In late 1960 the BFI was approached by the Pilkington Committee to give evidence. Very soon thereafter, in January 1961, new Articles of Association were presented to the board of governors including an extension to add responsibility for television. A month later the Treasury (then the BFI's sponsoring department) agreed to these changes but with the stipulation that they should not be charged against the Treasury grant.

The BFI's statement of intent in its evidence to Pilkington dated November 1960 was clear:

> Governors of the Institute believe that in the field of television there is evidence of need for public services which should include a central information point and reference library on television, and that demand for these will grow. They hope that the Committee may think fit to refer in their report to the need for such services, and to recommend that in the interests of convenience and economy the Institute should supply them.[9]

They stressed the importance that the body which serves the public in this way should be clearly independent and free from commercial pressure. For Quinn, it was 'impossible to be involved in cinema without responsibility for television and particularly the useful purposes of television'.[10] On the resourcing issues, the Institute accepted that some public money should be devoted to the extension of its work into television, for example the preservation of television material in the National Film Archive, but believed that the programme providers should make

a contribution towards the cost of maintaining an informational and educative service on television. In arguing for an allocation of money for this purpose as a condition of broadcasting franchises, the precedent was drawn with the arrangement in the 1930s whereby the BFI received an annual allocation of money from the Sunday Cinematograph Fund.

The BFI's submission was complemented by that from the Arts Council of Great Britain (dated February 1961) which suggested that there was a need for archives of television and that 'both the BBC and the ITV companies should be urged to consider this aspect of their responsibilities'.[11]

Taking stock

The BFI's new Articles of Association were approved at an Extraordinary General Meeting of members on 14 April 1961 and were portrayed as a de jure recognition of a situation which had existed de facto for a number of years, A subsequent board of governors paper summarised the current BFI television activities. It referenced the Archive agreement with the BBC to preserve television newsreels, the selection of television material with advice from the Standing Conference on Television Viewing (although this was superseded a year later when the Television Advisory Committee was set up); increasing TV-related enquiries through the Information Department; the Stills Department holding 500,000 TV stills; Education setting up a joint committee with the Association of Training Colleges and departments of education to consider the impact of television as well as film; the Film Distribution Department holding over fifty films made specially for television or telerecordings of programmes as transmitted, which were used by teachers working with SEFT; the fact that the NFT had curated television seasons including 'The Captive Cinema' – a season of documentaries from Associated-Rediffusion – in 1957. It had also hosted lectures including an afternoon devoted to the work of the *Tonight* team introduced by Alasdair Milne and Antony Jay. *Contrast* had by then completed its first year under the editorship of Peter Black.

The BFI quickly moved to attempt to get additional financial provision through amendments to the Television bill, 1963.[12] The networks of power were orchestrated through the board of governors. The chairman, Sylvester Gates, a banker, offered to raise the proposal to fund the expansion of BFI television services from the commercial television levy with the Economic Secretary to the Treasury. Another governor, Eirene White, sought to include an amendment to the Television bill requiring the ITA to make an annual payment to the BFI 'for preservation of television film broadcast by Authority and for the study of their broadcasts generally'.[13] She withdrew the amendment when the Assistant Postmaster General assured her that the ITA would have power to do what was proposed in the Act.

In the same vein, at the end of 1963, Gates and Quinn had a meeting with Lord Hill and Sir Robert Fraser (respectively chairman and director general of the ITA) to request ITA support for development of the BFI's television work, and in

The BFI and television

particular for financial help from the ITA and the ITV companies for capital for television projects including the provision of an information centre, and the costs of transferring television programmes to film for preservation purposes. Lord Hill's response was reported to have been friendly but guarded and he suggested that the BFI should formulate its proposals on paper for the consideration of the ITA Council. He also made it clear that he thought it likely the ITA would wish to consult the BBC about its attitude towards the Institute's plans for development.

There was considerable organisational engagement in this period with the new television responsibilities. Relationships were forged or strengthened with key stakeholders: ITA, the ITV companies and the BBC. The initiatives in this period – *Contrast*, the World Television Festival and the setting up of the Archive's Television Acquisition Committee – were tied both to funding issues and to the gradual development of a legitimacy for the BFI to speak and act for television.

In November 1963 a Governors' Review Committee noted that television 'had taken the place of film as the principal medium of entertainment and information', and confirmed the need for greater BFI involvement and to seek additional funding. The consistent line was that the BFI's role would be complementary to the work of the two statutory corporations ITA and BBC, as its task would be maintaining good standards in television, while those of the BBC and ITA tended to carry out a negative function and they were not specifically concerned, as the Institute was, with audience education. Concern was also expressed at the lack of a national policy for the long-term preservation of television material.

In the discussion Quinn urged examination of the present activities of the Institute in the light of the changed circumstances and questioned whether the Institute's work was aimed at the right public. This explicit mention of a public for the Institute's TV activities came in the same period that a governor, Paul Adorian, suggested that the BFI should conduct market research into the readership of *Contrast*.

When Institute priorities were again considered at the September 1964 governors' meeting, television was one among many possible priority activities – suggesting that the early enthusiasm was being tempered by the difficulties encountered with the two major initiatives which had taken place, the World Television Festival and the launch of *Contrast*. Quinn made it clear that none of the priority activities could be carried into effect without involving the Institute in substantial increases in expenditure but he still expressed the desire to sustain *Contrast* though external sponsorship and to increase the TV information service.

Uneven development

Archival activity moved ahead with some circumspection. Technology issues were debated internally and externally in parallel with the early work of the Selection Committees.[14] Ernest Lindgren, the curator, reported to the BFI Governors' meeting on 4 February 1963 that a meeting between electronic and cinemato-

graph engineers had considered the best form in which TV programmes could be preserved and recommended magnetic tape for preservation with a 35mm optical negative film for reference, but this was seen as inordinately expensive. Technology issues have remained a concern since the introduction of videotape in the late 1960s to this day with continued format-shifting necessary as technology has progressed.

All was not straightforward in the emerging day-to-day relationships with industry. It was reported at the governors' meeting on 10 June 1963 that a contract entered into with the BBC in 1954 for storage of a complete set of its newsreels was being terminated as the volume of material was too great to continue. However, in September 1963 good progress was reported in the acquisition of television film and recordings from the ITV companies and by this time Associated-Television (ATV) was the only company which had entirely refused to co-operate.[15]

Some further stresses emerged in 1964.[16] The Archive's relationship with BBC television broke down over the acquisition of selected TV titles as in the previous 18 months the Archive had been asked to return preservation deposits to the BBC for use as production library materials, negating the care the NFA had expended in preserving materials. The BBC had deposited no new film as preservation was no longer a priority, but was happy to provide copies if the BFI was prepared to meet the cost. Lindgren asked the governors to make a request at the top level of the BBC for the BFI to be considered as the responsible body for preservation. It was agreed that the matter would be discussed with Kenneth Adam, the BBC representative on the board of governors. The responsibility for archival work for television had become a site of some contention.

Contrast was first published in 1961. Under Peter Black's editorship it attempted to assess TV as a medium, by establishing certain principles and 'to provide comment on television programmes and on trends and developments in television'.[17] The editorial board included James Quinn, Stanley Reed (former head of education, now BFI secretary), Paddy Whannel (head of education), John Huntley (head of Film Services), Penelope Houston (editor of *Sight and Sound*), plus the editor of *Contrast* itself (initially Peter Black and then from 1963 David Robinson). Articles were wide-ranging and an ambitious agenda was set: from studio reports to genre analysis to authorship and production issues, as well as debate (particularly around Pilkington-related matters) and international coverage. Notable contributors included Richard Hoggart, Marty Feldman, Philip Purser, Roy Shaw and J. B. Priestley.

The failure to attract a significant readership led to a paper about the financial position by Stanley Reed to the governors.[18] It was agreed that the ITA and other possible sponsors should be formally approached with a view to their providing continuing subsidy and failing that the magazine should be discontinued. All approached indicated an unwillingness to provide the necessary resources. The external context had changed and the Pilkington Report effect had lessened considerably.

The BFI and television

The story of *Contrast* had a long-drawn-out endgame possibly because of contradictory views within the BFI. In February 1964, Quinn was urging that, in order to assist in the development of the Institute's work in television, the publication of *Contrast* should be continued, and submitted a budget. There would be budget reductions by 'abandoning' the office allocated to *Contrast*, reducing the editor's salary to a nominal sum and cutting contributors' fees. Some governors expressed doubts but agreed to continue the magazine for one further issue after the one in press and then to reconsider matters. A survey of readership was undertaken and results were reported back at the May 1964 meeting. It showed that half the readership of four to five thousand was professionally involved in television, and that the 30 to 40 age group predominated, followed closely by the 20s to 30s. The majority of readers were London-based, with Home Counties and Midlands also well represented. The officers regarded these results as encouraging and undertook to address themselves to the task of making *Contrast* financially viable, although subsidy was seen as the only immediate option.

12.1 Cover of the Autumn 1961 issue of the BFI's quarterly television magazine *Contrast*, which ran from 1961 to 1965

In September 1965 Stanley Reed, now BFI director, noted the need to consider the future of *Contrast*, and at the following meeting it was reported that as the twenty thousand circulation needed for viability was unlikely to be achieved, winding it up was proposed to save money. Reed's view was that 'what had emerged from the experiment was that there were relatively few people interested in television as a medium as distinct from particular types of material transmitted'.[19] However, he added an important caveat that the Institute would wish to avoid any impression that it was losing interest in television and he suggested that money saved in winding up *Contrast* should be diverted into the organisation of an information service on television for the general public.

Discussion also returned to the possibility of including some coverage of television in *Sight and Sound*. The director said this had been considered but that the editor of *Sight and Sound* (Penelope Houston) thought this inexpedient. This debate continued within the BFI for a further ten years.

The other high-profile television initiative of this period which did not achieve the success hoped for was the first World Television Festival. First mooted at the February 1963 governors' meeting, it was to be mounted under the 'Contrast' banner with financial support from the BBC and ITA. The dates were initially fixed as 17 to 24 July but problems emerged both with sponsorship and with issues of rights to screen television to a paying audience (a problem which it took more than twenty years to overcome). No charge for admission could be made so the NFT had to be compensated for loss of business. The Festival eventually took place in November 1963. It was opened by the Postmaster General and had over fifty foreign visitors attending. When the BFI explored the possibility of funding for a second Festival with the ITA in 1965 there was no enthusiasm and the idea was dropped.

1965: a change of leadership and a revaluation

Stanley Reed became director in late 1964, and began work with a new chairman, William Coldstream. Labour had come to power for the first time since 1951 and a renewed emphasis on the arts had begun to emerge from government. Education had gained a new political emphasis after publication of the Newsom Report and this was having an effect on the BFI's work in this field. In television the BFI began to review future options and priorities.

The material context had changed, a new set of discourses emerged and the networks of power altered. The work on television had been a key area of development for the first half of the decade but this changed with variable relations to the television industry and little engagement by the academic community. Furthermore, there was a significant influx of new governors at this time, including Paul Adorian from Associated-Rediffusion and David Kerr MP, who was a great supporter of the Archive. The latter replaced the influential Eirene White MP as she had to resign following her appointment to a government position.

The BFI and television 227

Archival matters returned to centre stage and at the 5 July 1965 governors' meeting, while the priority concern was finding money for vaults at Berkhamsted, the discussion also looked at the issue of television acquisitions. A need for additional recurrent resources of £30,000 was identified to enable acquisition of both ITV and BBC materials from the selection panel's recommendations of material meriting preservation. The governors suggested sending a letter to the Department of Education and Science (DES), now the responsible department in government, posing the problem faced and setting out the financial implications of the Institute fulfilling the role it had been given in respect of television and to ask what steps the government was prepared to take in this direction.

In parallel, conversations continued with the ITA. In September 1965, Reed and Ernest Lindgren met Sir Robert Fraser, director general of the ITA, to discuss preservation of television material. By November a letter had been received from Fraser, suggesting that some contribution from ITV would be made toward the acquisition of television material.

Negotiations about this financial involvement of the broadcasters in television archiving continued. In October 1967, Reed reported that in the new arrangements being made by the ITA with television companies there would be a provision that companies must contribute to a fund to be set up by the ITA 'to finance a scheme to support those Arts and Sciences and Training on which television depends', and that support for a number of BFI projects might be obtained from such a fund. A meeting between the BFI chairman and Lord Aylestone, chairman of the ITA, was mooted to sound out the scope of the fund and assess the likely response to applications for assistance from it from the BFI.

Other activities

There were other developments across the BFI in this period as a range of departments sought to adapt to the BFI's extended remit. In July 1966, Stanley Reed reported an approach by Granada for assistance in compiling experimental 'dry-run' TV programmes, a Television Experimental Committee, similar to the Experimental Film Fund for film in the 1950s. Denis Forman continued to be influential. The ACTT had said it would raise no objections if the Institute could find the funds; and there was reason to hope Granada would provide these. The 'dry-runs' would be made with non-union crews, no transmissions would be guaranteed and, it was suggested, the results might be distributed in the same way as, for instance, *The War Game* (i.e. non-theatrically). This project was never realised.

Information Services continued to build its collections of information. Education and SEFT began to embrace the study of television within the context of popular culture as indicated by the publication of *Talking About Television* by A. P. Higgins (1966) and Stuart Hall and Paddy Whannel's *The Popular Arts* (1964). However, the late 1960s also saw the emergence of a reaction to a growth of television activity and a new emphasis on the specificity of film. In particular, Paddy

Whannel, head of education, questioned the basis for BFI grant-aided SEFT moving into television, and was sceptical about the growth of Mass Media Studies where he believed the film/cinema elements were badly taught.

Consolidation in the 1970s

In the late 1960s and early 1970s the BFI was embroiled in the broader cultural struggles of the time, but the early 1970s witnessed a revival of television activity. Denis Forman returned as chairman for a short period and was very keen on developing TV work at the BFI, and first under Stanley Reed and then with the appointment in 1972 of Keith Lucas as director there is a noticeable renewed emphasis on the BFI's television work. The BFI positioned itself as a key player in the development of a TV culture by establishing a series of activities which were widely supported in the industry and academy, and beginning to engage with a new range of audiences.

The networks of power within and without the BFI were operating in a new material context. The contest for a democratic television system (with the activities of the Free Communications Group and others); the emergence of a lobby for a different kind of broadcasting structure during the Annan Committee deliberations; the upsurge in academic activity around television as a medium, all had an effect in and on the BFI.

There was new interest at governor level with increased representation from television: Howard Thomas (Thames Television), Wynford Vaughan Thomas (HTV), John Freeman (London Weekend Television), Nicholas Garnham (ex-BBC, by then a TV academic, elected as a member governor), Roger Graef (film-maker, later a founding board member of Channel 4) and Alan Sapper (ACTT). Within the BBC the BFI approach was still not well received, but it had sympathetic allies in the IBA for TV archiving and education.

A range of views began to be debated on the board of governors. Garnham suggested in a paper to the governors when they were considering the putative British Film Authority that both the BBC and ITV, as regulated public service organisations, should have a statutory obligation for archiving. He also suggested that the Archive should be broken away from the BFI with television culture becoming the responsibility of the IBA. The issue of statutory deposit and the tie with copyright, a position supported by ACTT, was also discussed.[20]

Many of the continuing TV concerns returned to the agenda within the organisation, including the possibility that the television magazine project should be resuscitated. There was a growing view that television should enter the BFI's bloodstream and, for the new director, Keith Lucas, a fear of a decline of the Institute if it failed to embrace television. His view was shaped by the downturn in cinemagoing in the UK. 'He didn't want BFI as a museum piece' and was supportive of an extended position for the BFI in relation to both TV and higher education. Among his executive only Penelope Houston was less than enthusiastic about television, ignoring what Lucas saw as the 'bigger picture'.[21]

Funding issues had been temporarily addressed through the ITCA grant but were to return in the late 1970s as, with recession and high inflation, the BFI's sponsoring department, the DES, while not discouraging BFI involvement in television, made it clear that additional funding was not available.

In March 1973, a Reserve fund of £15,000 was allocated specifically for TV activities which would be decided by the officers. In July 1973 governors responded forthrightly to the executive's pressure for a TV magazine ('from a content and feasibility point of view this was not a viable proposition at this particular time'), but again encouraged the inclusion of a TV section in *Sight and Sound*. The idea emerged again in March 1976 when 'A Proposal for a Television Magazine: A Paper from the Publications Advisory Committee' written by Peter Lennon led to a sharp disagreement between the Chair of the Publications Advisory Committee (Colin Young), who endorsed the proposal and suggested the Institute should make funds available, and the chair of the Advisory Committee on Education (Nicholas Garnham), who questioned both the economics and demand for the magazine and its fit with overall Institute publications policy. He favoured investment in the new Television Monographs. The governors requested a detailed project specification backed up by market research into potential circulation.

The Annan Report

The material context then became a key factor in developments. The emerging debate over the Fourth Channel played a crucial role in shaping BFI's television activities. In October 1973, in reply to the Department of Posts and Telecommunications, the BFI supported a public enquiry on these matters. Staff, when canvassed, offered suggestions: the Channel should be for educational purposes, be run by a consortium of public bodies and not operated by the ITV companies. When the Annan Commission was appointed, the BFI staff drafted an initial response which was then considered by a sub-committee of governors (Nicholas Garnham, Philip Jenkinson, Howard Thomas and Percy Livingstone). The governors insisted that the BFI should focus on subjects in which the BFI was particularly interested: archival matters and acquisition of programmes (suggesting a need for £150,000 per annum to enable all programmes that the NFA 'considers worthy of preservation' to be acquired and the legal authority to acquire selected television programmes before they were junked or wiped), copyright (via a blanket licence to enable screenings at NFT and RFTs, as well as in education), documentation (and the possibility of setting up a central documentation and information centre for TV), research (to augment growth in television studies in schools and colleges) and the relationship between the cinema and television (through Production Board investment in independent work which could be shown on the new channel, but also by reviewing the number of films screened on television – of which it opined there were too many). Specifically, the BFI argued that 'its funds should be increased to enable [it] to devote appropriate funds to these [television's] needs'.[22]

Internally, the BFI's engagement with the broader debate led to the consideration of unresolved issues and new television projects. In the period before Annan reported, discussions about television activity continued internally through the Director's Working Party 3 (Television), chaired by Brenda Davies, which reported in October 1976.[23] Its key recommendation was for a TV journal appearing every two months. The Governors did not pursue this option as the proposal still lacked a financial case, and because of financial constraints there was no chance of providing the investment which would be needed to launch it.

Television also took centre stage at a joint governors/senior staff away day in 1976. The agenda included an item 'BFI and Television' which led to a long debate about the need for a Television Institute and whether this should be taken on by the BFI, notwithstanding the existing activities. The conversation indicated a level of uncertainty and anxiety: a desire to do more but without much hope of additional funding being made available; an awareness that television was now such an important part of the culture but also a fear that increased television activity would lead to a diminution of film work. The paradox was expressed by Alan Sapper, general secretary of the ACTT: that more support for television activities would be 'like a cuckoo in the nest' but that if the BFI was not to support such moves it might be overlooked 'when it came to the point that there was a need'. For Keith Lucas, 'the BFI might get into difficulties if it started on television in a small way but on the other hand by getting into television it had a future'. Michael Relph, chairman of the Production Board, noted that though the two media were different there were sufficient affinities for the Institute to lay claim to being the suitable body to perform the function for television as it did for film but that this must be done without detriment to services for film. Support from industry was seen as paramount but there was still scepticism about the BBC's attitude. The chairman, John Freeman, thought ITV companies would support the archival activities but wondered if government would have any interest.

Reflecting the BFI's evidence to Annan, a number of governors (R. S. Camplin, John Freeman, Michael Relph) argued for archival activities for television being taken on by the BFI, and that it should become the agency which identified the material likely to be of lasting artistic consequence.

In early 1977, Lucas recommended a continuation of the gradual growth strategy for television working within existing budgets.[24] At the time the BFI awaited a clarification of its future relationship to the proposed British Film Authority and ahead of the announcement of the DES grant for 1977/78. Annan was published two months later, covering two areas directly relating to the BFI: the Archive, which it was proposed would also acquire sound recording and become the National Film and Broadcast Archive, but with little additional funding; and the proposal to establish an open broadcasting authority providing for independent production with great potential importance to the Production Board.

With no further funds immediately in prospect, a budget of £10,000 was allocated to make 'the most effective public gesture' for the BFI in relation to television:

The BFI and television

to support television screenings, seminars and lectures at the NFT; to underwrite Television Monographs; to support BFI activities at the Edinburgh Television Festival; and to provide grant aid for modest research in a university.

Negotiations continued for additional funding from Government but the Minister rejected this until the financial position of the country had improved. As a consequence, in February 1978 Keith Lucas recommended a 'gradual enhancement of "bloodstream" TV activities, positive promotion of work already underway as part of argument for additional resources, and modest initiatives including, the exploration of the means to launch a TV magazine (but as a joint venture)'.[25]

Departmental initiatives

Within the BFI there was a considerable increase in television activity in this period across all departments. A new Television Acquisition Officer, Paul Madden, was appointed in 1970 and at this time remained the only full-time television person in BFI. In the Library (then a section of the NFA), a new deputy librarian, Gillian Hartnoll, was an influential ally in promoting television work. New agreements with the BBC were established and the arrangements with ITCA to buy preservation materials (film) maintained; while the Library and Information section sought to develop a television documentation policy in conjunction with the BBC and IBA.

A new set of networks emerged. Influential contacts were forged, particularly among journalists, who supported the TV work of the Archive both through practical activity but also through membership of the TV Advisory Committee. The need to be able to screen the television the BFI had archived again became a priority. A set of negotiations involving the director and key external stakeholders, brokered by the middle management's network of contacts with the unions, led to the negotiation of an agreement to allow the NFT to exhibit television to paying audiences, the Performers' Alliance Agreement. This initiative was eventually signed in 1980 but its necessity was proved by the 1976 TV Drama season at the NFT with an accompanying Dossier, which required no fewer than four hundred letters being written to individuals appearing in the programmes to obtain their permission.

The Library too made gradual progress. In October 1971 the Special Collections Unit received its first television collection – Associated-Rediffusion TV scripts. Then in April 1975 the viability of extending library coverage of television, which had been limited to book and script acquisitions and documentation of feature films made for television, was given a three-month trial and then made fully operational. This involved the development of a programme title index for television fiction (series, serials and plays) as well as documentaries listed in the London editions of *TV Times* and *Radio Times*. By 1978 resources had been identified to appoint a Television Information Officer and then the following year an Assistant Television officer whose appointment coincided with a grant finally being made to the Library by the ITCA.

The first title in the Television Monograph series – *Structures of Television*, written by Nicholas Garnham – appeared in 1972. This was the most visible pronouncement to the academy that the BFI had an interest in television. The Monographs were commissioned through the cross-departmental Occasional Publications Committee programme chaired by David Wilson from the Editorial department, with members drawn from Film Availability Services, Education Advisory Service (EAS), the Archive and *Sight and Sound*.

In EAS, Douglas Lowndes worked on the controversial *Viewpoint* series for Thames Television. EAS undertook a range of television activities often in conjunction with SEFT including an extra-mural course in Television Studies at Birkbeck, University of London, and the development of a book on the television industry (*Hazell: The Making of a TV Series*) deemed to be needed for O level and written by Manuel Alvarado (from SEFT) and Ed Buscombe from the BFI. Through SEFT, Television Studies articles appeared in *Screen* and then in a more concerted fashion in *Screen Education*. The BFI partnership with SEFT also led to sessions at the Edinburgh Television Festival in the late 1970s, at first seeking to highlight archival work but later seeking to inform intellectual debates that were emerging about television

Finally, in Production the availability of the first generation of portable video-making equipment led to a debate about the democratisation potential and whether it could provide a different perspective for education. It was also seen as a means of freeing film-makers from cost constraints and providing a radical new agenda through practice. Its emergence paralleled the debate about the setting up of a National Film School and was overlaid by differences of attitude over the control of entry to the industry

After 1980

The 1980s are marked by the directorship of Anthony Smith and a new relational materiality. The networks of power were altered with a Conservative government now in office and a new context emerging with the foundation of Channel 4 and the development of an independent production sector, with BFI involvement through its Production Board and its involvement with the funding of workshops. Within the BFI budgets were made available which enabled television work to flourish. There was rapid expansion with an emphasis on in-house 'broadcasting' research through the Broadcasting Research Unit, on education and NFT seasons; and enhanced archival activity with the assignment of Channel 4 archival responsibility to the BFI.

In legal and operational terms, the Archive television work was further boosted by the introduction in 1985 of off-air recording for ITV (and Channel 4). This had been considered for the first time in the early 1970s but implementation was deferred. Archival work was given additional legitimacy by successful lobbying of first the 1988 Copyright, Designs and Patents Act, to include a clause enabling

12.2 The National Film Archive's Video Unit in Berkhamsted in the 1980s

designated archives to carry out this function, and then the 1990 Broadcasting Act to provide a legal underpinning for the funding of public service commercial archives by the ITV companies. The inclusion in the 1986 Charter of a duty for the BBC to provide a public access archive of its programmes led to a contract for the BFI to provide this service and this began in August 1990.

In 1980 a TV Projects Group was set up with a budget to enable proactive developments across the Institute. Its first chair was Paul Madden and then, when he left to become a commissioning editor at Channel 4, I took over the role. Within a supportive structure the Group took the initiative to support a range of activities. These included taking full advantage of the now formalised Performers' Alliance agreement with seasons at the NFT (including David Mercer, *Doctor Who* and an all-day *Jewel in the Crown* screening) and in the RFTs (with Monty Python opening at Bristol Watershed). The acquisition of the Southern Television collection for the Library was facilitated when it lost its franchise and a range of seminars and conferences was organised.

In the Education Department the first TV Summer School, 'TV Fictions', was organised in 1981, followed in 1985 by 'In Front of the Children: Television', a reconsideration of children and TV. There was a series of collaborations: on a Channel 4 series *Open the Box* (produced by Michael Jackson, later chief executive of Channel 4); with Her Majesty's Inspectorate in the debate about popular television and schooling; and teaching materials were produced about *Coronation Street* and TV sitcoms alongside the distribution of previously impossible to access early examples of key programmes. Publishing maintained its ambitious programme of television-related books.

In 1984 it was agreed to run a whole year of television activities, which included the first International Television Studies Conference (followed in 1986 and 1988 by two further conferences), and books on MTM, on *Boys from the Blackstuff* and on Trevor Griffiths tying in to seasons at the NFT. In the same year the initial research was undertaken into the representation of ethnic minorities in British television. This work led to investment by the BBC into further research leading to the two-part documentary *Black and White in Colour* directed by Isaac Julien and transmitted on BBC2 in 1992.

In 1987 an ambitious project – One Day in the Life of Television – was started, proving a timely intervention, in collaboration with all the UK television companies, just ahead of major changes in UK television with the inauguration of satellite services. Based on archiving every programme shown on 1 November 1988, and securing diaries from members of the audience as well as those working in the industry on their experience of television that day, it resulted in a two-hour television documentary directed by Peter Kosminsky for ITV, a book (based on the 25,000 diaries submitted)[26] and an exhibit at the new Museum of the Moving Image. It also had a spin-off in two research projects several years later: the Television Audience Tracking Study (1991–96) and the Television Industry Tracking Study (1994–98).[27]

The Museum of the Moving Image had opened in 1988 and included an entire gallery devoted to television with popular participatory exhibits allowing visitors to read the news and be interviewed about their film knowledge by Barry Norman, then presenter of the BBC's main film programme.

Recent history

Wilf Stevenson became director in 1988 and continued to support a high level of television activity. The BFI played an important role as a centre for debate about the rapid developments in television as the cable and satellite services began to have a profound effect on the ecology of British television. In 1989 the BFI published a series of monographs, 'The Broadcasting Debate', during the passage of the 1990 Broadcasting Act and then, in 1993, organised a Commission of Inquiry and published another series of monographs ('The BBC Charter Review') around the renewal of the BBC Charter. In tandem, the Archive pursued a campaign – Missing Believed Wiped – to find key programmes which had been lost. Eight missing episodes of *Steptoe and Son* were rediscovered, restored and then retransmitted by the BBC. The NFT continued to organise regular seasons of television and for a number of years ran a television festival. In 2000 the BFI canvassed industry and critics to establish a TV100: the most important British television programmes in a number of genres. *Fawlty Towers* ranked highest. Perhaps of greatest significance in relation to the age of convergence that marks the twenty-first century, in 1996 the BFI embarked on a series of pilot online projects, which culminated in the launch of Screenonline (screenonline.org.uk) in autumn 2003, providing an ency-

clopaedic reference resource for British film and television. With the support of the whole industry, and underpinned by an extension to the Performers' Alliance agreement first signed in the early 1980s, streamed television material was made available online to UK schools, universities and libraries.

With the addition of the ITC library to the BFI's Library in 2003, and the amendment of the 2003 Communications Act to include Channel 4 within the ambit of the designated Archive scheme, the BFI's legitimacy as a television institute appeared well established. However, the relational materiality was changing rapidly. The networks of power had been transformed by the creation of the UK Film Council, with a remit covering only film, but with responsibility for agreeing the BFI's plans and acting as its funder. The relationship with Ofcom, the new regulator for converged media, was quickly established in respect of the archival provision and media literacy, and with the increasing importance of the Web, the BFI was in a position to take advantage of its legitimacy and knowledge. The early establishment of Screenonline provided a considerable competitive advantage in the new environment, but as the first decade of the new century progressed, like all media organisations the BFI had to come to terms with the uncertainties associated with convergent technologies as the implications of fundamental changes in audience behaviour and expectations emerged.

Notes

1 The BBC was represented on the BFI board of governors from 1949.
2 Director's Report, 11 October 1957.
3 The Academy eventually incorporated television into its remit and changed its name to British Academy of Film and Television Arts (BAFTA).
4 Telephone interview with James Quinn, September 2006.
5 David Francis (interview July 2007) believed this was Ernest Lindgren's clever use of politics to gain extra resources for the Archive. Paul Madden (interview September 2007) confirmed Lindgren's limited commitment to television as a source of actuality material.
6 Cf. Hilde Himmelweit, *Television and the Child: An Empirical Study of the Effect of Television on the Young* (Oxford: Oxford University Press, 1958). See also Terry Bolas, Chapter 8 above.
7 The key figures, Stanley Reed, an NUT member, by then BFI secretary, and Paddy Whannel, head of education For more about the NUT Conference see Terry Bolas, Chapter 8, pp. 137–8.
8 Reported at Governors Meeting 13 February 1959.
9 *Report of the Committee on Broadcasting, 1960*, vol. II Appendix E, Cmnd.1753 (London: HMSO, June 1962), p. 1091.
10 Interview, September 2006.
11 *Report of the Committee on Broadcasting*, pp. 1052–3.
12 Governors Minutes, 4 February 1963.
13 *Hansard*, 27 June 1963.
14 At the 4 January 1964 governors' meeting, it was reported that of the television programmes considered by the Television Committee between 1 March and 30 April 1963, 14 out of 71 BBC programmes, and 10 out of 61 ITV programmes had been

selected for acquisition; 32 out of 403 BBC series episodes and 34 out of 524 ITV series episodes had also been selected for acquisition, but there is no mention of how many had been acquired.
15 Governors Minutes, 22 September 1963.
16 See Governors Minutes, 5 October 1964.
17 Peter Black, 'Foreword', *Contrast* 1:1, Autumn 1961.
18 Governors Minutes, 2 December 1963.
19 Governors Minutes, 4 October 1965.
20 Director's Report including 'Discussion Paper on the Implications for the BFI of the proposed British Film Authority' with Appendix B 'A Proposed BFI Position' by Nicholas Garnham, dated 18 May 1976.
21 Interview with Keith Lucas, February 2008.
22 Governors Minutes, 18 January 1975.
23 The other members were Ed Buscombe (vice-chairman), Paul Madden, Colin McArthur, Jane Mercer, David Wilson.
24 Governors Minutes, 18 January 1977.
25 Keith Lucas, paper to the board of governors, 'BFI Involvement in Television' (February 1978).
26 Sean Day-Lewis (ed.), *One Day in the Life of Television* (London: Grafton Books, 1989).
27 See *inter alia* David Gauntlett and Annette Hill, *TV Living: Television, Culture and Everyday Life* (London:, Routledge/BFI, 1999); *Television Industry Tracking Study: Third Report* (BFI 1998, mimeo); Richard Paterson, 'Work Histories in Television', *Media, Culture and Society* 23:4, 2001.

13

The *Sight and Sound* story, 1932–1992

Geoffrey Nowell-Smith

Sight and Sound has been the BFI's flagship magazine for over 75 years. But the BFI did not found *Sight and Sound*. If anything it was the other way round. Not only was *Sight and Sound* older, having started publication early in 1932 as 'a review of modern aids to learning' under the auspices of the British Institute for Adult Education, but its very first issue – Volume 1, Number 1, Spring 1932[1] – began with an article by A. C. Cameron, entitled 'The Case for a National Film Institute'. This was followed up in the next issue by a an editorial endorsing the celebrated booklet 'The Film in National Life' which led directly to the foundation of the BFI the following year. The principal authors of 'The Film in National Life' were none other than Cameron himself and R. S. Lambert, both of whom were on the editorial board of *Sight and Sound*. The newly founded British Film Institute then took over publication of the magazine at the end of 1933.

Early days

Throughout the 1930s, *Sight and Sound* was the BFI's house magazine, promoting BFI policies, such as the foundation of the National Film Library, and keeping readers in touch with BFI activities, particularly in the regions. In the early years it was mainly devoted to the cause of promoting education through film, which indeed was a major purpose of the fledgling film institute itself. It was also supported largely by advertising from the manufacturers of 16mm projectors and other audiovisual equipment. But even at the beginning it did not expect its readers to be interested only in education and visual aids. From the outset it ran a column devoted to films that readers might like to see. In the first issue the film critic C. A. Lejeune recommended two films by G. W. Pabst, *Westfront 1918* and *Kameradschaft*, Murnau's *Tabu* and some more popular items including a film starring the popular French actress Annabella and the Douglas Fairbanks vehicle *Round the World in Eighty Minutes*. Lejeune's column was taken over in 1935–37 by Alistair Cooke, who tended to recommend more Hollywood films. Paul Rotha also became a regular contributor, mainly writing about documentary, but his concept of the

form was quite elastic and he managed to review Eisenstein's *October* and *Thunder over Mexico* under the documentary rubric in the Spring 1934 issue. Generally as time went on the focus of the magazine shifted towards the development of cinema as an art form rather than just a medium of education. The avant-garde artist and documentarist László Moholy Nagy issued a call to arms against industrialised film-making (Summer 1934). The magazine also printed an article by Alfred Hitchcock called 'My Own Methods' (Summer 1937, abridged from a chapter in a book to which Hitchcock had contributed).[2] And the great Marxist art historian Arnold Hauser, recently arrived in Britain from Hungary via Vienna, contributed three articles on film aesthetics – two on documentary ('The High and the Low Road', Winter 1938/9, and 'Fiction or Fact', Winter 1939/40) and one entitled 'The Film as Product of Society' (Winter 1939/40) which pinpointed the tendency for film metaphors (as found for example in Eisenstein and Pudovkin) to lose their potential for meaning in societies where the prevailing ideology worked to occlude social antagonisms.

Meanwhile in 1934 the BFI had also set up another magazine, the *Monthly Film Bulletin* (hereinafter *MFB*), initially for members only, to provide information on new educational and informational films. But, as with *Sight and Sound*, it soon emerged that there was more interest in entertainment than in information, and the *MFB* rapidly turned into a reviewing medium, giving diminishing space to informational films and more to new fiction-film releases. This brought it into occasional conflict with the film trade which had something of a stranglehold over the Institute, particularly at the beginning.

When the War came, *Sight and Sound* was badly hit by paper restrictions. In 1942 it was reduced in size to a format half the area of its previous 10½ by 8½ inches, with fewer pages, no illustrations and a generally sober tone as befitted the times. When it returned to normal, it made an effort to catch the aspect of the popular mood that was on the look out for less solid highmindedness. An article from Los Angeles by Harold Leonard in the first full-size issue in 1946 singled out Vincente Minnelli as an exciting Hollywood newcomer, while questioning how much in his films was due to him as director and how much to the MGM producer Arthur Freed – an issue which is still debated today. The same issue also contains a mention of the Czech animator Jiři Trnka, who also was to remain a favoured *Sight and Sound* film-maker right until his death in 1969. In 1948 the magazine's longstanding editor, R. W. Dickinson, finally got his name on the title page and a sense emerged that it was a magazine looking for people who wanted to read it rather than just make use of it.

The *Sequence* crew

These immediate postwar changes, however, were too few and too late. The exciting magazine at the time was *Sequence*, not *Sight and Sound*. John Grierson saluted it in *Sight and Sound* itself in Spring 1949 (p. 51) as 'brave, irreverent, and new'. When

The *Sight and Sound* story

Denis Forman arrived at the BFI in 1949, determined to revitalise the Institute and to give it a magazine which would make the intellectual world of the time ('*New Statesman* readers', he calls them in his memoirs)[3] take notice, it was to *Sequence* that he turned – not just for inspiration but for personnel.

Sequence had been founded under the aegis of the Oxford University Film Society in 1946. The original moving spirits behind it were Peter Ericsson, who became the publisher, and Lindsay Anderson, soon joined by Penelope Houston and Gavin Lambert and later by another university friend, Karel Reisz. When the editors left university they brought the magazine to London, where it soon acquired a reputation for unorthodoxy. It was a combative magazine, not afraid to take on the sacred cows of contemporary film culture. It showed no interest in the heritage of the British documentary movement, rescuing only Humphrey Jennings from the general indifference. As Penelope Houston said later (*Sight and Sound*, Autumn 1958), *Sequence* not only failed to take up the torch of the documentary movement but 'threw it down and stamped on it'. Politically it was left of centre, but its commitment to cinema was aesthetic more than political or social. It welcomed Italian neo-realism, as everybody did, but its conspicuous enthusiasms were for Max Ophuls, John Ford, MGM musicals (especially those directed by Minnelli) and interesting novelties from all over. It was the *Sequence* editors who persuaded the Academy cinema to give a London showing to Nicholas Ray's *They Live by Night*, which the producing studio, RKO, had more or less shelved.

By 1949, *Sequence* was struggling to survive and was encouraged by Grierson to appeal for help to the BFI. The editors met with Forman, who made them an offer. No, he would not help *Sequence* but he would offer the team a bigger opportunity: they could take over *Sight and Sound*. Ericsson, who actually owned *Sequence*, was not convinced, but Lambert jumped at it. *Sequence* carried on for a few more issues, finally running out of steam at the beginning of 1952. Meanwhile Lambert installed himself in the BFI offices, with Houston soon joining him as his assistant, and set about transforming *Sight and Sound*.

The first months of the revamped *Sight and Sound* were hectic and even chaotic. Lambert decided to turn it into a monthly, although he and Houston already had another monthly magazine to run, in the form of the *MFB*. Forman established a committee to write reviews in the *MFB* but in practice the members of the committee played only a very minor role. Lambert instituted a system of giving longer signed reviews to films judged important and shorter unsigned ones to lesser films, which were then rated I, II or III according to whether they were 'good of their kind'. Lambert and Houston, with help from Anderson, Reisz and a few others, provided most (and in some issues, all) of the longer reviews (an average of about 15 per issue) leaving the shorter notices (25 or more) to the rest of the committee (and eventually to whoever could be found to do the writing). The experiment of trying to run two monthlies in tandem lasted for 18 months, from December 1949 to June 1951, after which *Sight and Sound* reverted, apologetically, to quarterly publication.

13.1 Editor Gavin Lambert working on the paste-up of *Sight and Sound* with his assistant Penelope Houston, early 1950s. In 1956 Houston succeeded Lambert and remained editor of the magazine until 1991

The first few issues under Lambert's editorship were innocent enough. The inheritance of *Sequence* was apparent not only in the choice of subject matter but in the tone, with a film quiz for hard-core cinephiles and a column devoted to bizarre quotes from the trade press and elsewhere. The magazine established its panorama of taste with reviews of Vittorio De Sica's *Bicycle Thieves* (Richard Winnington), the Stanley Donen/Gene Kelly musical *On the Town* (Lambert), and Ophuls's *Reckless* and *Letter from an Unknown Woman* (Karel Reisz and Simon Harcourt Smith). Alan Brien, later a prominent theatre critic, covered the famous Festival du Film Maudit in Biarritz, organised by André Bazin, though he confessed himself mystified by the choice of films, having expected something more like Cannes, but on the Atlantic coast rather than the Mediterranean.[4]

The focus was mainly on new American films, followed by French and Italian. A series on classics was inaugurated by Roger Manvell in April 1950, starting with Fritz Lang's *Siegfried*. There was on the whole very little on British cinema, which was left to the *MFB* to cover on a regular basis (though Manvell did include Anthony Asquith and A. V. Bramble's *Shooting Stars* from 1928 in his selection of classics). Then, in the April 1950 issue there appeared a devastating review, signed by Frank Enley, of Ealing Studios' *The Blue Lamp*, using it as an excuse to lay into the general cosiness of British films, their snobbery and their overall inferiority

The *Sight and Sound* story

to their American equivalents. A storm erupted. The film's producer, Michael Balcon, protested to Cecil King, the BFI chairman. Forman, asked to investigate and administer a rebuke, became quite angry in turn when he discovered that the author of the offending piece was Lambert himself, who had hidden under a pseudonym to avoid trouble. Forman reported back to King, who responded as one would expect from a newspaperman (he was publisher of the *Daily Mirror*). King challenged Balcon as to whether he really wanted to force the editor to resign. Balcon hesitated and that was enough. King interpreted his hesitation as a climbdown and Lambert was let off with a friendly warning.[5] For safety's sake, however, Forman announced that the magazine would henceforward have an editorial board, chaired by himself, to provide general oversight on all matters 'except the copy for the next edition'.[6]

Lambert was not unduly chastened by the experience. Although he never wrote a review of similar ferocity of a British film, neither he nor his fellow writers felt the need to spare anyone. If David Lean or Carol Reed made a film the editors didn't like, they said so – though the tone tended to be one of sorrow rather than anger, a sense that the man who had made *Brief Encounter* in 1945 had demeaned himself with *The Sound Barrier* in 1952 or that *Outcast of the Islands* was a sad disappointment after *Odd Man Out* or *The Third Man*.

It is interesting to compare the writing in *Sight and Sound* and the *MFB* in the early and mid-1950s with the criticism that was current elsewhere and specifically that which was emerging in France in *Cahiers du cinéma* from mid-decade onwards. In relation to Italian neo-realism, *Sight and Sound* persevered with the mainstream line shared by critics in France and in Italy itself.[7] Rossellini lost his place in the pantheon to which Eric Rohmer and the other *Cahiers* critics elevated him, while De Sica and a variety of lesser lights continued to be admired.

When it came to French cinema, *Sight and Sound* would have seen nothing much wrong in François Truffaut's notorious 1954 claim[8] that Jacques Becker's *Casque d'or* (1951), Robert Bresson's *Diary of a Country Priest* (1950), Jean Cocteau's *Orphée* (1950), Jean Renoir's *The Golden Coach* (1953) and Jacques Tati's *Les Vacances de Monsieur Hulot* (1953) were just about the only really worthwhile films made in France since 1945. It is true that Penelope Houston found herself out on a limb not liking *Hulot* (which she saw in a dubbed version), and they might have wanted to add Ophuls to the list of masters. But Becker was hugely admired, Bresson warmly welcomed and Renoir praised to the skies, especially by Lambert. As for the mainstream of French 'quality cinema', *Sight and Sound* and the *MFB* did not think much of it, reserving particular scorn for Christian-Jaque's films with Martine Carol and her much overexposed and frequently censored cleavage (*MFB*, July 1952).

It was when it came to American cinema, however, that a gulf was beginning to open up, highlighted in a review of French critical magazines by Anderson in *Sight and Sound* in October–December 1954. While *Cahiers* was promoting a pantheon of 'auteurs' who could do no wrong, the tone of both *Sight and Sound* and the

MFB was one of disappointment mixed with indifference. None of the directors who had promised much in the 1940s – Nicholas Ray, John Huston, Fred Zinnemann, Elia Kazan – seemed to live up to their initial promise. Hitchcock and even Ford were thought (by Penelope Houston and Lindsay Anderson respectively) to be in decline since their glory days in the 1930s and 1940s. Fritz Lang was given up as a lost cause, though Anderson made an exception for *The Big Heat* (*Sight and Sound*, July–September 1954). The existence of Howard Hawks and Otto Preminger was barely acknowledged. Minnelli and Donen were still admired in the musical and Anthony Mann and Budd Boetticher in the western. But westerns as a whole tended to be relegated to the *MFB* where the reviews often did not bother to say who a film was directed by. Samuel Fuller was recognised but not liked, with adverse comment on both his propensity for violence and his Cold War attitudes. It was, of course, the *MFB*'s job to review films individually, as a service to film societies and independent exhibitors, not to occupy itself with the development of particular directors. Even so, from a modern standpoint, it is odd to find the *MFB* in January 1957 praising Boetticher's direction of *Seven Men from Now* and then in August reviewing the same director's *The Tall T* equally positively, but without mentioning his name at all. By contrast, and very much to his credit, Lambert was quick to spot the arrival on the scene of Stanley Kubrick, giving enthusiastic reviews both to *The Killers* (*MFB*, March 1956) and to *The Killing* (*Sight and Sound*, Autumn 1956).

When it came to comedy, both *Sight and Sound* and the *MFB* had fairly catholic tastes. Fernandel was enjoyed, as was the Italian comic Totò. David Robinson (*Sight and Sound*, April–June 1954) thought Norman Wisdom was a great comic, though ill-served by his films, and even gave an appreciative nod in the direction of Jerry Lewis, whom most English critics, if they noticed him at all, found insufferably vulgar. Melodrama, however, was the sticking point. Both magazines make frequent use of the word 'melodramatic' as a pejorative while the noun 'melodrama' was used loosely but most often with a vague sense of disapproval.

There were two attempts to take melodrama seriously. One was an article in the July–September 1951 issue by an unknown 19-year-old called R. E. Durgnat, who tried to address the problem of the relationship of character to action and placed the melodrama midway between the pure action film and the drama of character in that it gave an action outcome to states of mind. These insights were never followed up. But an article by the American critic Pauline Kael (*Sight and Sound*, October–December 1954), entitled 'Morality Plays: Right and Left', proved more controversial. Having defined melodrama as a 'morality play with the sermons removed', she first laid about the melodramatic falsity of American Cold War films before applying the same analysis to *Salt of the Earth*, a left-wing independent production set among Mexican migrant workers. Angry letters flooded in from supporters of the film's political message – but on the whole failing to counter Kael's strictures on its dramatic devices. Then, in the next issue, but this time from the left, Anderson provoked another storm with an analysis of the final sequence of Kazan's

The Sight and Sound story

On the Waterfront, finding something implicitly Fascistic in the melodramatic way the narrative was resolved. This too raised a predictable storm of protest.

The Houston years and the challenge of *Movie*

By 1956 the *Sequence* group who were at the core of the magazine began to break up. Lambert left for America and Houston replaced him as editor. Reisz had left his job as co-ordinator of programmes at the NFT. Tony Richardson, who had been an occasional contributor, was busy helping George Devine create the English Stage Company at the Royal Court, where *Look Back in Anger* was performed in April 1956. (Richardson then took the production to New York and later made the film version which inaugurated the British New Wave.) Anderson occupied himself with Free Cinema but had also turned his attention to politics. His departing salvo 'Stand Up! Stand Up!' in *Sight and Sound* (Autumn 1956) arguing for politically committed film criticism was followed by the equally polemical, 'Get Out and Push!', in Tom Maschler's collection of essays, *Declaration*, which was an inaugural moment for the New Left in Britain.[9]

The loss of so many of its most stimulating writers left *Sight and Sound* with a void which it was slow to fill. But there were cultural changes afoot which were to sweep the magazine along their wake – and at one point to threaten it with shipwreck. On the positive side was the emergence of an international art cinema of which *Sight and Sound* soon became the standard bearer. The arrival in Britain of films by Ingmar Bergman (*Smiles of a Summer Night* was released in Britain in 1956, *The Seventh Seal* in 1958), Andrzej Wajda (*Kanal*, released in 1958) and Satyajit Ray (*Pather Panchali*, released 1956), together with the first stirrings of the French New Wave (Chabrol's *Le Beau Serge* was screened in London as part of Free Cinema in September 1958), signalled a broadening of the horizons of the art cinema culture, and *Sight and Sound* took full advantage – being rewarded with a steady increase in circulation which by 1960 had already reached 16,500 and was to continue to rise throughout the 1960s and 1970s.[10] Meanwhile the first feature films by Richardson (*Look Back in Anger*, 1958) and Reisz (*Saturday Night and Sunday Morning*, 1960) gave the magazine a cause to fight for. Set against this, however, was a growing alternative film culture which was beginning to seek out the kind of films which *Sight and Sound* and the *MFB* increasingly treated with disdain.

The first voice from this alternative film culture to reach the offices of *Sight and Sound* came in the form of a letter from Ian Jarvie printed in the Winter 1958/59 issue, deploring the 'pieties' of the canon of taste shared by newspapers such as the *Observer*, the official film society movement and, for good measure 'the best part of the NFT audience'. This was just a pinprick. More was to come.

In the spring of 1960 a student magazine in Oxford called *Oxford Opinion* entrusted its film pages to a group of writers led by Ian Cameron and V. F. Perkins, who used their position to launch a full-scale attack on the orthodox film culture, with *Sight and Sound* as their principal target. Heavily influenced by *Cahiers*

du cinéma and the 'politique des auteurs', *Oxford Opinion* celebrated the work of Hollywood directors such as Hitchcock, Hawks, Ray, Preminger and Robert Aldrich whom *Sight and Sound* had disregarded or disdained. What they objected to most in *Sight and Sound*, however, was not its tastes but what they saw as an underlying lack of respect for artistic achievement in the American cinema and a tendency to dismiss films before the reviewer had made a proper attempt to get to grips with them. As Cameron put it in *Oxford Opinion* 40 (June 1960) in answer to a correspondent:

> Because we refuse to judge films on political or moral grounds, we are thought by some correspondents to be concerned exclusively with style and something weak-kneed and greenery-yallery called beauty. The word criticism covers two related but distinct functions of a critic – elucidation and evaluation. The most important of these is the first: the critic has to analyse or, if necessary, explain the meaning and style of a film. But he can also say how good it is.

Sight and Sound's immediate response to being attacked was to decide (not without reason) that, although the organ-grinder's monkey might be in Oxford, the organ-grinder himself was in Paris. It therefore commissioned an article from Richard Roud criticising some of the excesses of *Cahiers du cinéma* ('The French Line', September 1960), while Penelope Houston ('The Critical Question', same issue) gave *Oxford Opinion* a magisterial ticking off for lack of engagement with the real world.

Cameron and Perkins held sway over the film pages of *Oxford Opinion* for just a few months, from April to June 1960. But the debate did not end there. Other participants entered the fray. On the left there was a magazine called *Definition* which ran for three issues in 1960 and 1961 and in its third issue (undated, but probably summer 1961) contained an attack on *Sight and Sound* by Alan Lovell from a left-wing position. Peter John Dyer, *Sight and Sound*'s associate editor, penned an intemperate counterblast against Cameron and Perkins in the film society magazine *Film* (issue 26, November–December 1960), which served only to bring out more writers in support of the newcomers. A previously unknown writer called Charles Barr chipped in from Cambridge in the pages of *Granta* (November 1960). A new magazine, *Motion* (first issue May 1961), initially declared itself neutral but soon veered towards a position closer to that of *Oxford Opinion*. *Motion*'s sixth and final issue, dated Autumn 1963, was to contain the notorious article 'Standing Up for Jesus' by Raymond Durgnat, slating *Sight and Sound* (the 'Dean St. clique') for its general prissiness on the one hand and intellectual incoherence on the other.

Meanwhile the *Oxford Opinion* writers, having left university, regrouped in London to found *Movie*, whose first issue (June 1962) continued the onslaught. Once again *Sight and Sound* felt impelled to respond, this time in the form of a well-crafted article by Houston entitled 'The Figure in the Carpet' (Autumn 1963) opposing what was beginning to be called the '*auteur*' theory' and offering a less metaphysical reading of Hitchcock than that put forward by *Cahiers du cinéma* and its British admirers.

The *Sight and Sound* story

By this time, of the little magazines which had been sniping at *Sight and Sound* from the sidelines only *Movie* was still in business, and that precariously. The onslaught had never dented *Sight and Sound*'s market position, which was a consequence of its guaranteed readership as the BFI's official magazine and the fact that it enjoyed the luxury of a subsidy from the BFI, whereas the others relied on volunteer labour and needed at least to break even. But *Sight and Sound* also improved as a magazine as the 1960s wore on, helped by the arrival of Tom Milne as associate editor (and editor of the *MFB*) in the summer of 1962. Milne was not only a superb editor from a technical point of view (a quality shared by his successors, David Wilson from 1971 to 1980 and John Pym from 1980 to 1991); he was also a brilliant writer with a fine judgement of films, often overlapping with those of *Movie* and its followers. His arrival brought with a broadening of taste at both *Sight and Sound* and the *MFB*, particularly when it came to American films.

In the long term what was to prove decisive for *Sight and Sound* was not the issue of taste nor that of auteur theory or critical method (though this was very important for the nascent discipline of film studies) but the attitude taken up to the various new waves which were erupting across Europe and beyond in the 1960s. *Sight and*

13.2 Cover of the Winter 1962/63 issue of *Sight and Sound* with still of Richard Harris in Lindsay Anderson's *This Sporting Life*. After 1963 the magazine ceased to give enthusiastic support to the British New Wave, leading to a definitive bust-up with Anderson at the end of the decade

Sound supported the British New Wave represented by Richardson, Anderson and Reisz, all former *Sight and Sound* writers, right up the implosion of the movement in 1963. *Movie*, by contrast, abominated it, comparing it unfavourably both to mainstream American cinema and to the more experimental work coming out of Europe. Meanwhile, in relation to New Wave cinema more generally, *Sight and Sound* was, perhaps surprisingly, more open to artistic modernism than either *Movie* or any of the other small magazines. The *Movie* and *Motion* writers also enthused about Antonioni and Godard and even Bergman, but their devotion to the classical virtues of the well-made film blinded them to the radical import of the innovation that was taking place all around. *Sight and Sound*, however, embraced the new cinemas wholeheartedly for what they were, the most striking example of this being an article by Susan Sontag on Bergman's *Persona* in the Autumn 1967 issue. By the latter part of the 1960s *Sight and Sound* was not only dominant in the marketplace, it was also attuned to the needs of its public, which consisted principally of people who went to local art-house cinemas, to the NFT or to the BFI's growing network of Regional Film Theatres. It was also extremely well respected in the USA, where a similar public existed.

Sight and Sound was to pay dearly, however, for its wholehearted embrace of international art cinema and its loss of commitment to the British New Wave and its successors. It became less interested in either cultural politics or politics itself, though as the European new waves moved leftwards, the magazine followed discreetly in their wake. The custom of starting the magazine with an editorial, entitled 'The Front Page' and devoted to issues of the day, was quietly dropped. The last proper editorial, in the Autumn 1965 issue, was on the BFI's regional expansion plans, and stated the BFI line originally put forward by the recently retired director James Quinn, but undercut it with a light touch of scepticism. Thereafter any politics in the magazine had to be read between the lines, if at all.

This was too much for Lindsay Anderson. Although his film *This Sporting Life* had been enthusiastically reviewed in the magazine when it came out in 1963 (together with a picture of its star, Richard Harris, on the front cover), *Sight and Sound* had shown itself no more than lukewarm about later films from the no longer new British New Wave and no longer used its pages to argue the case for independent British cinema (arguably, at that particular historical juncture, pretty much a lost cause).

Anderson became a BFI governor, along with Karel Reisz, in 1969, at what was proving to be a critical moment in the history of the BFI. When the BFI Governors decided in 1970 on a thoroughgoing review of all BFI policies, Anderson seized the occasion to get back at *Sight and Sound* for having, in his opinion, betrayed both him and the cause he represented. Anderson's paper criticising *Sight and Sound* and the *MFB* was briefly and inconclusively discussed at the governors' meeting on 21 April 1970 and then again at a special meeting convened at the Isola Bella restaurant in Soho on 2 June. It soon became clear that, while other governors might share some of Anderson's criticisms of the magazines, they were far from

The Sight and Sound story

united over the solutions. Indeed, by handing over the issue to a board of governors dominated by trade interests, Anderson risked making things worse rather than better for his cause. George Hoellering from the Academy Cinema stoutly defended the magazines' independence. 'In my opinion,' he wrote to the chairman of governors, Sir William Coldstream, '*Sight and Sound* is an outstanding film magazine which the BFI has the honour to publish – *not* the official magazine of the BFI.'[11] Making it a house magazine, he argued, as the critics seemed to want, would only have the effect of reducing its circulation and pointlessly increasing its need for subsidy. On the questions of whether the *MFB* should be allowed to continue publishing reviews which might be negative, the governors were again divided. In the end the only changes demanded by the governors were an end to the distinction between longer and shorter notices in the *MFB* and the imposition of an Editorial Committee reporting to the board of governors, the old editorial board instituted by Forman having fallen into disuse.

Defeated, Anderson resigned from the board of governors, dragging the unfortunate Reisz with him. Also smarting from a sense of defeat was the Short Filmmakers Campaign, which had wanted *Sight and Sound* and the Institute as a whole to pay more attention to short films, both in their own right and because of the role they could play as a seedbed for future feature film-makers. The spokesman for the group was Roger Graef, who penned (but did not send) a furious letter to Stanley Reed, director of the BFI, accusing him of a total lack of interest in short films and their makers.[12] Graef became a member of the BFI Members Action Committee, as did Ian Cameron, who had his own grievance against *Sight and Sound* and the fact that it was subsidised and unfair competition to *Movie* and other magazines in a similar position.[13]

Meanwhile *Sight and Sound* was not without its critics in the BFI itself, particularly in the Education Department, which had been impressed by the seriousness of *Movie*'s commitment to American popular cinema. (At one point both Alan Lovell, who had criticised *Sight and Sound* in *Definition*, and V. F. Perkins, who had done the same, but from a different position, in *Movie*, were working in the department.) Mutual suspicion between the two departments, however, did not prevent Paddy Whannel reaching an agreement with Houston for the Education Department to have an input into the Cinema One series of books which she and James Price of Secker and Warburg inaugurated in 1967. Out of this agreement was to come Peter Wollen's *Signs and Meaning in the Cinema*, a book which was something of an oddball in the series but went to become its long-term bestseller.

In the 1970s, *Sight and Sound* continued very much along the lines laid down in the 1960s. Both it and the *MFB* had a redesign at the end of 1970. They were also allowed to recruit more staff. No longer did the associate editor of *Sight and Sound* duplicate as editor of the *MFB*. Instead the *MFB* had its own editor and associate editor (in the 1980s it added a further assistant editor, mainly to help checking film credits, which were becoming more complicated). Circulation had now reached 30,000, and remained at that level throughout the 1970s, with a peak of 34,000 in 1974.

In spite of this success, the position of Penelope Houston as editor was not secure. The new director, Keith Lucas, who arrived in 1972, was all set to ask her to leave but seems to have lost his nerve at the last minute. Meanwhile, however, he had allowed Jan Dawson, the editor of the *MFB*, to form the impression that she would be appointed Houston's successor. When this did not materialise, Dawson herself decided she had no alternative but to resign from the *MFB*, and Richard Combs was appointed in her place.

Combs held the editorship of the *MFB* from 1973 to 1990, during which time it increasingly emancipated itself from its elder and more prestigious sibling. It became a place where younger writers could cut their teeth and where attention could be paid to films which *Sight and Sound* was not interested in. These films included not only exploitation, which *Sight and Sound* never liked, but also avant-garde and small-scale independent films, which could qualify for a review in the *MFB* if they got a public showing, not necessarily theatrical. The *MFB* also became the place where scathing reviews could be published of films by renowned British film-makers – the most devastating being Tom Milne's demolition of the film by then BFI chairman Richard Attenborough, *A Chorus Line*, in January 1986.

In the 1970s, *Sight and Sound* became increasingly detached from the BFI as a whole. It moved into a little mews across the road from the main building in Dean St. It no longer had the same link to the NFT it had possessed when Richard Roud was chief programmer (and Karel Reisz before him). Although Houston remained a member of the Executive Committee, she paid little part in its long-winded proceedings, preferring to study the racing form-book while listening with half an ear in case something was said which might affect the interests of the magazines. (Tom Milne had always avoided committee meetings entirely.) Only her deputy David Wilson, as chair of the Occasional Publications Committee (OPC) overseeing the allocation of funds to BFI publications, and as a prominent ASTMS member, was actively engaged in BFI affairs.

When Anthony Smith arrived at the BFI in 1980, he left the magazines untouched but restructured around them so that Houston lost official responsibility (which she had in any case not exercised) for BFI publications in general. The OPC was abolished and Wilson was moved into the newly created Publishing Department as chief editor and John Pym stepped up from his position as associate editor of the *MFB* to take his place. To replace Pym, Combs wanted the writer Gilbert Adair, but Smith refused to endorse the appointment, insisting instead on the post being given to Steve Jenkins, whose talents were somewhat underused in the Distribution Library editing *Films on Offer*, and shortly afterwards Pam Cook joined the team as a second associate. Both magazines continued very much on the course carved out for them in the 1970s, with the *MFB* continuing to cover a wide sweep of fringe cinema as well as theatrical releases.

The *Sight and Sound* story

A new magazine for the 1990s

By 1990, however, there was a growing consensus that *Sight and Sound* under Penelope Houston's editorship had had its day. It was no longer just sniped at by the industry for being arty or from the left for being part of the establishment. The establishment itself now thought it was time for a change. Circulation was static and even beginning to decline, but not catastrophically. It was, as ever, consistently well written and impeccably edited. But culturally it was no longer at the cutting edge. Just where that edge might be, nobody could say for sure, but it was definitely not to be found in the art-film culture of which *Sight and Sound* had been a leading voice since the 1960s if not earlier. A new editor seemed to be called for, if not a fresh magazine.

The magazine itself, it should be said, was not blind to the problems that confronted both it and its preferred readership. In the late 1980s it ran a number of articles on the decline of market and commercial opportunities for the sort of European art cinema that was the magazine's staple fare.[14] But most of these articles were written from the standpoint of a helpless bystander, unable to change the course of history and equally unable or unwilling to move to a new vantage point from which to view it.

The job of forcing the issue lay with Colin MacCabe, recently appointed head of the Research Division in which the magazine was now housed. MacCabe was already frustrated with Houston because she showed no interest in running articles showcasing the division's work.[15] But even with a new and more accommodating editor, a quarterly *Sight and Sound* devoted almost exclusively to art cinema seemed unlikely to make the cultural impact that MacCabe thought the BFI's flagship should achieve in the 1990s. Changing the editor, therefore, was only a first step. Houston was persuaded, with reluctance, to step down from the position as editor she had held since 1956 and to accept alternative employment within the Institute writing a history of the film archive movement.[16] Once this was agreed, the remaining steps were to find a new editor and to devise a suitable format for a relaunched magazine.

After some hesitation, it was decided that, if the new *Sight and Sound* was to make the cultural impact expected of it, it should be a monthly, and if so the only thing to do was to merge it with the *MFB* and produce a magazine which combined comment and opinion with full coverage of all films released, including plot synopses and credits, as the *MFB* had traditionally done and for which it was highly valued by its 4,500 or so subscribers.[17] It was also decided to uncouple the magazine from BFI membership. Members would be able to add the magazine to their subscription, but it would no longer be integral to the package so that it would have to stand or fall on individual sales alone, without the cushion provided by the traditional membership structure.

When the post was advertised, Richard Combs and John Pym both applied, but more to have their say about what the magazine should be like than with a realistic

hope of being appointed. The final shortlist was whittled down to two candidates: Kevin Jackson, an expert on Humphrey Jennings; and Philip Dodd. MacCabe, supported by BFI governor Matthew Evans, opted for Dodd, whose intellectual versatility was thought likely to be an asset if the new magazine was to make a impact outside the film world.

While Dodd worked on the format for the new magazine and on assembling a team of contributors, a transitional issue was produced (60:1, Winter 1990/91), edited by Pym with Milne as associate editor. No mention was made of imminent changes, but Pym and Milne slyly took the opportunity to feature a selection of Penelope Houston's contributions over her long period as editor.

When the new magazine was ready to be unveiled, a massive party was held to celebrate the event, but the magazine itself was quite modest about its changed identity. The editorial in the first issue was pragmatic and understated, as if anxious not to alienate the traditional readership of the magazine. But it became more affirmative as it went on. Having delicately taken its distance from the purists of 'Film culture', the editorial concludes, echoing a phrase of Bertolt Brecht:

> *Sight and Sound*, then, has no interest in nostalgia for the good old things; it wants to start from the bad new things. It is committed not to Cinema but to the extraordinary range of existing and potential cinema cultures, in Britain and elsewhere.

The first recognition of changes in the surrounding culture came in the form of a section of the magazine devoted to new video releases, which were beginning to overtake theatrical box-office as the most important market for films. Meanwhile the choice of J. Hoberman, B. Ruby Rich, John Powers and Peter Biskind as regular columnists suggested a renewed trans-Atlantic orientation for the magazine, while the opening up of its pages to writers from other fields (Jeanette Winterson, Angela Carter) seemed to herald a broadening of cultural sensibility. Queer cinema, body-horror, cyber-punk, topics that the old *Sight and Sound* would have treated gingerly if at all, made it into the pages of the magazine and even on to the front cover. A revolution seemed to be in the making.

In the end, however, the new *Sight and Sound* was undone by its readership, which remained devoted to Cinema with a capital c. Circulation rose slightly, but not enough. The letters page was filled with nerdy letters about screen ratios and censorship cuts. When Dodd left the BFI in 1997, to become director of the ICA, and was succeeded by his deputy Nick James, the magazine recovered its traditional equilibrium. It is now very much a film magazine – and one of which Gavin Lambert would not have been ashamed.

Notes

1 References in this chapter to issues of *Sight and Sound* and the *Monthly Film Bulletin* will normally be given by date in parentheses only.
2 The book was Charles Davy (ed.), *Footnotes to the Film* (London: Lovat Dickson. 1937). Hitchcock's article is also reprinted in David Wilson's excellent anthology *Sight and*

Sound: A Fiftieth Anniversary Selection (London: Faber and Faber, 1982) as is Arnold Hauser's 'Fiction or Fact', referred to below.
3. Denis Forman. *Persona Granada* (London: André Deutsch, 1997), p. 24.
4. Brien's article (in the December 1949 issue) also appeared in a slightly different form in *Sequence* 12. The Festival du Film Maudit, dedicated to films which for various reasons had never been seen in France, was a founding event in the formation of post-war French film culture.
5. *Persona Granada*, pp. 25–6, and interview by the author with Penelope Houston, July 2006.
6. *Persona Granada*, p. 26.
7. For France see the article by Antonio Pietrangeli in *La Revue du Cinéma*, 13 May 1948.
8. François Truffaut, 'Une certaine tendance du cinéma français', *Cahiers du cinéma* 31, January 1954.
9. Tom Maschler (ed.), *Declaration* (London: MacGibbon and Kee, 1957), pp. 153–78.
10. Circulation figures are given as reported annually to BFI Governors, based on print run less known returns. For most of the period about 50 per cent of sales were to BFI full members as part of their membership package. A further 30–40 per cent were US sales.
11. BFI Governors Minutes, 16 June 1970.
12. Graef's draft is preserved in his papers donated to BFI Special Collections.
13. The BFI had a fund for assistance to small magazines but the fund was too small to make much difference to magazines, such as *Movie*, which might have constituted real competition to *Sight and Sound*. Meanwhile small start-up magazines like *Brighton Film Review* (forerunner of *Monogram*) and the pioneering *Cinemantics* were refused grants. The fund did useful work in later years, for example supporting the scholarly *Film Dope*, but it remained an anomaly in that it was administered by people who had a vested interest in not allowing competition.
14. See notably Julian Petley, 'Where Have the Foreign Films Gone?' *Sight and Sound*, Autumn 1989. There were also articles on the decline of the western (Ed Buscombe, 'End of the Trail?', Autumn 1988) and the marginal character of the RFT audience (David Docherty, Summer 1987).
15. MacCabe had appointed the distinguished black American scholar Cornel West as Visiting Research Fellow. West gave a superb lecture at the NFT – all about the glories of black oral culture and the relative poverty of its written one. As if to prove the point, his text as delivered to *Sight and Sound* was judged unpublishable.
16. Published as *Keepers of the Frame* (London: BFI, 1994).
17. This posed a design problem, which was elegantly solved by running the credits alongside the review in narrow columns of small print. Even in tiny print, however, the credits for Brian De Palma's *Dressed to Kill* in the opening issue of the new design ran to no fewer than five columns while for Wim Wenders's *Bis ans Ende der Welt* (*Sight and Sound*, new series 2:1, May 1992) the music credits alone took up a whole column.

14

A public showcase for the BFI

The Museum of the Moving Image

Lorraine Blakemore

> Avoid orthodoxy at all costs
> Leslie Hardcastle

When the first Museum concept paper reached the board of governors in 1979, authored by the controller of the NFT, Leslie Hardcastle, it was to represent the start of the most ambitious undertaking in the British Film Institute's history in terms of scale, financial commitment and projected visitor numbers. The climate at the Institute out of which the Museum of the Moving Image (MOMI) was to emerge was one in which it was increasingly clear that the BFI needed to target a wider public and to shake off its image as, in the words of chairman Sir Basil Engholm, 'erudite scholarly hermit'. In November 1979, shortly after taking up his position as director, Anthony Smith wrote in a confidential report to governors: 'We must realise that our primary public is the whole public. The specialist groups and the connoisseur audiences must be served through the greater public and not the other way round.'[1] The controversial nature of this statement must not be underestimated, as it suggested an entire reconfiguration in how the BFI operated as an educational body. That all concerned recognised the implicit value of reaching the wider public was to the Museum's advantage, but the change in thinking at the BFI that the prospect of the Museum would bring in – with its intended appeal to families and tourist groups – was a source of tension and even suspicion. Smith's taunt that the BFI 'must not be afraid of coach parties!' masked some very real discontent amongst certain of the staff.

As Smith was unquestionably the single most important figure in making MOMI a financial reality it tends to be assumed that the first concept and design proposal submission to the board postdated his arrival as director in late 1979. However, during much of that year when the BFI found itself without an appointed director, it was Engholm and the acting director, Gerry Rawlinson, who pushed the project forward. Sympathetic to Hardcastle's notion of a museum, Rawlinson afforded him the opportunity to pitch his ideas in a paper, to be discussed first at a planning meeting held on 28 March 1979 between Engholm, Rawlinson, Hardcastle

A public showcase for the BFI

and David Francis (National Film Archive), and then delivered to the Board on 24 April. Rawlinson wrote: 'Normally a proposal in such an embryonic form would not have been presented to governors. However, the completion of implementation of any major proposal preferably should coincide with the Institute's 50th Anniversary in 1983, and therefore the preliminary views of governors of this proposal are needed virtually now if we are to meet this 1983 deadline.'[2]

The presentation seems to have been received positively. The minutes declare: 'Governors considered the proposition an exciting one, a contribution to the conservation of the national heritage and as a missing link in the BFI's public image – attracting people who would otherwise remain unaware of the BFI and its activities.'[3] Questions were raised, however, about both the location and the name. The board felt that the BFI's commitment to the regions justified asking whether the project needed to be London-based. They were reassured that travelling exhibitions might be mounted to counteract criticism. The term 'museum', Hardcastle and Francis assured them, was not fixed and should not be viewed in this context as implying a static exhibition. (By 1983 the Museum was being described as a mixture of the Grand Palais in Paris, the Philips Company's Evoluon in the Netherlands, the classroom of a comprehensive school, plus an evocation of Disneyland.)[4]

A museum of the type proposed was to remain at the conceptual stage for the remainder of 1979 and into early 1980 since there was still a projected cost exercise[5] to be undertaken and a subsequent briefing to the Office of Arts and Libraries (OAL), which the BFI member governor Lawrence Brandes insisted was essential in relation to ongoing funding. Hardcastle provided a series of basic questions in his Design Brief (July 1979) as a stimulus for further inquiry, ranging from whether a one-storey structure was adequate to contain the operation proposed; whether it was possible to design a building which satisfied the problems of eventual funding as well as the planning requirements of the local authorities; and what were the basic restraints and virtues of using the Waterloo site for this purpose.[6]

A number of aspects to the development of MOMI – some of which were to become defining features – began to take root at the early drafting stages. At an overarching level the one element that seems to have been non-negotiable was that the Museum should endeavour to cover the entire history (and prehistory) of the cinema, and moving images more widely. The plan became grounded in a desire to work through three different levels of participation: as an entertaining experience for the casual visitor; a formal study of film and television; and an introduction for young people (with the latter assuming special importance and significance for pan-museum activities). Museum content would be divided into roughly twenty sections, each one responsible for a particular aspect of the history and (though not achieved in the way planned) with one-eighth of the sections subject to an evolving programme of change. Where possible they would tie in with NFT seasons or external events. Guards as guides, if not yet actors, was a clear objective. Each of the exhibits could be appreciated in three ways: 'They will be interesting when static, intriguing when activated by the visitors themselves, and take on a new

14.1 An early sketch by Leslie Hardcastle of the projected interior of the Museum of the Moving Image

dimension when controlled and explained by the Museum Guides.'[7] Acquiring original artefacts was not to be part of the Museum's remit, with a few exceptions. Finally there were concepts arrived at via a consciousness of the specific moment in moving image history in which the Museum found itself – namely, the potential for showcasing television history alongside that of film; the exploitation of new technologies, and an early videotheque idea for a series of video/audio booths linked to the main BFI Information Division where visitors could view selected material and have access to related information.[8]

Raising the money

The first approach to financing MOMI was made to the Department of Education and Science (DES), which ultimately decided against providing any financial support to the BFI on the grounds that it felt its responsibilities in this area were adequately covered by the Science Museum – although, as Francis remarked, the 'mahogany and brass behind glass' display at the Science Museum was as far from the concept of MOMI as it was possible to be. The DES was not to be persuaded, however, and it was quickly established that funds would have to be raised almost entirely from private sources and the BFI would be effectively 'going it alone', with the resultant museum operating on a commercial, self-supporting basis.

The relative early successes of the fundraising committee set up in 1980 to locate the necessary capital sums, with Elspeth Howe (wife of the chancellor of the exchequer Geoffrey Howe) as chair, prompted the official launch of the MOMI project at the opening night of the 1981 London Film Festival. This rather early public announcement generated interest and curiosity from the rest of the BFI and led to Smith sending out a notice to all staff just prior to the LFF opening. To ensure that there were no misunderstandings over the nature of the scheme, he made it clear that it would not be a 'glass-case museum' but a place where 'the public could see in three-dimensional form and, in action, materials which reveal and explain the whole impact of moving pictures on human culture'.[9] Possibly the most important declaration was that fundraising for the project was entirely separate from the rest of the Institute.

By late 1982, Lady Howe's Committee had raised £2.5 million with the earliest key donation coming from Yue-Kong Pao, the Hong Kong Chinese shipping magnate. The 1983 celebration plans to tie in with MOMI had long since been abandoned, though Smith still hoped it would be possible to lay the foundation stone by that date. Discord over the plans for the Museum and its fundraising campaign was audible in some quarters. Kevin Gough-Yates wrote: 'You can smell the high level of sponsorship. It certainly isn't going to help the Institute perform any of its current obligations more satisfactorily'.[10]

A financial report on the Museum's viability was carried out by accountants Stoy Hayward,[11] who concluded that, subject to better staffing and greater promotional spend, the concept had a 'real possibility of success', and the board met on 29

September 1982, at what was to be a critical gathering for the Museum plan in terms of it making the leap from concept to actual project status. With board members retaining right of veto over whether the project could eventually progress to the building stage, it needed to satisfy every demand. There was a full discussion as to how certain of the core concepts might be enhanced or modified, with Jeremy Isaacs arguing that 'if the museum were to be a success the adequacy of space available to provide an enjoyable and memorable experience was in some doubt'. It was deemed important that space should be as flexible as possible to allow designers freedom to provide imaginative exhibitions which would attract people to the museum again and again. Certainly the extent of space available for the proposed exhibits was to prove the greatest design challenge. It was also felt that 'the project should be more glamorous if it were to attract people successfully, although it was accepted that historical accuracy was important as the Museum should have a reputation of excellence as well as entertainment value'. In reply to doubts voiced over the actual Museum site, Sir Richard Attenborough, the new chairman, said that 'there were many advantages to it being attached to the NFT, such as staffing, longer opening hours and public image. It also added greatly to the concept as a whole.'[12] From the Board's response it is also clear that positive encouragement was given for Hardcastle to employ the verve that he was famous for at the NFT.

In July 1982 the Board had been asked to approve expenditure of £200,000 to Bovis Ltd to bring plans to a more advanced stage. Hilary Bauer, the assessor from the OAL, reminded Rawlinson in a letter of 'our particular concern that no extra costs of the Museum of the Moving Image should fall on the public purse – i.e. that neither capital nor running costs would need to be funded at the expense of other activities financed by means of your grant-in-aid'.[13] In order to convince the OAL of the Museum's ability to be self-supporting, Bauer requested of Rawlinson a development plan addressing the questions of ongoing revenue requirements such as those for maintenance and acquisitions, the estimated yield from admissions and the proposed number of staff to be employed. By this stage the annual admission figure estimates were set at a modest 300,000. At the September meeting it was noted – in terms of revenue – that 'after an initial two year build up period, the venture should be self-financing on the basis of sales and admissions'.[14]

The BFI's chief management accountant, Chet Shukri, submitted an updated version of Museum capital costs on 7 September 1982 and the figures reveal a considerable increase in estimates when compared with the earlier scoping document of 1980. Whereas the first paper claimed overall capital costs of around £3 million at 1980/81 prices, this new set of figures saw the cost rise to £5,471,350 at 1984/85 prices. Anticipated inflation played some part in this increase and there had been no contingency in the original calculations, but there had also been a clear underestimation for museum content and display, for example, which grew from £205,000 to £674,000 (with only £117,000 due to inflation). Since MOMI was still several years away from completion and to encounter delays that would put a further strain on finances, the eventual cost would more than double.

As a result of Stoy Hayward's calculations of the potential income arising from the Museum's activities (other than admission), more generous figures were adopted for shop sales, coffee bar and hire of exhibition space as well as the additional cinema space planned for use in the evening. It was stated that 357,000 visitors needed to be attracted per annum in order to break even, where a relatively high proportion of visits by children was expected (at discounted rate). Figures attached to staffing costs and numbers bore little resemblance to the eventual set-up at MOMI which required more staff than planned.

The Report decided to focus its comparative assessment of competing attractions in London on Madame Tussauds, the London Dungeon, London Transport Museum and the Museum of London. In certain respects the evidence gathered actually undermined hopes for success at MOMI, especially in relation to sales and catering. Comments elicited about importance of location, general decline in museums and the time required to build up reputation highlight, if nothing else, how much change there was in the leisure industry between 1982 and 1988 and how impressive MOMI's initial success really was. For comparison, Hardcastle contacted Evoluon, an influence on MOMI, which achieved an annual attendance of between 400,000 and 450,000 visitors (the exception being the first year of operation in 1966 when 500,000 visited), with half of the total annual attendance achieved in summer months. Evoluon had noticed two phenomena in their own research on museums globally: successful museums do not build up attendance over the years but achieve their average high in the first year of operation; and there is a definite relationship between square metres and attendances, in that museums which enlarged also found a corresponding increase in attendance.

Following the presentation by Stoy Hayward, the most important statement to emerge at the September 1982 meeting, in terms of the self-supporting capabilities of a future MOMI and the inherent difficulties in any such policy was that 'should the Museum eventually make a profit, after payment of possible extra rent to the GLC, these excess funds should go to the BFI as a whole, as any extra monies made already do'.[15] Bauer later put a request to Smith to meet with her senior colleague at the OAL, assistant secretary Rodney Stone. Reiterating the 'no call on public funds' message, she went on to suggest: 'It may be that the Museum should be established as a limited company entirely separate from the BFI. Such an arrangement would not, of course, preclude co-operation between the BFI, the NFT and the Museum in the day to day running of the Museum, but it would protect the BFI from any financial liability in the event of the Museum failing to cover its costs.'[16]

A sensitive issue for the BFI, the rejection of any separate control and funding of an 'independent' MOMI may have parallels with Smith's dialogue with Bauer over the status of the National Film Archive (NFA) and the suggestion in a report that it 'should be funded directly by the Minister and be established as an independent organisation responsible to its own Trustees'.[17] Smith viewed this proposal as 'disastrous' and noted how 'the Institute acts as financial "banker" to its depart-

ments and therefore very effectively husbands public monies to the best advantage'. By this, Smith refers partly to the subsidising of NFT financial shortfalls. The determination to create a tangible connection between the NFA and NFT in the planning and development of MOMI not only provided a counter-argument to the DES Report recommendations but signalled the importance of protecting the overall integrity of the BFI.

The final push to secure capital costs for MOMI bore fruit in the successful negotiations between Smith and the philanthropist billionaire, J. Paul Getty, who went on to become the most generous benefactor of the BFI. Getty, a committed film enthusiast, had previously shown support through a series of gifts to the Archive. The news of Getty's initial donation was met with enthusiasm by the OAL, followed by a letter to Smith from Stone on 1 August 1984 in which he writes, 'the Minister would like to congratulate the BFI on your remarkable fundraising efforts on behalf of the museum. He agrees that the stage has now been reached where it would be sensible to begin discussions on the contract, with a view to starting construction work at the earliest date.'[18]

Part of the Getty donation was not allocated to any specific project and was termed the General Capital Fund. Formally, £925,000 from this fund would go towards the MOMI project, reducing the shortfall. Rod Morgan, the BFI management accountant for the Museum project, writes that 'it is assumed that [...] funding of the MOMI shortfall will be met from interest/capital from the General Capital Fund, the balance of which at 31/12/87 will be the endowment which it is hoped to preserve at £3 million'.[19] Maintaining this level of the endowment was important as it was going to have to pay for the potential operating deficit at MOMI of £100,000 per annum – established by Rawlinson and Morgan as inevitable, even if MOMI were to 'break even'.

From fundraising to planning

By March 1987 the total funding shortfall was pitched at £1,088,000. Morgan issued a memorandum entitled 'MOMI Capital Budget Appraisal' which detailed the various overruns, budget under-provision, consequences of delayed opening and omissions. Smith concluded that this analysis was realistic. Maximum revenue had been obtained from the Getty endowment through investment but the project remained underfunded. He believed that it was 'vital to provide adequately for the Museum display, as the building had been constructed for this purpose'.

Until this point the Content Budget had not been altered to any degree, but, as a result of Museum Control Committee discussions in mid-1987, it was decided to transfer some of the Contingency Budget over to Content Budget. This followed the successful outcome for the BFI in gaining planning permission to utilise the car park (Undercroft) and as a consequence double the main exhibition area with this additional basement storey which would house pre- and early cinema exhibits. Action over the Content Budget could be pursued more firmly with input from

the designer Neal Potter, who had joined the Institute to work on MOMI in November 1986. A yardstick of £1,000 per square metre had been written into the budget, which, in Potter's opinion, although adequate, was not going to provide for anything outstanding. Morgan's memorandum to the Museum Finance Committee in March 1987 states that 'despite the size of these current estimates, the Designer has commented that though constructing the exhibition within these figures is feasible, and an attractive display will result, the resultant exhibition will not be state-of-the-art "high tech", the costs of which would be even higher. It is possible however, that private sponsorship of particular displays may enable such an exhibition in certain areas.'[20] One donation having a particular stipulation was that of the Wolfson Foundation which provided £50,000 for construction of an educational space to be known as the Wolfson Study Unit.

When looking back at the scheme for MOMI, the architect Brian Avery said, 'Under a bridge and above a car park – there couldn't be another brief like it!' The challenges it presented were immense, not only from a construction point of view but bureaucratically too. The site was located on the south side of the NFT on a car park owned by the Greater London Council and underneath the approach ramp to Waterloo Bridge. William Rees-Mogg, chairman of the Arts Council, tentatively suggested allowing the BFI to use the Hayward Gallery (which would then cease to operate) for the new Museum site, but this idea proved deeply unpopular outside of the Institute and was abandoned.[21] The design solution needed to respond to its immediate surroundings and neighbours on the South Bank. By virtue of the 'black box' conditions imposed by a museum of cinema, most attention would be drawn to the exterior, the façade, where playful motifs could effectively separate MOMI from the concrete brutalism of the majority of the South Bank. Avery determined to draw inspiration from the BFI's own links with architectural history on the South Bank, with the Telecinema and the Festival of Britain in 1951. On the inner wall of the glass exterior facing the National Theatre, Avery planned to advertise the museum to passers-by with projected cinematic images, but ultimately this was scaled back to still images.

Contributing to the BFI's problems with bureaucracy was the transfer of licensing responsibility from the abolished GLC to a new department at Lambeth Council, which ignored existing agreements between the Institute and the GLC over safety requirements. Lambeth invoked the outdated Cinematograph Act (passed in the days of nitrate film) and insisted the space be licensed as a cinema and not a museum, with each of the projectors in chief technical officer Charles Beddow's Image Workshop being separately encased in costly protective glass. Designed as a place for special presentations, it had different types of screens enabling the projection of high-density images, 3–D films and flat-screen images. A further key feature, the Control Room, drew influence from Beddow's experience of the Telecinema where the projection room was entirely exposed to the public view so that all of the various operations could be on display and better understood.

Potter is aware how MOMI marked a turning point of sorts in terms of changes

within the design profession and commends 'the new generation of designers who weren't in-house, didn't get stale, suddenly breaking new ideas and exciting interiors and interpretation techniques for museums'.[22] Significant developments in computer-aided design took place shortly after MOMI was completed and Potter correctly judges that MOMI just missed out on technological innovations that revolutionised working practice: 'MOMI must have been one of the last major design projects to be produced without the aid of a computer. There were no desktop publishing programmes available so everything was done with photoset type and paste-ups. Changes to final artwork today take 48 seconds. In 1988 even quick changes took 48 hours.'[23]

Shaping the content

The 'Treasures of the Film Archive' series of film screenings, instituted as the '360' collection (one for each day of a year-long repertory cycle, though never reaching this figure owing to lack of sponsorship) and developed for exclusive use in the MOMI Cinema, was the counterbalance to the more transitory experience of viewing film clips and extracts in the museum exhibition space. Selection for this 'classic' feature film series was the responsibility of David Meeker at the NFA, and unapologetically subjective. The quality of prints was exceptional since they were taken from definitive master preservation materials. A goal set by the BFI, quoted in the *BFI in the Eighties* booklet, states: 'The museum should evolve not only as an attraction in its own right but as a resource for attracting individuals onwards to the more specialist services of the Institute.'[24] The 'Treasures' series was one such way this might occur, encouraging cinephilia among the young, but there is little evidence that any real connection was made between the experience of visiting MOMI and its relationship to other departments aside from a very general notion of 'collections' pertaining to the Institute.

In sourcing three-dimensional artefacts a consideration was that these types of material were, foremost, the passion of private collectors and at the time of MOMI's planning it was these collectors and enthusiasts to whom the BFI turned for support. Once approval had been given for the project, an appeal was made to those with both knowledge and objects: 'MOMI is seeking assistance, advice, expertise and ideas from those directly involved in the British film and television industries. It is also calling on the support of BFI members to help make MOMI a truly unique experience. All equipment, personal papers and records, set designs, costumes, models, ephemera and material relating to the development of film and television must be saved.'[25] Such assistance came willingly and, in the case of Joe Dunton, preceded the formal appeal. Other types of co-operation were envisaged, such as that between similar organisations and film museums in particular.

There was difficulty in determining precisely the kind of space MOMI actually was. From the point of view strictly of collection development, there was inconsistency and slippage between on the one hand being taken seriously as a bona fide

A public showcase for the BFI

museum and on the other as a visitor attraction. Early concept statements drafted by Hardcastle show that there was no strong impetus to collect original artefacts, barring a few key items that would illuminate a particular theme or portray a technical advance such as a Mitchell camera. However, the sourcing of objects would not so neatly conform to this specific aim and as the museum project gained ground, so the notion of the 'collection' became more fluid. The vital presence of Francis ensured that what had been acquired or promised would, at the very least, be approached in spirit according to basic conservation principles, even if in reality MOMI was ill-equipped and under-funded to pursue truly satisfactory standards. A useful meeting took place in October 1984 between Francis and Colin Sorensen, director of the Museum of London, with Sorensen making absolutely clear that, if MOMI was to veer towards being seen as a 'museum', there were a number of consequences to bear in mind. Francis summarises:

> If we wish at any time to belong to the Museums Association we must follow the accepted practice for lighting original material [...] [Sorensen] feels that if we have 'Museum' in our title there may well be a feeling in the profession that we are undertaking the preservation of objects associated with the MA's terms of reference. Also we will have problems with donations because there is an unwritten rule in the museum world that once you have accepted a donation you are responsible for its long-term survival and care. However, if you do not call yourself a Museum, and do not follow the standards referred to above it may be difficult to borrow material from other national collections.[26]

14.2 The masterminds of MOMI, David Francis (curator of the National Film Archive) and Leslie Hardcastle (controller of the National Film Theatre), walking past the site of the Museum shortly before its opening in 1988

Sorensen's remarks raised an issue to which, arguably, not enough thought had been given in the planning of the Museum, that of the long-term need to look after the collections. Lack of funds prevented the installation of full air-conditioning and humidity controls, regrettable given the considerable heat and humidity generated by buildings of this type. Conservation care of objects would attract ever more stringent regulations from the professional museums community in the years to follow. To understand how this became a source of potential criticism of MOMI, something should be said about the nature of the curatorial role adopted at the start of the Museum's life.

In the most basic sense, the curatorial role was held in the Institute as a whole and not the Museum. Staff working for the Archive, for Stills, Posters and Designs and in the Library were, in effect, performing curatorial functions in the course of their various job roles. There was no official secondment from these divisions to the Museum, yet there was implicit understanding that assistance should be forthcoming on an ad hoc basis. MOMI staff would often perform curatorial duties irrespective of their main roles. That MOMI required its own dedicated curator is undeniable – to some small degree this role was taken on by Hardcastle's PA Janet Corbett who became 'Keeper' of sorts after a combination of on-the-job training and some professional study – but it became a misused term in a rather unique set of circumstances. Hardcastle was deemed to be Curator, but, as Francis says, 'Leslie saw the Curator as a different role, more in terms of a Director if you like, whereas I saw it more as a person who is responsible for the content, material, handling, etc. He saw himself as overall creative influence.'[27] Potter alludes to this creative influence when he remembers how 'Leslie spent years producing sketches that were drawn in what I called "a wide angled pen". He imagined the space to be much bigger than it really was and would turn every element into a major exhibit.'[28]

Everyone involved with the project viewed David Robinson as a key player in the interpretative process. Potter says: 'I think he just had this ability to sum up in good journalistic terms what certain elements of film history meant and how they could be portrayed. The great ideas in MOMI – the Temple of the Gods and the Agit-Prop Train – came from David Robinson.'[29] A pivotal brainstorming weekend took place in May 1985 attended by Hardcastle, Francis, Robinson and Brian Coe, producing the 'Fitterworth Notes' (narrative concepts); these were then structured to form what Hardcastle referred to as the 'Bible'. A key decision that would influence the future of MOMI greatly was that special exhibitions were to be accessible only through the main museum, as part of the general entrance fee, and not via a separate entrance.

Getting the balance right for the treatment of British cinema was of paramount importance. From the start it was to be the subject area that would provoke the most intense debate, whether internally at the BFI or as part of any wider evaluation of museum content. In fact, British cinema had a fairly small part to play in the first designs to appear, but a significant change occurred after the initial concept that led to a major revision, not least because voices had raised concern that, as

a museum of the moving image in London, it should strongly reflect the British cinema.[30] Lindsay Anderson's letter to Hardcastle is indicative of the debate:

> I know very well that Hollywood always gets the lion's share of any exhibition of this kind, because it seems so much more glamorous, and also, probably, because designers are familiar with Hollywood and not with Elstree or Denham or Pinewood. But I do think it will be regrettable if MOMI runs out of steam when it comes to the British cinema. [...] Wouldn't it be nice, too, if there were some mention or honourable emphasis given to the British filmmakers who emerged through the Institute into the struggle for commercial filmmaking? Are you going to draw attention to the fact that the Free Cinema 'movement' did emanate from the NFT. [...] I know it's not the fashion to care much about British films – but I do think it's an area you should be conscientious about.[31]

The ideological divide that was always going to make MOMI liable to a certain criticism within the BFI and under scrutiny for the narrative it promoted is nowhere more sharply defined than in a 1987 paper authored by Cary Bazalgette of the BFI Education Department entitled 'MOMI Working Script: Comments'.[32] Bazalgette makes reference to an earlier Policy Group meeting where she views the existing museum plans as a 'white, male, Eurocentric view of moving image cultures'. She urges the team to be mindful of new developments in film and media education and to consider a more conceptual structure than the narrative planned. It is interesting to compare this comment with that of Francis who confesses in the pre-opening publicity booklet that 'at one time we had conceived of MOMI in a more impressionistic way. But we felt in the end that would only be understood by people who already had a lot of knowledge. If interested but uninformed visitors feel that exhibits don't relate to each other clearly, they become irritated, so we decided that the chronological development was the right method, even if it was harder work.'[33]

Bazalgette frames the rest of the debate around a key question she poses to the MOMI team. She asks: 'How does the museum want to present the relationship between technological developments and the social world which both gives rise to them and in turn is affected by them?' Throughout the Museum's concept areas she detects either a privileging of technological concerns over any consideration of social factors, or an imbalance between those earlier exhibits where there is little mention of, or distinction made between types of audiences, and those where it is given weight, but still circumvents explanation. She goes on to draw attention to global aspects of cinema, the reception of certain items intended for display that require sensitive handling from a race and gender point of view, and ends by suggesting that a new concept area looking at women as audiences might be considered. Francis has gone so far as to say that around the period feedback was offered it was already too late for prolonged debate, which is what would have been required since opposing viewpoints still held firm.

MOMI Education, as distinct from BFI Education, began in earnest with the appointment of Margaret O'Brien as Education Officer in early 1988. Owing more to traditional museum education practice than to BFI education policy (although

strongly supported by BFI Head of Education Philip Simpson), MOMI Education coincided with the Education Reform Act 1988 and the new compulsory GCSE at 16–plus which tended to limit activities such as museum visits unless linked to the new national curriculum. Despite its early success and widespread acclaim, MOMI Education never quite achieved the importance predicted in a 1986 policy paper by Colin MacCabe, in which he suggests that 'there are general cultural questions that the Education Department might now address using for its primary teaching area, not the schools, but our own South Bank complex'.[34]

The Museum is launched

A few months prior to the Museum opening, the NFT and MOMI became linked together under the new title of 'BFI South Bank'. Discussion around joint NFT/MOMI operations resulted after a period of negotiation in a staff structure which unified NFT and Museum teams in several areas: press, promotion, administration, accounts, box-office, front of house and projection.[35] There was the hope that through interest in and popularity of the new Museum there might be ways to reinvigorate and refresh the NFT and there was most optimism in how the Marketing Department, available for the first time to the NFT and funded largely by the MOMI budget, could make a difference.

The MOMI team found itself under extraordinary pressure to meet the scheduled launch date of 15 September 1988. The hothouse environment of the project, the sheer timeframe from its genesis to the impending opening, as well as a certain psychological resistance to completion, contributed to the high stakes. Potter warned, without irony: 'We run the risk of opening as the Museum of the Still Image'. Swift action was taken and the deadline was met, though work continued through the night on the eve of the launch and Potter remembers: 'As I left the site at 6 o'clock of the opening morning we left a building site – that is how I perceived it – complete chaos, and we came back two hours later to an international success beyond anyone's wildest dreams.'[36] Pre-launch publicity had guaranteed extensive press coverage, but no-one had anticipated the controversial nature of the opening ceremony speech by the Patron of the BFI, HRH Prince Charles, which veered away from a celebration of the moving image and the event itself to what has become infamous as his attack on 'the incessant menu of utterly gratuitous violence on both cinema and television'. Though surprised and unprepared, neither the Institute nor MOMI was adversely affected, with the public keen to experience the new attraction.

The Museum's importance as a major cultural space made it the subject of debate on national television and recipient of a number of awards, one of the most notable being recognition of the training of the museum guides (by now known as the Actors Company) undertaken by Mo Heard. First person interpretation was not new – as witnessed by its use at open air museums and heritage centres such as Wigan Pier and Beamish – but it hadn't been employed in such a way before,

A public showcase for the BFI

and the intensive research (and stamina) required performing their roles made the Actors really distinctive in the mind of the public. At their best the Actors could encourage real interest in the workings of pre-cinema objects and devices through demonstration, though to the more reticent visitor they represented a phenomenon that was hard to reconcile with more traditional museum going.

The most enduring scheme to develop alongside the Actors Company and MOMI Education was that of the partnership between Channel 4 and MOMI, which resulted in the Animator in Residence scheme. Established in 1990, selection through a national competition enabled young people to work for three months in MOMI's Animation Studio producing material to be considered for commission by Channel 4. The Museum had gained significant publicity with the Bugs Bunny and Roadrunner murals created by Chuck Jones for the official opening and remained closely associated with training in animation throughout the decade.

To achieve in excess of 550,000 visitors in its first year of operation was hugely beneficial to MOMI in one sense. By doing so it bode well for future targets, echoing those earlier Evoluon statistics. However, those same figures were then taken as indicative of a further increase in projected visitor numbers in subsequent years – which in fact never materialised. In a memorandum to Hardcastle about MOMI attendances 1989–90, Paul Collard, deputy controller, acknowledged that the projected attendance figures of 645,000 were not being met and noted that

14.3 Members of the Actors Company invite visitors to enter the foyer of a recreated 1930s picture palace. The featured film is William Wyler's *Wuthering Heights* (1939)

'there are a number of possible explanations: there is an underlying decline in our attendances, occasioned by the diminishing impact of the initial launch publicity, and there is a natural capacity to the museum, which will limit the numbers that can be got through the museum to a number significantly lower than those desiring to go through the museum'.[37] He remembers that in February 1990, when MOMI broke all previous records of attendance during the half-term period, at around 24,980 visitors, it was an unbearable place to be in.

Recently, Collard has commented on the reasoning behind MOMI and South Bank budgetary decisions. He reflects:

> There were two articles of faith on budgets – one was that next year NFT audiences are going to rise and secondly, MOMI is not going to cost any subsidy. The basic tension between the articles of faith which were unshiftable, and the need to operate within a cultural paradigm which was undeliverable, resulted in budgets which within two months of every financial year would go horribly off the rails, much to the astonishment of everybody![38]

From 1991–92 internal memoranda reveal that the South Bank revenue and expenditure positions were causing considerable worry and questions were raised about how financial accounts were presented. In addition to the net overspend for MOMI during that same year, there was the question as to how, in the future, capital requirements would be funded. A BFI South Bank Report made mention of the fact that 'MOMI did not have a depreciation fund to meet the likely eventuality of all the video equipment becoming faulty around the same date'.[39] A follow-up report also noted that 'there has never been a budget allocation to cover the costs of the exhibitions, they have either been paid for by outside funding or by using unspent budget heads'.[40] This remained true for the Irn-Bru-sponsored Pop Video exhibition (July 1992 – January 1993) and subsequent exhibitions such as the Western (1994).

In late 1991, Hardcastle retired as Controller of the South Bank though he continued to be involved with MOMI, assuming the title of Museum Consultant. Now that his energies could be channelled into the Museum exclusively, it promised a more hands-on approach to certain aspects, such as temporary exhibitions and planning for the future of the permanent space. His replacement as controller was, in fact, a 'museums person', Jürgen Berger, previously at Frankfurt Film Museum, and an acquaintance of Hardcastle through their shared communication about touring exhibitions and sponsorship ideas. Berger was able to bring to the South Bank an understanding of collections and conservation (he was the first to draw up an Acquisitions and Disposal Policy (A and D) for MOMI) but lacked the necessary leadership and management skill. Adrian Wootton, who entered the job in 1993, was a more natural successor to Hardcastle.

Aside from the problems faced by the Museum in its quest for financial self-sufficiency, there were other factors that weighed against it in terms of it being self-supporting. Wootton describes what the options were for reinvigorating MOMI but also what obstacles lay in its path. He explains: 'It became clear very rapidly to me that with MOMI you could not turn this rather large ocean liner around in

anything like the same way that you could with the rest of the organisation and that was because, I felt, there were some innate structural problems with it.' Here he is referring to the capital infrastructure and the inability to replace or re-energise modules and the small scale of the temporary exhibition area with its lack of a separate entrance. Wootton adds that 'the BFI used Getty funds to fund marketing campaigns from time to time when its visitor numbers really dropped off.'[41]

Over a couple of years, amidst the recession, visitor numbers at MOMI had decreased considerably (though it continued to rate highly in popularity polls) and along with the National Audit Office (NAO) report into the BFI (1993) and the introduction of performance indicators, it was a challenging time for the Museum. At a Management Board away day in 1993, attention turned to MOMI. An option was discussed but never pursued. The notes read:

> It was observed that although the Museum of the Moving Image had been established as a self-funding operation, it was not doing so. It was proposed that, if the grant from the DNH was cut further, the BFI should indicate that MOMI would have to close down. This would have to be presented as the only option open to the BFI, if the BFI was to continue to function in its current form. The decision to close MOMI would present a challenge to the Government to save a national asset; the success of the museum would be emphasised as much as its need for subsidy. Not only would a campaign to save MOMI be politically embarrassing for the Government, but also the original donors would be called upon to help. It was pointed out that the BFI itself would be the object of public recrimination for making such a decision and that the argument for subsidy would have to be made publicly.[42]

By the end of 1993 attendances began to gain ground, albeit slowly, and there was renewed emphasis on securing registered museum status for MOMI, which was provisionally recognised by the Museums and Galleries Commission (MGC) in 1994, with full registration status following two years later under Phase 2 of its scheme. With the focus turning more to 'collections' at the BFI and the potential for future Lottery funding creating what the then BFI director Wilf Stevenson referred to as 'pre-lottery fever', it was judged that there was more to aim for than could possibly be achieved by one person. Caroline Ellis, formerly of the Cuming Museum, Southwark, was newly appointed to this end as Curator of MOMI and, after a 'handover' period, Hardcastle retired.

An updated A and D policy and Collections Management Plan aimed to 'encourage public confidence in the Museum as a suitable repository' and give added emphasis to the collection of British material. MOMI became the official European partner to Warner Brothers, Burbank Studios, enabling greater access to new material on loan. Replacement of technical equipment was a pressing requirement as predictions around equipment 'end of life' were looming. The Major Projects Fund (Getty monies) provided the finance for this purpose with the support of Michael Prescott, Assistant Director. Prescott, more significantly, was responsible for the ongoing development of the BFI IMAX Project which it was soon claimed would be a vital lifeline of sorts in bolstering attendances at MOMI with plans for cross-ticketing and promotion, and as a sponsorship attracting asset. Derided by

14.4 The last picture show. Leaflet advertising a last chance to visit MOMI before it closed 'for refurbishment' in 1999. It never reopened.

A public showcase for the BFI

David Robinson as a 'spectacular gimmick'[43] and remarked upon by independent assessors as being 'questionable how a *recreational* concept like IMAX contributes centrally to the artistic and cultural objectives to the BFI', it was eventually granted close to £15 million by the Heritage Lottery Fund, with a further £5 million to be secured as match-funding by the BFI.

Under the plans for BFI 2000, there had been scope for redevelopment and expansion of MOMI (with the NFT relocating to a West End site) and Ellis submitted a proposal as part of a wider lottery bid in late 1997, around the same time as the award was made to the Institute for the IMAX project. Behind the scenes there was some concern over continuing with the IMAX Project, and the arrival of Alan Parker as chairman and John Woodward as director marked a rupture of sorts with existing strategy. The Fundamental Review that defined Woodward's directorate, summarised in *A Time of Change*, had dire consequences for MOMI. Woodward's initial impression of the Museum on his arrival was that it was 'in an appalling state',[44] and very early in 1998 documents outlining a new National Cinema Centre make no mention of MOMI or any future museum. That MOMI was to close down was a decision taken without too much sentiment. The delay in making plans public concerned negotiations between the Institute and the Science Museum and the National Museum of Photography, Film and Television in Bradford for the future of the collections. Extracts from notes of a meeting held in June 1998 state:

> The BFI is looking for an organisation prepared to take over MOMI as it stands, or to move the collections elsewhere, putting them on display, caring for them and maintaining the MOMI name. This will enable the BFI to close the Museum thus reducing the revenue deficit but allowing it to continue to fulfil its remit for film and to keep long-term options open.[45]

Options for MOMI didn't include the possibility of approaching original (or new) sponsors or initiating a public campaign to 'save' the Museum. Getty's contribution to the BFI in the form of an endowment was, according to Smith, a means to prevent MOMI from plunging into financial difficulties, but as a letter from the deputy director Jon Teckman to Woodward reveals: 'The fact that the endowment no longer exists actually gives us an even firmer grounding to close on financial grounds.'[46] A redeveloped museum, in some form, became one of the presiding themes through which the announcement of the closure was eventually made on 7 May 1999 and the newly created Collections Department concentrated on interim access via a planned touring exhibition.

Closure

MOMI closed to the public on 31 August 1999. The statement in the 1997–98 BFI Annual Review that MOMI was aiming to become 'the world's most comprehensive moving image museum and educational facility' now appeared rather remote from reality. Nevertheless, a Museum Advisory Board was set up to support the planning

of a new museum and during the *Guardian* interview with the ex-Chair Alan Parker at the South Bank, Barry Norman – a former BFI governor – reminded him: 'you have the museum next door which has to be fought for to exist again in another form'.[47] At the Board of Governors' meeting on 25 October 2000 the scheme of work for the new museum was presented and discussed, revealing many of the same concerns that had surrounded the original MOMI, even down to the notion that the museum must be 'fun', not too Hollywood-focused and that the word 'museum' might deter visitors. Public and professional disappointment with the touring exhibition Moving Pictures, launched at Sheffield Millennium Galleries in February 2002 and rashly over-promoted as 'an opportunity to experience a true blockbuster' resulted in a BFI policy change. The Institute now wished to distance itself from any redevelopment of MOMI and found a timely, if opportunistic, excuse in the government announcement that all national museums were to be free-entry, rendering the Museum business plan 'unviable'. A final analysis of the Institute's collections by the Board revealed that 'though the BFI's moving image and stills, posters and design collections were unrivalled, the breadth and depth of the museum's 3–D collections needed to be assessed'.[48] Potter, like everyone else who worked on MOMI in the 1980s, believes that what made the Museum a success was far more than film-related objects. He reflects: 'This mantra of collections – that's not what made MOMI work. It was the showmanship, storytelling and entering into the spirit of the place by being able to suspend disbelief. Once you start knocking that out you're left with a few badly decorated plasterboard walls under a bridge at Waterloo!'[49]

Notes

1. Report to Governors by Anthony Smith, 27 November 1979, BFI/D-76.
2. Papers for Governors Meeting G476, March 1979, BFI/D-76.
3. Papers for Governors Meeting G483, May 1980, BFI/D-76.
4. BFI Leslie Hardcastle Papers, *Notes on the Museum of the Moving Image* (May 1983).
5. G483, March 1980, BFI/D-76.
6. *The Museum of the Moving Image Exhibition Gallery and NFT 4 (Telekinema): A general brief on which to base a feasibility study and cost estimation – prepared by L. Hardcastle* (1 July 1979), BFI/D-32/C/1.
7. David Watson, 'The Museum of the Moving Image: Now Under Construction', *Three Sixty*, November 1984, p. 12.
8. The videotheque idea was not realised during the lifetime of the Museum.
9. BFI Office Notice No. 16/81, 12 October 1981.
10. Kevin Gough-Yates, 'BFI Noose?' (1982). Leslie Hardcastle Papers.
11. *A Financial Report on the Proposed Museum of the Moving Image – Draft*, Stoy Hayward and Co., 10 September 1982, BFI/D-78.
12. BFI Paper Archive, G508/ 1.82. BFI/D-78.
13. BFI Paper Archive, letter from Hilary Bauer, OAL, to Gerry Rawlinson, BFI, 27 July 1982.
14. BFI Paper Archive, G508/1.82–BFI/D-78.
15. Ibid.

A public showcase for the BFI

16 BFI Paper Archive, letter from Hilary Bauer to Anthony Smith, 8 October 1982.
17 BFI Paper Archive, *Eighth Report from the Education Science and Arts Committee on Public and Private Funding of the Arts*.
18 BFI Paper Archive.
19 BFI Paper Archive, *Project Financing: Status and Projections 31/1/86–31/12/87 – prepared by Rod Morgan* (March 1986).
20 MC11 Museum Control Committee (March 1987). BFI, Leslie Hardcastle Papers
21 Paper on *Hayward Gallery change of use for MOMI* by Leslie Hardcastle, 22 March 1984. BFI Leslie Hardcastle Papers. Plan also mentioned in Roy Shaw, *The Arts and the People* (London: Jonathan Cape, 1987), p. 50.
22 Lorraine Blakemore interview with Neal Potter, 15 July 2005.
23 Ibid.
24 BFI/D-76.
25 Personal papers of Leslie Hardcastle.
26 Notes from a meeting between David Francis and Colin Sorensen, 3 October 1984. Personal papers of David Francis.
27 LB interview with David Francis, 23 September 2005.
28 LB interview with Neal Potter, 15 July 2005.
29 Ibid.
30 Interview with David Francis.
31 Letter from Lindsay Anderson to Leslie Hardcastle, 17 December 1987. Personal papers of David Francis.
32 BFI/D-13.
33 John Fordham, 'Setting the Scene: A look at MOMI', p. 5, from publicity booklet [red logo on black background], 1988 – BFI Leslie Hardcastle Papers.
34 BFI Paper Archive, G541/3.86.
35 BFI Paper Archive, G550/6.87, 21 October 1987.
36 Interview with Neal Potter, 15 July 2005.
37 Memorandum (12 April 1989). Leslie Hardcastle Papers.
38 LB interview with Paul Collard, 22 February 2007.
39 BFI MOMI Papers.
40 BFI MOMI Papers.
41 LB interview with Adrian Wootton, 10 July 2007.
42 BFI Paper Archive, Notes, 20 April 1993. BFI/109.
43 David Robinson, 'Where Did It All Go Wrong?', *Guardian*, 30 November 1996.
44 LB interview with John Woodward, 28 February 2007.
45 BFI/D-9899/46/K/3.
46 BFI/6–A/5/D.
47 NFT *Guardian* Interview with Alan Parker, conducted by Barry Norman, 7 January 2000.
48 BFI Governors Meeting, 27 February 2002.
49 Interview with Neal Potter.

15

Towards the millennium

Geoffrey Nowell-Smith

Anthony Smith's appointment at Magdalen did not start until the beginning of the new academic year and besides he was keen to be still in post at the BFI at the time of the official opening of MOMI, which was due to take place in September 1988. This meant that Wilf Stevenson had four months as Director Designate to work out what he would do when he stepped into Smith's shoes in the autumn.

One thing that had struck him on his arrival as deputy director in 1986 was the apparent lack of long-term planning, particularly financial, by the Institute. In 1983, Smith had masterminded the production of a booklet, *The BFI in the Eighties*, which set out the BFI's aspirations for the rest of the decade. But it was mainly just that, a statement of the aspirations the various parts of the BFI had for what they would like to do if resources were available. Planning ahead for what would actually be done tended to await the news of the following year's financial settlement from the government, which would dictate the availability of funds. In 1987, however, the government announced that in future it would give grant-aided bodies such as the BFI, along with the coming year's settlement, advance information on the likely settlement for the following two years, on the basis of a formal corporate plan. With the sponsorship funds from John Paul Getty now also on a stable footing, it now seemed a lot easier to plan ahead than it had been previously.

At the July 1988 meeting of the board of governors – Smith's last appearance as director – Stevenson was able to announce the completion of a forthcoming Corporate Plan for the Institute, covering the period from April 1989 to March 1993, for all of which the likely level of government grant was either already known or soon would be.

The proposed Corporate Plan, which was to be fully discussed and enthusiastically approved by governors in November, envisaged a number of structural changes in the way the BFI was organised, and these too were submitted to the board for approval before Stevenson formally took on the post of director.

The new structure was not in fact very different from the old. It envisaged four operating divisions. The Archive would remain unchanged, except that it regained the front office of Stills which it had lost in 1980. The South Bank would be reor-

ganised to provide unitary management for the NFT and the new Museum. Distribution would remain unchanged. The Information Division would be renamed Research and Information and would, for the time being at least, take Production under its wing. There was no convincing rationale for this last proposal, but it served the function of bringing Colin MacCabe, who was shortly announced as head of the new division, closer to the centre of things at the Institute, both running some of the more intellectual parts of the BFI and potentially acting as a source of cultural leadership across the board.

In addition to the operating divisions, there was to be a centralised service division, also including Funding and Development, reporting to a person described as Deputy Director, but whose formal responsibilities were slightly diminished. Now that the Institute had a Royal Charter it no longer needed a Company Secretary, and the Accounting Officer required by the OAL was, in any case, already the Director. The governors were at first sceptical, as was the OAL assessor on the Board, Derek Lodge, who pointed out that the change would need ministerial approval.[1] As an interim arrangement the governors agreed to have Barrie Ellis-Jones take on the role of Acting Deputy Director in October. Over the next few months agreement was reached about the scope of the permanent post and Michael Prescott was recruited to fill it in September 1989, with the title Assistant Director.[2]

The committee structure was tightened. There was to be a senior executive committee consisting of the Director, Assistant Director and the four Heads of Division to discuss major questions of policy, with a secondary committee, chaired by the Assistant Director and similar to the old Resources Group but intended to be 'more strategic', to ensure that policy decisions were enacted.

Film and television policy

While the new structure was bedding down, two questions of external policy emerged to occupy the new director's attention. The first of these concerned the government's plans for the future of television, which involved the intended creation of a Broadcasting Standards Council with powers to adjudicate on matters of taste across the entire broadcasting spectrum, including the BBC. The government was also preparing a new Broadcasting bill, in the light of the 1986 Peacock Committee report, confidently expected to contain measures to increase competition and weaken the public service remit of terrestrial broadcasters. Together, these proposals encapsulated the two faces of the Conservative government – liberal in economics and socially and culturally authoritarian – and, from board level downwards, the BFI was opposed to both. The BFI prepared a critical response to send to the government, following it up with a series of publications between 1988 and 1990 entitled 'The Broadcasting Debate', to stimulate wider discussion of the issues at stake. None of this was sufficient to stop the government in its tracks. The BSC was duly set up, under the chairmanship of William Rees-Mogg but with a sympathetic chief executive in the form of Colin Shaw, and the Broadcasting

bill became law in 1990. Stevenson did, however, secure for the BFI what it most wanted, which was a clause in the bill making the Institute the official repository for all ITV programmes. This clause came into effect at the beginning of 1993 at which time the National Film Archive formally changed its name to National Film and Television Archive.

Meanwhile Attenborough had persuaded Margaret Thatcher to take an interest in the state of the British film industry which, after the euphoria of the mid-1980s, was now back in the doldrums. A seminar was held at 10 Downing St in June 1990 at which the production side of the industry argued the case for significant government intervention. Attenborough asked Stevenson to take charge of the industry side's preparations for the seminar, which, given the prime minister's ferocious attention to detail, had to be meticulous. A small working party was formed, which came up with a six-point plan to push forward plans for structural reform in the relations between government and the industry, ranging from tax incentives to greater involvement with Europe, and structural changes, including the formation of a British Film Commission. The proposals put forward by the working party were subsequently published in a series of pamphlets produced by the BFI and entitled 'UK Film Initiatives'.

In November 1990, Margaret Thatcher resigned as prime minister and her successor, John Major, called an election early in 1992. One of the first acts of the new administration was to remove responsibility for the film industry from the Department of Trade and Industry and give it to the newly created Department of National Heritage (DNH), which also became the sponsoring department for the BFI, in place of the OAL. This was on the whole a welcome development but there was a brief hiatus while the former DTI, OAL and Home Office officials regrouped and got accustomed to their new brief.[3] The new government was less Europhobic than the previous one had been and the working party successfully argued the case for the UK to rejoin the European Community's Eurimages initiative and support the European Community's MEDIA programme. The Treasury was also prepared to modify its rigid stance on tax incentives, though initially not to the full extent that the working party had hoped. But a slow ripple effect ensued which was to become a wave when Labour returned to office in 1997. The venture was also successful to the extent that it banged heads together and gave the industry a forum, previously lacking, at which to discuss important issues and plan accordingly. Stevenson's role in driving things forward was greatly appreciated by the more strategic-minded people in the industry.[4]

In relation to the BFI itself, however, the initiative was marginal and a distraction. It gave the BFI the makings of a new role, as 'advocate' for the film industry, and it gave people in the industry an insight into the importance of the BFI's work in the preservation of British cinema and the promotion of British films through its distribution and exhibition activities. But little of this penetrated into the BFI's own work; nor did the venture lead, as some people hoped it might have done, to an enhanced role for the Production Board in the panorama of British film-making.

Organisation

In his short tenure of the deputy post, Ellis-Jones contented himself with a minor tidying up operation and shortly after Michael Prescott's arrival he left the BFI to take up a job in Strasbourg running the European Commission's Eurimages programme. Irene Whitehead then took over as permanent head of Funding and Development (renamed Planning Unit in 1990). Prescott, however, was determined to be a vigorous new broom. With a background at the Inland Revenue and at the Treasury, he had a quasi-Thatcherite zeal for public-sector reform. Sensing that he might be called on to take the flak for unpopular decisions in the future, he happily cultivated an image as the BFI's enforcer, thereby taking some of the pressure off Stevenson when things got tough.

Between them, Stevenson and Prescott set about modernising the BFI's management structures. Equal Opportunity and Disability policies were enacted,

15.1 Wilf Stevenson, BFI director from 1988–97

spearheaded by Irene Whitehead. Administration was streamlined. Computerisation continued apace. Rather speciously, it had been claimed in 1987 that staff needed computer terminals to enable them to access the SIFT database and Getty was persuaded by Anthony Smith to contribute to this first phase of a general computerisation of the Institute. A network was installed and more and more staff were hooked up to it. But the BFI was to pay a price for being early into the field. The system chosen for the BFI by consultants Thomson McLintock was both expensive and (it soon turned out) incompatible with what was to become the industry standard. So although the BFI acquired the means to communicate with itself it could not communicate so easily with the outside world, for example by the exchange of floppy disks or, later, through the emerging internet.

In Prescott's area there remained a problem with Accounts, which survived until 1990 with an archaic computer system that was little more than a glorified adding machine. Modernisation was imperative and with advice from the consulting arm of the Institute's auditors, Stoy Hayward, Prescott pushed through the choice of a new system. Along with a change of system came a change of personnel. The head of finance, the prickly but much loved Chet Shukri, was forced into early retirement and was succeeded by Ian Nelson, who was charged with implementation of the new system.[5]

Meanwhile, the government had just instituted a system of what were called performance indicators as a way of measuring how public-sector institutions were doing. In the late 1980s, Stevenson, followed by Ellis-Jones, had compiled a list of what seemed to be measurable activities, which were duly reported to the OAL, but this had little immediate effect on the internal workings of the Institute. Prescott developed them into a key management tool and a way of putting pressure on heads of division to maintain high levels of activity even when money was tight. But like all targets (which is what they became), they didn't necessarily put the pressure in the right place and arguably distracted attention from other areas in need of attention. They also tended to be pitched unrealistically high and survived as targets even after the budget had set the bar at a more realisable level.[6]

The Corporate Plan

The main priority for the BFI in Stevenson's first years as director was the implementation of the Corporate Plan approved by governors in November 1988. This was an ambitious task. The plan set a target of a 56 per cent growth in revenue by 1993, as against an increase in expenditure not to exceed 33 per cent. Where the growth in revenue was to come from was never entirely clear. The Library, Stills, Distribution and Education were tentatively cited as areas from which additional income could be raised, and a hope was expressed that sponsorship would be forthcoming for previously unsponsored activities.[7] It was reckoned that the BFI would have an accumulated deficit of £400,000 at the end of the first two years of the plan, but that by the end of 1993 it would be comfortably in surplus.

On the face of it the BFI's financial position was encouraging. Getty was proving a reliable sponsor, making regular donations which could be banked even if as yet there were no specific capital projects in hand on which to spend the money. Cash increases in government grant (25 per cent between 1987/88 and 1990/91) were, however, deceptive. Any increases tended to come with strings attached and, with annual inflation still running at 8 per cent, this apparent largesse actually concealed a small but significant real-terms decrease in funding for the Institute's base activities.

Where the Institute faced most problems, however, was in the area of self-generated funds. The BFI was not a commercial organisation. It had pockets of commercial expertise, on the South Bank and in Distribution in particular, but nowhere in the Institute, from governor level downwards, was there any enthusiasm for pursuing commercial objectives at the expense of cultural ones. While there was room for improvement in many areas, there were limits to how far BFI departments could go in maximising revenues without losing their main cultural raison d'être. There was also no certainty that moves to popularise the BFI's offerings would actually produce more revenue, and there was an obvious danger that it might lose its existing public without finding a new one. To increase revenue, therefore, the Institute was very dependent on finding additional sponsorship. There were some notable successes, notably a partnership with the champagne manufacturers Piper Heidsieck to create a collection of prints for regional screening parallel to the '360' list of classics for showing at MOMI, but it proved very difficult to raise enough money to reach the ambitious revenue targets of the Corporate Plan.

The South Bank

The crucial area if financial targets were to be achieved was the South Bank. This now had four sub-divisions, the NFT, the LFF and other festivals, MOMI, and (an important potential profit-maker) Catering and Retail. Of these the NFT was the most immediate cause for concern. Growth in BFI membership, which by 1988 had reached 44,000, was not translating itself into box-office revenues. Film culture was changing, in real but not always easily definable ways. Interest in the more adventurous parts of European and world cinema was declining, with fewer foreign-language films being taken into distribution (though the BFI, through its own distribution arm, worked hard to remedy this). On the other hand, overall interest in the panorama of world cinema was still sufficient to merit giving at least an airing to new films from various parts of the world. This played to the advantage of the LFF, which had developed in the 1980s into a massive and massively popular event, programmed by Derek Malcolm from 1984 to 1986 and then by Sheila Whitaker. But it was less advantageous to the NFT, where attendances were steadily declining from their peak of 300,000 in the early 1980s to barely 200,000 at the end of the decade (they were to fall even further later). From 1987 onwards, this fall in box-office was causing concern at governor level – particularly since it

was happening at a time when attendances at commercial cinemas were beginning to rise again after reaching a low point of 50 million per year in 1985. A special sub-committee of governors met in September 1988 to formulate questions which governors felt were not satisfactorily answered in the policy papers they had been served up with over the preceding 12 months. Questions were pertinent and intelligent, but neither the governors nor the NFT itself were able to come up with answers and box-office continued its seemingly inexorable decline. Asked in 1989 to account for the fall and to suggest measures to stem it, Whitaker was resolute in defence of current policy, which she saw indeed as the only possible one if the theatre's cultural remit was to be maintained. Hardcastle (admittedly somewhat distracted by the prodigious volume of work being put in to get MOMI off the ground) had little to add other than to defend his programmer. In response, Stevenson decided to once again separate regular NFT programming from the LFF and other festivals, leaving Whitaker in charge of festivals while a search was launched for a new NFT programmer. The immediate result was an uncomfortable interregnum between Whitaker's departure at the end of 1990 and the arrival of her successor, Deac Rossell, some months later. During this period box-office figures plunged yet further as audiences struggled with a programme booklet which no longer featured the 'seasons' by which NFT regulars organised their viewing.

MOMI in 1989 was still an unknown quantity. Extremely high hopes were held as to how it could perform and the contribution it could make to BFI finances. Attendance figures for the first six months had exceeded expectation and an ambitious target of 650,000 attendances was set for the 1989/90 financial year. In the event attendances were 520,000, which was pretty close to break-even, and in March 1990 Prescott reported to governors that overall break-even would be reached in 1991/92. This proved to be a dangerously optimistic prediction. Never again was MOMI to reach the 500,000 attendance mark, and the combined losses of the NFT and MOMI continued to rise throughout the decade.

In 1991 the Museum's mastermind, Leslie Hardcastle, retired as head of the South Bank operation, retaining a behind-the-scenes role as museum consultant. His successor was Jürgen Berger, formerly of the Frankfurt Film Museum, an altogether less dynamic character. Berger's inexperience of working in a cut-throat commercial environment led to increasing responsibility falling on his deputy, Paul Collard, who had been brought in as a possible successor to Hardcastle but had been forced somewhat into the background during Hardcastle's continuing tenure. Collard's warnings that the situation at the South Bank was untenable in the long term went unheeded – or, in so far as they were heeded, only led to his being fingered as a troublesome doomsayer. Feeling that his position was threatened, Collard resigned at Christmas 1992 and was not replaced. Shortly afterwards, Berger offered his own resignation, which was accepted, and he was replaced in August 1993 by Adrian Wootton.[8]

Wootton proved to be a vigorous and effective leader, who also brought some much needed stability after the unpleasantness surrounding the resignations of

Berger and Collard and the sidelining of Whitaker. But he was unwilling to take on responsibility for the Museum, for which a new specialist curator was then found, in the person of Caroline Ellis. Wootton's appointment came at a time of general economic downturn, which hit MOMI particularly hard. In 1992/93 the overall deficit at the South Bank was £3 million. Revenues recovered somewhat in 1993/94 and 1994/45, but expenditure was also rising. It is hard to discern from the published accounts for 1994/95 and beyond just how much South Bank expenditure was attributable to the NFT and how much to MOMI but it was widely felt inside the BFI that MOMI's losses were being hidden, and Deac Rossell, who left in September 1993, was not alone in feeling that even then the NFT was being made to carry the can for losses which were in fact attributable to MOMI's failure to meet its targets.[9]

There were compensations. MOMI continued to rate highly as a visitor attraction, and was arguably all the more attractive to visitors through failing to meet its attendance targets and being less crowded as a result.[10] The third theatre on the site enabled the BFI to put in place the '360' scheme for mint-condition prints of essential classics of the cinema to be projected on a regular basis (if not quite with a different film on every day of the year except Christmas). A successful grant application to the Foundation for Sport and the Arts enabled plans to be drawn up for the complete redevelopment of the riverside restaurant at the NFT. Once these plans were implemented (which required the passing of an Act of Parliament), catering revenues increased by leaps and bounds, providing a welcome and much-needed boost to South Bank finances.

The Archive

Besides the South Bank, the other big spending parts of the BFI were the Planning Unit, which although it supported commercial activities was not itself revenue-earning, and the Archive, whose commercial potential remained untapped. The National Film Archive was an enormous repository of films, relatively few of which could be publicly shown, either for lack of suitable viewing prints or because of copyright restrictions which meant that prints donated to the NFA could often be shown only to non-paying customers and on BFI premises. Any showing outside these limitations required the explicit consent of the donor and rights holders. The nitrate duplication programme had considerably increased the availability of prints, and David Francis, the curator since 1973, had adopted a liberal interpretation of the words 'BFI premises' to include universities where there were BFI-funded lectureships and then universities more widely. RFTs with good projection facilities were also on occasion allowed to show archive prints, but had to take their own responsibility for copyright. But this fell far short of the Archive's full potential as a public resource.

In preparation for the second Corporate Plan, all heads of division had been asked to come up with proposals for staff cuts, which unfortunately were looking

increasingly necessary.[11] Only MacCabe, who had a lot of reorganising to do on his own patch, obliged. Faced with this obduracy Stevenson therefore found himself having to go it alone. His first target was the Archive, whose operations he felt he now understood well enough to be able to locate points where savings could be made. In October 1989 he put forward a restructuring plan which involved axing the post of Deputy Curator (vacant following the recent resignation of Michelle Aubert) and transferring the Archive's cataloguing section to the Library and cutting its staff from six to three. Meanwhile, as part of a longer-term strategic project to shift the Archive's priorities towards increasing access to the collections, he tried to convince the curator, David Francis, to relax some of the conditions of the donor access agreement under which materials had been traditionally deposited in the Archive. Francis was furious. The cataloguing department was both integral to the Archive and a world leader in its field.[12] And the donor agreement, in Francis's opinion, was sacrosanct and essential if further donations were to be secured. On Friday 6 November a stormy meeting took place at which Francis said that unless the plan was withdrawn he would have to resign. Stevenson replied that the plan would not be withdrawn and that Francis should be considered to have resigned. The following week an exchange of memos culminated in a curious result. Francis confirmed he would resign but Stevenson accepted to put the contentious restructuring on hold.[13] This followed a personal appeal by Francis to Attenborough to persuade him that, as a donor to the Archive, he would be the first to suffer if the proposals were enacted, and some anxious consultations among governors. At the end Attenborough decided he had no case to intervene. The upshot was that the

15.2 Works nearing completion on phase III of the J. Paul Getty Conservation Centre in 1992, which added a new film and video vault and a two-storey paper store housing stills, posters and designs, and the BFI Library's Special Collections

Towards the millennium 281

Archive lost a fine curator (only the second in its fifty-year history) and its future was hanging in the balance.

Potentially, an opportunity had now arisen to reform the Archive root and branch by bringing in a new curator less hidebound by archival shibboleths. But given the furore, this would have been a dangerous step to take. Instead the choice fell on Clyde Jeavons, a former deputy curator, and very much a person of the Lindgren school, though a more amenable personality than either of his predecessors.

The task facing him was not simple. The Archive was traditionally the jewel in the BFI crown and the only part of the organisation to which governments of every complexion felt an unequivocal obligation.[14] But an unintended consequence of J. Paul Getty's generosity towards the Archive had been a loss of the sense that this was truly a national institution to which government owed a duty similar to that owed to the British Library. Instead it was now seen as a part of the BFI that had benefited particularly well from Getty's munificence. For many people inside and outside the BFI, including some governors, it was a big swallower of resources which had not fully adapted to the world of the enterprise culture touted by the Conservative government. Jeavons was being expected to adapt to this world in a visible way, while preserving the Lindgrenian principles on which the Archive was founded.

The key to satisfying these conflicting demands was to be found in the nitrate duplication programme, but herein also lay a problem. As explained earlier in this book, duplicating a film properly meant making internegatives for both sound and picture as well as a new print. This meant enormous expenditure on film stock and ever increasing demands on storage facilities. The more successful the Archive was in preserving the heritage, the more it cost, and by 1990 the NFA's preservation budget stood at over £1 million a year. Meanwhile, by making footage duplicated a key performance indicator, the OAL was effectively tying the BFI into greater and greater expenditure, with little hope of financial return. But problems were cropping up elsewhere. Acetate stock was proving also vulnerable to decay while colour emulsions were prone to fading, regardless of whether they were on a nitrate or an acetate base.[15] There was an urgent need to prioritise within the duplication programme, which crude performance indicators did not reflect. After a brief hiccup caused by teething problems at the new Conservation Centre at Berkhamsted, the nitrate duplication programme was to prove quite successful in quantitative terms in dealing with decaying stock – so much so that by the beginning of 1995 Jeavons was forced to report to Prescott that strictly speaking there was no decaying nitrate left to duplicate.[16] There were still large numbers of nitrate films to be copied, but they were on the whole stable, while the colour fading and acetate problems, for which there was no earmarked government funding, were far from being resolved. The appointment in 1992 of Dr Henning Schou as the Archive's new head of conservation brought much-needed expertise to addressing the technical problems of tackling decay. Meanwhile, from 1993 onwards, attention switched to 'access-led' preservation, which by the end of the year 1993/94 was

running at nearly 1.5 million feet per year, in addition to 3 million feet preserved for technical or safety reasons. This was all valuable work for the future, but less so for the present, since the other still unresolved question was who would profit from the making of new copies so long as access restrictions prevailed.

Another major issue preoccupying the Archive in the 1990s was Statutory Deposit, now referred to as Legal Deposit. After the failure of David Kerr's bill in 1969, this had retreated to the back burner, but in the early 1990s the British Library had begun to take an interest in the phenomenon of media convergence and the emergence of non-print textual media such as the CD-ROM as well as the proliferation of audiovisual material. A joint paper by the BFI and the British Library recommending Statutory Legal Deposit was submitted to the DNH in January 1996 and the DNH published its own Consultation Paper in February 1997. Meanwhile a government Working Party chaired by Sir Anthony Kenny had been set up which produced its final report in July 1998. However, for various reasons and much to the chagrin of the BFI (the British Library was less concerned), the Legal Deposit Libraries Act which finally emerged in 2003 included no provision for statutory deposit of films or other audiovisual products.

Research

In the immediate term, what Stevenson wanted MacCabe to do was promote research as a core BFI activity. As a way of giving the BFI an enhanced role in film and media education, he asked MacCabe to explore the idea of setting up a BFI MA programme in association with a partner in the university system.

The scheme MacCabe came up with for the MA was ingenious. It was to be a one-year course, full time, with a first semester devoted to intensive teaching and learning, a second semester in which students took on work placements in the BFI or elsewhere in the cultural or media industries to get a sense of the nut and bolts of the business, and a third semester devoted to writing a dissertation. The students were to be funded by sponsorship raised in the main from television; the eventual partner, Birkbeck College in the University of London, would validate the degree and provide some teaching facilities; and the cost to the Institute would be limited to the salary and overheads for a course director and use of a viewing theatre to show films from the Archive. The first course director was John O. Thompson but he was replaced after two years by Laura Mulvey, who held the post until the course was wound up in 1998 and converted into a regular Birkbeck MA. As well as being an excellent course, attracting high-calibre students, the MA provided BFI departments with talented interns to undertake precious tasks at virtually no cost.[17]

Meanwhile MacCabe was assigned a small budget, beginning in 1989, to promote two research initiatives: one was the appointment of short-term Research Fellows from outside the BFI to give lectures and seminars which would introduce both BFI staff and the wider public to new ideas of film and media aesthetics; and the other was to enable selected BFI staff to be relieved of their day-to-day duties in

order to undertake research which might be useful to the BFI, the industry or the culture more broadly. Neither initiative was an unalloyed success. The research fellows came and went. Some of them – notably John Berger, Yuri Tsivian, Marina Warner and Cornel West – gave inspiring talks which helped justify the ambition inelegantly expressed in the Corporate Plan for the BFI South Bank to develop as 'the centre of ideas and intellectual controversy in respect of contemporary work in film and TV as they interact with society'. But the visitors' impact inside the BFI was slight and the exercise was discontinued when budget cuts had to be imposed in 1992. The internal research initiative did not fare well either. Its intention was laudably democratic, recognising that there was energy and talent to be tapped among lower or middle ranking staff. But the implementation of the project lacked focus; little important knowledge was created; and this initiative too was abandoned when money became tight.

In the more established parts of the division, MacCabe's arrival had an immediate galvanising effect which was widely welcomed. But there were tensions and disruption too. It was always a moot point whether MacCabe could continue to be operationally in charge of BFI production as well as head of division (while also holding down an ongoing visiting professorship at the University of Pittsburgh for five months of the year into the bargain). A new head had to be found for Production. The obvious candidate was Jill Pack, MacCabe's very able deputy since 1985. But an interview panel chaired by the Production Board chair Margaret Matheson decided instead in favour of promoting the relatively inexperienced Video Officer, Ben Gibson, to take on the role. Suspecting sex discrimination, Pack threatened legal action, which was averted by an out-of-court settlement.[18] For his part, Gibson felt his freedom of action was limited by MacCabe's continuing role as his superior, and after a couple of years negotiated the reinstatement of Production as an autonomous division.

Library and Information Services, too, were unhappy with the new dispensation, and also managed to get out from under, passing under the control of Michael Prescott in January 1990. The Library was then undergoing a rather troubled computerisation and neither MacCabe nor his deputy, Richard Paterson, really wanted operational control of an area with such specialised demands. The move was described as 'by mutual agreement',[19] and led to the division being renamed Research and Education as it no longer had an informational role to perform.

In 1989, MacCabe turned his attention to Publishing, which he judged to be under-performing. He commissioned a report from a senior editor at publishers Macmillan, which recommended a slimmed-down and more commercially focused operation, possibly not even needing a head of department. The problem was real, since the department was overstaffed on the editorial side and too much time was spent on managing the production and marketing of unremunerative publications emanating from elsewhere in the Institute. But the solution was a holding one only and it was soon realised that a publishing house did need a specialised publisher to run it after all. Ed Buscombe was promoted to head the reconstituted depart-

ment. After a year or so in the doldrums, Publishing revived. Together with David Meeker from the Archive, Buscombe started a new series of books, the BFI Film Classics, designed to accompany Meeker's selection of 360 films for screening at MOMI and elsewhere.

After Publishing it was the turn of Periodicals. As explained in Chapter 13, it was widely felt that *Sight and Sound* was overdue for a change of editor and possibly a more extensive revamp. Penelope Houston was reluctantly persuaded to relinquish the editorship and Philip Dodd was appointed in her place. After much debate it was decided to merge the BFI's magazines, *Sight and Sound* and the *Monthly Film Bulletin*, and make *Sight and Sound* a monthly, incorporating the *MFB*. The first issue of the new magazine came out in May 1991. At the same time BFI membership was being simplified. Henceforward there was to be only one basic membership category, with Library access and a discount subscription to *Sight and Sound* being available as add-ons rather than as integral to the notion of full membership of the Institute. Some of the core readership failed to renew their subscriptions, but more were attracted by the new-format magazine, which was widely available on news stands, and the decline in sales that had been taking place over the past decade was halted. Shortly afterwards, the task of compiling credits for new films, previously performed by staff on the *MFB*, was assigned to SIFT under the scholarly direction of Markku Salmi. This produced a small cost saving for *Sight and Sound*, as did the introduction of computerised in-house typesetting and page make-up, but the costs of the magazine remained unsustainably high throughout its first three years in the new format and were only gradually brought under control as budgetary stringencies began to bite.[20]

There were changes too at Education. During the 1960s and 1970s the BFI and SEFT had pioneered film studies as an academic discipline and optional school subject at CSE (later GCSE) and A level. But this was the work of a handful of enthusiasts, with little impact on the educational mainstream. During the 1980s, however, under Philip Simpson's leadership, the BFI Education Department had made great strides in putting forward film and media studies as possible mainstream school subjects. The announcement by the Conservative government in 1986 that it intended to introduce a national curriculum for use in all maintained schools seemed to the BFI to provide a golden opportunity to argue the case for media education. Early in 1987, Simpson and Anthony Smith had lunch with Kenneth Baker, Secretary of State for Education, and found him sympathetic. Then, in a paper presented to governors in January 1989,[21] Cary Bazalgette of BFI Education picked up on a new political buzzword and called for media education to be regarded as every child's 'entitlement' from primary school onwards. A working group was formed, funded by the Gulbenkian Foundation, to push the idea forward.

After nearly ten years at the helm, Simpson left the Education Department in 1989, to take up an academic post. To replace him, MacCabe pressed for, and got, Manuel Alvarado, a former Education Officer at SEFT. Encouraged by MacCabe,

Alvarado set out to redress the balance in the department's work, which he thought was overly focused on the school curriculum to the detriment of technical training on the one hand and high-level research on the other. It was clear however, that curriculum work was paying dividends. MacCabe decided in early 1993 that Alvarado was making insufficient headway against the media education tide. The department was downsized and Alvarado's contract was abruptly terminated. At the same time Jim Cook, one of the last survivors of the glory days of the 1970s, was made redundant, as were two other members of staff. Bazalgette was left to preside over the rump of the department.

There were then delays. A BFI-sponsored Commission of Inquiry into English as a subject, chaired by the philosopher Mary Warnock (by now Baroness Warnock), held a conference at the NFT in March 1993 and published its final report a couple of months later.[22] The report claimed, among other things, that the idea of media education as an entitlement was now 'widely' accepted. Unfortunately this came out when Kenneth Clarke, who had succeeded Baker as Secretary of State for Education, had just been replaced by John Patton, an arch-traditionalist who, unlike his predecessors, was vehemently opposed to novelties such as media education. To bypass Patton, a direct approach was made by Stevenson and Bazalgette to Sir Ron Dearing of the School Curriculum and Assessment Authority, who had been charged with bringing clarity to the confused maze of conflicting demands made on the curriculum since the 1988 Education Reform Act. Sir Ron was noncommittal. Media education was left with what Bazalgette later described as a 'foothold' in the curriculum.[23] Thereafter media education gradually established itself across the school system, but the heady vocabulary of entitlement faded away.

Then in 1995, in one of the many restructurings to which the BFI was prone in the 1990s, the Research and Education Division regained the Library but was almost immediately split in two. One half, headed by Richard Paterson, consisted of Education, book publishing, *Sight and Sound*, online development and a reintegrated Library and took the name Information and Education. MacCabe retained control of the other half, called Research, which contained the MA and the London Consortium research programme, together with BFI TV, a unit created in 1990 to make TV programmes about cinema independently of the Production Board. BFI TV's first production was *Black and White in Colour*, screened on BBC2 in June 1992. Thereafter it expanded fast, notably with a series of films commissioned for the centenary of cinema in 1995/56, taking up an increasing amount of MacCabe's energy and time.

Distribution

Distribution in the early 1990s escaped some of the rigours imposed on the BFI in response to increasing financial stringency. It was not a massive spender like the Archive, nor did it have to struggle with ambitious revenue targets like the South Bank. Instead it enjoyed a certain budgetary flexibility with the ability to

reinvest money if it was ever in surplus. Although Prescott was occasionally exasperated with the way Ian Christie managed the division's activities, it was able to continue with the policy established in the 1980s of putting films into distribution whenever opportunity arose. It also set up a regional exhibition consortium and tried to establish the RFT network as the basis for a kind of third circuit in film exhibition, negotiating first-run rights for films such as Quentin Tarantino's cult *Reservoir Dogs* (1992). Its main achievement in the period, however, was not in the area of cinema exhibition at all, but lay in its management of the transition between two technologies. Having rescued 16mm distribution in the late 1980 through the setting up of a subsidiary, Glenbuck Films, which it later absorbed in-house, it put much of its energies in the 1990s into sell-through video. The original Connoisseur Video label, launched in September 1989 with a selection of art-cinema classics including Max Ophuls's *La Ronde* (1950), Jacques Tati's *Jour de fête* (1949), Pier Paolo Pasolini's *Medea* (1969) and Wim Wenders's *Wings of Desire* (1987), was followed by a second, more specialised label, Academy Video, in 1994.[24] In 1997 these became BFI Video under the aegis of Heather Stewart. The venture was never really profitable, but the films were well chosen and the videos produced to a high technical standard, and the basis was laid for the highly successful move into DVD in 2000.

In 1993, MacCabe was put in charge of coming up with ideas for how the BFI should celebrate the forthcoming Centenary of Cinema, scheduled for 1995 or 1996. Christie was also involved and one result was that MacCabe and BFI TV got to produce a series of films to be screened on Channel 4, while Christie arranged to take a year away from his normal duties devising and writing a five-part film on the beginnings of cinema for BBC2, entitled *The Last Machine*. While he was thus engaged, a new restructure led to the division being amalgamated with the former Planning Unit with the title Cinema Services Division and under the command of Irene Whitehead, previously Head of Planning. Thus redundant, Christie was given a part-time role as consultant and worked for a while on other Centenary projects, before accepting an invitation from Anthony Smith to come to Magdalen with a brief to introduce film studies into that bastion of traditional learning, the University of Oxford.[25]

Planning Unit

When Irene Whitehead took over the Planning Unit in 1989, she inherited a large number of client organisations doing all sorts of different things for all sorts of clienteles and with varying levels of professionalism and for which the BFI was responsible in varying degrees. A lot of funding was still distributed by the Regional Arts Associations, for which the BFI provided the film component. A report on government funding of the arts by the former OAL permanent secretary, Sir Richard Wilding, published in 1989, had recommended consolidating these RAAs into a smaller number of Regional Arts Boards (RABs) with more execu-

tive authority and either devolving to the regions the Arts Council's responsibility for films about the arts and films by visual artists or transferring them to the BFI. Although often imperialistic in its pretensions, the BFI on this occasion was not and supported the status quo.[26] The RABs were another matter. Unlike the loosely structured RAAs, which let the BFI and the local film officers get on with their own thing, the RABs were more vigorously proactive and very firmly focused on 'the arts' – of which cinema was never quite one and television and video not at all. Meanwhile the reshaping of the former Arts Council of Great Britain as Arts Council England was to lead to radical new initiatives in Wales and Northern Ireland, including the setting up of film councils. In 1995, Whitehead brought to governors a proposal already adumbrated in the corporate plan for the period that the BFI should wherever possible get out from under the inappropriate tutelage of the RABs and work with organisations more specifically devoted to film and other modern media.[27] This would mean the film councils in Wales and Northern Ireland and 'media development agencies' in the English regions, of which the London Film and Video Development Agency, set up by the BFI to cope when the Residuary Body handling former GLC arts funding, was itself wound up, provided a prototype. Like many put forward by the BFI at the time, this plan was to be overtaken by events.

On the whole the regions did well in the early and mid 1990s. The government generally indicated that regional development, like the nitrate programme, was an area where the BFI should avoid making cuts. Stevenson, too, was very committed to the regions and passed on some of his enthusiasm to the new chairman, Jeremy Thomas, who joined Whitehead and Stevenson at a number of meetings outside London. Later Thomas was to claim he knew more about the BFI's regional activities than about some of those taking place in Stephen St.[28] It was only in 1996 that, very reluctantly, the BFI began to cut back on regional funding, also closing down the Afro-Caribbean Unit which was the spearhead of BFI activity in the ethnic field.

Meanwhile the work of Planning (and that of its successor, Cinema Services) was made more onerous – but in the long run more efficient – by the new demands placed by government on the public sector to be more accountable in the deployment of funds. This meant more rigorous assessment of client organisations – a process which could be painful for the client in the short term but in the long run proved beneficial more often than not.

A new chairman

In December 1992, Attenborough resigned as chairman after eleven years in the top seat. He had been a good chairman and, although a known Labour supporter (except for a brief period in the SDP), had got on well with a series of Conservative ministers since 1981. He had also, during his periods of absence while making films, been ably served by his deputies, notably Denys Hodson and John Donachy.

He firmly believed that the chairman of the BFI should be a film-maker (producer or director) and persuaded the OAL to appoint as his successor Jeremy Thomas, producer of Bernardo Bertolucci's *The Last Emperor* (1987) as well as of films by directors such as Nagisa Oshima, Nicolas Roeg and David Cronenberg. On his arrival in January 1993, Thomas freely confessed to his inexperience in chairing meetings of a body such as the BFI board of governors, with all the interests on it that had to be reconciled. On budgetary and organisational matters, however, he was more confident: *The Last Emperor*, he remarked later, had a budget far greater than that of the BFI, and a much higher level of financial risk.[29]

Thomas proved to be a supportive chairman, very committed to what he thought the BFI ought to be about, which was raising the profile of cinema as an art. But he did not find it easy to get to grips with what was going on inside the organisation, which was going through uncomfortable times, particularly as far as staff morale was concerned. In November 1992, Stevenson had warned staff that retrenchment was in the offing, with a strong likelihood of redundancies. The Cabinet Office Staffing Review, initiated in 1991, had come up with a 'Management Overview Report' highly critical of management/staff relations and an excessively top-down management style. One of its recommendations was for the staff newsletter, *BFI News*, to contain more feedback from staff. Whether by coincidence or design, the first issue to contain such feedback was that for December 1992, immediately following the announcement of likely redundancies. Feedback, needless to say, was overwhelmingly negative. In one respect, however, the management had learnt its lesson. Corporate plans from 1992 onwards were put in the hands of Michael Prescott, who adopted a low-key approach based on consultation with heads of division as to what their objectives were, how they could be achieved most economically and what priority areas they had for additional funding, should any become available. Once the difficulties of 1992/93 were weathered, the BFI managed on the whole to live within its means for the next two or three years.

If Thomas failed to impose himself on the board in his first couple of years in the job, this was at least partly due to the antics of Alexander Walker, a BFI member governor since 1988, who monopolised board meetings with endless speeches denouncing this, that or the other aspect of BFI policies and management. Walker, the influential film critic of the London *Evening Standard*, was frequently justified in his criticisms but the manner of his interventions was counterproductive and mainly had the effect that throughout Thomas's first year in the chair little substantive discussion took place at board meetings and if governors had useful contributions to make they often preferred to make them outside the meeting.

Thomas and Walker were to clash again a year or two later. In May 1992 the government had announced that the National Audit Office was to undertake a review of the BFI. A draft of the review was sent for comment to the BFI and the review itself was published in January 1994. On the whole the BFI got off quite lightly. The review focused on four areas: general financial management and accountability; the losses on the South Bank; the Archive; and regional funding.

Modestly, the review made no attempt to assess the BFI's cultural impact, which it felt it was not equipped to measure with the tools at its disposal. In general terms it expressed itself satisfied with the BFI management's assurances that steps were in hand to tighten up controls, though it called for better alignment of activities with 'core objectives' in future business plans. As for the South Bank, which had had a disastrous year in 1992/93, it again expressed guarded optimism (only partially justified) that the worst was over and that better leadership and more realistic budgeting would lead to improvements across the board. For the Archive, it declined to comment on the main area of concern, which was the slow progress in getting the Berkhamsted Conservation Centre to run smoothly and effectively, on the grounds that this was currently the subject of a review led by consultants Stoy Hayward whose results it did not wish to pre-empt; it did however consider that the Archive needed more of a business strategy. On the regional front, finally, it called for relations with clients to be further formalised with the establishment (in the new jargon) of 'service-level agreements' to ensure value for money.

But if the BFI could heave a sigh of relief that it had not been hauled over the coals more painfully by the review team, it was in for a shock when the House of Commons National Heritage Select Committee considered the state of the British film industry later in the year. Invited to give evidence, Alexander Walker launched into a tirade against the BFI, denouncing a Production Board overspend (not in reality all that serious) on a film called *Don't Get Me Started*, the plans for the IMAX cinema, and 'media studies'. In the course of it Walker uttered the memorable phrase that 'the BFI's largesse that it obtains is never big enough for its ambition but is always too big for its achievements'. Walker pressed home his attack in an *Evening Standard* article on 8 December 1994, prompting a measured reply from Thomas on the 15th which disposed of some of Walker's more extreme claims but did little to assuage the critics of the BFI, and particularly of the IMAX, who were growing in number and vehemence.[30]

The IMAX and the Lottery

The 'grand project' for the 1990s was to be the IMAX cinema for which a site had been earmarked in the middle of a traffic roundabout at the south end of Waterloo Bridge, near to MOMI and the NFT. When the idea was first floated there seemed to be no likely source of funding for such a project but one soon emerged in the form of the National Lottery. The idea of a National Lottery, some of whose proceeds would be channelled towards 'good causes', cultural as well as charitable, was put forward by the Conservative government in 1991, with legislation following under the National Lottery Etc Act in 1993. Applications for funding were to be admissible from 1994. Various funds were established for distributing the money raised. In principle the Lottery would fund capital projects only, not revenue, and in theory it would be governed by a principle of 'additionality'. That is to say, Lottery money would be additional to, and not a replacement for, existing public funds for

15.3 The BFI London IMAX, with Waterloo Station in the background

the arts. But exactly what projects would be admissible and how the money would be distributed remained to be clarified. When the project was first announced, the BFI was optimistic that the RFTs could be major beneficiaries and possibly film production too – provided the government was prepared to agree that films should be classified for accounting purposes as capital assets. But even if film production were to benefit (which eventually proved to be the case), the money for that purpose was to be channelled through the Arts Council, with the BFI playing only an advisory role in its deployment. The IMAX, however, looked from the outset a prime target for a Lottery bid and considerable resources (including some 'Getty' money) were put into feasibility studies for the project.

The IMAX had the enthusiastic backing of the chairman, Jeremy Thomas, of Stevenson and Prescott and, when Prescott left in 1995, his successor Jane Clarke. It encountered less enthusiasm lower down the line or among traditional supporters of the BFI. Thomas liked the idea because it would offer facilities for enhanced projection of spectacular films; he was also optimistic about its commercial prospects – an important consideration now that it was clear that MOMI was unlikely to achieve regular break-even. The fact that much of the programming of an IMAX venue would consist of travelogues and the like, which had little in common with regular narrative cinema, did not seem to act as a deterrent to the project's supporters, but it weighed heavily with cinephiles. Alexander Walker was not the only national film critic to deplore it as a distraction, with David Robinson dismissing it as a 'spectacular gimmick'.[31] The bid was finally approved in 1996 with a Lottery grant from the Arts Council of £5 million (later increased to £15 millon, thanks to vigorous lobbying by Clarke), and attention turned to finding matching funds.

The turning point

In 1995 the BFI was in a precarious position about which it was nevertheless possible to be optimistic. A mixture of retirements, resignations (some forced) and redundancies had removed from the scene all the senior management left over from previous regimes and Stevenson had a new management team entirely of his own choosing. Lottery bids had been put in or were being prepared for a number of new and exciting projects. On the South Bank there was the IMAX, which was to be cross-promoted with MOMI and physically linked to MOMI and the NFT by an 'electric avenue' creating a unitary attraction. There was a redevelopment plan for MOMI aimed at bringing in new audiences and restoring it to profitability. It is true that the NFT itself might be irreparably damaged by the construction of the massive 'Crystal Wave' proposed by the Richard Rogers Partnership for the South Bank arts complex as a whole, but the BFI would have to be compensated and in any case there was the possibility of funding being found to replace the existing NFT with a National Cinema Centre closer to the entertainment (rather than 'arts') venues of the West End. Also on the South Bank, though at some distance from the NFT/MOMI/IMAX complex, there was another exciting project mooted, going under the title 'The Imagination'. Notionally modelled on IRCAM in Paris and the Media Lab at the Massachusetts Institute of Technology, this was to be a state-of-the-art facility showcasing the latest developments in multimedia technology, and doubling as new offices for the BFI.

If everything had panned out right and all or even most of the plans had been realised, the BFI would have been in a very strong position. It would have had three interlinked attractions on the South Bank site: the NFT, the IMAX and a revitalised MOMI capable of achieving the attendance level needed for break-even or even profitability. Even if the 'Crystal Wave' had made it necessary to give up all or part of the NFT operation on the old site, other and possibly better sites might have been available to take its place. And if the 'Imagination' had been built, the Institute would have been able to sell its old offices in Stephen St, for which, thanks to a further gift from Sir John Paul Getty, it now owned the freehold

In the event, very few of these schemes came to any sort of fruition, at least not immediately. An application to the Millennium Commission in partnership with British Telecom and IBM for a UK network of videotheques which would make digitised material from the Archive available over the telecommunications infrastructure with the BFI at the hub (the 'Imagination Network') was turned down as 'insufficiently distinctive'; the plans, however, were not abandoned but put into a development phase to re-emerge after the Millennium in the form of Screenonline in 2003. The proposed National Cinema Centre, for which several sites were investigated, also failed to attract funding. Large-scale South Bank plans were put into abeyance and the BFI continued with the NFT and MOMI as before, both of them continuing to require a high level of subsidy. On the Lottery front the best news was from the Archive. In June 1996 an ambitious plan, co-ordinated

by Richard Paterson on behalf of the BFI, was submitted to the Heritage Lottery Fund under the title 'An Archive for the twenty-first century'. The plan aimed not only at overcoming the legacy of what many considered to be a historic underfunding of that major national institution whose needs were consistently ignored in regular BFI grant settlements but also at putting the Archive and the BFI in general at the forefront of new technology. As well as film and television archiving as such, the plan envisaged putting resources into the conservation and digitisation of stills, posters and designs and of library holdings, and prospected integration of the archive holdings catalogue with the SIFT database. The Commission baulked at the enormous cost (estimated at £74 million) and at some of the new technology aspects, but it was impressed by the arguments relating to heritage and awarded a grant of £15 million for the film and television archiving part of the proposal. This part of the plan had been mainly prepared by Anne Fleming, then deputy curator of the NFTVA. In 1997, Fleming succeeded Jeavons as curator and, together with her new deputy Henning Schou, she took over the task of revising and preparing to implement the project.

Meanwhile a new corporate plan, devised by Stevenson, had been working its way through the planning process. First presented in outline to governors in November 1995, but already the subject of extensive consultation inside the BFI, the new plan, entitled 'BFI 2000', set out to maximise the effectiveness of the way the BFI's considerable resources were deployed while at the same time addressing changes in the funding situation. Stevenson was determined that the BFI should be in a position to take advantage of all the funding possibilities available from the various sectoral funders and at the same time prepare itself for a possible change of government at the next election. Internally, too, the organisation needed to be more flexible, more geared to responding to consumer demand and more in tune with the digital revolution then gathering pace. To this end the plan proposed the setting up of seven 'Groups' which would commission initiatives in various fields with the existing Divisions performing a servicing role for these Group-led initiatives. It was an imaginative scheme which, in more favourable circumstances, could have revitalised the BFI and its relations with the public it set out to serve. Unfortunately, it cost money to get going – £1.25 million in additional costs, according to some estimates – and money was what the BFI at that moment simply didn't have. In 1996, as attempts were made to get the scheme off the ground, the Institute braced itself for disruption and the imminent possibility of a new wave of redundancies.

Getty

The biggest setback to the BFI's plans, however, lay in the fact, known only to a very few people, that John Paul Getty Jr had ceased to be a regular funder of BFI projects. By the mid-1990s he was no longer the semi-reclusive invalid whom Smith used to visit in the Harley St clinic. His health was restored, he was recently

Towards the millennium 293

married, and was now living in a mansion in the Chilterns equipped with a cricket ground. Although he happily invited his friends from the NFTVA to come and watch matches on the ground, his relations with the BFI as an institution were no longer as cordial as they had been in the early days. Since the late 1980s he had been making regular quarterly payments to the BFI which were not necessarily tied to any particular project but which could be spent on capital projects that came up as and when and meanwhile could be allowed to accumulate in an interest-bearing account or as stocks and shares to form an 'endowment' which to be called upon when the time was ripe. Throughout the early 1990s these payments were running at £600,000 per quarter or £2,400,000 per year and the balance held in the fund in 1995 was a nominal £5.5 million, though actually rather more as the sum reported in the accounts did not allow for the increase in value of stocks and shares since their purchase date.

This, however, was a high point. In November 1994, Getty wrote to Stevenson announcing that he no longer wished to keep up his regular payments at the same high level and would be reducing them to £300,000 per quarter for the year 1995/96 while keeping the situation under review for future years.[32] He remained, however, open to specific proposals to support major BFI projects, particularly for the Archive.

There seem to have been two reasons behind Getty's decision to withdraw regular support for the BFI. The first had more to do with the government than with the BFI itself. Already in 1992 Getty had expressed annoyance at the fact that his generosity to the BFI seemed to be being used as an excuse for the government's failure to support the BFI fully out of grant in aid or to match his generosity with matching funds for capital projects. When David Mellor was secretary of state at the DNH, a scheme was therefore devised, brokered by Stevenson, to create an Archive and Recorded Materials Fund, jointly supported by Getty and the department, to support capital projects for the 'acquisition, conservation and preservation of historically important film, tape and paper materials'.[33] Supposed to come into effect in 1993, this scheme was kyboshed by the DNH shortly after Mellor left in September 1992. Although the BFI repeatedly tried to bring together Getty and successive secretaries of state to revive the idea, the philanthropist became increasingly disillusioned by the obduracy of the DNH in failing to support the sort of initiatives he had in mind, including, notably, further capital spending on the conservation centre at Berkhamsted, which the DNH considered could be supported, if at all, only through a successful Lottery bid.

The second reason was the IMAX. This too dates back to 1992, when Stevenson sounded out Getty's personal financial adviser as to whether it would be worth approaching Getty for funds to match the hoped-for Lottery grant. But Getty did not bite.[34] In fact, he considered the idea antithetical to what he thought the BFI should be about. In correspondence he maintained a diplomatic silence on the subject, but he made no secret when talking to his friends how much he disliked the idea. Although in 1998 some of the monies from the endowment were to be

diverted to provide some of the matching funds needed to supplement the Lottery grant for the IMAX, this was not with his approval. In 1995 he announced he was reducing his quarterly payments to zero and thereafter his only support for the BFI was to be matching funds for the 'Archive for the twenty-first century' project in 1998.[35]

Enormous changes at the last moment

By 1996 there was widespread disquiet throughout the BFI about the way things were going – and not only among people threatened with redundancy. There was concern at governor level too, but it was muted, and little of it surfaced at board meetings, and still less in the minutes. Early in 1997, however, the chairman began to take discreet soundings among senior members of the board and a consensus emerged that it was time for a change. At the board meeting on 25 June 1997 the deputy chair, Matthew Evans (Thomas himself was away filming), announced that Stevenson had decided to leave the BFI in September and that severance terms were being negotiated which would need Treasury agreement. Jane Clarke would serve as Acting Director until a successor was found.

What followed over the next few months was, frankly, a shambles. High hopes had been placed by the BFI, not least by Stevenson himself, in the incoming Labour government, elected by a landslide on 1 May 1997. In November 1996 Stevenson had drafted a proposal for a 'British Film Agency', partly modelled on the French Centre National de la Cinématographie but also harking back to the British Film Authority plans from the 1970s, which would rationalise a whole lot of functions relating to the cinema. In particular the BFI had hoped that the new government would act promptly to institute the sort of reforms in the way film production and film culture were to be supported that Stevenson and the BFI had been calling for for some time. Reforms were indeed instituted, but it soon became clear that the BFI was not to be part of the new dispensation.

The new Culture Secretary was Chris Smith, who had briefly in the mid-1990s been the Labour shadow for the DNH where he had become aware of the intense lobbying on the part of David Puttnam and others in favour of promoting what were coming to be known as the creative industries. Now in office, he made it his business, assisted by his personal adviser John Newbigin, to put the new ideas into practice. Within weeks of taking up his post, he flew to Cannes to deliver a speech at the Film Festival on what the new Labour government would do for the British cinema, followed by a similar speech in Los Angeles in October.[36] Back in London a Film Policy Review Group was set up, which reported in March 1998. This report barely mentions the BFI except to observe that it would in future 'focus its strategy to give greater emphasis to access and understanding of the moving image'.[37]

Before the Group reported, however, the BFI had already had wind of the new government's general intentions. In June 1997, Matthew Evans summarised to the DNH (as it still was: it changed its name to DCMS, or Department for Culture,

Towards the millennium

Media and Sport, in July) the BFI's ideas on restructuring film finance, but no reply seems to have been forthcoming. To add insult to injury, the DCMS curtly informed the chairman of the BFI, Jeremy Thomas, who was due to retire in December, that his successor was to be Alan Parker. This created outrage among the governors, who had expected to be consulted on the matter of the chairmanship, as they had been under previous governments.[38] Not only that, but Parker was a decidedly unpopular figure in BFI circles, ever since the insulting remarks about the BFI he had made in his contribution to British Film Year, the Thames Television production *A Turniphead's Guide to British Cinema*, in 1986.

While waiting for Parker to arrive, the governors initiated the process of finding a successor for Stevenson. Adrian Wootton was in the frame, as was John Willis, Director of Programmes at Channel 4. Invited to join the selection panel, Parker refused to approve any of the candidates and insisted on the appointment of John Woodward, then chief executive of the Producers' Alliance for Cinema and Television (PACT). Woodward could not join the BFI until the beginning of February 1998. Jane Clarke was asked to remain as acting director until then, but she herself resigned at the end of 1997, leaving the BFI officially in the hands of a troika consisting of Richard Paterson, Ian Nelson and Anne Fleming.

In the event Parker did not turn out to be the bogeyman that everyone in the BFI had feared. His first act, together with Woodward, was to attempt to stop the IMAX before building started, only to be told that it was too late and 'the train has already left the station'.[39] He and Woodward also patched up relations with Getty, who assured them that he would look favourably on any new projects they proposed to him. Meanwhile, as one of her last acts before leaving, Clarke reached an agreement with Getty for him to provide the matching funds for the 'Archive for the twenty-first century' project. This turned out to be Getty's last act of munificence towards the BFI. The Major Projects Fund to which he had contributed so generously was wound up.[40] Parker and Woodward never did find a new project for him to support.

Endgame

Woodward's main task on arriving at the BFI on 2 February 1998 was to stabilise things and to make sure that the BFI could deliver its brief as recently redefined by the DCMS within the means available. It was clear that the BFI was dangerously over-extended and there would have to be retrenchment in certain areas. But which? Woodward was reluctant to give up hopes for the NCC, plans for which were pushed forward by Wootton, with a special sub-committee of governors dealing with the property side. Film and television production was vulnerable, but Woodward stayed his hand and initially proposed expanding the scope of BFI TV while putting new feature film production on hold until the government's plans became clearer.[41] MOMI was a huge problem, since it could not survive without renovation – which would be possible only with additional funding and with space

being freed up by moving the NFT. Consultants KPMG were recalled to make sense of what was actually happening inside the organisation since the meltdown in late 1996 and early 1997 and to advise on the viability of future projects.

KPMG delivered the first part of their report, a 'SWOT' (strengths, weaknesses, opportunities, threats) analysis of the BFI as they saw it, in May 1998.[42] It found an Institute divided and in chaos, with the only redeeming features its material and human assets – precious collections and dedicated staff. Radical reform aimed at reducing the chaos and valorising those assets was given as the only way forward. Meanwhile the DCMS had published its Film Policy Review which declared that the BFI should henceforth concentrate on educational activities. Woodward reduced the organisation of the Institute to four divisions. Production remained, even though it was fairly clear it would soon have to be given up. The NFT and MOMI were separated, with Adrian Wootton becoming Head of Exhibition, responsible not only for the NFT but for regional ('UK-wide') film exhibition. A new division called BFI Collections was created, headed by Caroline Ellis, rolling together MOMI, the NFTVA and the BFI's film and video distribution activity. The Research and Education divisions were re-amalgamated under the Education banner. Richard Collins, an academic and former SEFT activist, was appointed to head it.

The new structure was very much based on functions, rather than sites of activity. Putting the NFT and regional exhibition together had been proposed before in the 1980s, but rejected on the grounds that the NFT was not a function but a place where things happened. The combination made slightly better sense in 1998 because Adrian Wootton, as overall head, was a dedicated regionalist, unlike Leslie Hardcastle before him. Meanwhile management of the NFT was put in the hands of Jim Hamilton, formerly of Edinburgh Filmhouse, while responsibility for programming was given to Geoff Andrew who, in his other role as film critic of *Time Out*, had been a fierce critic of previous NFT programming (and much else in the BFI besides).

As for the division known as BFI Collections, it made a sort of sense if the idea behind it was that the Archive could be imagined as a museum which curated artefacts in the dual sense of conserving them and presenting them to the public. Such an idea seems to underlie a paper presented by Ellis to governors early in 2000, which was highly critical of previous Archive policy on access to the collections.[43] The problem was that the Archive, given the massive scope of its responsibilities, could not easily be reconceptualised in this way and all that happened was that its identity was obscured at a time when it needed to have as high a public profile as possible if it was to attract public and private funding.

Another problem facing the new administration was that the BFI in 1998 was not only financially insecure and organisationally in chaos, it was also intellectually debilitated. Ever since Forman's choice of Gavin Lambert as editor of *Sight and Sound* and Karel Reisz as programmer at the NFT, the BFI had made a habit seeking out bright young intellectuals to run its vanguard activities. Paddy

Towards the millennium

Whannel's appointment of V. F. Perkins and Peter Wollen to posts in the Education Department in the 1960s was only the most conspicuous example of a fairly widespread practice. Many senior Institute positions were held by people who had written books or contributed to *Sight and Sound*, *Screen* or other journals. There was also a very high level of accumulated knowledge and expertise, in the Archive, in Information and throughout the BFI. A working knowledge of foreign languages, if not widespread, was at least reasonably well represented in most parts of the organisation.[44]

In the 1990s this 'intellectual capital' began to be dissipated. There was a steady haemorrhage of qualified staff who were not replaced by people with equivalent qualifications or gifts. A number of departing staff on the education side found jobs in higher education, taking advantage of the expansion of film and media studies which the BFI itself had done so much to promote. There were a few imaginative appointments, such as that of Rob White as books editor in 1995, replacing Paul Willemen; and Woodward also partially reversed the outward flow of intellectuals

15.4 Poster for John Maybury's film about the artist Francis Bacon, *Love Is the Devil*, one of the last BFI productions to be released before the incorporation of the department into the UK Film Council in 1999

to academia in choosing Richard Collins as head of the recreated Education Division. But it was the slow loss of hidden expertise rather than the departure of high-profile intellectuals that on the whole did the most harm to the organisation.

One high-profile loss, however, did cause a stir. In the middle of 1998, Parker and Woodward decided that Colin MacCabe was, on balance, more a liability than an asset to the organisation. BFI TV was closed down, as was the MA programme, and MacCabe's contract was terminated without notice. At the same time there were other retrenchment measures. The search for premises for a National Cinema Centre was called off and a period of closure was announced for MOMI, pending rebuilding. The idea was for MOMI exhibits to go on tour while rebuilding took place, but the rebuilding never happened and MOMI closed for good, not with a bang but a whimper.

With two new BFI features, *Under the Skin* (Carine Adler, 1997) and *Love Is the Devil* (John Maybury, 1998), gathering favourable publicity, there was still some hope for BFI Production, and Parker and Woodward argued strongly that the £3 million so-called Alpha Fund to support film production should be taken away from the Arts Council and devolved to the BFI. This initiative, however, came too late. Step by step the DCMS was edging towards a plan which would not only remove production from the BFI's brief but lead to the subordination of the BFI to a new organisation of a totally different type. The intention was summarised in the Film Policy Review Body's report, 'A Bigger Picture', published in March 1998, which said, among other things:

> We shall also establish a single unitary body which will work with Government to deliver a coherent strategy for the development of film culture and the film industry. The body, which we intend to call British Film, will have full responsibility for drawing up the strategy, and all DCMS funding for film, both grant-in-aid (excluding the NFTS [National Film and Television School]) and Lottery, will flow through it. It will come into being by 1 April 2000 at the latest, and earlier if the necessary preparations can be made in time.

Such a body was indeed established, in shadow form in 1999 and then more formally in April 2000, with the name Film Council (later UK Film Council). By the middle of 1998 it was becoming increasingly likely that BFI production would come under the aegis of the Council, along with Arts Council-administered Lottery funding for film and the government-supported British Screen. What was not yet quite clear, and became the subject of anguished negotiations and lobbying throughout the latter part of the year, was what the status of the BFI itself would be.

What was negotiated was a semi-independence, in which the BFI would retain its chartered status and its own board but would receive its government funding via the Council, with whom it would have to agree its spending plans for the year. On the BFI board of governors, only the two member governors, Alan Howden and Ray Deahl, opposed the new dispensation and argued that the BFI should retain complete independence.[45] The rest of the board acquiesced, no doubt thinking that resistance was futile, but governors did make a last-ditch attempt to put the BFI

Towards the millennium

back at the centre of plans by proposing that the BFI board should be the ultimate authority, to which the chief executive of the Film Council would be responsible. Needless to say, the DCMS rejected this, though the secretary of state did pay heed to the board's concern that the BFI should not be allowed to degenerate into a mere delivery mechanism for strategies determined by the Council.[46]

In August 1999 the DCMS announced the appointment of the first chairman of the new Council. It was to be Alan Parker, chairman of the BFI Governors since 1997. Two months later it was announced that the chief executive of the Council was to be none other than John Woodward, Parker's choice as director of the BFI from the beginning of 1998. There were widespread rumours of a stitch-up, with the same team moving so swiftly from one organisation to another. In fact there was no stitch-up. No Machiavellian genius had planned this from the outset, and the new roles for Parker and Woodward emerged only after a slow process in which the roles had first to be defined and then people found to fill them.

In their new roles Parker and Woodward acted briskly. BFI Production was taken under the wing of the embryonic Film Council in late 1999 and fully absorbed in April 2000, at which point it effectively lost its identity. The DCMS and Film Council set up working parties on film education and on a national strategy for film exhibition. The education working party, chaired by the BFI governor Alan Howden but reporting to the DCMS rather than the BFI as such, came up with interesting recommendations, particularly relating to the promotion of 'cine-literacy', and the BFI agreed to implement these – while pointing out that its brief was the moving image in general, not just film.[47] The exhibition report, again reporting to the DCMS, also provided a valuable blueprint around which the BFI and Film Council could work together.

The blow fell in the autumn of 2000. The constitutional arrangements had been sorted out, with amendments to the BFI's Charter to recognise its status as dependent on the DCMS and Film Council, rather than on the Privy Council as had been the case since 1933. Relations between the two bodies were on the whole amicable. But then the Council unveiled its new plans for film activity across the country in a document entitled 'Film in England'.[48] The plans were on the whole positive, offering a substantial tranche of money for regional activities, with the BFI contributing useful expertise to their formulation. But the manner in which the plans were presented was unfortunate. The active role of the BFI was relegated to providing programme support for the RFT circuit and co-ordinating the activities of the regional film archives. Everything else became the sole responsibility of the Council. In terms of executive responsibility, this all made sense, But when John Woodward came to the September 2000 meeting of the BFI board of governors to present a draft of the document, the governors were appalled to find that Appendix H to the document, entitled 'The Role of the BFI', contained no indication that the Institute should even be consulted or in any way involved in the formulation of cultural strategy; this was seen as the sole prerogative of the Council, with the BFI relegated to the implementation of policies the Council had decided.

Joan Bakewell, the new chair of BFI Governors, was therefore mandated to go to the October meeting of the Film Council's Board of Directors, on which she was BFI representative, to protest at the way the document violated the BFI's understanding of the constitutional agreement between the two bodies.[49] Parker offered a half-hearted apology for the confusion, but other statements such as one he had made in May to the effect that he was confident 'that the Institute [was] on course to meet the educational objectives of the Film Council'[50] – as if the BFI was not expected to have objectives of its own – made it all too clear where the power would continue to lie.

How was all this allowed to happen? How did it come about that the once proud BFI, founded in 1933, incorporated by Royal Charter since 1982, and which in 1996 had visualised itself at the heart of a new strategy for British film and the cinema in Britain, had been turned into little more than a delivery mechanism for a strategy laid down by an upstart body conjured up as part of New Labour's plans for the 'creative industries'?

For a start it needs to be understood that government strategy (basically, Chris Smith's) really was about the creative industries – a term preferred by Smith and his team to 'cultural industries'.[51] Given that focus, it was never likely that the BFI, whose interests were, in the eyes of the modernisers, positively antiquarian, could be put at the centre of a strategy whose main aim was the development of a sustainable domestic film industry with that of film culture firmly in second place. There were also many other interests to be taken into account, such as that of the Arts Council which preferred a status quo in which it and the BFI were both non-industrial arts bodies. That the BFI at least retained some semblance of independence was partly due to the good offices of Richard (by now Lord) Attenborough who acted as an informal but trusted adviser to Smith and the DCMS during the setting up of the new arrangements.

Inside the BFI itself Woodward was replaced as director by his former deputy, Jon Teckman. Richard Collins became deputy; then, when he left, the role was devolved to Adrian Wootton, who had been twice passed over for the top job. Woodward's reorganisation stayed intact for a couple of years, although with the closure of MOMI at the end of 1999 it had lost some its raison d'être. Teckman himself left in 2002. Bloodied and mutilated, but with most of its vital organs still intact, the BFI limped on into the twenty-first century.

Notes

1 BFI Governors Minutes, 23 July 1988.
2 Reported to Governors, 19 April 1989. Prescott had previously applied for the original Deputy post, but no appointment was made at the time.
3 RP/CD/LB interview with Wilf Stevenson, 20 January 2006. The departmental reorganisation was widely anticipated in the civil service.
4 GNS interview with David Puttnam, 11 February 2010.
5 Shukri's departure was partly motivated by an unfavourable staffing review of the BFI

by the Cabinet Office, reporting at the end of 1992, which singled out the Finance Department as having particularly low morale. It is not clear that staff in Finance were particularly disaffected: they could just have been more outspoken.
6 GNS interview with Ian Nelson, 12 January 2007.
7 Curiously, but perhaps not surprisingly, the Library, Education and Stills never figured in the list of 'Key performance indicators' later drawn up by Prescott as possible sources of income.
8 According to Collard (GNS interview, 14 November 2006), Berger then tried to withdraw his resignation, but was not allowed to. In 1994 Caroline Ellis was appointed Curator at the South Bank in an attempt to help revive MOMI and make it more of a professional museum.
9 LB interview with Deac Rossell, 12 March 2007.
10 GNS interview, 14 November 2006.
11 The likely need for cuts had been identified earlier, when Stevenson was still deputy director. See p. 194 above.
12 See note 22 to Chapter 2 above.
13 The relevant correspondence is to be found in BFI/D-1.
14 GNS interview with Rodney Stone (former assistant secretary at the OAL), 2 February 2006.
15 Colour fading was a well known problem, as anyone who watched prints of old colour films, particularly on 16mm, could attest. The problem with acetate stock was first identified at the National Film Archive in the 1980s, where the Chief Technical Officer, Harold Brown, gave it the name Vinegar Syndrome because of the vinegary smell given off when cans were opened for inspection.
16 GNS interview with Clyde Jeavons, 19 May 2006.
17 Part of the plan was that these interns would in due course rise to provide a new generation of leaders and experts at the BFI, which never in fact happened. For a critical view of the MA and its purposes see John Caughie and Simon Frith, 'The British Film Institute: Re-tooling the Culture Industry', *Screen* 31:2, 1990, pp. 214–22.
18 CD interview with Jill Pack, 14 March 2008.
19 See Gillian Hartnoll, *A Brief History of the BFI Library* (London: BFI, 1999), p. 42.
20 The idea was even floated of outsourcing the operation, along with other 'commercial' activities which weren't in fact performing commercially. A report in 1995 by the consultants KPMG on marketing opportunities for the BFI warned, however, that this could lead to a loss of 'intellectual capital': it would seem that someone at KPMG read the French sociologist Pierre Bourdieu, even if BFI management didn't.
21 Copy in BFI/D-58.
22 The other members were Anthony Smith, Alan Howarth, Robin Alexander, Marilyn Butler: see BFI Governors Papers, April 1994.
23 Cary Bazalgette, *Education at the BFI, 1950–2001* (unpublished document, 2001; copy in the BFI National Library), p. 5.
24 Connoisseur Video was the product of a joint venture with Anatole Dauman's Argos Films which gave access to Dauman's impressive catalogue of French cinema. The *faux*-French name Connoisseur was chosen (by Ian Christie) because at the same time William Pallanca of the art-house film distributor Connoisseur Films retired, offering the BFI rights to his collection.
25 The post was part-funded from Getty's BFI endowment, of which Stevenson was custodian. Stevenson agreed to the release of funds, but withdrew them suddenly three years later, when the fund was in difficulties.
26 See paper by Stevenson to Governors, 27 June 1990, and Governors Minutues, 29 September 1991.

27 Governors Minutes, 28 June 1995.
28 GNS interviews with Irene Whitehead, 14 January 2008, and with Jeremy Thomas, 4 December 2010.
29 GNS interview with Jeremy Thomas, 4 December 2010.
30 A copy of the transcript of Walker's evidence to the Committee, given on 26 January 1995, is appended to the papers for the Governors meeting on 22 February 1995.
31 Quoted by Lorraine Blakemore in her chapter on MOMI, p. 269.
32 BFI/D-9495/C/9.
33 BFI/D-9192/C/10.
34 BFI/D-9293/C/10.
35 BFI/D-9697/C/8. In answer to a question posed by Lorraine Blakemore in the interview referred to in note 3, Stevenson admitted that Getty's unwillingness to fund the IMAX was a severe blow, but did not elaborate on the wider breakdown in the relationship. In mitigation it could be argued that the withdrawal of the quarterly payments was not that serious a blow to the BFI. The Berkhamsted Conservation Centre ('the best thing I have done,' Getty told Stevenson) was up and running, the Stephen St freehold had been acquired and, with no suitable projects for him to fund immediately in the offing, the accumulation of funds in a capital account was a potential source of embarrassment to the BFI, since the government could use it as evidence that the Institute was better off than it actually was and an excuse to cut back on its grant.
36 Published in Chris Smith, *Creative Britain* (London: Faber and Faber, 1998), pp. 85–90.
37 *A Bigger Picture: The Report of the Film Policy Review Group* (London: DCMS, 1998). The co-author of the report was Jon Teckman, the BFI's assessor at the DCMS and later deputy director and then director of the BFI.
38 See Governors Minutes, 25 June 1997.
39 GNS interview with John Woodward, 27 February 2009.
40 Getty's agreement with Clarke, dated 3 December 1997, stated that he would donate £3.375 million to the project and guarantee a further £1.25 million if the BFI failed to find that sum from other sources. The BFI does not seem to have found that money but appears instead to have drawn on what was left in the Major Projects Fund. A brief note in the 1997/98 Accounts refers to the money left in the Fund as already committed 'to provide matching funding for the IMAX and other projects already approved'. *Sic transit gloria ...*
41 For more on the last years of the Production Board, see Christophe Dupin, Chapter 11, especially pp. 214–16.
42 Copy in BFI/153.
43 Governors Papers, 26 January 2000. As part of the reshaping of the Institute according to function, MOMI Education was transferred to the new Education Division.
44 See Geoffrey Nowell-Smith, 'Grandeur and Misery of Film Culture', *Vertigo* 6, Autumn 1996, pp. 5–7.
45 Governors Minutes, 30 September 1998.
46 Governors Minutes, 31 March 1999. See also letters from Chris Smith to Alan Parker of 24 May 1999 and 12 July 1999, quoted in a BFI memo to the Film Council of October 2000, on which more below on p. 300.
47 Richard Collins reporting to BFI Governors, 28 July 1999.
48 *Film in England: A Development Strategy for Film and the Moving Image in the English Regions* (London: Film Council, November 2000). Available at the time of writing on www.ukfilmcouncil.org.uk/media/pdf/7/r/england.pdf.
49 BFI/D00013/B/5.
50 Ibid.

51 The seminal text for new Labour was John Myerscough's *The Economic Importance of the Arts in Britain* (London: Policy Studies Institute, 1988), which introduced the term 'cultural industries' (modelled on the French 'industries culturelles') into the debate in Britain. The preference for creative over cultural seems to have had its main proponent in David Puttnam.

Epilogue 2011

Geoffrey Nowell-Smith

The BFI took some time to recover from the shocks administered to it as a result of the creation of the Film Council. The new constitutional arrangements meant that its grant was no longer awarded directly by the DCMS but via the Council, which then took on responsibility for overseeing its budget. This worked all right in the first few years when both the Council and the Department felt that a certain generosity was in order. The BFI was therefore able to hang on to some of the money it had originally been awarded for functions such as production and regional support which now became the province of the Council. But this honeymoon did not last long. When Chris Smith lost his post as secretary of state after the 2001 election, to be replaced by Tessa Jowell, the promotion of film culture rather disappeared from the Department's priorities, while the BFI's ability to intervene, if only marginally, in the debates surrounding national film and media policies disappeared entirely. Although the BFI still did what it could to 'encourage the art of film', it had less and less power to affect the context in which this encouragement took place. The now renamed UK Film Council (UKFC) also felt empowered to take its own initiatives in areas such as education and training which had hitherto been a BFI preserve. Meanwhile, the baby which the BFI had so tenderly nurtured in the 1970s and 1980s, academic film studies, was beginning to stand on its own feet and increasingly detached from its presumptive parent. Academics now looked to the BFI as an information resource or as an outlet for their publishing ambitions, rather than as a focal point for ideas.

From governor level downwards, the BFI had great difficulty in adapting to the changed – and constantly changing – circumstances. Jon Teckman, promoted from deputy director to director after Woodward left for the Film Council, struggled manfully to keep the ship afloat, if not necessarily on a clearly defined course. An ambitious scheme entitled 'Project Rosebud', started in 1998 and aimed at commercially exploiting the BFI's information resources with the aid of various private-sector partners, was allowed to drag on long after it had become clear it was going nowhere; by the time it was terminated in 2001 it had cost the BFI the best part of £1 million, to little tangible benefit. The crew was mutinous too and

in January 2002, when pay negotiations broke down, a strike was called, the second in the BFI's history, with the issue needing to be settled by the conciliation service ACAS. In October Teckman resigned as director, having decided not to seek an extension of his three-year contract. Adrian Wootton, who had replaced Richard Collins as deputy director, became acting director. At the end of the year Joan Bakewell also came to an end of her term as chair of governors. With the DCMS and the UK Film Council equally unhappy about the way things were turning out, a new start was clearly necessary.

The new start came in the form of the appointment of the film director Anthony Minghella as chair of governors, taking office in January 2003. Minghella led from the front, effectively acting as executive chairman for six months, while a search was conducted for a new director. The choice fell on Amanda Nevill, the director of the National Museum of Film, Photography and Television in Bradford, where she had overseen a spectacular revamp of its previously rather shabby premises. Passed over again for the top job, Wootton left the BFI to become chief executive of Film London, the metropolitan film agency set up by the UKFC. Urged on by the UKFC and DCMS, Minghella and Nevill set about a major review of the BFI's organisation and strategies.

The review produced little in the way of clearly articulated new strategy but it did lead to yet another internal reorganisation from which it was possible to deduce that the new team intended to give priority to the external face of the BFI and in particular to film and video exhibition. The Southbank (NFT and IMAX) and BFI Film Festivals became separate divisions, headed respectively by Eddie Berg and Sandra Hebron. The bulk of the BFI's other operations, including everything from the Archive to what was left of regional programme support, was put into a division called UK Wide, headed by Heather Stewart, with a smaller division called Trading created alongside it to manage potential money-makers such as *Sight and Sound* and book and DVD publishing. The rationale for this rather lop-sided structure lay in the 'big idea' the BFI had for the future, a prospective Film Centre on the South Bank where all the Institute's visible activities, from film exhibition to the library, could present themselves to the public together. Realisation of such a scheme would require a lot of money – £160 million at an early estimate, more than five times the organisation's annual turnover – but in the mean time it gave the BFI something tangible to fight for, and something with a fair chance of finding favour with a government not averse to spectacular public spending. The vacant MOMI space was to be used as a 'pilot' for the new Film Centre and £4.5 million was allocated to spruce up the NFT with a more audience-friendly entrance opposite the National Theatre and other enhancements.

While this ambitious scheme worked its way upwards through the echelons of government preparing the impending Comprehensive Spending Review, the BFI made progress on other fronts. A critical report from the National Audit Office had drawn attention to the lack of a strategy for managing and promoting the BFI's film and related collections. In response the BFI, supported by the regional film

archives, undertook a review of the sector leading to the formulation of a Screen Heritage strategy which bore fruit with the allocation of a £25 million capital grant from the government to help secure the nation's moving image collections. The BFI's erratic attempts to establish a major online presence finally bore fruit with the launch of the Screenonline information resource at the end of 2003. A programme of digitising archive films was initiated.

The development of the MOMI area included a gallery space for the showing of artists' film and video work and a mediatheque where films digitised by the archive could be screened with copyright clearance. Also included was a new franchised bar and restaurant, which provided welcome income. But when the enhanced facilities opened under the new name of BFI Southbank in March 2007, the immediate result was a fall in NFT box-office revenues as prospective customers struggled with a massive publicity brochure which seemed to advertise everything except the films they actually wanted to see. After a few months the BFI Southbank brochure reverted to something near its traditional format and the haemorrhage was stemmed, but it was some time before NFT audiences recovered to their previous level and indeed exceeded it – although it still remains lower than it had been in the 1970s and early 1980s when only two auditoria were available to be filled. Fortunately for the BFI, the IMAX finally came into its own with significant income both from its garish advertising wrap and from the availability of mainstream films and became profitable around 2007. The 3–D boom led by the release of *Avatar* was a further bonus and contributed to making the Southbank less of an overall financial liability.

Elsewhere in the organisation, the Trading division was disbanded in 2007. Under new leadership, BFI Video was allowed to stand alone and form its own productive relations with other parts of the BFI such as the Archive, the Southbank and distribution and soon proved a cultural and financial success. But the wide availability of film stills via the internet and DVD grabs meant that the Stills department was getting less income. It was downsized and further financial savings accrued with the outsourcing of book publishing to the academic publisher Palgrave.

In late 2007 Minghella was diagnosed with cancer and resigned as chairman of the BFI. He died on 18 March 2008. His successor at the BFI was Greg Dyke, who had been director general of the BBC until forced to resign in 2004. Although a less charismatic figure than Minghella and less interested in cinema or in film culture, he was to prove an effective campaigner for what he saw as the BFI's interests when a new crisis loomed early in 2009.

By the time Dyke took office, relations between the BFI and the UKFC were becoming increasingly strained. The basis structure was anomalous and needed a lot of good will to make it reasonably functional. Stewart Till, who had succeeded Alan Parker as chairman of the Council, was not seen as particularly sympathetic towards the BFI and its objectives and was known, or at least rumoured, to be at best lukewarm in his support for the Institute's flagship project, the Film Centre.

Epilogue 2011

The UKFC was also generally sceptical – not always without reason – of the BFI's ability to manage large projects of any kind and in 2007 intervened in what seemed to the BFI an unhelpful manner in the governance of the Screen Heritage programme, in which the Council had no real stake, neither having raised the money nor having any particular interest or expertise in archival matters.

With Dyke now in charge at the BFI and Till due to step down as chair of the UKFC, the two organisations began separately to undertake a review of their activities – with obvious implications for the relationship between them, now widely felt to be dysfunctional. When the House of Lords Communications Committee set up an inquiry into British film and television content early in 2009, both the BFI and the UKFC submitted oral evidence, in the course of which Eric Fellner, vice-chair of the BFI, floated the idea that it might be time for the BFI to regain its independence.

At this point John Woodward, CEO of the Film Council, decided on a bold move. In May 2009, with a new chair, Tim Bevan, due to arrive but not yet in post, he commissioned a document setting out the legal and financial options for a possible merger between the two organisations. Two possible models emerged. Either the BFI might be absorbed into the UKFC through the creation of a BFI Trust of which the UKFC would be sole trustee, or the UKFC could be folded into the BFI. The former model, which was the preferred one, would leave the UKFC in control; the BFI would retain its charitable status but probably have to lose its Royal Charter. The latter would make the UKFC the trading arm of a still chartered BFI. Either way, savings of up to £500,000 per annum could be expected through a merger of the back-office of the two organisations and the removal of unproductive interfaces between them.

Uppermost in Woodward's mind was the political context. Even if Labour were returned to power at the next election, there would still be financial stringency ahead. If, as was looking increasingly likely, a Conservative government were elected, things might be even worse, given the Tory party's known aversion to quangos. Under the circumstances a merged organisation which had already demonstrated a will to make savings in its budget had a better chance of survival than either component on its own.

The first the BFI heard of the UKFC's plan was in July 2009 when the new films minister, Sion Simon, summoned Dyke and Nevill to a meeting where they were told that the prospective £45 million funding for the Film Centre was dependent on acceptance of the merger. An emergency meeting of the BFI Governors was called to discuss the proposal. The governors agreed to enter into discussion of the merger and the minister announced that its terms would be settled by March 2010.

There then followed a series of intense negotiations, under the auspices of the DCMS, to determine how a merger could best be pushed forward. Although the BFI accepted the economic rationale behind a merger, it made it very clear that, in Dyke's words, it was 'not to be railroaded'. Expert legal advice obtained by the BFI strongly suggested that the UKFC's preferred option, under which the Council (a

company) would control the Institute (a charity) was unlikely to be compatible with the latest state of charities law. Gradually there emerged the idea of a 'reverse takeover' whereby the BFI would incorporate into its operations some of the activities of the UKFC (i.e. those which the UKFC had initiated which duplicated or overlapped with BFI activities) while creating a subsidiary company able to continue to distribute Lottery funding for allowable activities.

Whatever the formal solution, however, two questions remained to be addressed: how would the respective interests of industry and culture be served by the merged body; and who would actually manage it?

Consultants were engaged to draw up a Strategic Outline Plan for the merger, with the UKFC version still generally thought to be the front runner. Other parties were drawn into the debate. Ed Vaizey, shadow films minister, commissioned a report on the film sector in general which contained a section on the BFI favourable to the idea of a merger but agnostic about the form it should take. Simon Perry, former chief executive at British Screen Finance, was one of many voices urging caution. The Lords Communications Committee declared itself opposed to any merger driven by considerations of cost.

By the end of 2009 the tide had begun to turn in favour of the 'BFI' version of the merger, which was thought to be marginally cheaper to implement and was less likely to run into difficulties with the Charities Commission. In early February 2010, however, Simon announced that he would be standing down as an MP at the next election and resigned his post as minister for the creative industries, leaving his secretary of state, Ben Bradshaw, to push the merger forward, in the hope that the plans would be finalised, at least in outline, by the end of the financial year and before the impending general election.

In the event, an outline agreement was reached before the end of March, leaving the BFI and its Charter formally intact but with crucial questions about the form the new organisation would take and the ends it would pursue still very much up in the air.

The election took place on 6 May. The outcome was a hung parliament shortly followed by the establishment of a coalition government led by the Conservatives. The new government acted quickly. Although the BFI pressed for the merger to go ahead on the grounds of the efficiency savings it would produce, the government was unconvinced. It wanted deeper cuts throughout the public sector. At the beginning of June the DCMS announced an across-the-board cut in the budgets of all funded bodies. The UKFC, which held the purse-strings, decided to make the brunt of the cut fall on the BFI, whose grant was slashed by 10 per cent. The DCMS then cancelled the previous administration's promise of £45 million towards the new Film Centre and a further £2.5 million for the digital access component of the Screen Heritage programme. On 21 June the new creative industries minister, Ed Vaizey, in answer to a parliamentary question from Ben Bradshaw, declared that the merger had been put on hold. This was followed a month later by an announcement by Jeremy Hunt, the secretary of state, that the UKFC would be abolished as part

of the government's bonfire of the quangos. There would therefore be nothing for the BFI to merge with. On the other hand, if Lottery money continued to be available for film, someone would have to be responsible for its distribution.

The proposed abolition of the UKFC aroused a storm of protest in film circles. Although it had backed a number of bad films (which is true of all producing organisations from the big Hollywood studios to the BFI Production Board), its success rate had been remarkable. The date selected for its abolition, 1 April 2011, came only a few weeks after the triumph of the UKFC-backed *The King's Speech*, first at the BAFTAs in London and then at the Academy Awards in Los Angeles, making the abolition of the Film Council seem even less opportune.

But the UKFC's loss was the BFI's opportunity – albeit an ambiguous one. Although the UKFC as such had been abolished, its purposes had not. An organisation was still needed to disburse Lottery funds for film production and to support wider film-cultural activity across the country. After a bit of hesitation it was formally announced that from 1 April 2011 this organisation would be the BFI, which would henceforth be regarded by the government as the 'lead body' for film in the UK. So the British Film Institute, which from its tiny beginnings in the 1930s had grown to encompass all branches of film-cultural activity, from education to archiving to small-scale production, distribution and exhibition, and which had seen some of this activity removed from it in the late 1990s, found itself once again centre stage with all its functions restored – and a larger role in film production to boot. Readers who have followed the full story told in this volume will not fail to notice one great irony in this last turn of the wheel. Historically, the BFI's great moments of expansion – into exhibition, production and regional support, but also the first concerted programme to preserve the heritage of nitrate film – took place under Labour governments. Then in the 1980s, with the Conservatives in power, it was private benefactors, notably Sir John Paul Getty, who did what the government of the day would not do, enabling growth to continue to take place in an unpropitious climate. In the twenty-first century, however, it was a Labour government, no doubt with the best of intentions, that downgraded the BFI, casting doubt on its mission and subordinating it to a body with more industrial aims. And now, in 2011, it is the Conservative-led coalition that has restored its autonomy and full range of functions. With what results for film culture, however, remains to be seen.

Select bibliography

'A Film Institute Within Sight', *Sight and Sound*, Autumn 1932, pp. 64–5.
'A National Film Library', *Sight and Sound*, Winter 1934–35, pp. 145–6.
'Adult Education: Its Place in Post-War Society', *Adult Education: A Quarterly Journal of the British Institute of Adult Education* 16:2, 1943.
ALDGATE, Anthony, *Censorship in Theatre and Cinema*. Edinburgh: Edinburgh University Press, 2005.
ANDREWS, Nigel, 'Production Board Films', *Sight and Sound*, Winter 1978–79, pp. 53–5.
ARTS ENQUIRY, *Interim Draft of the Factual Film in Great Britain*, unpublished confidential document, [October 1944].
ARTS ENQUIRY, *The Factual Film: A Survey Sponsored by the Dartington Hall Trustees*. London, Oxford University Press for PEP, January 1947.
ASHLEY, Walter, *The Cinema and the Public: A Critical Analysis of the Origin, Constitution and Control of the 'British Film Institute'*. London, Ivor Nicholson and Watson Ltd, 1934.
AUTY, Martin and Gillian HARTNOLL, *Water Under the Bridge: 25 Years of the London Film Festival*. London, British Film Institute 1981.
AUTY, Martin, and Nick RODDICK, *British Cinema Now*. London: BFI, 1985.
BARKER, Martin, *A Haunt of Fears: The Strange History of the British Horror Comics Campaign*. London: Pluto Press, 1984.
BARR, Charles, *All Our Yesterdays: 90 Years of British Cinema*. London: BFI, 1986.
BAZALGETTE, Cary, *Education at the BFI, 1950–2001*, unpublished document, 2001 [Copy in the BFI National Library].
——, 'Analogue Sunset. The Educational Role of the British Film Institute, 1979–2007', *Comunicar* 35, 2010, pp. 15–24.
BELL, Oliver, 'The First Ten Years', *Sight and Sound*, October 1943, pp. 56–8.
——, 'Whither the National Film Library?', *Cine-Technician*, November-December 1947, pp. 184–5.
BERESFORD, Bruce, 'One Way In', *Films and Filming*, May 1971, pp. 55–7.
BOLAS, Terry, *Screen Education: From Film Appreciation to Media Studies*. London: Intellect, 2009.
BORDE, Raymond. *Les Cinémathèques*. Lausanne: L'Age d'Homme, 1983.
BRITISH FILM INSTITUTE, *Memorandum and Articles of Association of the British Film Institute Incorporated on the 30th Day of September, 1933*, and updates from 1937, 1948, 1961 and 1964.
——, *British Film Institute Annual Report*, 1934 to 1982 and 1988/89 to 2009. London: BFI [Between 1983 and 1987 the BFI's annual report was contained within the *BFI Film and*

Television Yearbook. London: BFI].
——, *The National Film Library. Its Work and Requirements*. London: BFI, 1935.
——, *The National Film Library. Its Policy and Needs*. London: BFI, 1941.
——, *The Film in National Life: Being the Proceedings of a Conference Held by the British Film Institute in Exeter, April 1943*. London: BFI, 1943.
——, *The British Film Institute, 1954–55*. London: BFI, 1955.
——, *The British Film Institute: The First Twenty-Five Years*. London: BFI, 1958.
——, *British Film Institute: A Report 1965*. London: BFI, 1965.
——, *British Film Institute: Outlook 1966*. London: BFI, 1966.
——, *British Film Institute: Outlook 1967*. London: BFI, 1967.
——, *British Film Institute: Outlook 1968*. London: BFI, 1968.
——, *British Film Institute Royal Charter*. London: BFI, 1983.
——, *The BFI in the Regions*. London: BFI, 1970.
——, *Policy Report of the BFI Governors*. London: BFI, 1971.
——, *The BFI in the Eighties: The Work of the British Film Institute and its Plans for the Future: A Report Produced on the Occasion of Its Fiftieth Anniversary in 1983*. London: BFI, 1983.
——, *BFI 2000: A Radical New Vision for the British Film Institute*. London, British Film Institute, 1997.
——, *360 Film Classics from the National Film and Television Archive*. London: BFI, 1998.
——, *Television Industry Tracking Study, Third Report*, mimeo. London: British Film Institute, 1999.
——, *British Film Institute Royal Charter*. London: BFI, 1983 (updated in 2000 as *British Film Institute Royal Charter as Amended and in Effect from 19 April 2000*. London: BFI, 2000).
——, *British Film Institute: Organisation, Methods and Staff Structure Report*. London, Organisation and Methods Division, OM.474/1/01, HM Treasury, 1959.
BROWN, Harold, 'Problems of Storing Film for Archive Purposes', *British Kinematography*, May 1952.
——,'Technical Problems of Preservation', *Journal of the Society of Film and Television Arts* 39, Spring 1970, pp. 8–15.
BROWN, Maggie, *A Licence to Be Different: the Story of Channel 4*. London: BFI, 2007.
BRUCE, David, 'A New Venture in Scotland', *Audio Visual*, June 1974, pp. 58–9.
BUSCOMBE, Edward, 'When Cinema Met Semiology', *The Bookseller*, 16 November 2001, pp. 28–30.
BUTLER, Ivan. *To Encourage the Art of the Film: The Story of the British Film Institute*. London: Robert Hale, 1971.
CAMERON, A. C., 'The Case for a National Film Institute', *Sight and Sound*, Spring 1932, pp. 8–9.
CATERER, James, '"Carrying a Cultural Burden": British Film Policy and its Products', *Journal of British Cinema and Television*, May 2008.
CAUGHIE, John, 'The Film Institute and the Rising Tide: An Interview with Colin MacCabe', *Screen* 41:1, Spring 2000, pp. 51–66.
—— and Simon FRITH, 'The British Film Institute: Re-tooling the Culture Industry', *Screen* 31:2, Summer 1990, pp. 214–22.
CHAPMAN, James, *The British at War: Cinema, State and Propaganda 1939–1945*. London: I. B. Tauris, 1998.
COMMISSION ON EDUCATIONAL AND CULTURAL FILMS, *The Film in National Life, Being the Report of an Enquiry Conducted by the Commission on Educational and Cultural Films into the Service Which the Cinematograph May Render to Education and Social Progress*. London: George Allen and Unwin Ltd, 1932.

CONEKIN, Becky E., *The Autobiography of a Nation: The 1951 Festival of Britain*, Manchester and New York: Manchester University Press, 2003.
COSTER, Patience, 'Harold Brown's Half Century', *Three Sixty*, August 1983, pp. 12–14.
COWIE, Elizabeth (ed), *Catalogue: British Film Institute Productions 1977–1978*. London: British Film Institute, 1978.
DAY-LEWIS, Sean (ed.), *One Day in the Life of Television*. London: Grafton Books, 1989.
DICKINSON, Margaret (ed.) *Rogue Reels: Oppositional Film in Britain, 1945–1990*. London: British Film Institute, 1999.
——, and Sarah STREET, *Cinema and State: The Film Industry and the British Government 1927–84*. London, British Film Institute, 1985.
DOCHERTY, David, David MORRISON and Michael TRACEY, *The Last Picture Show? Britain's Changing Film Audiences*. London: BFI, 1987.
DONALD, James, Anne FRIEDBERG and Laura MARCUS (eds), *Close Up, 1927–1933: Cinema and Modernism*. London: Cassell, 1998.
DOYLE, Barry, 'The Geography of Cinemagoing in Great Britain', 1934–1994: a Comment', *Historical Journal of Film, Radio and Television* 23:1, 2003, pp. 59–71.
DRAZIN, Charles, *The Finest Years: British Cinema of the 1940s*. London: André Deutsch, 1998.
DUPIN, Christophe, *Analysis of a Conflict of Interests: Origins, Creation and First Achievements of the British Film Institute, 1929–1936* [MA dissertation]. London: Birkbeck College / British Film Institute, 1998.
——, 'Early Days of Short Film Production at the British Film Institute: Origins and Evolution of the BFI Experimental Film Fund (1952–1966)', *Journal of Media Practice* 7:2, 2003, p. 77–91.
——, *The British Film Institute as a Sponsor and Producer of Non-commercial Film: A Contextualised Analysis of the Origins, Administration, Policy and Achievements of the BFI Experimental Film Fund (1952–1965) and Production Board (1966–1979)* [PhD thesis]. London: Birkbeck College, 2005.
——, 'The Postwar Transformation of the British Film Institute and its Impact on the Development of a National Film Culture in Britain', *Screen* 47:4, 2006, pp. 443–51.
——, 'The Origins and Early Development of the National Film Library: 1929–1936', *Journal of Media Practice* 7:3 (2007).
——, 'The BFI and Independent British Cinema in the 1970s', in Robert SHAIL (ed.), *British Cinema of the 1970s*. London: BFI, 2009.
DURGNAT, Raymond, 'Standing up for Jesus', *Motion* 6, Autumn 1963.
—— 'Shoot Out in Dean Street', *Films and Filming* 2, February 1972, pp. 41–2.
'Editorial', *Screen* 12:3, 1971, pp. 9–12.
'Editorial Reel', *16mm. Film User*, November 1946, p. 3.
EASEN, Sarah, 'Film and the Festival of Britain', in Ian MacKILLOP and Neil SINYARD (eds), *British Cinema of the 1950s: A Celebration*. Manchester: Manchester University Press, 2003, pp. 51–63.
ELLIS, John (ed.), *1951–1976: British Film Institute Productions*. London: British Film Institute, 1977.
——, 'Production Board Policies', *Screen* 17:4, Winter 1976–77, pp. 9–23.
EYLES, Allan (ed.), *NFT 50: A Celebration of Fifty Years at the National Film Theatre*. London: BFI, 2002.
FELDMAN, Susan, *The British Film Institute and Regional Film Theatres: Developing a Profile of Subsidized Film Exhibition in Britain*, unpublished project, Arts Administration Studies, The City University, 1980.
FIAF, *50 Years of Film Archives 1938–1988*. Brussels, FIAF, 1988.
FIELD Audrey, *Picture Palace: A Social History of the Cinema*. London: Gentry Books, 1974.

Select bibliography

FILM COUNCIL, *Film in England: A Development Strategy for Film and the Moving Image in the English Regions*. London: Film Council, 2002.

FILM POLICY REVIEW GROUP, *A Bigger Picture: The Report of the Film Policy Review Group*. London, DCMS, 1998.

FORD, Colin, 'Getting the Films Seen', *Journal of the Society of Film and Television Arts* 39, Spring 1970, pp. 21–3.

FORMAN, Denis, 'The Work of the British Film Institute', *The Year's Work in the Film*. London: British Film Council, 1949, pp. 69–76.

——, 'The Work of the British Film Institute', *Quarterly of Film, Radio and Television*, Berkeley: University of California Press, 1954, pp. 147–58.

——, *Persona Granada: Some Memories of Sidney Bernstein and the Early Days of Independent Television*. London: André Deutsch, 1997.

FRANCIS, David, 'From Parchment to Pictures to Pixels, Balancing the Accounts: Ernest Lindgren and the National Film Archive, 70 Years On', *Journal of Film Preservation* 71, July 2006.

FRAYLING, Christopher. *The Royal College of Art: One Hundred and Fifty Years of Art and Design*. London: Barrie and Jenkins, 1987.

FRIEDMAN. Lester D., *Fires Were Started: British Cinema and Thatcherism*. Minneapolis: Minnesota University Press, 1993.

GAUNTLETT, David and Annette HILL, *TV Living: Television, Culture and Everyday Life*. London: Routledge/BFI, 1999.

GIBSON, Ben, 'Seven Deadly Myths: Film Policy and the BFI, a Personal Lexicon', in Duncan PETRIE (ed.), *New Questions of British Cinema*. London: BFI, 1992, pp. 29–39.

——, 'Laissez-faire Eats the Soul: Film Funding in the UK', *Journal of Popular British Cinema* 5, 2002, pp. 21–36.

GOMEZ, Joseph A., *Peter Watkins*. Boston: Twayne, 1970.

GRAY, Richard, *Cinemas in Britain: One Hundred Years of Cinema Architecture*. London: Lund Humphries, 1997.

GRIERSON, John, 'The Prospect for Cultural Cinema', *Film* 7, 1956.

GRIEVESON. Lee and Haidee WASSON (eds), *Inventing film studies*. Durham, NC: Duke University Press, 2008.

GROOMBRIDGE, Brian, *Popular Culture and Personal Responsibility: A Study Guide*. London: National Union of Teachers, 1961.

HALL, Stuart and Paddy WHANNEL, *The Popular Arts*. London: Hutchinson Educational, 1964.

HALLIWELL. Leslie, 'Strictly for Eggheads: Thoughts on Running a Specialised Hall', *Sight and Sound*, April–June 1954.

HANCOCK, Margaret, 'Newsreel', *Film* 9, 1956.

——, 'Edinburgh', *Film* 18, 1958, pp. 29–30.

HARCOURT Peter and Peter THEOBALD (eds), *Film Making in Schools and Colleges*. London: BFI Education Department, 1966.

HARPER, Sue, *Picturing the Past*. London: BFI, 1994.

HARTNOLL, Gillian, *A Brief History of the BFI Library and Information Services (1933–1996)*. London: British Film Institute, 1999.

HARVIE, Jen, 'Nationalizing the Creative Industries', *Contemporary Theatre Review* 13:1, 2003.

HEWISON, Robert, *Too Much: Art and Society in the Sixties 1960–1975*. London: Methuen, 1986.

——, *In Anger: Culture in the Cold War 1945–1960*. London: Weidenfeld and Nicolson, 1981.

——, *Culture and Consensus: England, Art and Politics since 1940*. London: Methuen, 1997 (2nd edition).

HIGGINS, A. P., *Talking about Television* London: BFI Education Department, 1966.
HIGSON, Andrew (ed.), *Young and Innocent? The Cinema in Britain, 1896–1930*. Exeter: University of Exeter Press, 2002.
HILL, John (ed.), *British Cinema in the 1980s*, Oxford: Oxford University Press, 1999.
——, 'The Rise and Fall of British Art Cinema: A Short History of the 1980s and 1990s', *Aura* 6:3, 2000, pp. 18–32.
HILLIER, Jim and Andrew McTAGGART, 'Film in the Humanities Curriculum Project: 1. Theory'; and Richard EXTON, '2. Practice', *Screen* 11:2, March–April 1970, pp. 46–57.
HIMMELWEIT, Hilde, *Television and the Child: An Empirical Study of the Effect of Television on the Young*. Oxford: Oxford University Press, 1958.
HODGKINSON, Tony, 'The British Film Institute', *Film Comment*, Fall 1964, pp. 31–4.
HOGENKAMP, Bert, *Film, Television and the Left in Britain: 1959 to 1970*. London: Lawrence and Wishart, 2000.
HOLMAN, Roger, 'The Archive's Catalogues', *Journal of the Society of Film and Television Arts* 39, Spring 1970, pp. 15–19.
HOUSE OF COMMONS. *Eighth Report from the Education, Science and Arts Committee, Session 1981–82*, 3 volumes. London: HMSO, 18 October 1982.
HOUSTON, Penelope, *The Contemporary Cinema*. London: Penguin, 1963.
——, *Keepers of the Frame: The Film Archives*. London: British Film Institute, 1994.
ISAACS, Jeremy. *Storm over 4: A Personal Account*. London: Weidenfeld and Nicolson, 1989.
——, 'Winning the Pools', *Sight and Sound*, Winter 1980–81, pp. 21–3.
——, 'Production and Policies', *BFI News*, July 1979, p. 4.
JACOBS, Alex and Paddy WHANNEL (eds), *Artist, Critic and Teacher*. London: Joint Council for Education through Art, 1958.
JANCOVICH, Mark, with Lucy FAIRE and Sarah STUBBINGS, *The Place of the Audience: Cultural Geographies of Film Consumption*. London: BFI, 2003.
JEAVONS, Clyde, 'The Problems of Acquisition', *Journal of the Society of Film and Television Arts* 39, Spring 1970, pp. 5–7.
JENKINS, Hugh, *The Culture Gap: An Experience of Government and the Arts*. London, Marion Boyars, 1979.
JOHNSTON, Claire, 'BFI', *Time Out*, 14 November 1970, pp. 70–5.
KELLY, Terrence, with Graham NORTON and George PERRY, *A Competitive Cinema*. London: Institute of Economic Affairs, 1966, pp. 112–16.
KENDALL, Neil Stephen, *Archive: A Study of the History, Work and Aims of Britain's National Film Archive*, BA dissertation, Manchester: School of Film and Television, Manchester Polytechnic, 1979.
KITSES, Jim, *Horizons West*. London: BFI, rev. ed., 2004.
——, and Ann MERCER, *Talking about the Cinema*. London: BFI Education Department, 1966.
LAMBERT, Richard S., 'The British Film Institute', *International Review of Educational Cinematography*, May 1933, pp. 315–20.
——, 'The British Film Institute', *Cinema Quarterly* 1:4, Summer 1933, pp. 212–15.
——, *Ariel and All His Quality: An Impression of the B.B.C. from Within*. London, Gollancz, 1940.
——, 'The British Film Institute', *International Review of Educational Cinematography*, May 1933, pp. 315–20.
LINDGREN, Ernest, 'A National Film Library for Great Britain', *Sight and Sound*, Summer 1935, pp. 66–8.
——, 'The National Film Library', *Sight and Sound*, Autumn 1937, p. 167.
——, 'Cataloguing the National Film Library', *Sight and Sound*, Autumn 1940, pp. 50–1.

——, 'Nostalgia', *Sight and Sound*, Autumn 1940, pp. 49–50.
——, *The Work of the National Film Library*. London: The British Kinematograph Society, 1945.
——, *A Plan for the Development of the National Film Library*, unpublished policy paper, June 1947.
——, *The Art of the Film: An Introduction to Film Appreciation*. London: Allen and Unwin, 1948.
——, 'The Importance of Film Archives', in Roger MANVELL, *The Penguin Film Review* 5. London: Penguin Books, 1948, pp. 47–52.
——, 'Preserving History in Film', *Kinematograph Weekly*, 3 May 1956.
——, 'Film Archives and Film Art', *Athene*, June 1956, pp. 26–30.
——, 'The National Film Archive: When, What and Why', 'Selecting for Posterity', 'The International Federation of Film Archives' and 'The Way Ahead', *Journal of the Society of Film and Television Arts* 39, Spring 1970, pp. 1–5, 24–8.
——, 'Out of the Vaults, On To the Screen', *BFI News*, October 1972, p. 3.
LLOYD, Matthew, *How the Movie Brats Took Over Edinburgh: The Impact of Cinephilia on the Edinburgh International Film Festival, 1968–1980*. St Andrews: St Andrews University Press, 2011.
LONDON FILM SOCIETY, *The Film Society Programmes, 1925–1939*. New York: Arno Press, 1972.
LOVELL, Alan, 'The BFI and Film Education', *Screen* 12:3, Autumn 1971.
——, (ed.), *BFI Production Board*. London: BFI, 1976.
LOW, Rachael, 'Appendix: The British Film Institute', in *The History of the British Film, 1929–1939: Documentary and Educational Films in the 1930's*. London: Allen and Unwin, 1979, pp. 183–205.
——, *The History of the British Film, 1929–1939: Film Making in 1930's Britain*. London: Allen and Unwin, 1985.
McARTHUR, Colin, 'One Step Forward, One Step Back: Cultural Struggle in the British Film Institute', *Journal of Popular British Cinema* 4, 2001, pp. 112–27.
——, 'The Big Heat and Critical Methods - A Personal Memoir', in *The Big Heat*. London: BFI, 1992, pp. 35–49.
MacCABE, Colin, 'BFI Production 1985–89', in *The Eloquence of the Vulgar: Language, Cinema and the Politics of Culture*. London: British Film Institute, 1999, pp. 12–17.
——, 'BFI Research and Education 1989–96', in *The Eloquence of the Vulgar: Language, Cinema and the Politics of Culture*. London: British Film Institute, 1999, pp. 17–29.
MacDONALD, Scott, *Cinema 16: Documents toward a History of the Film Society*. Philadelphia: Temple University Press, 2002.
McKIBBIN, Ross, *Classes and Cultures: England, 1918–1951*. Oxford: Oxford University Press, 2000.
MacPHERSON, Don (ed.), *Traditions of Independence: British Cinema in the Thirties*. London: British Film Institute, 1980.
MAJDALANY, Fred, 'Films', *Time and Tide*, 4 September 1954.
MANNONI, Laurent, *Histoire de la Cinémathèque française*. Paris: Gallimard, 2006.
MANVELL, Roger, *Film*. Harmondsworth: Penguin Books, 1944 (rev. edn, 1946).
——, *The Film and the Public*. Harmondsworth: Penguin Books, 1955.
MASCHLER, Tom (ed.), *Declaration*. London: McKibbon and Kee, 1957.
MAYER, J. P., *British Cinemas and Their Audiences*. London: Denis Dobson, 1948
MEMBERS' ACTION COMMITTEE, *A New Screenplay for the BFI*, unpublished pamphlet, c. 1971.
MILES, Peter and Malcolm SMITH, *Cinema. Literature and Society: Elite and Mass Society in Interwar Britain*. London: Croom Helm, 1987.

MINISTRY OF EDUCATION, *Half Our Future: A Report of the Central Advisory Council for Education (England)*. London: HMSO, 1963.
MURPHY, Robert (ed.), *The British Cinema Book* (2nd edition). London: BFI, 2002.
NAPPER. Lawrence, *The Middlebrow, 'National Culture' and British Cinema 1920–1939*, PhD thesis. Norwich: University of East Anglia, 2001.
NATIONAL AUDIT OFFICE, *Report by the Comptroller and Auditor General: The British Film Institute*. London, HMSO, 1994.
——, *Film Council: Improving Access to, and Education about, the Moving Image through the British Film Institute, Report by the Comptroller and Auditor General*. London, HMSO, 2003.
NATIONAL FILM ARCHIVE, *The National Film Archive*. London: BFI [1956].
——, *Rules for Use in the Cataloguing Department of the National Film Archive*, compiled by David Grenfell (5th edition). London: BFI, 1960.
——, *The Rescue of Living History: A Report on the Needs of the National Film Archive by a Committee of the Governors of the British Film Institute*. London: BFI, 1969.
NATIONAL FILM LIBRARY, *Catalogue of the Loan Section of the National Film Library*. London: BFI, August 1941.
NATIONAL FILM THEATRE, *National Film Theatre: Fifty Famous Films, 1915–1945*. London: BFI, 1960.
NEWLAND, Newland (ed.), *Don't Look Now. British Cinema in the 1970s*. London: Intellect, 2010.
NORKETT, Trevor, *A History of the National Film and Television Archive*, MA Dissertation. London: University College London, 1994.
NOWELL-SMITH, Geoffrey, 'In the Picture – Chasing the Gorgon', *Sight and Sound*, Spring 1965, pp. 40–1.
——, 'Radio On', *Screen* 20:3–4, Winter 1979, pp. 29–39.
——, 'But do we need it?' in Martin AUTY and Nick RODDICK, *British Cinema Now*. London: BFI, 1985.
——, 'Grandeur and Misery of Film Culture', *Vertigo* 6, Autumn 1996, pp. 5–8.
——, 'The 1970 Crisis at the BFI and Its Aftermath', *Screen* 47:4, Winter 2006, pp. 453–9.
PATERSON, Richard, 'Work Histories in Television', *Media, Culture and Society*, 23:4, 2001.
PERKINS, Victor, 'Fifty Famous Films 1915–1945'. *Oxford Opinion* 38, April 1960, pp. 36–7.
PETLEY, Julian, *BFI Distribution Library Catalogue 1978*. London: BFI, 1978.
PIERSON, Michele, 'Amateurism and Experiment: the BFI's Experimental Film Fund (1952–66)', *The Moving Image* 5:1, Spring 2005, pp. 67–94.
PIETZ, May, 'Interview with Paddy Whannel', *SEE, Magazine of the Screen Educators' Society* 3:1, 1969.
POLE, Nicholas, '10 Years of the BFI Production Board', *AIPandCo*, March 1986, pp. 20–9.
PROLO, Adriana and Henri LANGLOIS, *Le Dragon et l'Alouette: correspondance, 1948–1979*, Turin: Museo Nazionale del Cinema, 1992.
PYM, John, *Film on Four, 1982/1991: A Survey*. London: BFI, 1992.
QUINN, James, 'Hope for the Future: the Work of the British Film Institute's Experimental Production Committee', *Athene* [Journal of the Society for Education through the Arts], June 1956, pp. 30–3.
——, *Outside London: A Report to the Governors of the British Film Institute*. London: BFI, 1966.
——, 'The British Film Institute', in *The Film and Television as an Aspect of European Culture*. Leiden: A.W. Sijthoff, 1968, pp. 30–51.
REED, Stanley, 'Appreciation of the Film', *Photographic Journal*, August 1950, pp. 285–91.
——, 'Film and the Child', *Visual Education* 1:9–12 September–December 1950.

Select bibliography

———, *Film Appreciation as a Classroom Subject*. London: BFI, 1951.
———, *Guidance in Aesthetic Appreciation: The Film*. London: BFI, 1955.
———, 'Opening a Door to Experiment', *Amateur Cine World*, April 1958, pp. 1199–201.
REEVES, Mervyn, 'The Film Societies and Adult Education', *Adult Education*, 21:4, June 1949, pp. 175–8.
Report of the Committee on the British Film Institute: Presented by the Lord President of the Council to Parliament by Command of His Majesty. London: HMSO, 1948 [Radcliffe Report].
Report of the Departmental Committee on Children and the Cinema. London: HMSO, 1950.
RICH, B. Ruby, 'The Very Model of a Modern Minor Industry', *American Film*, May 1983, pp 47–54, 64.
RICHARDS, Jeffrey and Anthony ALDGATE, *British Cinema and Society, 1930–1970*. Oxford: Basil Blackwell, 1983.
ROSSELL, Deac, *Forty Years, 1952–92: The World's Leading Cinémathèque Celebrates its Fortieth Anniversary*. London: British Film Institute, 1992.
ROUD, Richard, 'The National Film Theatre's First Ten Years'. *London Film Festival Catalogue*. London: BFI, 1962.
———, *A Passion for Films: Henri Langlois and the Cinémathèque Française*. London and Baltimore: Johns Hopkins University Press, 1999.
SAINSBURY, Peter, 'The Financial Base of Independent Film Production in the UK', *Screen* 22:1, 1981, pp. 41–53.
———, 'BFI Production Division', *Sight and Sound*, Autumn 1981, pp. 242–3.
———, 'Independent British Filmmaking and the Production Board', in John ELLIS (ed.), *1951–1976: British Film Institute Productions*. London: British Film Institute, 1977, pp. 11–16.
———, 'Production and Independence 2: Funding', in Elizabeth COWIE (ed.), *Catalogue: British Film Institute Productions 1977–1978*. London: British Film Institute, 1978, pp. 7–11.
———, 'Production Policy', in Rod STONEMAN and Hilary THOMPSON (eds), *The New Social Function of Cinema, Catalogue: British Film Institute Productions '79/80*. London: BFI, 1980, pp. 9–11.
SAMSON, Jen, 'The Film Society', in Charles BARR, *All Our Yesterdays: 90 Years of British Cinema*, London: BFI, 1986.
SELFE, Melanie, *Encouraging a National Film Culture: The Changing Role of Sight and Sound 1935–1945*, MA dissertation, Nottingham: University of Nottingham, 2003.
———, *The Role of Film Societies in the Presentation and Mediation of 'Cultural' Film in Post-war Nottingham*, unpublished PhD thesis, Norwich: University of East Anglia, 2007.
SEXTON, Jamie, 'The Film Society and the Creation of an Alternative Film Culture in Britain in the 1920s', in Andrew HIGSON (ed.), *Young and Innocent? The Cinema in Britain, 1896–1930*, Exeter: University of Exeter Press, 2002, pp. 291–305.
SHAW, Roy, *The Arts and the People*. London: Jonathan Cape, 1987.
SMITH, Anthony, *The Geopolitics of Information*. London: Faber and Faber, 1980.
SMITH, Chris, *Creative Britain*. London: Faber and Faber, 1998.
SMITHER, Roger, 'Henry Langlois and Nitrate, Before and After 1959', in Roger SMITHER and Catherine A. SUROWIEC (eds), *This Film is Dangerous: A Celebration of Nitrate Film*, Brussels: FIAF, 2002.
STONEMAN, Rod and Hilary THOMPSON (eds), *The New Social Function of Cinema, Catalogue: British Film Institute Productions '79/80*. London: BFI, 1980.
'Tasks Before the British Film Institute', *Sight and Sound*, Autumn 1933, pp. 74–5.
THOMPSON, Denys (ed.), *Discrimination and Popular Culture*. Harmondsworth: Penguin 1965.

TUCKER, Nicholas, *Understanding the Mass Media*. Cambridge: Cambridge University Press, 1966.
VERTIGO, Editorial, *Vertigo* 1:6, Autumn 1996, pp. 3–4.
WASHINGTON, Irving, 'It's the BFI Show!', *Time Out*, 10 December 1971, pp. 12–14.
WASSON, Haidee, 'Writing the Cinema into Daily Life: Iris Barry and the Emergence of British Film Criticism in the 1920s', in Andrew HIGSON (ed.), *Young and Innocent? The Cinema in Britain, 1896–1930*. Exeter: Exeter University Press, 2002, pp. 321–37.
——, *Museum Movies: The Museum of Modern Art and the Birth of Art Cinema*. Berkeley and Los Angeles: University of California Press, 2005.
WEHBERG, Hilla, 'Fate of an International Film Institute', *The Public Opinion Quarterly*, July 1938, pp. 483–5.
WHANNEL, Paddy, 'Towards a Positive Criticism of the Mass Media', *Film Teacher*, 17 May 1959, pp. 28–30.
——, 'Receiving the Message', *Definition* 3, 1961, pp .12–15.
——, 'While the Iron Is Hot', *Sight and Sound*, Summer 1962.
——, 'Teaching Film'. *Liberal Education* 5, January 1964, pp. 3–4.
——, 'Teaching and Discrimination', *Forum* 3:2, Spring 1964.
——, 'Film Education and Film Culture', *Screen* 10:3, May–June 1969, pp, 49–59.
——, 'Servicing the Teacher', *Screen* 11:4–5, July–October 1970, pp. 48–55.
—— and Peter HARCOURT, *Film Teaching*. London: BFI Education Department, 1964.
—— et al., 'An Open Letter to the Staff of the British Film Institute', *Screen* 12:1, Spring 1971, pp. 2–8.
WILDING, Richard, *Supporting the Arts: A Review of the Structure of Arts Funding*. London: Office of Arts and Libraries, 1989.
WILLIAMS, Raymond, *Britain in the Sixties: Communications*. Harmondsworth: Penguin Books, 1962.
WILSON, David (ed.), *Sight and Sound: A Fiftieth Anniversary Selection*. London: Faber and Faber, 1982.
WILSON, Norman, 'Film Societies – the Next Phase', *Sight and Sound*, July 1945.
WITTS, Richard, *Artist Unknown: An Alternative History of the Arts Council*. London: Little, Brown and Company, 1998.
WOODWARD, John, *A Time of Change*. London: BFI, 1998.
WOOLLOCK, Stephen, *'Coming to a Town Near You?': Cultural Policy and Identity in Local Art-House Exhibition*, unpublished PhD thesis, Norwich: University of East Anglia, 2007.
WRIGHT, Ian, 'In the Picture – Art Circuit', *Sight and Sound*, Spring 1966, p. 71.

Index

Page numbers in *italics* refer to illustrations

16 mm
 as distribution gauge 91–2, 104, 185, 286
 as production gauge 205

Abbott, John 24
Academy Cinema 70, 104, 111, 239, 247
ACAS 164, 304
ACTT 158, 186, 207, 210, 227, 228
 Workshop Declaration 210
Adair, Gilbert 248
Adam, Kenneth 197, 224
Adler, Carine 212, 298
Adorian, Paul 145, 154, 155, 226
Afro-Caribbean Unit 287
Akerman, Chantal 180
Akomfrah, John 214
Aldeburgh 105, 119, 120
Algar, Nigel 171
Alpha Fund 214–5, 298
Alvarado, Manuel 232, 284–5
Amber Films 210
Ambrose, Anna 209
Anderson, Lindsay 52, 70, *138*
 and Free Cinema 76, 81
 and MOMI 263
 and *Sequence* 34, 75, 239
 as BFI governor 111, 200, 246–7
 as critic 81, 239, 241–3
Andrew, Geoff 296
Anger, Kenneth 96, 97
Annan Committee 228, 229–31
Anstey, Edgar 32, 70, 145, 153, 159

Antonioni, Michelangelo 79, 143, 246
Army Bureau of Current Affairs 87, 98
Arts Council England 214, 287, 290, 298
Arts Council of Great Britain 30, 31, 83, 117, 118, 169, 186, 202, 222, 259
Arts Enquiry 30–1
Ascendancy 2
Ashley, Walter 19
Asquith, Anthony 14, 26, 32, 70, 79, 240
Associated–Rediffusion 222, 226, 231
Association of Independent Cinemas 124
ASTMS 162–4, 165
Aston Clinton 25, 42, 50, 52, 53, 160, 193
Aston University 127
At the Fountainhead 208
Attenborough, Sir Richard (later Lord) 79, 300
 as BFI chairman 3, 187–9, *188*, 194–5, 246, 256, 280, 287–8
Aubert, Michelle 190, 280
 see also Snapes, Michelle
avant-garde
 American 96–7
 and BFI Production 205–6
Avery, Brian 259
Aylestone, Herbert (Lord) 227

Baines, Jocelyn 113, 153
Baker, F. W. 17, 22
Baker, Kenneth 284, 285
Bakewell, Joan 300, 305
Balcon, Michael 26, 34, 110, 111, 113, 152, 158, 170, *198*, 199, 203

Baldwin, Stanley 19
Barbin, Pierre 64
Barker, Dennis 158
Barnes, Peter 77
Barr, Charles 244
Barry, Iris 14, 24, 47
Battleship Potemkin 19, 78
Bauer, Hilary 256, 257
Baxter, Brian 83
Bazalgette, Cary 263, 284–5
Bazin, André 240
BBC 32, 191, 207, 213, 220, 222, 223, 224, 226, 228
 and *The War Game* 107–8
 BBC2 187, 234, 285
 BBC Radio 192
 Third Programme 88
'BBC Charter Review' 234
Beadle, Gerald 221
Beau Serge, Le 76
Beaufoy, Simon 212
Beautiful People 214, 215
Becker, Jacques 75, 241
Beddow, Charles 259
Before Hindsight 208
Belfast 20, 105, 120
Bell, Oliver 16, 21, *22*, 25, 32, 58, 90
Bennett, Ed 2, 208
Beresford, Bruce 110, 166, 169–70, 202–3, *203*
Berg, Eddie 305
Berger, John 283
Berger, Jürgen 266, 277–8
Bergman, Ingmar 76, 124, 143, 243, 246
Berkhamsted 42, 46, 104, 108, 160, 185, 192, 237
 Conservation Centre 192–3, 195, 281, 289
Berlin Film Festival 2, 211
Bernstein, Sidney 36
Berwick Street Collective 206
Bevan, Tim 307
BFFS
 see British Federation of Film Societies
BFI
 see British Film Institute,
BFI Awards 187–8
BFI in the Eighties, The 272
BFI News 126, 158, 288
BFI Southbank 264, 306
BFI TV 285, 286, 295, 298

'BFI 2000' 269, 292
BFI Video 286
 see also Connoisseur Video
Bicycle Thieves 78, 240
Birkbeck College 232, 282
Birmingham 89, 105, 119, 124
 Film and Video Workshop 210
 Film Society 99–100
 Arts Lab 127
 Midland Art Centre 61–3, 105

Birth of a Nation, The 78
Biskind, Peter 250
Black and White in Colour 234, 285
Black Film and Audio 186
Black, Peter 222, 224
Blakemore, Lorraine 4
Blease, W. Lyon 92
Blue Lamp, The 240–1
Boetticher, Budd 79, 142, 242
Bond, Ralph 89, 158
Boorman, John 187
Borde, Raymond 54, 56, 61
Boyle, Edward 41
Boyle, Mark 202
Bradford 105, 120
 National Museum of Film, Photography and Television 269, 305
Bradshaw, Ben 308
Brakhage, Stan 96
Bramble, A. V. 240
Brandes, Lawrence 255
Brass, Sir William 18, 26
Bresson, Robert 79, 241
Brien, Alan 240
Briggs, Asa 113, 145, 153
 Briggs Report 145–6, 154–5
Brighton 20, 105, 119, 120, 125, 127
Bristol 120, 127, 185
 Arnolfini Galley 127
 Watershed 127–8, 190, 233
British Board of Film Censors 18, 31
British Federation of Film Societies (BFFS) 176, 187
 Film Societies Unit 176
 see also Federation of Film Societies
British Film Academy 26–7, 34, 220
British Film Authority 173, 174, 228, 230, 294
British Film Commission 274
British Film Institute

Constitution and Aims and Articles of Association 17, 31, 41, 111–12, 189, 221, 222, 299
Royal Charter 3, 173, 188–9, 273, 300, 307
for BFI departments, personnel, etc., see individual entries
British Film Producers Association 32
British Film Production Fund 31, 37
British Film Year 187
British Institute for Adult Education 15, 20, 237
British Instructional Films 17
British Kinematograph Society 18, 21, 51
British Library 282
'British New Wave' 81, 243, 246
British Universities Film Council 145
Broadcasting Act (1990) 233
'Broadcasting Debate, The' 234, 273
Broadcasting Research Unit 191, 232
Broadcasting Standards Commission 273
Brooks, Sid 185
Broomfield, Nick 206
Brown, Harold 50, *53*
Brown, J. W., 15, 17, 18, 20, 21, 23
Brownlow, Kevin 52, 109
Winstanley 204
Brunel, Adrian 14
Buchan, John 17
Buñuel, Luis 75
Burton, Nick 208
Butler, Ivan 3–4
Butler, R. A., 30, 37, 137
Butler Report on Secondary Education 30
Buscombe, Ed 183, 232, 283–4

Cagney, James *39*
Cahiers du cinéma 241–4
Cameron, A. C. 15, 17, 20, 23, 237
Cameron, Ian 136, 243–4, 247
Camplin, R. S. (Bob) 33. 41, 157, 158, 169, 230
Cannes Film Festival 38, 209, 211, 215, 294
Caravaggio 211
Cardiff 120
Carné, Marcel 189
Carnegie Trust 16
Carter, Angela 250
Casson, Lady (Margaret) 173

Catalogue of Stills, Posters and Designs 183–4
cataloguing rules (NFA) 54
Cavalcanti, Alberto 197
CEA 17, 32, 37, 77–8, 124
Cecil, Lord David 15
Central Booking Agency 36, 42, 90–1, 92, 95, 96, 104, 171
Central Office of Information 32, 34
Centre national de la cinématographie 174, 294
Chabrol, Claude 76, 243, 265
Channel 4 2, 3, 176, 185–6, 187, 190, 194–5, 209–10, 212, 213, 229, 232, 233, 235, 295
Channon, Paul 109, 186–7
Chorus Line, A 248
Christie, Ian 171, 182, 185, 286
Christie, J. S. 165
Churchill, Joan 206
Cinema Book, The 183
Cinema One 141, 247
Cinema Quarterly 89
Cinémathèque de Toulouse 56, 63
Cinémathèque française 24, 46, 47–50, 52, 55–7, 59, 69, 79, 111
Cinematograph Exhibitors Association *see* CEA
Cinematograph Fund 37, 39, 42
Clair, René 75
Classic Cinemas 78, 105
Clarke, Jane 290, 294, 295
Cleland, Sir Charles 16–18
Clément, René 79
Close Up 14
Coalition government (2010) 3, 308
Cocteau, Jean 79, 241
Coe, Brian 262
Coldstream, Sir William 102, 109, 111, 113, 147, 152–3, 173, 226, 247
Collard, Paul 265, 278–9
Collins, Norman 32, 137
Collins, Richard 298, 300, 305
Combs, Richard 248, 249
Commission on Educational and Cultural Films 15–17, 18
Committee on Visual Aids in Education 26
Communist Party 95–6
Connoisseur Video 286
Conservative governments
(1951–1964) 34, 72, 198

(1970–1974) 128, 152, 156, 169, 202
(1979–1997) 232, 287, 289
coalition with Liberal Democrats (2010) 308
Contemporary Films 95–6
Contrast 221, 222, 223, 224–6
Cook, Jim 147, 156, 285
Cook, Pam 248
Cooke, Alistair 237
Copyright Act (1951) 35
Copyright, Designs and Patents Act (1988) 232
Corbett, Janet 262
Cornerhouse (Manchester) 2, 105, 128
corporate plans 272–3, 276–7, 283
 'BFI 2000' 269, 292
Cramp, C. T. 16
Crow, R. W. 18, 20, 21
'Crystal Wave' 291
Cukor, George 79
Czechoslovakia 49, 79

Dalton, Hugh 30
Dartington Hall Trust 30
Davies, Brenda 38, 166, 190, 192, 230
Davies, Terence 211
 Distant Voices, Still Lives 211
 The Long Day Closes 1
Davis, John 111, 158, 159
Dawson, Jan 165, 248
Day, Will 55
De Feo, Luciano 23
De Sica, Vittorio 75, 240, 241
Deahl, Ray 299
Dearing, Ron 295
DEFA 81
Definition 244, 247
Department for Culture, Media and Sport 294–5, 296, 298–300, 304–5, 307–8
Department of Education and Science 102, 106, 156, 157–8, 168–9, 208, 227, 229, 255
Department of National Heritage 274, 282, 293, 294
Department of Trade and Industry 274
Deren, Maya 96, 97
Design Council 30, 31
Despins, Chuck 205
Dibb, Mike 174, 207
Dickinson, R. W. 21, *22*, 32, 238

Dickinson, Thorold 26
Distribution Department/Division 182, 184–6, 190, 285–6
 see also Film Availability Services; Film Services
Distribution Library 40, 106, 160–1, 166, 171
Dizdar, Jasmine 214, 215
documentary 238
 documentary movement 15, 239
 BFI productions 206
Dodd, Philip 250, 284
Donachy, John 287
Donen, Stanley 79, 240, 242
Donnebauer, Peter 206
Donner, Clive 111
Don't Get Me Started 289
Douglas, Bill 2, 204, 211
Doyle, Barry 120
Draughtsman's Contract, The 1, 2, 210
Drew, Wayne 188
Dupin, Christophe 4–5
Durgnat, R. E. (Raymond) 43, 242, 244
Dwoskin, Stephen 205
Dyer, Peter John 136, 244
Dyer, Richard 183
Dyke, Greg 306, 307

Eady Levy 37, 72, 203, 211
Eady, Sir Wilfred 72
Ealing Studios 240
Eccles, David 152–3, 156, 170, 203
Edinburgh 89
 Film Festival 93–4, 116
 Film Guild 94
 Television Festival 231, 232
Editorial Department 166, 182, 232
Education Advisory Service (EAS) 146–8, 156, 166, 182, 232
Education Department (BFI) 42, 104, 114, 125 133–45, 182, 284–5
 expansion in 1960s 139–144
 in 1970 crisis 112–13, 145–7, 154–7
Eisner, Lotte 50
Eisenstein, Sergei 75, 95, 143, 238
Ellis, Caroline 267, 279, 296
Ellis-Jones, Barrie 182, 273, 275, 276
Elton, Arthur 32
Empire Marketing Board 21
Engholm, Basil 166, 175–6, 179–80, 188–9, 191

Index

and MOMI 252
Ericsson, Peter 239
Ervine, St John 15
Etherley, Gill 205
Eurimages 274, 275
Evans, Matthew 187, 195, 250, 294
Evening Standard 289
Executive Committee 180–1
Experimental Film Fund 2, 34, 104, 106, 109, 199–202

Farr, William 21
Fassbinder, R. W. 163
Federation of British Industries 15, 17
Federation of Film Societies 92–3, 94–5, 98
 viewing sessions 94–8
Fellner, Eric 307
Festival of Britain (1951) 34, 37, 71–2, 197–8, 219, 259
Feuillade, Louis 79
FIAF 24, 46, 47–9, 58–60, 61–3, 65, 162
Film (periodical) 97, 98, 121, 244
Film and Video Library 184
 see also Distribution Library
film appreciation 42, 87–91, 125, 140, 220
Film Appreciation and Distribution 133–4
Film Availability Services (FAS) 125, 163, 166, 168, 170–2, 174, 232
Film Centre (BFI, projected) 305, 307, 308
film centres (regional) 126–7, 185
 see also Watershed, Cornerhouse
Film Council
 see UK Film Council
film culture 1–2, 14–15, 98–100, 111, 116, 126, 144, 145, 155, 187, 190, 250
Film in National Life, The 16, 21, 22, 69, 237
film institute societies 20, 89
Film London 305
Film Policy Review 294, 296, 298
 'A Bigger Picture' 298
Film Services 106–8, 142, 164–6
film societies 87–101, 122–3
 and film culture 98–100
 programming 96–7
 relations with BFI 89–93
 see also Federation of Film Societies
Film Society, the 14, 59
Film Teaching 140

Film Workshops 185–6
Films on Offer 171
Fleming, Anne 292, 295
Flower, F. D. 140
Ford, Colin 109, 153
Ford, John 75, 77, 79, 239, 242
Foreign Office 35, 79, 81
Forman, Denis
 as director of the BFI (1949–55) 32–6, 33, 37, 38, 64, 69, 70, 71–2, 73, 76, 93, 198–9, 219, 239, 241, 296
 as chairman (1971–3) 58, 147, 152–4, 156, 157–8, 159, 161, 170, 172, 228
 at Granada Television 64, 182, 220, 221, 227
Forman, Helen 109, 111, 145, 153, 154
Foster, Norman 161
Fountain, Alan 209
France 79
 see also Cinémathèque française, French New Wave
Francis, David 65, 162, 166, 172, 183, 184, 189, 279–81
 and MOMI 253, 261–2, *266*
Franju, Georges, 47, 79, 96
Fraser, Robert 222, 227
Frayling, Christopher 195
Frears, Stephen 202
Free Cinema 43, 76, 81, 200–1
Free Communications Group 228
Freed, Arthur, 238
Freeman, John 172–3, 228, 230
French, Henry 32, 37, 70
French Institute
 see Institut Français
French New Wave 43, 76, 111, 143, 243
Frontroom Productions 210
Fuller, Samuel 79, 136
Fuller, W. R. 32, 70
Funding and Development (BFI) 185, 186, 273, 275
Furber, Bobby 164

Gallivant 214
Garnham, Nicholas 158, 165–6, 175, 176, 228, 229
Gavin, Barrie 166, 205–6
Germany
 Nazi period 23, 81
 East (GDR) 81

Getty, Sir John Paul 3, 185, 191–3, *192*, 258, 272, 276, 277, 281, 292–4, 295
Gibson, Ben 212–3, 283
Gidal, Peter 205, 206
Gillett, John 78
Gladwell, David 205
Glasgow 89, 105, 117, 119
Glenbuck Films 185, 286
Godard, Jean-Luc 79, 124, 143, 246
Goebbels, Joseph 23
Gold Diggers, The 210
Goldbacher, Sandra 212
Gordon, David 187
Gordon Walker, Patrick 26, 32
Gott, Sir Benjamin 15
Gough-Yates, Kevin 161–2, 164, 168, 255
Gowrie, Grey (Earl) 186
GPO Film Unit 23
Grade, Leslie 121
Grade, Michael 194–5
Graef, Roger 194, 228, 247
Granada Television 153, 162, 182, 22, 227
Granta 244
Grasshopper Film Group 97, 201
Greater London Council 186, 259, 287
 see also London County Council
Greenaway, Peter 210, 215
 A Walk through H. 209
 The Falls 209
 A Zed and Two Noughts 211
Greene, Hugh Carleton 107
Grierson, John 32, 33, 238, 239
Griffith, D. W. 70, 75, 79
Grigor, Murray 116
Groombridge, Brian 137–8, *138*
Guardian, The 158
 Guardian lecture 270
Gulbenkian Foundation 199

Hall, Stuart 138, *138*, 227
Halliwell, Leslie 123
Hamilton, Jim 296
Hancock, Margaret 92–3, 94
Harcourt, Peter 139, 140, 141, 143
Hardcastle, Leslie 162
 and the National Film Theatre 106, 166, 172, 184, 189, 278
 and MOMI, 176, 19, 252, 261, 263, 265, 266, *266*, 267

Harris Films 185
Hartnoll, Gillian 190, 231
Hassan, Mamoun 166, 170, 204–5, 206
Hatton, Maurice 110–112
Hauser, Arnold 238
Hawks, Howard 75, 79, 143, 242, 244
Hayward Gallery 259
Healey, Denis 180
Heard, Mo 264
Hebron, Sandra 305
Hensel, Frank 24
Herostratus 110
Hibbin, Nina 126
Higgins, A. P. (Tony) 136, 227
Hill, Alan 157, 159, 162, 164–6, 168–9
Hill, Charles (Lord) 222–3
Hill, Frank 32, 70
Hill, John 210
Hillier, Jim 144, 174
History of the British Film. The 27
Hitchcock, Alfred 14, 70, 75, 79, 238, 242, 244
Hoare, Frank 78
Hoberman, J. 250
Hodgkinson, Tony 134
Hodson, Denys 287
Hoellering, George 111, 113, 247
Hoggart, Richard 226
Home Office 18–19, 107, 186, 274
Hornsey College of Art 142, 143
Housing the Cinema Fund 118, 119, 179
Houston, Penelope 34, 79, 106, 111, 136, 166, 172, 224, 226, 228, 239, *240*, 241–2, 243–50, 284
Howden, Alan 121, 299
Howe, Elspeth 191, 255
Howe, Geoffrey 180, 191
Hoy, J. H. 32
Hull and Humberside 119, 120, 122
Humanities Curriculum Project 144
Hunt, Jeremy 308
Huntley, John 77, 78, 106, 119, 122, 127, 134, 135, *138*, 143, 164–6, 168, 171, 224

'Imagination Network' 291
IMAX 267–9, 289–90, *290*, 291, 293–4, 295, 306
Independent Broadcasting Authority (IBA) 228
Independent Filmmakers' Association

Index

(IFA) 203, 207, 210
Independent Television Authority (ITA) 222–3, 224, 226, 227
Independent Television Commission (ITC) 235
Information
 see Library and Information
Information Division 182–4, 191
Inner London Education Authority (ILEA) 147
Institut français, Kensington 70, 94
International Institute of Educational Cinematography 14, 18, 23
Isaacs, Jeremy 187, 190, 194–5 *208*, 209
Istituto Luce 23
Italy
 Fascist period 23
 postwar 79
 neo-realism 241
ITV companies 176, 222–3, 227, 228, 233
 Independent Television Companies Association (ITCA) 211, 229, 231
 archiving of ITV programmes 274
Ivens, Joris 97

Jacey Cinemas 120, 125
Jackson, Jane 209
Jackson, Kevin 250
Jackson, Michael 233
James, Nick 250
Jarvie, Ian 213
Jeavons, Clyde 161, 190, 281, 292
Jenkins, Hugh 3, 166, 168
Jenkins, Steve 248
Jenkinson, Philip 158, 165, 229
Jennings, Humphrey 75, 79, 239, 250
John Player Lectures 82
Joint Council for Education through Art 136
Julien, Isaac 234
Juvenile Liaison 173–4, 206–7

Kael, Pauline 242
Kazan, Elia 242–3
Keen, Jeff 202
Keiller, Patrick 212
Kennedy, Anthea 208
Kenny, Anthony 282
Kerr, Dr David 109, 111, 113, 158, 226, 282

Kinematograph Renters Society
 see KRS
King, Cecil 32, 36, 137, 241
Kitses, Jim 133, 141, 142, 143
Klein, Carola 209
Knowles, Alan 166, 171–2, 182, 188
Kosminsky, Peter 234
Kötting, Andrew 212, 214
KPMG 296
KRS 15, 32, 37, 90, 160, 164
Kwietniowski, Richard 212

Labour governments
 (1945–1951) 1, 25, 30–2
 (1964–1970) 2, 102, 104, 116–18, 226
 (1974–1979) 166, 169, 180
 (1979–2010) 274, 294, 307
Lambert, Gavin 34, 70, 74, 75, 239–41, *240*, 243, 296
Lambert, R. S. 16, 17, 19, 22, 237
Lambert, Verity 190
Lambeth, London Borough of 259
Lang, Fritz 75, 79, 240, 242
Langlois, Henri 24, 46–65, *62*, *64*, 74, 79, 111
Lassally, Walter 200
Lawson, John 17
Le Grice, Malcolm 205
League of Nations 14, 21, 23
Lean, David 26, 27, 79, 189, 241
Leat, Mike 164
Leavis, F. R. 135, 138, 140
Ledoux, Jacques 56, 61
Lee, Jennie 3, 56, 83, 102–3, 106, 109, 110–11, 118, 142, 201–2
Lejeune, C. A. 237
Lennon, Peter 174, 207, 229
Levita, Cecil 17, 18
Levita, Florence (Lady) 17, 18
Levy, Don 110
Lewis, Jonathan 208
Library and Information Services 36, 38, 106, 108, 162, 183, 193, 262, 276, 283, 295
 and television 220, 227, 231
Lindgren, Ernest 22, *22*, 23, 24, 25, 32, 34–5, 38, *51*, 69, 70, 73, 74, 106, 109, 146, 147, 197, 220, 223–4, 227, 281
 and Henri Langlois 46–65
 role in 1970 crisis 155, 156, 161–2

Listener, The 16, 19
Liverpool 125
 see also Merseyside
Liversidge, H. 126
Livingstone, Ken 186
Livingstone, Percy 229
Lloyd, Dennis (Lord Lloyd of Hampstead) 161–2, 168, 172
Lodge, Derek 273
Loach, Ken 189
London County Council (LCC) 38, 72, 78, 81
 see also Greater London Council
London Film and Video Development Agency (LFVDA) 287
London Film Festival 38, 43, 78, 110, 116, 277–8
London Film Institute Society 21, 59
London Filmmakers's Co-op 205
London Weekend Television 172, 173
London Women's Film Group 206
Lottery
 see National Lottery
Love Is the Devil 214, 298
Lovell, Alan 100, 121, 136–7, 141, 142, 143, 156, 244, 247
Low, Rachael 16, 27
Lowndes, Douglas 143, 147, 163, 166, 172, 176, 232
Lubbock, Eric 109
Lucas, Keith 159–61, *160*, 162, 164–8, 172–6, 194, 228, 230–1
Luce, Richard 186
LWT *see* London Weekend Television

McArthur, Colin 125–6, 147, 163, 166, 168, 171, 172–3, 175, 182, 184, 188
MacCabe, Colin 190, 211, 212–3, 249, 263, 273, 280, 282–5, 298
Mackendrick, Alexander 159
McLaren, Norman 70, 79
Madden, Paul 231, 233
Magdalen College, Oxford 195, 286
Major, John 274
Malcolm, Derek 277
Malraux, André 55
Man with a Movie Camera 98
Manchester 20, 89 105, 119, 120, 124, 182
 Cornerhouse 127, 128
Mannoni, Laurent 56
Manvell, Roger 25, 27, 52, 240

Markle Foundation 191
Marmot, Janine 213
Martin, Angela 183
Matheson, Margaret 190, 283
Matias, Diana 155
Mazzetti, Lorenza 76, 200
Maybury, John 215, 298
Meadows, Shane 213
MEDIA Programme 274
Meeker, David 171, 284
Mellor, David 293
members and membership 36, 70, 73–4, 114, 152, 157–8, 189, 249, 286
 in Regional Film Theatres 123
 member governors 157–8, 165–6, 288, 289
Members Action Committee 2, 112–14, 121, 125, 157, 158, 171, 247
Menage, Chiara 213
Merseyside 20, 105, 125
Michelle, Marion 61–3
Miller, Hugh 14
Milne, Tom 245, 248, 250
Minghella, Anthony 305, 306
Ministry of Education 138–41
Ministry of Information 25, 31, 32, 91
Minnelli, Vincente 79, 238, 239, 242
Moholy Nagy, László 238
Mollo, Andrew 204
MoMA 24, 47, 69
MOMI 3, 176, 191, 193, 234, 252–70, 277, 291, 295, 296, 298, 305
 Actors Company 264–5
 MOMI Education 263–4
Momma Don't Allow 200
'Mongoose case, the' 19
Montagu, Ivor 14, 90
Monthly Film Bulletin (*MFB*) 20, 33, 39, 97, 136, 238–49
Morgan, Rod, 258–9
Morrison, Herbert 3, 26, 31, 32, 37, 103
Motion 244, 246
Movie 79, 136, 141, 244–5, 246, 247
Mulloy, Phil 208
Mulvey, Laura 209, 210, 282
Murnau, F. W. 143, 237
Museum of Modern Art, New York
 see MoMA
Museum of the Moving Image
 see MOMI
Museums and Galleries Commission 267
Museums Association 261–2

Index

My Childhood 204, 211
Myer, Carole 210
Myres, J. L. 15
Myles, Lynda 214

National Audit Office 267, 288–9, 305
National Cinema Centre (BFI, projected) 269, 291, 295, 298
National Film and Television Archive (NFTVA)
 see under National Film Archive
National Film Archive 2, 40, 161–2, 279–81
 access 190–91, 279–80, 281–2
 'an Archive for the 21st century' 292, 294
 and the NFT 74, 75
 and statutory deposit 109, 282
 and Stills Department 183
 and television 2, 219, 220, 221, 223–4, 227, 230, 232, 234
 as National Film and Television Archive 274, 291, 293, 296
 cataloguing 54–5, 280
 expansion in 1950s and 1960s 42, 104, 108
 nitrate programme 170, 281
 premises 160
 see also Aston Clinton; Berkhamsted
 status within BFI 58, 106, 154, 162, 182, 186, 296
 support from J. Paul Getty 192, 293
National Film Finance Corporation 186, 202, 208, 210
National Film Library 1, 2, 21–3, 24, 25, 31, 32, 34, 35, 42, 46, 48–50, 57, 69, 89
National Film School 104, 202, 232, 298
National Film Theatre (NFT) 69–83, 104, 188, 190, 191
 and education 136, 142
 and MOMI 264, 273
 and the Cinémathèque française 58
 and the film trade 37, 77–8
 as part of BFI South Bank 277–9, 291, 305, 305
 criticisms of 75, 98, 213
 devolution from BFI mooted 154, 186
 early years at Telecinema building 35–6, 73–4
 finances 83, 277–9, 306

 Free Cinema screenings 76, 200
 London Film Festival 78, 278
 NFT 2 83, 110
 preceded by screenings at Institut Français 69
 programming 74–82, 278
National Lottery 214, 289–90, 291–2, 293, 298, 309
 Alpha Fund 214–5, 298
 Heritage Lottery Fund 269, 292
National Museum of Film, Photography and Television 269, 305
National Union of Teachers 136, 137, 221
Nelson, Ian 276, 295
Neubauer, Vera 208, 209
Nevill, Amanda 305, 307
Newby, Chris 212
New London Film Society 59
New York Film Festival 78
Newbigin, John 294
Newcastle 105, 120, 125, 127
 Amber Films 127
 Tyneside Film Theatre 125, 190
Newsom Report 226
Newsreel Collective 206
newsreels 34, 35
nitrate film stock 18, 54, 170, 281
Norman, Barry 234, 270
Normanbrooke, Lord 107
Northern Ireland 105, 206, 287
 see also Belfast
Nottingham 105, 119, 120
 Broadway 128
Nouvelle vague
 see French New Wave
Nowell-Smith, Geoffrey 4, 175, 183

Oakes, Philip 207
O'Brien, Margaret 263–4
O'Leary, Liam 60
Observer, The 13, 243
Occasional Publications Committee 183, 232, 248
Ofcom 235
Office of Arts and Libraries 180, 186, 253, 256, 273, 274, 276, 282, 288
Ogborn, Kate 213
Olivier, Laurence 26
On the Waterfront 243
'One Day in the Life of Television' 234
Ophuls, Max 239, 240, 241, 286

O'Pray, Michael 210
Ormiston, Thomas 17
O'Sullivan, Thaddeus 208
Other Cinema, The 207
Ové, Horace 2, 206
Oxford Opinion 75, 136–7, 234–5
Oxford University Film Society 239

Pabst, G. W. 75, 237
Pack, Jill 283
Painlevé, Jean 63, 96
Pao, Sir Yue-Kong 191, 255
Parker, Alan 215, 269, 270, 295, 298–300, 306
Paterson, Richard 4, 233, 283, 285, 292, 295
Patton, John 285
Peck, Ron 213
Peddie, J. M. 32
Penguin Books 87
Periodicals Department 284
 see also Editorial Department
Perkins, V. F. (Victor) 75, 113, 136, 141, 158, 243–4, 247, 297
Petit, Chris 2, 207, 208, *208*, 209
Pilkington Committee and Report 221–2, 224
Planning Unit 275, 279, 286–7
Plato (film distributor) 95–6
Policy for the Arts, A (1965) 118
Policy Group 181
Policy Review (1970) 113, 152, 153, 162, 164, 173
 Policy Report (1971) 153–4, 160
Popular Arts, The 100, 138, 227
Porter, Vincent 185
Potter, Neal 259–60, 262, 264, 270
Potter, Sally 210, 212
Pound, Stuart 205
Powell, Dilys 32, 78
Powell, Michael 26, 189
Powers, John 250
Preminger, Otto 79, 163, 242
premises 17, 25, 38–9, 42, 79, 160, 163, 192–3, 242
Pressburger, Emeric 26, 189
Prescott, Michael 267, 273, 275–6, 281, 283, 286, 288, 290
Pressure 2, 206, 207
Price, Harry 19, 22
Prince of Wales *188*, 189, 264

Privy Council 16, 18, 26, 37, 39, 299
 Lord President of the Council, 26, 31, 37, 39, 41, 102
Production Board 2, 153, 186–7, 202–16
 and art cinema 209–11
 and Channel 4 185–6, 209–10, 211
 and Production Department 173–4, 206–7, 212, 213
 and radical avant-garde 205–6, 208–9
 demise 213–6
 growth in 1970s
 move into feature production 203–4
 premises 160–1
 regional production 210, 212
 replaces Experimental Film Fund 104, 109–10, 202
 see also Alpha Fund; Film Workshops
'Project Rosebud' 304
Projects (successor to Regional Department) 184, 185
Prouse, Derek 76
Przibram, Heini 98
Publishing Department 183–4, 283–4
Purser, Philip 226
Puttnam, David 294
Pym, John 183, 245, 249

Quay brothers 209, 212
Queen's Film Theatre (Belfast) 105
Quinn, James
 and regional expansion 104, 110, 117, 118–9, 124, 246
 and television 220–6
 as director 36–9, *39*, 42, 58, 63, 64, 74, 78, 102

Raban, William 205
Radcliffe Committee and Report 1, 31–2, 37, 39, 40, 70, 103, 113, 117, 197
Radcliffe, Sir Cyril 1, 31
Radio On 2, 208, 209
Radio Times 220, 231
Rank, J. Arthur 70
Rank Organisation 111, 159
Rapunzel Let Down Your Hair 208, 209
Rawlinson, Gerry 168–9, 175–6, 179, 183, 184, 193–4
 and MOMI 252, 256, 258
Ray, Nicholas 79, 239, 242
Ray, Satyajit 76, 189, 243

Index

Reed, Carol 26, 70, 241
Reed, Stanley
 and education 133–4, 143–4
 and Ernest Lindgren 57, 58, 60
 and the NFT 74, 77, *77*
 and the regions 42, 117, 120, 122
 as BFI secretary 41, 117, 140
 as director 102, 107–9, 159, 173, 202
 1970 crisis 145–7, 153–5, 157, 247
Rees-Mogg, William 259, 273
Regional Arts Associations 126–7, 171, 173, 286–7
Regional Department 125, 166, 169, 170–2, 173, 174, 182, 184
Regional Film Theatres 2, 104–6, 118–22, 122–5, 126–8, 170–1, 185–6, 191, 207, 246, 286
Regional Production Fund 210, 212
regions 31, 103, 104, 116–28, 169, 170–1, 289
Reichsfilmarchiv 24, 47
Reisz, Karel 52, 137
 as critic 34, 239, 240, 243
 as film-maker 2, 76, 81, 200, 215, 246
 as BFI governor 111, 246–7
 as NFT programmer 34, 74, 75, 76, 81, 248, 296
Relph, Michael 203, 230
Renoir, Jean 21, 75, 79
Research and Information Division 273, 282–5
 reconfigured as Research and Education 283
 split 285
research fellows 282–3
Resources Committee/Group 180–1
Rhodes, Lis 213
Rhodes, Richard 172
Rich, B. Ruby 250
Richard Rogers Partnership 291
Richardson, Alex 141
Richardson, Dorothy 14
Richardson, Tony 2, 76, 111, 200, 243, 246
Riddles of the Sphinx, 209
Riefenstahl, Leni 81
Rive, Kenneth 121
Roberts, S. C. 36, 37
Robinson, David 65, 76, 224, 242, 262, 269, 290
Rohdie, Sam 147, 155–6

Rohmer, Éric 241
Rossell, Deac 278, 279
Rossellini, Roberto 96, 241
Rotha, Paul 21, 26, 52, 237
Roud, Richard 54, 65, 76, *77*, 78–9, 82, 110, 244
Royal Charter
 see under British Film Institute
Royal College of Art 30, 159
Russell, Lee 141
Russell, Patrick 65
Russell Taylor, John 64

Sainsbury, Peter 166, 173–4, 190, 205, 206–9, 211
Salles Gomes, Walter 57
Salmi, Markku 183, 284
Samuel, Herbert 16
Sankofa 186
Sapper, Alan 228, 230
Saturday Night and Sunday Morning 243
Saunders, Vernon 153, 157
Schlesinger, John 111
Schou, Henning 281, 292
Scientific Film Association 37
Scott, Ridley 2, 215
Scott, Tony 202, 203
Scottish Federation of Film Societies 92, 94
Scottish Film Council 37
Screen 144, 146–7, 154–6, 172, 232
Screen Education 232
Screenonline 234, 235, 306
SEFT (Society for Education in Film and Television) 137, 139, 141, 146–7, 154–6, 221, 222, 227–8, 284
 Society of Film Teachers (SFT) 133–4, 136, 137, 147, 221
Sequence 33–4, 238–40
Shannon, Roger 215
Shapiro, Susan 208
Shaw, Colin 273
Shaw, Roy 139, 224
Sheffield 120
 Millennium Gallery 270
Shell 38, 110
Shukri, Chet 256, 276
SIFT 276, 292
Sight and Sound 237–50
 and art cinema 104, 246, 249
 and television 220, 221, 226, 228

circulation and readership 36, 42, 99, 111, 113, 172, 246, 247, 250
criticisms of 111, 136, 243–4, 246–7
and *Sequence* 34–5, 238–9
Forman reforms 33–4, 35–6, 238–9
foundation and early years 1, 20, 21, 25, 33–4, 35–6, 237–8
1990 relaunch 249–50
Simon, Sion 307–8
Simpson, Philip 183, 263, 284
Sinden, Tony 202, 205
Smith, Anthony 3, 176, 179–95, *181*, *208*, 209, 211, 232, 248, 272, 284, 286
and MOMI 192, 252, 257–8
and sponsorship 191–2
Smith, Chris 215, 294, 300, 304
Smith, Peter 204
Smither, Roger 51, 56, 65
Snapes, Michelle 183, 190
see also Aubert, Michelle
Society for Education in Film and Television
see SEFT
Society of Film Teachers
see under SEFT
Sontag, Susan 246
Sorensen, Colin 261–2
So That You Can Live 206
South Bank (London) 38–9, 71, 78, 81–2, 259, 291
BFI South Bank 272–3, 277, 291, 305, 306
statutory deposit 35, 109, 282
Stevas, Norman St John 186–7
Stevenson, Wilf
as deputy director 5, 194
as director 234, 267, 272–94, *275*
Stewart, Heather 286, 305
Stills, Posters and Designs 108, 222, 262, 272, 276
Stone, Rodney 186, 257–8
Stoy Hayward 255, 257, 276, 289
'structured programming' 125–6, 171, 175
Summer Schools 25, 53, 134–5, 139, 142–3, 179–80
Sunday Entertainments 16, 29, 39, 222
Sutherland, Duke of 18
Sutherland Trophy 187

Tati, Jacques 241, 251, 286
Taylor, Dr Stephen 32

Taylor-Mead, Elizabeth 208
Teckman, Jon 269, 300, 304–5
Telecinema, the 2, 34, 37, 71–3, *71*, 198–9, 259
Television, BFI and 219–235
see also BBC, ITV
'Television Monographs' 229, 232
Templeman, Connie 208
Thames Television
Viewpoint 232
Thatcher, Margaret 180, 186, 274
They Live by Night 239
Thomas, Howard 176, 228, 229
Thomas, Jeremy 287–9, 209, 294–5
Thomson McLintock 276
Thompson, John O. 282
'360 films' 260, 277, 279
Till, Stewart 306–7
Time Out 112, 209, 296
'Treasures of the Film Archive'
see '360 films'
Treasury, the 32, 33, 38, 42, 70, 72, 82, 83, 102, 117–8, 140, 168–9, 221, 274
Organisation and Methods branch 39–42
Trnka, Jiří 97, 238
Truffaut, François 76, 241
Tsivian, Yuri 282
Turniphead's Guide to the British Cinema, A 295
TV Projects Group 233
TV Times 231
Tweedsmuir, Lady 32
Tyneside see Newcastle

UK Film Council 3, 215–6, 235, 298–300, 304–5, 306–9
Ulrich, Walter 175
Under the Skin 298
Unit Five Seven 201
University of London Extra-Mural Department 134
University of Oxford 286
University of Warwick 147

Vaizey, Ed 308
Vaughan, Hemming 89
Vaughan, Olwen 21, 24, 25, 59–60, 65, 89
Vaughan Thomas, Wynford 225
Venice Film Festival 38, 211
Vertov, Dziga 89

Index

video 185, 286
Vidor, King 79
Visconti, Luchino 79

Wales 287
Waley, H. D. *22*
Walker, Alexander 288–9, 290
War Game, The 107–8, 165
Warner, Marina 283
Warnock, Mary (Baroness) 285
Waterloo Bridge 72, 110, 289
Watershed (Bristol) 2, 127–8, 190, 233
Watkins, Peter 2, 107–8, 165
Welcome to Britain 206, 207
Weldon, Huw 107
Welles, Orson 75, 79, 189
Welsby, Chris 206
Wenders, Wim 163, 208, 286
West, Cornel 283
Whannel, Paddy 133–48, *135*, 247, 297
 and television 224, 227, 228
 as Education Officer 42, 133–38
 as head of Education Department 100, 106, 125, 139–45
 1970 crisis 145–6, 154–5
 resignation 146, 155–6
Wheare Report on Children and the Cinema 134
Whitaker, Sheila 190, 277–8, 279
White, Eirene 32, 41, 221, 222, 226
White, Rob 297
Whitehead, Irene 275–6, 286–7
Wilding, Richard 186
 Wilding Report 286–7

Willemen, Paul 297
Williams, Christopher 147
Willis, John 295
Wilson, David 183, 232, 245, 248
Wilson, Harold 72, 102, 142
Wilson, Norman 93
Winnington, Richard 240
Winstanley 204
Winterson, Jeanette 250
Wistrich, Enid 174–5
Wlaschin, Ken 82, 83, 10, 172, 190
Wolfson Foundation 259
Wollen, Peter 113, 141, 209, 210, 209, 210, 247, 297
Wood, Robin 143
Woodward, John 214–5, 269, 295–300, 304, 307
Woolf, C. M. 17
Woolf, Virginia 14
Woolford, Ben 213
Woollock, Stephen 122
Workers Educational Association 91
Wootton, Adrian 260, 278–9, 295–6, 300, 305
World Television Festival 223
Wright, Basil, 34, 70, 78
Wright, Joe 213
Wyatt, Will 194
Wyler, William 79, 97

York 119, 120, 126
Young, Colin 229

Zinnemann, Fred 242